Media Authorship

Contemporary media authorship is frequently collaborative, participatory, non-site specific, and difficult to assign individually. In this volume, media and film scholars explore the theoretical debates around authorship, intention, and identity within the rapidly transforming and globalized culture industry of new media. Defining media broadly, across a range of creative artifacts and production cultures—from visual arts to video games, from textiles to television—contributors consider authoring practices of artists, designers, do-it-yourselfers, media professionals, scholars, and others. Specifically, they ask:

- What constitutes "media" and "authorship" in a technologically converged, globally conglomerated, multiplatform environment for the production and distribution of content?
- What can we learn from cinematic and literary models of authorship—and critiques of those models—with regard to authorship not only in television and recorded music, but also interactive media such as video games and the Internet?
- How do we conceive of authorship through practices in which users generate content collaboratively or via appropriation?
- What institutional prerogatives and legal debates around intellectual property rights, fair use, and copyright bear on concepts of authorship in "new media"?

By addressing these issues, *Media Authorship* demonstrates that the concept of authorship as formulated in literary and film studies is reinvigorated, contested, remade—even, *reauthored*—by new practices in the digital media environment.

Cynthia Chris is Associate Professor of Media Culture at the College of Staten Island, City University of New York. She is the author of *Watching Wildlife* and co-editor, with Sarah Banet-Weiser and Anthony Freitas, of *Cable Visions: Television Beyond Broadcasting*.

David A. Gerstner is Professor of Cinema Studies at the City University of New York's Graduate Center and the College of Staten Island. He is the author of *Queer Pollen: White Seduction, Black Male Homosexuality, and the Cinematic* and *Manly Arts: Masculinity and Nation in Early American Cinema*. He is also editor of *The Routledge International Encyclopedia of Queer Culture*, and co-editor with Janet Staiger of *Authorship and Film*.

Media Authorship

EDITED BY
CYNTHIA CHRIS AND
DAVID A. GERSTNER

Routledge
Taylor & Francis Group

NEW YORK AND LONDON

First published 2013
by Routledge
711 Third Avenue, New York, NY 10017

Simultaneously published in the UK
by Routledge
2 Park Square, Milton Park, Abingdon, Oxon OX14 4RN

Routledge is an imprint of the Taylor & Francis Group, an informa business

Library of Congress Cataloging in Publication Data
Media authorship / edited by Cynthia Chris and David A. Gerstner. – 1st [edition].
 pages cm – (AFI film readers)
1. Arts–Authorship. 2. Creation (Literary, artistic, etc.) I. Chris, Cynthia, 1961- editor
of compilation. II. Gerstner, David A., 1963- editor of compilation.
NX195.M43 2012
302.23–dc23 2012023370

ISBN: 978-0-415-69942-6 (hbk)
ISBN: 978-0-415-69943-3 (pbk)
ISBN: 978-0-203-13601-0 (ebk)

Typeset in Spectrum MT
by Cenveo Publisher Services

SFI Certified Sourcing
www.sfiprogram.org
SFI-00453

Printed and bound in the United States of America
by Edwards Brothers, Inc.

For Peter Wollen

contents

figures

acknowledgments

It may be a commonplace that every book is a collective effort, but this one has been, for the co-editors, an exemplary experience in collaboration. We begin to acknowledge comrades in this project by thanking Erica C. Wetter and Margo Irvin of Routledge, Aiswarya Narayanan and other key Taylor & Francis production people who have buoyed this project from the start with encouragement and procedural expertise, and AFI Readers series editors Charles Wolfe and Edward Branigan, for their faith in this volume and sage advice.

We thank the extraordinary bunch that we call our colleagues at the Department of Media Culture at the College of Staten Island, which provides the setting for much of our work together: faculty members C. W. Anderson, Jillian Baez, Racquel Gates, Michael Mandiberg, Tara Mateik, Edward D. Miller, Sherry Millner, Jason Simon, Valerie Tevere, Cindy Wong, Bilge Yesil, Ying Zhu, as well as staff members Janet Manfredonia, Rosemary Neuner-Fabriano, and John Szelgua, for their day-to-day support and good cheer. Liza Zusman, a graduate of CSI's Cinema Studies Program, performed astonishingly efficient research assistance during the manuscript's preparation. Special thanks to Catherine Burke for her thorough and comprehensive indexing. The City University of New York Research Foundation provided a much-appreciated PSC-CUNY Research Award to Cynthia Chris in support of this project, and Christine Flynn-Saulnier, Dean of Humanities and Social Sciences at CSI, also assisted in funding.

We thank the authors in this collection. Their enthusiastic participation was a boon to sustaining our energy in this project. We also appreciate the generosity of those who gave permission for visual material to be reproduced in several chapters: Patrick Cariou, Andrea Geyer, Mel Horan, Aaron Koblin, and Robert Overweg. We also thank Jason Salavon for allowing us to reproduce his *MTV's 10 Greatest Music Videos of All Time: 2. Vogue* on our cover. This work, authored by Salavon, embodies several nested layers of authoring, appropriation, sampling, collaboration, and homage, pointing to the swirling complexity of authorship that brought us to this project.

Cynthia thanks Liz Brown, Paula Chakravartty, Ronald Duculan, Anthony Freitas, Ellen Seiter, Jeannie Simms, Liz Snyder, Kristine Woods,

and especially Arlene Stein for being there along the way, as well as David Gerstner, whose partnership in this project has been exhilarating. David thanks Paula Massood and Joe McElhaney for sharing their pleasures with art and ideas. He also is most grateful to Janet Staiger for years of mentorship and opening the possibility for a new collaboration with Cynthia Chris, a working relationship that has been both intellectually and creatively rewarding. Lastly, Michelangelo has yet again remained a steadfast companion whom David lovingly thanks.

introduction

cynthia chris and
david a. gerstner

A writer will write. With or without a movement.
—Cherríe Moraga

At any moment the reader is ready to turn into a writer.
—Walter Benjamin

Something I think about when I'm watching things like
Olympic meets is "When will a person not break a record?"
If somebody runs at 2.2, does that mean that people will
next be able to do it at 2.1 and 2.0 and 1.9 and so on until
they can do it in 0.0?
—Andy Warhol

The historical relationship between "new" media and authorship is vexed.
While many applaud the aesthetic enhancements and political possibilities
that new media enables for producers (and users), some question the very
concepts of cultural and technological "progress" insofar as that it actually

offers something "new." These debates were especially heightened during the nineteenth and twentieth centuries when a series of new media was ushered in at breathtaking pace. This seemingly mad rush of technologies—resulting in the sudden mechanical reproduction of textual, visual, and, eventually, aural material—stretches even further back, at least as far back as the printing press introduced in the fifteenth century by Johannes Gutenberg. However, it is the introduction of photography in the nineteenth century—whose invention is variously dated to landmarks such as Nicéphore Niépce's *La cour du domaine du Gras* (1826) or Louis Daguerre's *L'Atelier de l'artiste* (1837)—that proved particularly contentious, since it was a medium designed with pretensions of satisfying both the industrial sciences *and* the arts, both of which were, to be sure, at theoretical and formal crossroads.[1] In rapid succession, telegraphy, telephony, cinema, radio, electronic computing, television, communications satellites, and the Internet promised increasingly widespread availability of more and more instantaneous information and communications. For good or for ill, "new media" renewed the modernist arts in which images—still and moving—competed and/or combined with speech, sound, and text. Each new technological intervention provoked critical and, invariably, moralist rumblings along with laudatory embraces and self-satisfaction that the "newest" and latest media had reached its zenith.[2]

Moreover, the twentieth century witnessed an urgent turn in critical thinking about media and authorship when the political sphere was illuminated by the effects that media technology had on mass culture and society. Consider Joseph Goebbels's Nazi-propaganda machine, or the United States' powerful "culture industry" that saturated much of the globe under the Marshall Plan when World War II drew to a close. Indeed, critics—particularly during the rise of fascism—were quick to question the ideological stakes associated with celebrating the wonders and promises that "new" media held for producers. In whose hands were these media held? To what ends did these media makers *and* users engage technology in order to achieve goals that were said to make life "better," "efficient," and "functional"? What were the different effects on cultural ideas and values when information was distributed via different media platforms (radio rather than film, for example)? If radio was a successful forum through which Franklin Delano Roosevelt, Winston Churchill, Adolf Hitler, and Benito Mussolini turned to widely spread propaganda messages, is it correct to say that all radio is ultimately a tool for propaganda that sells a bill of political or commercial goods? Put more simply, is some media-propaganda "good" while others not so good?

As pervasive as the dissemination of media technology has been, the critical response was (and remains) varied and intense. On the one hand, Frankfurt School members Theodor Adorno and Max Horkheimer (intellectuals whose Jewish-grounded thinking raised anti-Semitic flags

for the Nazis and who were forced to emigrate from fascist Germany to the United States) drew connections between Goebbels's industry of hyper-mediated constraint with America's capitalist culture-industry practices. For these writers who lived in Los Angeles at this time, America's rigid mass-production systems—à la Hollywood in particular—led to a "stamp of sameness" on all mediated creativity.[3] For them, radical political resistance and art practices filtered through new media had come to an abrupt halt. By the late 1990s, Brian Winston echoed the Frankfurt School position that the romance with new media offers little in the way for political liberation. As Winston views it, "there is a profound tendency to historical amnesia behind, for example, the oft repeated assertion that the pace of change is now so fast as to be uncontrollable or that 'nobody could predict' this or that development. The historical implications of the word 'revolution' are not denied by this amnesia; instead a supposed transformational movement from 'then' to 'now' is celebrated."[4]

On the other hand, contra to Horkheimer and Adorno's positions, many refute "culture-industry" flattening of creativity, political action, and innovation precisely because authorial intervention is enabled by new technology. *Wired* magazine editor-in-chief Chris Anderson's enthusiastic claim that digital technologies would end the era of lowest-common-denominator media (and other products) is well known. Anderson argues that new media technologies enable suppliers to, for the first time, meet the demands of niche markets and, therefore, support production by and for greater numbers of creative artists and entrepreneurs.[5] Along similar lines, Lev Manovich goes so far as to say that media playing fields are not only leveled but reconfigured, asserting that new technology—especially social media—makes available to young "design students" a global platform where many of their projects "not only rival those produced by well-known commercial companies and most well-known artists but also often explore areas not yet touched by those with lots of symbolic capital."[6] Judith Halberstam, in a chapter entitled "Technotopias," calls for a "transgender aesthetic" in contemporary art that marks resistant forms of "subcultural" art practices. Here, "technotopic inventions" serve bodily representations through "decay, detachability, and subjectivity"; a queer artist's "preoccupation with the body as a site created through technological and aesthetic innovation" is key to dismantling the hetero-masculinist shutting down of radical art practices through new media.[7] From these perspectives, art and technology are seen as acting together as vectors of liberation.

Media Authorship continues these discussions by considering recent authorial–artistic practices in relation to contemporary and ever-broadening media technology. Our intention is neither to uncritically celebrate nor dismiss *in toto* the socio-political transformations that the

3

mediated authorship process offers. Whereas Gregory Turner-Rahman argues in this collection that the "digital author" now encounters an expansive authorial engagement within the very "glitches" and "errors" the technology invariably makes available, Mark Andrejevic observes less optimistically that the very media Turner-Rahman marks as sights for transformative modes of authorship in fact facilitate the "capture and use of personal data [that] have little to do with a culture of openness, but are all about new forms of privatization that allow companies to make money by creating proprietary databases accessible only to those who are willing to pay." For one author, in other words, digital media spurs collaborative possibilities and playful revision among "networks of tinkerers." In contrast, from a different writer's viewpoint, the tools that ostensibly provide online authoring simultaneously serve the lucrative practice of data mining where every keystroke informs market research.

However one turns on this discussion, the stakes are high. Sarah Banet-Weiser, Inna Arzumanova, and Patricia White assess women's access to and engagement with new media technology under the terms of a neoliberal economy. These writers query "postfeminist" media production and the way it shapes—or contains—women's cultural capital. What does it mean for women to give voice to, to make visible, to author women's subject-position in a postfeminist culture? To what extent is a feminist political stance made available when global-market consumerism dictates narrowly defined creative choices? By studying women's direct involvement with new-media technology, the writers, here, consider YouTube "hauler" videos (Banet-Weiser and Arzumanova) and Lebanese filmmaker's Nadine Labaki's "performance of authorship" (White) in order to challenge the celebratory rhetoric that troublingly aligns postfeminism, new media, and liberation.

From our perspective then, and as these collected essays demonstrate, the dynamic that occurs between authorship practices and technology yields significant cultural, political, and bodily effects. Yet, it is valuable to bear in mind Ellis Hanson's comments, "there is no such thing as the 'great paradigm shift;'" instead, "change happens in different places and at different speeds."[8] It is through this lens of different modes of temporality and spatiality that we open and engage "new media authorship."

media

What these aforementioned debates make clear is that these terms—"new," "media," and "authorship"—however slippery, carry significant currency. As we point out in the following text, although the term "new" is not in the title of our book, its relevance to the topic at hand

is implicit to the conversations around media authorship. For the purposes of this collection, therefore, we will need to develop working definitions around this terminology. To begin, let us consider our core term, "media." Since the late sixteenth century, according to Raymond Williams, the singular term "medium" (now commonly but inconsistently pluralized as media) has indicated "an intervening or intermediate agency or substance." Put another way, a mediated intervention can be said to be the "substance" that makes available the language we encounter, in, for example, newspapers and broadcasting.[9] However, in what sense is "media" an "intermediate agency"? How is it possible for a non-human entity to have agency? As Williams argues, the term has come to mean over time both a *technology* that is distinct from other technology (say, the print medium as distinct from radio) or a vehicle through which we locate *content* (the newspaper is exemplary as a medium for advertising, while film might be seen as a conduit, or medium, for specific ideologies about romance and so forth).

"Media," then, is at once form and content. Marshall McLuhan referred to these blurred boundaries that we understand as "media" when he stated that the "medium is the message."[10] As Friedrich Kittler famously noted, "the general digitalization of channels and information erases the differences among individual media."[11] Not surprisingly, this confluence—or, precisely, what is known as media convergence—occurs not only on technological but also political–economic grounds. More recently, Lisa Gitelman argues that the term "media" is wildly imprecise, in that it has misleadingly "lumped together" disparate communication apparatus[es] so that entire industries (which are, admittedly, heavily consolidated) are amalgamated into a single monolith that we have come to know as "the media."[12] In such a muddled and monolithic environment, authorship invariably looks more and more like a branding strategy. (For example, Steve Jobs was not the sole inventor of the iPad and iPhone but, for many, Steve Jobs was *the* author of all Apple products.) Michel Foucault, in so many words, identified this authorship strategy in Western commodity culture as the "author-function."[13]

For Williams, the tension between superficially divergent definitions of "media" is readily and usefully resolved in the following way: "The technical sense of *medium*, as something with its own specific and *determining* properties (in one version taking absolute priority over anything actually said or written or shown), has in practice been compatible with a *social sense of media in which the practices and institutions are seen as agencies for quite other than their primary purposes.*"[14] Following Williams, we are in a position to suggest that even within dissipated agency and corporatized identity formation, social and creative determination remains *relevant and possible* through the use of media technology. As Kittler argued, it may be the case that "media determine our situation," but "Our media systems

merely distribute the words, noises, and images people can transmit and receive. However, they do not compute these data."[15] Gitelman locates at least one possibility for relevant media authorship insofar as "[media's] material properties do (literally and figuratively) *matter*, determining some of the local conditions of communication."[16] In other words, the term "media" occupies not only mediating technologies but, more significantly, technologies for social intervention that *may* allow for "agencies" that are something quite different "than their primary purposes." Of course, this is easier to recommend than it is to put into practice.

authorship

Why is identifying authorship in media culture sometimes difficult? What ideological dynamics impede distinct authorial intervention so that media's neutralizing effect on creative difference, arguably their "primary purposes," is disrupted, shifted, re-envisioned? Why is it difficult to engage media's material properties so that they *do* matter? For nearly as long as new media technologies enabled new cultural practices, "authors" in all manner of media have redefined and challenged precisely what it means to author.

Like their twentieth-century counterparts, the twenty-first-century writers in *Media Authorship* seek to theorize authorship in all its resonant variability. To be sure, as early as 1934, Walter Benjamin, in a lecture later published as "The Artist as Producer," suggests that the writer may no longer be distinguished from the reader in a mass-mediated (and corporatized) world. The reader, in turn, "gains entrance to authorship."[17] As this intermingled relationship unfolds between author and reader, new *producers* of expertise, criticality, and meaning are made available. However once-provocative such an observation, however profound its impact on subsequent debates over just what constitutes modern authorship, students writing on the subject of authorship in the humanities and social sciences often find that their arguments hinge on two essays by French authors: Michel Foucault's "What Is an Author?" and Roland Barthes' "The Death of the Author." Although Benjamin's writing conceptually anticipates Barthes' 1968 article, "The Death of the Author" has become something of (to borrow Jane Gallop's terms) an "elegant slogan."[18] In fact, when Gallop researched material for her book *The Deaths of the Author* (2011), she "discovered that critics who use [the term "the death of the author"] generally refer to two articles—and by and large to only two articles—which appeared within a year of each other, the one by Barthes in 1968 [penned in 1967] and the other by Foucault in 1969."[19] Indeed, these landmark essays haunt this very text, as several of the contributors and the editors are irresistibly drawn to these luminaries: Foucault's "What Is an Author?" figures into chapters by Anderson,

Aufderheide, Banet-Weiser and Arzumanova, and Boateng; Barthes' "The Death of the Author" appears in chapters by Andrejevic, Aufderheide, and Harrison.

Much ink is spilled on the cultural contexts in which these two essays were published and why they carry such significance to this day. France's post-1968 culture is most often cited for the manifesto-like style the essays display. In short—and as many have shown—the essays do not kill off the author as much as they re-evaluate the author's hegemonic status by foregrounding the *reader's involvement or interaction with* an "authored" text. Foucault, for example, activates the author with his question, "What is an Author?," assuring the reader that the author is far from dead. For Foucault, the author-function serves an ideological function for Western society's commodity-driven culture.

It is a bit trickier to overcome the apparently murderous implications of Barthes' essay. The author's "death" appears *fait accompli* since his very title makes such a pointed assertion. However, Barthes filters "the author" through several different formulations that invariably suggest a sensual encounter between the author's "work" and the "text" that, once the reader engages it, springs to life.[20] On the one hand, and like Benjamin before him, Barthes argues, "we know that to give writing its future, it is necessary to overthrow the myth: the birth of the reader must be at the cost of the death of the Author."[21] On the other hand, Barthes reminds us a few years later that, "as *institution*, the author is dead."[22] More provocatively, the author's death, according to Barthes, is merely a little death, *la petite mort*. And while *la petite mort* translates, literally, as "the little death," the term is also used as a French colloquialism that refers to orgasm. Thus, when Barthes, in 1971, offers that the "pleasure of the Text also includes a friendly return of the author," *la petite mort* conjures a "friendly return" (an authorial haunting?) that suggests an erotic conjoining between the author (who passes away as soon as her words mark the page) and the reader-*as*-writer whose "birth" takes place at the very moment of this passing.[23] The erotic experience, therefore, resonates precisely because a death occurs.[24] Usman Shaukat's "friendly return of the author" in "Sufi Homoerotic Authorship and Its Heterosexualization in Pakistan" echoes—and literally spills more ink on—Barthes' insistence that we "give writing its future." Shaukat evokes traditional Sufi poetry's queer sensibility that, as he shows, has been absconded with and heterosexualized by Pakistani conservatives and the liberal establishment in media outlets such as YouTube and television talk shows.

Thus, the impact of Barthes's eroticized death between author and reader cannot be underestimated for its pleasures and perverse implications. "In *The Pleasure of the Text*," Gallop reminds us, Barthes "affirms the reader's perverse desires ... even though I know [the author] is dead and

gone, I nonetheless desire the author."[25] Orgasm/*la petite mort* is not, in other words, death once and for all. The author's "death" provides an opening for multiple interpretations and possibilities. These possibilities are the preferred model for authorship that we situate in this book.

Certainly, desire is difficult to ignore in a hyper-mediated age. Ellis Hanson knows this all too well when he, in his recent writings, renovates our indefatigable desire for the author and identifies our media-digitalized culture as one that simultaneously arouses and enervates a mediated body. According to Hanson, affective experience is "prostheticiz[-ed]" as it is reduced to the emoticon, announced in Tweets and performed for audiences of virtual "friends"; information is "deprofessionaliz[-ed] … democratized," in a heady, decompartmentalized stew; what was once perversion, then difference, has become sexual consumer sovereignty ("whatever your pleasure, there is most likely a Web site for it").[26]

If Hanson's remarks hold true, how do we account for the authorial act in social-mediated-digitized culture? What becomes of the desire for the author, traditionally understood? How do we take note of *la petite mort* so sensually conceived by Barthes (and perhaps Benjamin) in the spatially and temporally commingled encounter between author and reader? If a sensual embodiment that was so crucial to the pleasures associated with modernist humanity and is seemingly dispersed across bodies and their relationships to technology, what becomes of the human experience within this new so-called "democratized" culture? Is it even possible to discuss the body at this historical juncture *as* human; or have we become, as N. Katherine Hayles identifies it, "posthuman"?[27] For Hayles, the very "incorporation" of body and technology is pivotal to the way we understand contemporary human-ness. "Formed by technology at the same time that it creates technology," Hayles writes, "embodiment mediates between technology and discourse by creating new experiential frameworks that serve as boundary markers for the creation of corresponding discursive systems. In the feedback loop between technological innovations and discursive practices, *incorporation* is a crucial link" (205, emphasis added). To what extent does this "feedback loop" that Hayles portrays as "crucial" for embodied "experiential frameworks" describe a complex *pas-de-deux* with technology and corporate sponsors?

In whichever way the debate hinges, Hayles' remarks on the "feedback loop between technological innovation and discursive practices" provide rich metaphors that allow us to grasp contemporary media embodiment and cultural production. As Hayles puts it, "One way to think about the transformation of the human into the posthuman, then, is a series of exchanges between evolving/devolving *inscriptions* and *incorporations*."[28]

In this way, *Media Authorship* does not shy away from the challenges that have appeared early in the twenty-first century. The writings here

demonstrate, while questioning, the wide, varied, and complex inter-ventions that emerge when new technologies raise the stakes on not only what one produces but, more significantly, these essays confront the cultural and political implications involved when authoring is enacted. For example, in Judd Ethan Ruggill and Ken S. McAllister's essay "Invention, Authorship, and Massively Collaborative Media," computer-game authoring is perceived as not only an act of human creativity but also a product of auto-invention within game technology itself: human and machine, therefore, collaborate in sorcerous play. These multifac-eted possibilities give way to "something daring and unpredictable" and, indeed, "fun." Susan Murray in "Amateur Auteurs? The Cultivation of Online Video Partners and Creators" remains more cautious. She reminds us that profit-motivation trumps the seemingly endless creative possi-bilities made available through web-based forums such as YouTube, plat-forms for authorial production that are at once "alluring and more deceptive than ever before." Elizabeth Losh also remains wary about what might be described as an intellectual classism that frames the way creative agency is distributed in new media industries, particularly given professional routines, high barriers to entry, and extreme specialization. Does new-media technology, therefore, liberate authorship practices or is authorial liberation—enabled by technology—a ruse that merely drives the ideological machine in which capital interests gain ever-stronger footing? Though not as bleak as Horkheimer and Adorno's assertion that "fun is a medicinal bath" that lubricates the drudgery of everyday life, Murray and Losh query creative freedom as well as just who is afforded entry into new-media creative realms.[29]

Given at once the possibilities and difficulties that shape author-ship within new-media technology, how do we ground its effects if its very contours are continually remolded as ever-developing "writing" tools? Although historian and critic Raymond Williams does not specifi-cally include "authorship" or similar terminology in *Keywords*, he intro-duces the historical imposition of the "author" in relationship to the once-new media technology: "printed books."[30] Under the heading "Literature," Williams explains the intimate connection between "litera-ture" and "literary" in order to situate the emergence of the author as one who "write[s] clear letters" as an extension of "polite learning." Williams notes that, between 1759 and 1773, critics championed "literary merit" and "literary reputation."[31] He points out that this historical moment "appears to be closely connected with the heightened self-consciousness of the profession of authorship, in the period of transition from patronage to the bookselling market."[32] The eighteenth century might be said, then, to usher in a pivotal moment in the relationship between artist and machine, knowledge and knowledge-production, and authorship and commodity. A "man of letters" (we use the gendered

form of the term purposefully) is both an authorized voice *and* one who controls the meaning that the medium disseminates (it is an appropriate coincidence that "genius," as Williams points out, comes on the scene at the same time).[33]

However, the rapid expansion of mechanical and, then, electronic media during the twentieth and twenty-first centuries altered the discourse about authorial privilege, interpretive possibilities, and, legal implications that authors continually face. For Patricia Aufderheide and Nate Harrison (and, implicitly, other writers in the collection), matters of fair use, copyright, public domain, and appropriation are critical to the way new technology is legally circumscribed. To cut short the creative exchanges that digital-media technology set in motion, in other words, is to bring to a standstill aesthetic and intellectual transformation. At the same time, Laikwan Pang questions the business of "public domain" that ultimately serves the "private sphere" so necessary for capitalism to sustain itself. Pang queries whether or not the tenets of an "ideal communist society," where the private sphere does not regulate user's access to media, may be more successful in providing access to a more level playing field. What becomes apparent in these discussions about fair use and public domain is the critical ideological debate that focuses our attention on what truly constitutes revolutionary access to works for creative and intellectual pursuits. What are its limits? And whose interests are served once access is gained through media-technology dissemination?

In a similar register, an essay by Pam Spaulding and Michelangelo Signorile, and another by Polly Thistlethwaite, demonstrate the current degree of confusion over the rights of authors in newly digital publishing arenas: the blogosphere and academia, respectively. Righthaven's lawsuit against activist Spaulding's blog, *Pam's House Blend*, illuminates the corporate-media strategies and the lengths to which these organizations will go to control and manage *how* information is managed across media. In Spaulding and Signorile's contribution to this volume, the authors demonstrate the seemingly never-ending efforts by the media industry to use the courts as mechanisms for censorship. Meanwhile, Thistlethwaite examines the impact of extra-legal constraints on the circulation of scholarly texts; specifically, movements toward open-access publishing in some disciplines, and efforts to restrict access to electronic versions of texts such as dissertations in favor of print publication.

Matthew Tinkcom and Edward D. Miller approach authorship and its public arena from a different perspective. Their essays investigate the ways information is authored and distributed during social movements such as the Arab Spring and Occupy Wall Street (OWS). Tinkcom and Miller drive home the political (if not always uneasy) possibilities that corporate and social media provide activists. For Miller, OWS

demonstrations reconfigured public space insofar as "occupied spaces' sightlines were less privileged than acoustics, and listening afforded occupiers the possibility of an articulated sense of self that is defined in relation to other articulating selves." Mediated sound creates new modes of political practice and re-pitches the individual's political position in relationship to a larger cultural movement. And, as Tinkcom points out, the media platforms from which fresh political practice emerges may derive from unexpected quarters, as was the case during the "Arab Spring": "after the government's blockade to web and cellular access was reported by Al Jazeera's news broadcasts in the region, the channel began to include a news crawl on its television broadcast and web pages that informed viewers—most pointedly those in Egypt—of the coordinates for satellite access to the channel, thus giving Al Jazeera's audience information about alternative media channels by which to learn about the events unfolding around them in Cairo and other Egyptian cities." Here, again, a pervasive tension surrounds the ostensible liberatory possibilities that new-media authorship delivers since these media are, frequently, owned and distributed by the very institutions (state or corporate) that the activists challenge.

Media Authorship's contributors, along with the other writers we have thus far introduced (Hayles, Hanson, Barthes, Williams, Benjamin), offer a vibrant, if contestatory, group of emissaries. The writings in our collection animate by querying an intimate yet historical mode of cultural production between author and reader, given the peculiarities that new media technology currently provides. If Barthes relies on the novel as the centerpiece for *la petite mort*, the authors we invite to this project reposition and transform the discussion because the "human" has, to be sure, transformed in relationship to mobile phones, Facebook, Twitter, and YouTube. The re-imaginings of authorship found in this work deliver another form of *la petite mort* insofar as this engagement, at this moment, is precisely the mediated "reconfiguration" where the desire for the author is no longer about becoming human; it is now the desire to embody and grasp the posthuman.

To summarize: These collected writings are interested in authorship as a *frictive* stance rather than a stolid occupation. We present authorship as contested terrain rather than a stable designation; it is an identity that is produced by media industries and creative imagination as much as it is contained by the legal discourses that regulate authorship. We are, therefore, more concerned with the embodied practices of authorship as mobile sites that are by necessity malleable and whose contours shift, given the cultural and technological circumstances in which these practices emerge. Herein, authorship is an invitation toward desire; that is, we invite the reader to enjoin with the authorial presence within these pages. Cultural production is at once an act of reciprocation and

rejoinder; it is an act not so much of representation as it is of sensual connectivity. As Benjamin so aptly called it, the most necessary status of the author hinges on camaraderie, on mutuality, on role-play, on a daisy chain of call and response:

> What matters is the exemplary character of a production, which is, first, to induce other producers to produce, and second, to put an improved apparatus at their disposal. And this apparatus is better, the more consumers it is able to turn into producers—that it is readers or spectators into collaborators.[34]

new

We draw these introductory notes to a close by remarking on the term "new." It is a term that haunts these pages, yet the very concept evaporates as we write about its relationship to media (we do not include the term in our book's title for this very reason). At the same time, and because that which haunts a subject invariably leaves a trace of its former self even as it dissipates, the "new" asserts itself at every turn when the terms "media" and "technology" are trotted out for discussion and industry promotion. Whether in the halls of academia, media corporations, or advertising agencies, "*new* media technology" serves as a catchall phrase to announce seemingly modern world progress.

Raymond Williams does not take up the specific term "new" as a keyword. Although he does not do so directly, he does provide several keywords through which we can piece together the socio-historical implications for the way "the new" satisfies and encourages consumer enthusiasm and capitalist idealism in and through media. Accordingly, we find ourselves "re-authoring" Williams as we once again turn to *Keywords*, which helps us trace the discursive encounters with "the new" in relationship to media technology and cultural production. Williams's "keywords" that offer a way to get at "the new" include: "generation," "progressive," "development," "evolution," and "revolution." Although he traces the oft-winding cultural trajectories that each term historically takes, we will concentrate on where and how "the new" may be teased out from these particularly and tantalizingly revealing keywords.

Taken together, and as Williams presents them, these terms connect through the ways they serve industrial production and its ideals about progress during the eighteenth, nineteenth, and twentieth centuries. For instance, while "generation" finds its etymological origins in matters of temporality as early as the thirteenth century, by 1781 the term is viewed "as part of the development of a new sense of HISTORY, and especially of history as developmental and progressive, that the idea of

cynthia chris and david a. gerstner

distinctiveness is strengthened and even formalized."[35] Williams goes on to point to these developments to trace "generational tastes" in relationship to the way "successive types of manufactured objects" are described.[36]

In this way, it is possible to view how "generational tastes" (the temporal shifts in interests in "successive" commodities) becomes linked with notions of materialist "progress" (e.g., consider the next generations of iPhone 3, 3G, 3GS, 4, 4S, and on and on). "Progress, as a law of history," Williams posits, "belongs to the political and industrial revolutions" of the eighteenth and nineteenth centuries. As such, it is aligned with both abstract (ideals) and materialist (commodities) interests: "In [the twentieth century], *progress* has retained its primary sense of improvement but has an important (as well as an ironic) sense which takes it simply as change: the working out of some tendency, in evident stages, as in the older sense."[37] In short, "the new." And, as Williams further points out, this teleological conceptualization moves in tandem with ideas about "evolution" *and* "revolution." According to Williams, these conceptual linkages to commodity production over the last 100 years "[have] become commonplace" insofar as the "evolution/revolution contrast … is carefully applied only to planned change, where in practice it is a distinction between a few slow changes controlled by what already exists and more and faster changes intended to alter much of what exists."[38] The *idea* of the new—the appearance of "more and faster changes" in the name of "evolution/revolution/progress"—thus aids and abets ideological and materialist capitalism.

Williams neatly ties these concepts together when he marks 1861 as the year that "progressive development" is introduced into the cultural vernacular and discursively wends its way in reference to "industry" practices by 1878. By the end of the nineteenth century and well into the twentieth, "progressive development" lends itself to commodity expanse and world trade. Williams identifies these "developments" as "ideas of CIVILIZATION and IMPROVEMENT."[39] Progress is thus an idea of the "new," or one might suggest, the reification of industrial production. In other words, abstract ideas are blurred with the production and marketing of material goods for purposes of promoting the idea that "more and faster" products lead to progress, the hallmark of civilization.

As Williams summarizes his notes on the variant ways that "revolution" is evoked, he gestures towards Walter Benjamin's critique of the ideological tropism, "progress." When Williams calls upon the "storm-clouds that have gathered around the political sense" of revolution, he echoes Benjamin's oft-cited description of Paul Klee's painting, "Angelus Novus," in "Theses on the Philosophy of History."[40] Here, Benjamin draws upon this painting because he views it as a provocative rendering of how we might conceive a non-teleological experiential history; that is,

a history that recognizes the deceitful promises associated with history-as-narrative. The appeal to organize history in such a linear fashion is ultimately impossible and, as Benjamin sees it, those who attend to history as "progress" remain suspect (it is important to bear in mind that Benjamin's writing is shadowed by the Nazi "storm" toward progress). Klee's painting suggests something more revolutionary than a revolution *toward* new "development" and the next-best "generation." The "Angelus Novus," instead:

> shows an angel looking as though he is about to move away from something he is fixedly contemplating. His eyes are staring, his mouth is open, his wings are spread. This is how one pictures the angel of history. His face is turned toward the past. Where *we perceive a chain of events,* he sees one single catastrophe which keeps piling wreckage upon wreckage and hurls it in front of his feet. The angel would like to stay, awaken the dead, and make whole what has been smashed. But a storm is blowing from Paradise; it has got caught in his wings with such violence that the angel can no longer close them. The storm irresistibly propels him into the future to which his back is turned, while the pile of debris before him grows skyward. This storm is what we call progress."[41]

The duplicity of progress that Benjamin's angel experiences is precisely the concerns that two writers in *Media Authorship* uses as their foreground. Boatema Boateng and Jane Anderson question contemporary, Western-grounded authoring practices in relationship to the historical and academic commodification of indigenous culture. Both Boateng and Anderson point to the discomfiting ways in which indigenous cultural ownership is reshaped, repackaged, and reproduced in the global market-place, often at the peril of those cultures who initially created the work. Thus, as Boateng argues, the adinkra and kente fabric, which originates in Ghana and are historically significant as a "cultural medium or text," finds its author-producers and users at risk precisely because the hyper-medi-ated global circulation of goods has proven "especially harmful for cultural forms that are located outside intellectual property law since they often occur with little benefit to their producers." Likewise, Anderson suggests that "political technologies," such as the archive that "authors" and controls cultural meaning for indigenous cultures, often prove to be the sites where "people subjected to colonial and colonizing projects [such as those established with archival practices] are rarely named as authors." Importantly, Boateng and Anderson raise the stakes on the liberatory value that "public domain" offers (as Laikwan Pang does), since this law is predicated on a Western juridical and commercial system. In effect, the

new mediatization of Indigenous culture work is marshaled through authorial revision and dissemination in the name of progress.

We invite you into "this storm we call progress." At once challenging, exhausting, pleasurable, and transformative, the authoring process through the technology available to us—that is, how we envisage our contribution to culture making—is imperative for the way we reimagine the world in which we live.

postscript

As you may have noted, the organization of our table of contents gestures towards an essay by Jacques Derrida titled "Signature, Event, Context." In this work, the author takes up "the problem of context" and why "[it] is never absolutely determinable."[42] We are seduced by Derrida's thoughts since, in organizing *Media Authorship*, we found ourselves involved in multiple intellectual and creative crosscurrents. The authors in these pages, in other words, write about the complex entanglements between media practices and their cultural possibilities. What becomes clear in these pages is that the phenomenological results that media technology yields are not fixed and determined once and for all ("No context can enclose," Derrida reminds us).[43] Our volume offers texts about "media authorship" in which, as Derrida marks it, a discursive "systemic chain" is regenerated, "grafted onto a 'new' concept of writing which also corresponds to whatever always has *resisted* the former organization of forces, which always has constituted the *remainder* irreducible to the dominant force which organized the—to say it quickly—logocentric hierarchy."[44]

15

notes

1. See Alan Trachtenberg's *Reading American Photographs: Images as History, Mathew Brady to Walker Evans* (New York: Hill and Wang, 1989), 5.
2. See Charles Musser's *The Emergence of Cinema: The American Screen to 1907* (Berkeley: University of California Press, 1994), 61.
3. Max Horkheimer and Theodor Adorno, "The Culture Industry: Enlightenment as Mass Deception." In *Dialectic of Enlightenment* [1944], trans. John Cumming (New York: Continuum, 1993), 128.

4. Brian Winston, *Media Technology and Society, A History: From the Telegraph to the Internet* (London: Routledge, 1998), 15.

5. Chris Anderson, *The Long Tail: Why the Future of Business Is Selling Less of More* (New York: Hyperion, 2006).

6. Lev Manovich, "The Practice of Everyday (Media) Life: From Mass Consumption to Mass Cultural Production?" *Critical Inquiry* 35, no. 2 (Winter 2009), 330.

7. Judith Halberstam, "Technotopias: Representing Transgender Bodies in Contemporary Art." In *In A Queer Time and Place: Transgender Bodies, Subcultural Lives* (New York: New York University Press, 2005), 124.

8. Ellis Hanson, "The History of Digital Desire, vol. 1: An Introduction," *The South Atlantic Quarterly* 110, no. 3 (Summer 2011), 583.

9. Raymond Williams, *Keywords: A Vocabulary of Culture and Society*, rev. ed. (New York: Oxford University Press, 1983), 203.

10. Marshall McLuhan, *Understanding Media* [1964] (London: Routledge, 2005).

11. Friedrich A. Kittler, *Gramophone, Film, Typewriter*, trans. Geoffrey Winthrop-Young and Michael Wutz (Stanford, CA: Stanford University Press, 1999), 1–2.

12. Lisa Gitelman, *Always Already New: Media, History and the Data of Culture* (Cambridge, MA: The MIT Press, 2006), 8.

13. See Michel Foucault, "What Is an Author?," in *The Foucault Reader*, ed. Paul Rainbow (New York: Vintage, 1984).

14. Williams, *Keywords*, 204 (emphasis original).

15. Kittler, *Gramophone, Film, Typewriter*, xxxix, 2.

16. Gitelman, *Always Already New*, 10 (emphasis original).

17. Walter Benjamin, "The Newspaper," in *Selected Writings: Volume 2, part 2, 1927–1934*, eds. Michael W. Jennings, Howard Eiland, and Gary Smith (Cambridge, MA: Harvard University Press, 2005), 741.

18. Jane Gallop, *The Deaths of the Author: Reading and Writing in Time* (Durham, NC: Duke University Press, 2011), 30.

19. Gallop, *The Deaths of the Author*, 2.

20. See Roland Barthes, "From Work to Text," in *Image-Music-Text* [1977], ed. and trans. Stephen Heath. 21st ptg. (New York: Noonday Press, 1999), 155–64.

21. Roland Barthes, "The Death of the Author," in *Image Music Text*, 142–48, 148.

22. Roland Barthes, *The Pleasure of the Text*, trans. Richard Miller (New York: Hill and Wang, 1975), 27.

23. On this, see Gallop, *The Deaths of the Author*, 5.

24. Barthes, *The Pleasure of the Text*, 27. The translator's notes on the challenges of *jouissance* and *jouir* (v) and Barthes's own musings on the terms of pleasure (19–21) are instructive preparation for passages on the untranslatable bliss of reading, which proves as productive as it is reproductive, as perverse as it is prosaic (14).

25. Jane Gallop, *The Deaths of the Author*, 31.

26. Hanson, "The History of Digital Desire," 592–94.

27. N. Katherine Hayles, *How We Became Posthuman: Virtual Bodies in Cybernetics, Literature, and Informatics* (Chicago: University of Chicago Press, 1999).

28. Hayles, *How We Became Posthuman*, 280. Although Hayles' term "in*corporation*" evokes "*corporation*," our reading of her text suggests a phenomenological exchange and not a carved-out space for authorial corporatization.

cynthia chris and david a. gerstner

16

For a different debate about corporate authorship, see Jerome Christensen, "The Time Warner Conspiracy," *Critical Inquiry* 28 (Spring 2002), 591–617; and Jerome Christensen, "Taking It to the Next Level: You've Got Mail, Havholm and Sandifer," *Critical Inquiry* 30, no. 1 (Autumn 2003), 198–215; also, Peter Havholm and Philip Sandifer, "Corporate Authorship: A Response to Jerome Christensen," *Critical Inquiry* 30, no. 1 (Autumn 2003), 187–97.

29. Horkheimer and Adorno, "The Culture Industry," 140.
30. Williams, *Keywords*, 184.
31. Williams, *Keywords*, 185.
32. Williams, *Keywords*, 185.
33. Williams, *Keywords*, 143.
34. Walter Benjamin, "The Author as Producer," in *Selected Writings: Volume 2, part 2, 1927–1934*, eds. Michael W. Jennings, Howard Eiland, and Gary Smith (Cambridge, MA: Harvard University Press, 2005), 777.
35. Williams, *Keywords*, 141 (emphasis original).
36. Williams, *Keywords*, 141.
37. Williams, *Keywords*, 245 (emphasis original).
38. Williams, *Keywords*, 122–23.
39. Williams, *Keywords*, 244.
40. Williams, *Keywords*, 274.
41. Walter Benjamin, "Theses on the Philosophy of History," in *Illuminations: Essays and Reflections*, ed. Hannah Arendt, trans. Harry Zohn (New York: Schocken Books, 1968), 257–58, emphasis added.
42. Jacques Derrida, "Signature Context Event" [1972], in *Margins of Philosophy*, trans. Alan Bass (Chicago: University of Chicago Press, 1982), 310.
43. Derrida, "Signature Context Event," 317.
44. Derrida, "Signature Context Event," 329–30 (emphasis original).

signature

part one

creativity, copyright,

and authorship

patricia a u f d e r h e i d e

The academic debate about the relationship between legal and literary conceptualizations of the author in copyright policy is decades old, and centers on the role of the Romantic-era concept of the author-genius. On one side, heftily weighted to cultural and literary scholars such as Michel Foucault and Roland Barthes, is the argument that legal regimes partake of the zeitgeist; they have developed their policies and to some extent their legitimacy with the Romantic-era notion of the author.[1] In a post-structuralist era, with the "death of the author," such regulations are weakened and made dysfunctional to the extent that they no longer reflect cultural expressions and expectations of more pluralistic creation of cultural meaning. Copyright policy falls out of sync with the culturally constructed notion of the author. Those who believe this argument might, for instance, find that pastiche work, appropriation art, remix, mashups, and aggregation blogs are evidence that participatory and collaborative culture is overtaking law, which will have to adjust its policies to accommodate changing cultural production practices and expectations.

On the other end of the spectrum is the acerbic view, represented by Mark Lemley and David Saunders, that legal regimes, which after all employ the concept of authorship significantly before the Romantic era, opportunistically intersect with the Romantic conceptualization of the author in literary terms.[2] However, the multiple functions of copyright law sometimes differ from and even conflict with the Romantic notion of the genius-author. A primary function of copyright law, for instance, is to propertize work that often lacks a traditional property dimension (for instance, a digital file), and to allow it to circulate in the marketplace as a commodity. Authorship has an extraordinary convenience for this purpose insofar as it affixes the origin of the work and provides an original property-holder. However, the aura of authorship does not stick to copyright's grant of limited monopoly, which is given to whoever purchases it from the original owner (often very quickly). The notion of originality, for instance, is quite different in copyright policy than in literature and in the Romantic concept of the genius-author. For the law, it is enough that someone executed the work, however derivative or tawdry it might have been. An author in the Romantic conceptualization of authorship, however, has departed from the given world and created something truly new.

Furthermore, copyright law, against the actual reality of production, routinely assigns authorship to fewer people than contribute to the work in order to achieve greater efficiency, and where there are multiple authors, copyright policy fails entirely to recognize collective creation except as an aggregation of individual authors. These practices, which fail to recognize any special right of individuals who may, for instance, have contributed to a corporate endeavor through work-for-hire arrangement, or who might have participated in a collective process in which the genius of authorship is exercised collaboratively (for instance, the Co-op Garden Committee), have practical advantages in the commodification of the intellectual "property." And, finally, changes in copyright law do not map neatly onto zeitgeist shifts in Romantic conceptualization of the author.

Using this point of view, one may see the law as a product of contingent decision-making, accreting around conflicts over property rights and with an associational but not necessary connection with cultural notions of authorship. From this perspective, it is unsurprising that legal regimes continue to invest in an Enlightenment concept of authorship and that they have not responded to the perception in literary circles of a shift toward a collective creation of culture, a fragmentation of concepts of the self, a fluid conceptualization of both product and meaning in cultural works. Property continues to be of immense and practical value, and even business models that value participatory creation—for example, blogs that employ images culled from TwitPics, sites that develop crowd-sourced

22

rankings, social media sites such as Facebook—when offering value for participation offer it on an individual basis.

Others, including Peter Jaszi, James Boyle, Lewis Hyde, Thomas Streeter, and Siva Vaidhyanathan, variously argue that the law, while a distinct realm, participates sometimes opportunistically and sometimes unconsciously in a Romantic association between property and creativity, creating a dangerously unbalanced copyright policy that can stifle creativity.[3] This problem emerges not only because law is inappropriate to the reality of creative practice, but because both consumers and creators participate in an overvaluation of the property rights created by the law. They participate in an unhealthy amalgam of property interest and moral assertion, which justifies imbalance. This argument was launched in the United States by Peter Jaszi, who argued that the concept of authorship was an "ideologically charged concept" that "has been an active shaping and destabilizing force in the erection" of copyright doctrine.[4] James Boyle drew heavily on those insights and applied them in his *Shaman, Software, and Spleens*, which emerged from an active scholarly conversation showcased in a conference and subsequent edited book, *The Construction of Authorship: Textual Appropriation in Law and Literature*.[5] Jaszi and Martha Woodmansee, who co-edited that book, begin from the Foucauldian position that historicizes the concept of authorship, crystallizing in the Romantic era and focusing on originality as a unique and creative intervention in the culture. They then note that changes over the last 150 years in copyright, accelerated greatly in the last 30 years, vastly extend the rights of copyright holders. This privileging of the author they find best attributable to a conforming of copyright law to the reverencing of the authorial role:

> Informed by the Romantic belief that long and intense legal protection is the due of creative genius, this latter model [one of "natural law" recognizing previous entitlement] dominates "authors' rights" discourse in Continental Europe, and it has also exerted consistent, shaping pressure on the Anglo-American law of copyright, at least since Wordsworth's time.[6]

One example is a 1991 ruling (*Feist Publications, Inc. v Rural Telephone Services Co., Inc.*, 499 U.S. 340 [1991]), which decided that databases such as telephone books are not copyrightable, because they are collections of facts without a distinguishing author. Thus, work that requires time and effort, and that adds value to the culture, is not recognized as worthy of protection. Another example of copyright law's privileging of individual authorship is the failure to recognize work produced collectively (for instance, in folk culture). Meanwhile, work that may repeat and recombine trite tropes, such as a movie poster, can win copyright protection.

Woodmansee and Jaszi understand the impetus for this allegiance in the development of a culture of "possessive individualism," in which the understanding of the self as something that can be owned fuels the expansion of capitalism. The early conflicts of incumbent and upstart publishers that brought forth the first copyright law in England, they argue, demonstrated the upstarts' perception of themselves as possessive individualists in the extreme (possession, in this case of books, being all). Incumbents invoked authors as wounded parties, in order to regain some advantage. Thus, crass economic advantage combined with a powerful new Enlightenment concept of the self to fuel new stakeholder interests in copyright. As those interests have developed, the entanglement between moral claims, the linking of selfhood with ownership, and economic interests of often-corporate copyright holders has steadily extended the copyright regime until it encompasses not merely books but almost all expression. Woodmansee and Jaszi argue that legal training and legal scholarship would benefit from the poststructuralist literary revolution historicizing the notion of authorship. This is because the enthusiasm with which recent reforms have embraced a Romantic notion of authorship, for whatever reason, has ever-more-adversely affected the ability of creators to access existing culture—precisely at a moment when such access has been facilitated by digital culture and enabled greater, more diverse, and more inclusive cultural creation than ever before. For instance, students are terrified to quote scholarly work for fear of plagiarism, and are beset by the perceived obligation to provide something uniquely original in their work. They argue:

> Western copyright laws—and the international copyright system derived from—are at once too broad and too narrow: they tend to deny or marginalize the work of many creative people while providing such intense protection to the works they cover that reasonable public access to those latter works is frustrated.[7]

Writing from a 2011 perspective, Jaszi saw signs in judicial interpretation that postmodern practice had begun to have an effect on law. He noted that Jeff Koons, who had lost a fair use lawsuit in 1992 for incorporating a piece of popular culture into his appropriation-style work, had won such a lawsuit in 2006. This time, Koons' appropriation was seen as an artistic practice. The driving force was a shift in the law toward the prizing of transformativeness (repurposing, not just re-use) as key to deciding fair use. That shift in interpretation itself was an indication at least of recombinant practices as creative acts, creating multiple authorship issues that need to be balanced.

From this vantage point, one can perceive the seepage of Romantic valuations of artistic creativity into judicial decisions, pragmatic manipulation

of the reverence for the author by corporate stakeholders lobbying for further limited monopoly rights, the limited functions of legal judgments as ways to resolve disputes, and widespread acceptance of Romantic genius-author concepts as interacting to create a situation that both in law and practice makes new creation fraught with legal concerns. This approach leads one to be as interested in how potential creators perceive copyright as in how justices, litigants, and legal scholars behave in defining and acting upon definitions of authors.

the construction and limits of us copyright law

US copyright law, however intertwined at a deep level with cultural expectations about authorship, has certain clearly expressed objectives. Among the clearest is that the goal of copyright policy is to foment culture, not merely to protect authors. Authorship protection, through limited monopoly rights, is merely one of the incentives, and a hotly debated one at that by the founders themselves. The Constitution asserts that copyright policy is intended to encourage the creation of new culture ("to promote the Progress of Science [meaning knowledge in general] and useful Arts [meaning crafts and professions]"), with a variety of incentives. Judges have consistently, even as monopoly rights have grown, recognized the value of balancing incentives to the monopoly right. Even in the 1991 *Feist* decision, the Supreme Court noted:

> …copyright assures authors the right to their original expression, but encourages others to build freely upon the ideas and information conveyed by a work. This result is neither unfair nor unfortunate. It is the means by which copyright advances the progress of science and art.

More recently, the Supreme Court in 2003 (*Eldred v. Ashcroft*, 537 U.S. 186) recognized that the key exception to monopoly rights, the fair use doctrine, is a key feature that protects copyright policy—even when heavily unbalanced in favor of monopoly rights holders—from unconstitutionality. This decision was reinforced in a 2012 Supreme Court decision that once again (and citing *Eldred*) argued that copyright imbalance was not unconstitutional, because of the existence of fair use (*Golan v. Holder*, 10-545, US Supreme Court, Term OY-2011, January 18, 2012). Without exceptions including the largest and most flexible one, fair use, monopoly rights holders would become private censors over the future of culture, with the government's sanction, thus violating the First Amendment. Although a welter of highly specific exceptions exists for specific constituencies, including teachers and librarians, everyone in the United States, in any medium, including holders of more narrow exceptions, has the right of fair use. Fair use applies to all of a copyright owner's monopoly rights, including the

owner's right to control adaptation, distribution, and performance. It applies across media (e.g., music, video, print), and across platforms (analog, digital). Part of US law for more than 150 years, and especially in recent decades, fair use has become a crucially important part of copyright policy. It is a core right; it is part of the basic package of freedom-of-speech rights available under the Constitution.

researching the link between creativity and copyright: documentary filmmakers

Since 2004, Peter Jaszi and I have collaborated to investigate how creators execute their creative decision-making in light of their understanding of copyright. The results of this work, which resulted in wide-ranging changes in creative practice, are summarized in our book, *Reclaiming Fair Use*.[8] One aspect of those results is focused upon here: the attitudes of creative communities about copyright, and the influence of those attitudes upon their creative choices.

We hypothesized, as Jaszi had argued (in the same vein as Boyle, Hyde, McLeod, Vaidhyanathan, and others), that a copyright regime heavily weighted toward limited monopoly rights holders as authors with implicit moral authority over-ranking users and new creators, and perceived to be so weighted, would constrain creativity.[9] In research with a range of communities of practice, we found similar results confirming this hypothesis. Furthermore, we discovered that the greatest constraint was invariably the timidity and confusion of the creators, rather than any actual action on the part of limited monopoly rights holders. At the same time, we perceived an explosion of creative work that was exuberantly recombinant: mashups, remixes, vids, political satire (some of it like *The Daily Show* and *The Colbert Report* on mainstream media), blogs commenting on everything from fashion choices to passive-aggressive note-leaving to media coverage, and memes of all kinds (tracked in sites such as *Know Your Meme* and *The Daily What*). These works, spurred by the digital facility, seemed to challenge by their very form—and sometimes aggressively in their content as well—the Romantic notion of authorship. Furthermore, the cultural environment in which they were created was rife with copyright critique, including celebrations of "piracy," the portrayal of copyright as "broken," and pranksterism (such as the Yes Men's antics), poking fun at intellectual-property claims.[10]

When we pursued the question of creative practice and authorial perception within communities of practice, we found a more complex and ambiguous relationship between creative activity, notions of authorship, and notions of copyright. We also saw development, through the process of claiming and practicing fair use rights, of a more complex notion of authorship. The first body of research was executed with

documentary filmmakers, who routinely invoke and quote copyrighted material in the process of capturing real life, and also are highly invested copyright holders. They are also typically independent producers, without protection from larger institutions. We conducted long-form interviews with seasoned documentarians who explained that they expected to license virtually any copyrighted material included in their films. They also explained that they could not obtain errors and omissions insurance—required for broadcast and theatrical distribution, and for many festivals—unless they cleared the work. Most broadcasters and theatrical distributors would not accept work that was only partially covered by such insurance. Thus, their own attitudes about copyright policy were being reinforced, and their actions enforced by corporate practice. The filmmakers provided us with an extensive litany of complaints about their licensing processes.[11]

One complaint they rarely had, however, was that of work being halted or blocked by inability to clear rights for work. When asked how they avoided this threat, documentarians provided us with similar answers: "We simply avoid starting any projects that would run that risk." That excluded work that would quote, among others, popular films or popular music, that would engage political topics (too much need for broadcast TV news, which would involve negotiations with the talking heads), and any attempt at parody or satire (which might not be taken as such). The documentarians' own self-censorship was by far the largest constraint on their decision-making. At the same time, documentarians struggled between an intuitive sense that some kinds of quotation should not require clearance—perhaps most commonly, moments when someone sang (the copyrighted) "Happy Birthday"—and their unexamined and powerful conviction that authors need and deserve broad protection. Often they told us that "nothing can be done" because the same law that made their jobs difficult also provided them protection. They perceived the limited monopoly rights of copyright holders not as a monopoly privilege provided as an incentive, as it is construed under the law, but as a moral right of the creator. They perceived any unlicensed use as "getting away with something," and in some way sordid, if undertaken as a general practice. This way of thinking established a disturbing cognitive dissonance for documentary filmmakers, since they also felt strongly that, at specific times in their own work, they should be able to reference their culture without paying individuals for the action. They described feeling personally violated by having to pay Time Warner for "Happy Birthday," when they had never chosen to use that song.

When told the news that they had rights under the fair use doctrine—which permits unlicensed access to copyrighted work if the use is transformative (for a different purpose) and in the appropriate amount for the new use—filmmakers responded with interested suspicion. They were

extremely concerned not to jeopardize their own financial futures, and they were also highly respectful of other creators. Documentary filmmakers frequently responded by defending the interests of the owners as creators—"What if that was my cousin who wrote the song? What if that's my film someone excerpts?" Only when they perceived copyright law as a set of incentives to encourage new culture—both offering limited monopoly rights and also exceptions to and limitations on those monopoly rights—could they separate what the law permits from questions of moral claims. Even so, it was a challenge to realize that future users might have a legitimate claim on an author's work; the implicit notion of moral rights acted strongly in their thinking.

And yet, their prevalent righteous indignation at being "held up" by (mostly corporate, but sometimes estate) copyright holders for uses that they perceived as being harmless referencing of the culture around them led them to invest in a notion of balanced copyright: protections for existing creators, and protections for new creators. In this thinking, they demonstrated an acceptance of the concept that, at some point, cultural expression becomes de-authored, and circulates in the culture; it gathers meaning through new uses people make of it. They also distinguished, implicitly, between the law's limited monopoly given to a corporate entity and a human author.

Even so, some filmmakers and many professors of film strongly voiced the opinion that a truly creative filmmaker should always be able to figure out how to make his/her own work, rather than "taking" someone else's work. This refusal to recognize the creative elements in recombining existing work—indeed, a failure to recognize that *all* creative work, as psychological studies have shown, builds upon existing culture—further demonstrated the vitality of the Romantic conception of the author among filmmakers. At the same time, filmmakers interviewed here also balanced the "Romantic ideal of the author" with the realization that, at least for documentary filmmakers, new work that uses existing work is also creative and should be valued. The realization that the law did not merely permit but encouraged the re-use of copyrighted work for the creation of new work, while a new idea for many, was an exciting one that challenged their surface assumptions about authorship. They welcomed this notion because it addressed cognitive dissonance about their perception of their own appropriation as ethical.

We perceived similar internal conflicts in other communities of practice. Specifically, we saw people invested, without necessarily having reflected about it, in the moral rights of the author (the right to control access to the author's work because of the sanctity of that author's creative act); copyright was seen naively as protecting those rights, although this goal was never articulated in US law. (It is present in some

28

European countries' copyright law.) At the same time, they found this notion enchaining at many points in their own creative process, which required referring to, excerpting from, and quoting copyrighted material. Poets, for instance, were strongly invested in a perception of themselves as original creators; mitigating their concern to invoke maximalist monopoly rights under copyright was the frequent need to refer to existing copyrighted material in their own work (even if it was an ironic use of a familiar phrase or a distinctive poetic pattern), and also the desire to see their work circulate and become part of the cultural language. As well, some contemporary poets experiment with recombinant techniques to create new work that involves digital technology. For them, it is crucial to reference the existing body of poetry (in particular) in order to create new work. These poets' concerns opened a conversation for other poets about the necessity to build upon existing tradition so as to develop new work more generally.[12]

conflicting values in other communities of practice

In some communities of practice, frustration about the difficulties in accessing existing culture was the primary experience of copyright policy. This frustration appeared to arise from a perceived conflict between moral values; they both valued the honoring of existing authorship and also their own core mission, which was not always associated with perceived authorship but which involved accessing copyrighted material without licensing. Teachers, librarians, and archivists all had missions that required repurposing, in ways that would be legal under the doctrine of fair use. Once again, the primary obstacle to use was self-censorship. For instance, media literacy teachers, who work in the K-12 environment and in after-school programs with young people, often went without current evidence from popular culture (films, advertisements, TV shows) in their teaching about popular culture. In this, they too faced institutional enforcement, because many schools and school systems have rules such as a requirement that teachers use exclusively material from the school's library or from approved databases. Restrictions on the teachers extended to the students. In the online video environment, students who had posted video to online sites often either chose not to use any copyrighted material where it would have been appropriate (thus diminishing to the quality of their work), or hid their work through passwords or on lesser-viewed sites for fear of censure. Students' fears were not unfounded, given that institutional enforcers included YouTube's ContentID and, more generally, the Digital Millennium Copyright Act's provisions that require Internet service providers to take down material receiving a complaint about copyright infringement.[13]

Higher education was rife with frustration. Creators of open course-ware—free curriculum materials made available by such major universi-ties as MIT, Yale, University of Michigan, and Stanford—routinely ruled out any courses that used copyrighted material extensively. In doing so they excluded many courses in the humanities, engineering, and science.[14] Librarians often chose not to digitize copyrighted work for inclusion in digitized special collections or institutional repositories because they lacked confidence that their choices would fall under fair use. Some librar-ians, lacking institutional precedent, also refused to post course materials repeatedly on e-reserves.[15] Communication scholars chose not to embark upon research projects because they feared they would not be able to proceed because of copyright concerns.[16]

managing conflicts within a romantic-authorship model

Practitioners who primarily experienced copyright policies as limitations, rather than as protection, expressed two kinds of responses: piratical attitudes and searches for alternative spaces. Each unconsciously paid due to the Romantic conception of authorship. Understanding copyright as exclusively benefiting existing monopoly rights holders led some to con-strue that their behavior as practitioners was illegal, even when it was not. Some practitioners saw themselves as seizing what was necessary in order for them to do their work, in a "by any means necessary" mode of think-ing. For instance, media literacy teachers usually had an entirely legal right to employ copyrighted material as teaching exemplars and to build such work into curriculum under fair use. However, they did not understand that this was legal. Some media literacy teachers simply brought copy-righted material into classrooms, believing their acts to be illegal (although usually they were not), and tried to hide this fact from superiors by shutting their classroom doors and hoping their students would not tell on them. The media literacy teachers who saw themselves as pirates construed their acts as morally justified (although they were clearly trou-bled by perceiving themselves as criminals), because they were doing the important work of education. Some media literacy teachers saw them-selves as the defenders of underserved children in underfinanced schools; those teachers believed they were forced into illegal actions simply to do their job of teaching. They viewed their decisions to use copyrighted material as similar to buying classroom supplies from their own pockets, tutoring students outside regular classroom hours, visiting a troubled student's home, or bending a host of other school-system rules simply to work as an effective instructor.

Media literacy teachers had an unarticulated, but traditionally Romantic, understanding of authorship, from which they often uncon-sciously excluded themselves for a perceived lack of unique originality.

30

Additionally, media literacy teachers were, often, creators of materials such as textbooks and teaching units, but they did not always construe themselves primarily as authors in creating these works. They saw themselves more as sharing materials that helped them do their work, and were usually more interested in being able to circulate those materials without penalty than they were about collecting royalties from the work or claiming credit. They all taught their students to respect copyright as an absolute right—except when "playing" with material within the four walls of the classroom, hidden from superiors' view. Thus, they faced enormous cognitive dissonance in doing their daily work, a dissonance created both by ignorance of the law and also by an overvaluation of originality in a Romantic sense in authorship.

In the anarchic environment of online video, which changes with the rapidly evolving "remix" digital culture and is marked by aggregation, recombination, and the fueling of social networks with shared media, piracy has taken on a positive valuation. In the process, however, clearly *illegal* activity such as downloading entire commercial works without payment is confused with clearly *legal* activity such as carefully crafted remix. The confusion for practitioners is due to a combination of ignorance about the law and confusion about the nature of creativity.

The term "piracy," publicized by large trade organizations such as Motion Picture Association of America and the Recording Industry Association of America, has been flipped in the remix environment. For instance, a prominent remix video artist, Elisa Kreisinger, calls her site "Pop Culture Pirate"; author Cory Doctorow opens a speech with the swashbuckling term "Aaargh!"; a Swedish P2P site proudly calls itself "Pirate Bay"; scholar Kembrew McLeod (a noted prankster as well on intellectual property issues) and co-director Benjamin Franzen titled a documentary on hip-hop culture's legal frustrations over remixing and appropriation as *Copyright Criminals*. The frisson of illegality is provocatively marked by the choice of title for a 2003 exhibit in which art and artists encounter the frustration over intellectual property arenas: "Illegal Art." Ironically, most of the work in the exhibit was legal.

Piratical stances register frustration with extended monopoly rights, and often against corporate overreach. They do not, however, in themselves challenge a Romantic conception of the author. Indeed, it is quite common in the artistic community to hold both attitudes. A 2005 conflict among artists, discussed in *Reclaiming Fair Use*, illustrates this:

> Artist Joy Garnett, who creates her own paintings using visual work she samples on the Web, used a photograph of a Nicaraguan revolutionary about to heave a grenade by political photographer Susan Meiselas in a collage of images called "Riot." As a matter of principle, Garnett as

31

a digital visual artist treats all imagery she encounters on the Internet as equally available for her repurposing. She and others regarded this act as transgressive. In this case, without being aware of its significance, she had chosen a richly resonant and even (for some) iconic photo- graph. It had become one of the most popular images of the revolution in Nicaragua, appearing in murals, on leaflets and even taken up by the winning revolutionaries the Sandinistas. Meiselas had never attempted to control its use, and as a Sandinista supporter was proud of its diffu- sion in revolutionary circles. But she was furious at seeing it brutally de- and recontextualized. Incensed, Meiselas sent a cease-and-desist letter to Garnett, for "pirating" her image. Garnett took the image off her site, but Garnett's friends in protest had already begun mirroring it on many other websites. ... Garnett's friends saw themselves as champions of digital freedom valiantly bucking analog-era censorship ... Meiselas' supporters were just as adamant in their defense of the principle of artistic integrity. In fact, both groups took absolutist positions that in different ways reflected a Romantic-genius view of authorship. They saw themselves as defending the right of artists to control their work—the only difference being which artist they had in mind. Recent litigation ... demonstrated that there is no need to choose, because fair use works effective to mediate controversies about the quoting of copyrighted material in art.[17]

Another approach to this frustration with copyright was to develop alternative sites of culture that allow for greater freedom for creative and intellectual practices. Thus, some open courseware designers turned to Creative Commons licenses that offered blanket permission to share work under specific terms. Creative Commons licenses can be issued as a blanket invitation to copy and repurpose at will, or with conditions such as non-commercial only, or reproduction only of the complete work. Some librarians and scholars have embraced open-access educational resources, such as institutional repositories, open-access online journals, the SPARC addendum, and other mechanisms to share material freely.[18] Some software creators have promoted the open-source environment for software development that, in turn, allows for collaborative development of work available to all.

Each of these approaches depends, ironically, on the current unbal- anced state of copyright policy, which highly values the rights of existing copyright holders. It is this right that permits a copyright holder to give

away his/her material under certain circumstances. These options work well in a community of creators, all of whom agree that they prefer to surrender or limit their monopoly rights under copyright. They create fenced-in cultural arenas within a much wider sea of copyrighted work whose current owners also highly value those monopoly rights, and depend on action of people who understand themselves to be (generous) authors. In some cases, particularly among educational-resources communities, such approaches are adopted pragmatically, for their efficiency, cost saving, and timeliness. In some cases, however, they are adopted ideologically, as part of a general attitude indicting copyright policy as a tool of greedy (and often corporate) owners. Many supporters of this "commons" approach to cultural creation imagine a steady expansion of this culture. So far, however, there is not much indication who the "commoners" are other than participants in communities of practice where other significant rewards for cultural creation are offered, such as tenure. Indeed, the fact that the majority of Creative Commons licenses are conditioned rather than providing access to materials with blanket permission suggests that even assertive ideological supporters of an information-commons environment still seek some of their monopoly rights.

achieving copyright understandings that enable creative practice

Our extensive research with communities of practice demonstrates the powerful pull of the Romantic conception of the author, as Woodmansee and Jaszi had postulated, as well as a powerful strand of cognitive dissonance among creators who recognize, implicitly or explicitly, the collaborative element in creativity and the participatory role of users. This clash is particularly acute in communities where collaboration in creation and user interaction with the work is encouraged. Our research shows as well that the Romantic ideological framework commonly affects interpretation of copyright law, in ways that further generate cognitive dissonance. Creative practice in the communities of practice that we have studied has typically paid much more attention to monopoly holders' rights than the law requires. When forced to choose between bowing to monopoly rights holders or executing creative practice, creators have sometimes reacted with extreme responses. For instances, they flaunt self-criminalizing labels such as "pirate," and attempt to create copyright-lite or copyright-free spaces that can be sanctuaries from the ruling law.

It was this dynamic that the creation of codes of best practices in fair use disrupted, to powerful effect. Ten codes of best practices had been created by 2012 among communities of practice as diverse as filmmakers,

librarians, and poets.[19] These codes enabled members of these communities to use their fair use rights more effectively, and the codes also permitted their gatekeepers to behave more rationally and make a better risk analysis. For instance, within a year of creating their code of best practices, filmmakers found that all insurers for errors and omissions—a required insurance for broadcast—accepted fair use claims routinely, for the first time in almost two decades. Some school systems have incorporated the language of media literacy teachers' codes of best practices, and teachers have begun to circulate both their own curriculum and the work of their students.[20] Open courseware designers launched dozens of new courses within 18 months of developing their own code.[21] Creating codes of best practices, a process that required group deliberation, also enabled discussions about creativity and culture that featured its collaborative and participatory nature.

conclusion

These transformations have significantly shifted the way practitioners understand the nature of creativity, authorship, and law. While documentary filmmakers have learned to see their work as recombinant in a way that previously they denied or struggled against, remixers (such as Jonathan MacIntosh and Elisa Kreisinger) have backed away from their claims to be renegades and have instead construed themselves as fair use activists; scholars proudly post work that incorporates fairly used copyrighted material on the Creative Commons website. Media literacy teachers now teach their students that it is legal to re-use texts without permission and to separate the law from more academic issues such as citation.

Conversations have been spurred in every community with which we have worked, below the surface of received wisdom associated with both authorship and law. For anyone actively engaging their fair use rights, both authorship and the law become something more like social artifacts rather than part of the given world. People come to see authorship as multiple and sometimes collaborative; they come to see creativity as a social rather than individual process; and they experience the fact that law is interpretable and can change through practice.

By and large, communities of practice have not necessarily recognized a postmodern reality; rather, they are keenly aware of the knowledge that new authors—who typically continue to be seen as making creatively original contributions to the culture—must necessarily refer to and transform their own culture, including the work developed by many other authors. This is a significant conditioning of the Romantic conception of originality, insofar as it recognizes that copying, quoting, and repurposing are crucial to creative acts.

notes

1. Michel Foucault, "What Is an Author?," in *Textual Strategies: Perspectives in Post-Structuralist Criticism*, ed. Josué V. Harari (Ithaca, NY: Cornell University Press, 1979); Roland Barthes, "Death of the Author," in *Image, Music, Text*, ed. Stephen Heath (New York: Hill and Wang, 1977).

2. Mark Lemley, "Romantic Authorship and the Rhetoric of Property," *Texas Law Review* 75 (1997); David Saunders, *Authorship and Copyright* (London: New York: Routledge, 1992).

3. Prudence S. Adler et al., "Code of Best Practices in Fair Use for Academic and Research Libraries" (Washington, DC: Association of Research Libraries Center for Social Media, School of Communication, American University Program on Intellectual Property and the Public Interest, Washington College of Law, 2012); Peter Jaszi, "On the Author Effect: Contemporary Copyright and Collective Creativity," in *The Construction of Authorship: Textual Appropriation in Law and Literature*, ed. Peter Jaszi and Martha Woodmansee (Durham, NC: Duke University Press, 1994); ———, "Is There Such a Thing as Postmodern Copyright?," in *Making and Unmaking Intellectual Property*, ed. Mario Biagioli, Peter Jaszi, and Martha Woodmansee (Chicago: University of Chicago Press, 2011); ———, "Toward a Theory of Copyright: The Metamorphoses of 'Authorship'," *Duke Law Review* (1991); James Boyle, *Shamans, Software, and Spleens: Law and the Construction of the Information Society* (Cambridge, MA: Harvard University Press, 1996); ———, *The Public Domain: Enclosing the Commons of the Mind* (New Haven, CT: Yale University Press, 2008); Lewis Hyde, *The Gift: Creativity and the Artist in the Modern World*, 25th ed. (New York: Vintage Books, 2007); ———, *Common as Air: Revolution, Art, and Ownership*, 1st ed. (New York: Farrar, Straus and Giroux, 2010); Thomas Streeter, *The Net Effect: Romanticism, Capitalism, and the Internet* (New York: New York University Press, 2010); Siva Vaidhyanathan, *Copyrights and Copywrongs: The Rise of Intellectual Property and How It Threatens Creativity* (New York: New York University Press, 2001).

4. Jaszi, "On the Author Effect."

5. Boyle, *Shamans, Software, and Spleens*; Jaszi and Woodmansee, eds., *The Construction of Authorship*; see also Keith Aoki, James Boyle, and Jennifer Jenkins, *Bound by Law? Tales from the Public Domain* (Durham, NC: Center for the Study of the Public Domain, Duke University Press, 2008).

6. Martha Woodmansee, "On the Author Effect: Recovering Collectivity," in *The Construction of Authorship: Textual Appropriation in Law and Literature*, ed. Peter Jaszi and Martha Woodmansee (Durham, NC: Duke University Press, 1994), 5.

7. Woodmansee, "On the Author Effect," 10–11.

8. Patricia Aufderheide and Peter Jaszi, *Reclaiming Fair Use: How to Put Balance Back in Copyright* (Chicago: University of Chicago Press, 2011).

9. Kembrew McLeod, *Freedom of Expression: Overzealous Copyright Bozos and Other Enemies of Creativity*, 1st ed. (New York: Doubleday, 2005).

10. In *Reclaiming Fair Use*, we discuss the unfortunate consequences of the copyleft's adoption of some of the ideological framing of large corporate copyright holders. Among them was a linking of moral rectitude with a policy position (copyright = respecting authors vs. copyright = greedy hoarders) and an assumption that copyright policy was about protecting monopoly holders, not encouraging new culture. This makes it possible for large media companies, which as incumbents are fighting for rapidly

outdating business models, to demonize critics as woolly-headed, immoral, and criminal. Large media stakeholders, which have powerful lobbies in Congress, continue to press for further imbalance in copyright, typically invoking the sanctity of authors' rights, as was true in the 2011–2012 conflict over two bills that proposed to limit international piracy by censoring the Internet. While that legislation was halted by massive protest including from large corporate stakeholders in the Internet space, one can expect continued pressure from media interests to alter copyright law. Therefore, an understanding of the contingent and motivated use of the notion of authorship by powerful corporate interests will continue to be relevant for policy-making.

11. Patricia Aufderheide and Peter Jaszi, "Untold Stories: Creative Consequences of the Rights Clearance Culture for Documentary Filmmakers" (Washington, DC: Center for Social Media, American University, 2004).

12. Michael Collier et al., *Poetry and New Media: A User's Guide* (Chicago: Poetry and New Media Working Group, Harriet Monroe Poetry Institute, Poetry Foundation, 2009).

13. Patricia Aufderheide, Renee Hobbs, and Peter Jaszi, "The Cost of Copyright Confusion for Media Literacy" (Washington, DC: Center for Social Media, School of Communication, American University, 2007), accessed from http://www.centerforsocialmedia.org/fair-use/best-practices/media-literacy/cost-copyright-confusion-media-literacy-0.

14. In work that culminated in the creation of the Code of Best Practices in Fair Use for Open Courseware (accessed May 20, 2012, http://centerforsocialmedia.org/ocw), the group that created that document interviewed their peers in order to understand the contemporary state of practice. That study informed the creation of the Code, but was never published.

15. Patricia Aufderheide, Brandon Butler, and Peter Jaszi, "Challenges in Employing Fair Use in Academic and Research Libraries" (Washington, DC: Association of Research Libraries, Center for Social Media, and Program on Information Justice and Intellectual Property, 2010).

16. International Communication Association Ad Hoc Committee on Fair Use and Academic Freedom, "Clipping Our Own Wings" (Washington, DC: International Communication Association, 2010).

17. Aufderheide and Jaszi, *Reclaiming Fair Use*, 63.

18. See SPARC's Author Rights Initiative, in Resources for Authors, Scholarly Publishing and Academic Resources Coalition, accessed March 30, 2012, http://www.arl.org/sparc/author.

19. All the codes of best practices are available at centerforsocialmedia.org/fair-use, and are discussed in *Reclaiming Fair Use.*

20. Renee Hobbs, *Conquering Copyright Confusion: How the Doctrine of Fair Use Supports 21st Century Learning* (Thousand Oaks, CA: Corwin, 2010).

21. Quoted in blog post at Center for Social Media, accessed January 2, 2012, http://centerforsocialmedia.org/blog/fair-use/no-more-skeletons-or-swiss-cheese-fair-use-open-courseware-works.

copyright shakedown

the rise and fall of righthaven

t w o

pam spaulding and
michelangelo signorile

pam

A firm called Righthaven emerged in 2010 for the sole purpose of obtaining out-of-court settlements from bloggers for thousands of dollars by threatening costly copyright infringement lawsuits. Righthaven's clients included newspapers that claimed their content had been used by blogs and websites without permission. Rather than ask for retractions or removal of the content under "fair use" guidelines, the newspapers, in a legally questionable practice, sold their copyrights to Righthaven, which then intimidated bloggers for cash payments and refused to accept the removal of the content as a settlement.

By late 2011, Righthaven was on life support after a series of setbacks in the courts, but only after it had financially debilitated many bloggers and website owners and threatened free speech. Many of the bloggers were political activists who earn little or no money from their blogs, often volunteering their time while working other full-time jobs. Many other blogs and media organizations, fearful of becoming Righthaven's targets,

refrained from writing about its pernicious practice and threat to free speech, thereby keeping Righthaven's activities largely underground. The bloggers, often as part of their settlement with Righthaven, were forced to remain silent.

a surprise in my inbox

In March, 2011, I was in Miami, Florida, covering Outgiving, an annual conference that brings together the Lesbian, Gay, Bisexual, and Transgender (LGBT) donor community and other organizations involved in the movement for full equality. It was also the first year that citizen journalists, more commonly known as bloggers, were invited to attend the gathering. It was a welcome opportunity for me to observe and report on this portion of the community's activities for my blog, *Pam's House Blend*.[1] While on a break between sessions, I went back to my hotel room to check my email only to discover this missive waiting for me from a reporter with *The Las Vegas Sun*:

> From: Steve Green <steve.green@lasvegassun.com>
> Date: Sat, Mar 5, 2011 at 11:31 AM
> Subject: Lawsuit against Spaulding
> To: tips@phblend.net
> Hi, I am a reporter for the Las Vegas Sun writing a story about the attached lawsuit alleging copyright infringement. The suit claims your website posted without authorization a Denver Post TSA patdown photo.

Background on similar lawsuits:

> http://www.lasvegassun.com/blogs/business-notebook/2011/feb/28/roundup-righthaven-faces-pr-problem-suit-against-n/
> http://www.lasvegassun.com/news/2011/feb/08/new-round-righthaven-suits-over-tsa-pat-down-photo/
> Please let me know if you want to comment on the lawsuit and thanks.

Needless to say, I was stunned. I replied:

> From: Pam Spaulding <pam@phblend.net>
> Date: Sat, Mar 5, 2011 at 5:11 PM
> Subject: Re: Lawsuit against Spaulding
> To: Steve Green <steve.green@lasvegassun.com>

My response:

> I haven't received this lawsuit—this is the first I've heard of it.

It's absurd—the photo is all over the web and I cited the story with photo as it appeared on the web site Ranker as part of its parody list of TSA "violations." And my post doesn't target Denver readers in the least.

Also, where is the takedown notice before filing a lawsuit? I was never notified about the infringement with a takedown email or snail mail to rectify the situation from their perspective.

I had not received any legal documents before I left town. When I returned to my home in Durham, North Carolina, a couple of days after receiving Green's email, I had also not received any overnight mail relating to this lawsuit. Two days later, the paperwork finally arrived. And to my surprise, it arrived via the standard United States Postal Service. This delivery set the tone for the professionalism Righthaven LLC showed me throughout the process. Although I am not an attorney, I certainly knew that any legal documents must be sent through a certifiable method of delivery. However, as an independent blogger, the fact that I was being sued for copyright infringement in federal court was foremost on my mind at the time, not the details of the process.

The legal paperwork sent to me read as follows:

Righthaven LLC v. Spaulding
Plaintiff: Righthaven LLC
Defendant: Pamela Spaulding
Case Number: 1:2011cv00537
Filed: March 3, 2011
Court: Colorado District Court
Office: Denver Office
County: US, Outside State
Presiding Judge: John L. Kane
Nature of Suit: Intellectual Property—Copyrights
Cause: 17:501 Copyright Infringement
Jurisdiction: Federal Question
Jury Demanded By: Plaintiff[2]

I quickly learned, after jumping onto Google to research Righthaven, that I was not alone in this sudden and unexpected legal action. I discovered that Righthaven had sued 27 other blogs/websites in March.[3] The photo in question, and that I had published, was widely circulated because of its humor value. The image showed a Transportation Security Agent (TSA) in a "compromising" position where they were patting down a man's groin during an airport security check. I later learned that Righthaven had also sued the conservative website *The Drudge Report*, as well as the news site *The Raw Story*, for using the same photo that was originally published

in *The Denver Post.*[4] In addition to suing for damages for the alleged copyright violation, Righthaven asserted that, as part of its damages claim, the ownership of my blog domain, http://pamshouseblend.com, must be transferred to them:

> Direct APlus, the current registrar, and any successor domain name registrar, to lock the Domain and transfer control of the Domain to Righthaven.[5]

This audacious power-grab and shakedown of small, part-time bloggers and news sites placed people like me—along with *The Drudge Report* and other web outlets that had published the TSA image—in a financially hazardous position. The choice was either to roll the dice and engage in a protracted lawsuit (where a win was not a guarantee) or settle with Righthaven on their terms. While under current copyright law any copyright holder may sue without notifying the defendant, the common "netiquette" practice around matters of "fair use" is to notify the alleged offender—*prior to filing a lawsuit*—with an email notification that requests specific images or content be removed. Righthaven's business model was to go straight to the lawsuit thereby counting on its victims to settle rather than incur the expenses involved in a court battle.

Ars Technica, another website in the copyright crosshairs, reported that Righthaven had sued Eric Gardner, one of its freelancers. Gardner had provided a grainy screen capture of the TSA photo (as it appeared on *The Drudge Report*) with his article, "Copyright Troll Righthaven Sues for Control of *Drudge Report* Domain."[6] In covering this story, *Ars Techinica*'s Nate Anderson writes:

> US copyright law allows certain "fair uses" of copyrighted material without consent of the rights holder; such uses explicitly include "criticism, comment, news reporting, teaching (including multiple copies for classroom use), scholarship, or research." Making a final determination relies on a "four-factor test":
> (1) the purpose and character of the use, including whether such use is of a commercial nature or is for non-profit educational purposes;
> (2) the nature of the copyrighted work;
> (3) the amount and substantiality of the portion used in relation to the copyrighted work as a whole; and
> (4) the effect of the use upon the potential market for or value of the copyrighted work.[7]

Ultimately, the definition of and rulings around "fair use" would prove detrimental to Righthaven's targeting of blogs' and news sites' use of image

and content. In fact, their legal tactics backfired in some instances when they took their cases to court and the resulting rulings actually expanded the concept of fair use. However, this legal good news was a bit down the line.

the legal process

Once it was clear that Righthaven had ensnared me in their legal shake-down, my first action necessitated that I remove the TSA image from my blog post. And it was also clear that I needed to retain legal counsel. Since I belong to several listservs that include bloggers, journalists, and attorneys, I sent an inquiry that explained the details of my situation along with Righthaven's background that was clearly laid out courtesy of a website (Righthaven Victims) that "lists the victims of Righthaven LLC 'shake-down' lawsuits that are causing irreparable harm to bloggers and advocacy websites."[8] The website also lists firms that represented bloggers who had been sued by Righthaven.[9]

What I conveyed to my fellow online journalists was the fact that Righthaven's sole reason for existing was to try to obtain the rights to the copyright of an article or image—sometimes weeks or months after the alleged infringement occurred. To do this, Righthaven staffers scoured Google so as to locate potential copyright infringements on websites and then slap website owners with a copyright-infringement lawsuit. This scavenger-hunt process was how Righthaven's methods earned the moniker "copyright troll" or "copytroll."[10] Righthaven chief executive officer, attorney Steven A. Gibson, made no bones about the fact that this model represented a potential windfall for publishers:

> Founded in 2010 with a $500,000 investment by Stephens Media—its first and largest client—Righthaven promised to fix the print media's financial ills by suing bloggers and website owners for reposting snippets or entire copyrighted articles. Newspaper content, Gibson said in an interview last year, had hidden value waiting to be unlocked through litigation under the copyright act, which allows $150,000 in damages per violation. "We believe there to be millions, if not billions, of infringements out there," he said.

Righthaven went on to settle more than 100 cases out of court for a few thousand dollars each. Many of its early lawsuits targeted websites for comments and forum posts by the site's readers.[11]

On the listservs to which I belong, members directed me to the Electronic Freedom Foundation (EFF). The organization's mission is to

41

defend free speech, privacy, innovation, and consumer rights on the Internet. Its website dedicates a section specifically related to Righthaven's highly questionable actions, "Righthaven's Brand of Copyright Trolling,"[12] and EFF's attorneys had already taken on several Righthaven cases filed in US District Court in Las Vegas;[13] these cases involved infringement based on copy that was reposted on blogs (not the TSA image) from *The Las Vegas Review-Journal*. After contacting EFF, I was referred to Rebecca S. Reagan, the organization's Intake Coordinator. Although the organization could not provide an attorney for my case, Reagan suggested I contact a firm that was handling similar cases and were filed in the US District Court for the District of Colorado.

Reagan's contact led me to J. Malcolm DeVoy of the Randazza Legal Group who took my case.[14] From DeVoy, I received the common sense, or general initial advice to: (1) not deal with Righthaven directly; and (2) set up my blog as an LLC, or "limited liability company."[15] This move would help shield my personal assets with the blog serving as the defendant in a prospective lawsuit. I also learned at this time that a good number of the people and organizations had been sued by Righthaven and settled. I had no idea how much Righthaven had "extorted" from them (the settlements are confidential with significant financial penalties for anyone disclosing the amount of the settlement). DeVoy, in an email to me, stated that "Righthaven's demands have reportedly escalated to the high four figures and low five figures." Needless to say, that took my breath away. A settlement of that magnitude would wipe out *The Blend's* coffers. The number of blogs that are self-sustaining are few and far between. The revenue a blog proprietor makes from advertising is very small. I, for example, write and report for the blog part-time while maintaining a full-time and unrelated job in academia (I'm a senior manager at Duke University Press). Although the Press partially underwrites *Pam's House Blend* and the blog accepts paid advertising, any ad revenue that is made is used to pay for the blog's contributors (who also write and report part-time) and to cover expenses for conferences and news events that I regularly attend in order to keep *The Blend* current and relevant. Indeed, a political blog is very much a labor of love; it definitely does not boost one's personal income. The large settlements that Righthaven potentially threatened could force many independent blogs to fold, including my own.

One of the more difficult and disturbing aspects of this debacle for me, personally, was seeing how many of my peers did not wish to write about what Righthaven was doing to their blogs in relationship to free speech and fair use. Many refused to take up the matter because they feared that they may become the next blog targeted by the "copytroll." My emails about the case were thus met with silence on listservs. A few people asked for more details about the situation or offered their sympathy

since it was I who took the public body blows that directly affected their work. Most of my colleagues also scrubbed their sites of any content cited by or associated with *The Denver Post*, *The Las Vegas Review-Journal*, and any other related news outlets that had an alliance and/or agreement with Righthaven.[16] After much handwringing, I decided that I would take the settlement path. I couldn't afford to pay an attorney to see this litigation through (no pro-bono offers came my way). My decision was based on two concerns: (1) no guarantee could be made that a court resolution was going to happen in timely fashion (and, hence, mounting expenses would occur); and (2) no guarantee that the court would ultimately rule in my favor.

Hence, my attorney, DeVoy, went through a couple of negotiation rounds with Righthaven and, by April 8, 2011, a settlement had been reached and my bank account for *The Blend* was drained. The blood money paid to Steven Gibson's company contained a 50–50 split with his clients.

authoring the fallout

And this brings us to my decision to blog about my encounter with Righthaven. While I am unable to discuss the terms of any settlement, I can and certainly did try to explain to my readers what had transpired. On April 19, 2011, I published "Is This the End of Predator Copyright-Troll Righthaven's Flight Under the Media Radar?" I wrote:

> NOTE: If you read and care about *PHB* (and many other blogs), it's worth taking the time to read this piece about Righthaven. Its lawsuit against me threatens the blog's existence. If you think about the number of blogs that have broken all kinds of stories that affect the LGBT and progressive communities and raised the attention of national media, the complicity of silence on this topic is scandalous, as you'll see below. …
>
> When I posted on a couple of listservs I am on—there was zero admission that anyone on the lists were also in this legal entanglement, but there were several general "I'm sorry this happened to yous" as reactions. There were also a couple of private blame-the-victim reactions, pretty crass considering there wasn't even a cursory look at what Righthaven was engaging in—such as squeezing autistic individuals on a fixed income over the same photo.[17]
>
> No one was blogging about it or discussing it publicly; after all, if they discussed my plight, it might turn Righthaven to Google them for possible IP violations. I actually generated interest from more than one

43

major blog to discuss Righthaven's shakedown operation *and every single one backed off out of the fear of being targeted.* There was no mainstream media coverage, aside from *The Las Vegas Sun.*[18]

I then went on to explain what Righthaven is and why so much silence by the mainstream media was in place. I continued:

Righthaven LLC is owned 50/50 by two limited liability companies. The first is Net Sortie Systems, LLC, which is owned by Las Vegas attorney Steven Gibson—the Nevada attorney who is behind all of the lawsuits filed by Righthaven. The second is SI Content Monitor LLC, which is owned by family members of investment banking billionaire Warren Stephens whose investments include Stephens Media, LLC, which owns *The Las Vegas Review-Journal.* Righthaven's business arrangement is memorialized in a Strategic Alliance Agreement between Righthaven LLC and Stephens Media LLC (an arrangement that some commentators (here) argue renders void Stephens Media's copyright assignments to Righthaven, thereby nullifying Righthaven's standing to bring its copyright infringement actions).

… [A] third media company—Media News Group—is also using Righthaven's "services"—as reflected by numerous copyright infringement lawsuits that have been filed by Righthaven in the Colorado over material appearing in *The Denver Post,* which is owned by Media News Group. News coverage of Righthaven's Colorado "client" can be found here and here (see also *Denver Post*'s "Notice to Readers About *Denver Post* Copyright Protections" on November 14, 2010).[19]

Thank Righthaven's partner in these predatory practices, *The Denver Post*/Media News Group, for my particular case.[20]

Righthaven founder Steven Gibson says that he continues to add new partners. Among them: *The Denver Post,* which teamed with the copyright-holding company in December. Since then, Righthaven has sued numerous bloggers—the most prominent being Matt Drudge of *The Drudge Report*—alleging infringement of a *Post* photograph of a Transportation Security Administration airport patdown (Drudge and Righthaven reached an undisclosed settlement in February).

The Post's publisher is William Dean Singleton, who also serves as executive chairman of MediaNews Group, which bills itself as the country's second-largest newspaper chain. Singleton holds another title: chairman of the board of The Associated Press. Is it possible that Singleton—who said at the AP's 2009 annual meeting that the news service would seek "legal and legislative remedies" against those that it believes unfairly uses its material—views the AP as a potential Righthaven partner?

It turns out that the heat on Righthaven's model and practices may have made the AP distance itself, and think up a different kind of "relationship." On February 3, 2011, the AP reported:

> The Associated Press Board of Directors today approved the establishment of an independent news licensing agency that will allow broader and better access to original news content while providing publishers support for innovative new business models. When launched this summer, the enterprise will include news content from AP and more than a thousand publications.
>
> AP will spin off its News Registry into the newly created entity, called the News Licensing Group, and expects to raise funding from the news industry. The News Licensing Group will be owned by news publishers, and fulfill a need for an efficient means to protect and license digital news content from thousands of news organizations to the wide and growing range of digital communications products and services.[21]

After the post went live, lots of discussion about Righthaven, its murky structure, and the effect it had on *Pam's House Blend* took place. However, given the confusion about the complicated topic, I took another crack at explaining it both in a blog and on the Internet radio show, "Radio or Not," with former *Air America* radio host, Nicole Sandler. On Sandler's program, I discussed in detail Righthaven's predatory business practices as well as the disturbing lack of coverage in the blogosphere and mainstream media.[22] On that same day, April 21, 2011, I published "The Visual Guide to the Business Model of Copyright Troll Righthaven, LLC." This post gave readers a road map that explained the corporate interests, the lawsuits, and how they are connected. My blog, in part, reads:

> Righthaven is suing in a random and sloppy way, activist bloggers, non-profits and personal bloggers for violation of copyright. This includes retroactive lawsuits prior to Righthaven's alleged holding of copyright.

The strategy of Righthaven is to sue thousands of these websites and counts on the fact that many are unfunded and will be forced to settle out of court. Most cases are being filed in a Nevada Federal Court and must be fought in this jurisdiction.

The earlier post went into great detail about Righthaven's rise (and future potential fall after some rulings and revealed agreements went public last week). Even with all this news in the wind, there has been nearly utter silence about this topic—unbelievably scandalous—as this affects the relationship between blogs and traditional media, as well as U.S. Copyright Law.

I've received comments and emails about the possible reasons for this silence, including the hoary "it's too complicated." Jesus, it's not that complicated and I'm no attorney. So to take that tired excuse off the table, I've constructed a visual guide to the relationships involved in Righthaven's business model. Take a look:

At its core, *The Las Vegas Review Journal* and *The Denver Post* are the intere$ted parties that have worked to profit and keep their hands clean of legal efforts that, among other things, involved suing *an autistic man on fixed income for thousands of dollars* for publishing a widely-circulated photo of a TSA agent feeling up a passenger's thigh. (That's the same one I was slapped for, along with *The Drudge Report* and *Raw Story*).

The good news (not for me, though) [and because of] the Electronic Frontier Foundation's work on the cases involving Stephens Media, LLC, the jig is up:

7.2 Despite any such Copyright Assignment, Stephens Media shall retain (and is hereby granted by Righthaven) an exclusive license to Exploit the Stephens Media Assigned Copyrights for any lawful purpose whatsoever and Righthaven shall have no right or license to Exploit or participate in the receipt of royalties from the Exploitation of the Stephens Media Assigned Copyrights other than the right to proceeds in association with a Recovery.

What this resulted in was the federal judge ruling that Righthaven did not actually have standing to sue in the first place. My case, as one of the lawsuits in Colorado's US District Court, had had its contracts with *The Denver Post* at that time, so the TSA photo cases were left to twist in the wind a while longer—but the bad news for Righthaven was just beginning.[23]

pam spaulding and michelangelo signorile

46

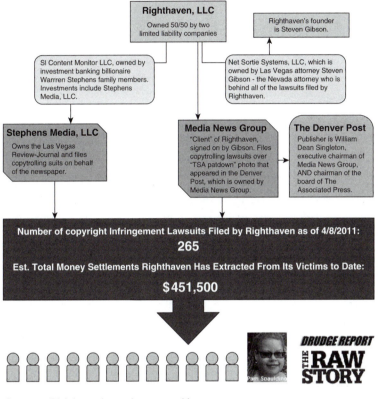

Visual Guide To The Business Model of Copyright Troll Righthaven, LLC

Righthaven, LLC
Owned 50/50 by two limited liability companies

Righthaven's founder is Steven Gibson.

SI Content Monitor LLC, owned by investment banking billionaire Warrren Stephens family members. Investments include Stephens Media, LLC.

Net Sortie Systems, LLC, which is owned by Las Vegas attorney Steven Gibson - the Nevada attorney who is behind all of the lawsuits filed by Righthaven.

Stephens Media, LLC
Owns the Las Vegas Review-Journal and files copytrolling suits on behalf of the newspaper.

Media News Group
"Client" of Righthaven, signed on by Gibson. Files copytrolling lawsuits over "TSA patdown" photo that appeared in the Denver Post, which is owned by Media News Group.

The Denver Post
Publisher is William Dean Singleton, executive chairman of Media News Group, AND chairman of the board of The Associated Press.

Number of copyright Infringement Lawsuits Filed by Righthaven as of 4/8/2011:
265

Est. Total Money Settlements Righthaven Has Extracted From Its Victims to Date:
$451,500

DRUDGE REPORT
THE RAW STORY

Sources: RighthavenLawsuits.com and Law.com

Figure 2.1

Tracing Righthaven's copyright trolling.

Righthaven continued to find itself in serious legal trouble when its cases moved forward in the courts. A sanction of $5,000 was levied on it for misleading a federal judge, and it was ordered to pay the legal fees of one defendant. US District Judge, Roger Hunt, told Righthaven attorneys that the outfit did not have the standing to bring a copyright lawsuit against the website *Democratic Underground*, based on the content of the agreements it had with publishers.[24] By September, Righthaven had seen more similar cases dismissed by Judge Hunt, and the litigation machine ground to a halt while the bevy of attorneys working on "research" to find victims to sue were laid off. In effect, no new lawsuits were now filed.[25]

And the hits just kept on coming. Former defendant Brian Hill placed Righthaven in a nasty public relations nightmare when he wrote about his case dismissal and then posted a YouTube video that put the company

47

in damage control mode.[26] Because of its sloppy legal work, the ruling in the EFF's case resulted in the publisher of *The Las Vegas Review-Journal* admitting that posting short excerpts of a news article in an online forum is not copyright infringement.[27] Perhaps the two most ignominious public defeats for Righthaven came when its domain name—http://righthaven.com—was sold in a public auction at SnapNames for a paltry $3,300. As of January 2012, the Nevada State Bar is investigating CEO Steve Gibson and two former Righthaven lawyers. They are now the targets of "formal proceedings."[28]

what happened to *pam's house blend*?

I can report that while the financial blow was significant, *Pam's House Blend* is alive and well. It exists now, however, as a channel on the progressive website Firedoglake (FDL) as http://pamshouseblend.firedoglake.com. A generous offer was extended to me by its proprietor, Jane Hamsher, that I could bring back all content from the blog, convert it to the native publishing platform used by her blog (Wordpress), and retain editorial control over my content.[29]

In the meantime, the complex issues surrounding media authorship, copyright law, and publisher rights continue to evolve. The Associated Press, an organization that once mulled a relationship with Righthaven, launched—along with other 26 other US news organizations including The New York Times Company and The Washington Post Company—NewsRight to track the online unauthorized use of copyrighted content. According to *The Nieman Journalism Lab*, NewsRight partners have its news stories embedded with a tracking code that monitors unpaid commercial use of the content on blogs or news aggregation sites.[30] When "unauthorized" use of content is discovered, NewsRight will go after violators and ask them to purchase a licensing fee. If those terms are not accepted, then journalists/bloggers are on notice that they are likely to be slapped with a lawsuit. Mike Masnick at the technology news site *TechDirt* is skeptical. He believes that NewsRight is just Righthaven in yet another problematic form:

> It doesn't sound like they'll totally pull a Righthaven, where their first move is to sue, but rather (from the various vague descriptions) it sounds like NewsRight will be going around simply trying to get blogs and aggregators to buy a license. But here's the thing: on what legal basis? That's the part that's not clear. Much of what blogs and newspapers do is simply not infringing (even if the AP likes to pretend it is). There may be some extreme cases where there is infringement, but most standard cases

seem like classic fair use. And that's where it gets worri-
some that this turns into a legal shakedown—whereby
sites are pressured to pay up just to avoid a legal fight,
no matter how strong the legal position of these sites
might be.

But, much more to the point, nothing in this plan
appears to be about adding value. That's the key way to
determine if a business model is heading in the right direc-
tion, or if it's really just someone trying to "free ride" on
the work of someone else. NewsRight appears to be the
worst kind of free rider, honestly. They're not adding any
value—they're just demanding people pay up to avoid a
negative cost (the legal threat). Also telling? The company
admits that half the staff is… lawyers, and that appears to
include the company's CEO.[31]

[That CEO would be David Westin, former ABC News president and
NewsRight's founding CEO, who spoke to Andrew Phelps of the Neiman
Journalism Lab].

"We have not been set up first and foremost as a litigation
shop," Westin said. "Now, that doesn't mean down the
road there won't be litigation. I hope there's not. Some
people may decide to sue, and we can support that with
the data we gather, the information we gather. But…
those are very expensive, cumbersome, time-consuming
processes." NewsRight's partner news organizations
include Advance Publications, A.H. Belo, Community
Newspaper Holdings, Gatehouse Media, The Gazette
Company, Hearst Newspapers, Journal Communications,
McClatchy, MediaNews, The New York Times Co., Scripps,
and The Washington Post Co. AP remains on the
NewsRight board and is a minority shareholder.[32]

I leave this discussion with a bit of irony about original reporting
by independent journalists, and how the mainstream media cribs with
abandon from bloggers without consequences. I was the first person to
score an interview with a North Carolina elections official, Sherre Toler,
who resigned her Harnett County position rather than preside over
the state's ballot initiative that would add language to the state constitu-
tion barring gays and lesbians from marrying. Toler emailed me a letter
that documented her decision and I spoke with her and published an
exclusive interview on *Pam's House Blend* on January 10, 2012.[33] On January 10,
The Associated Press (via *The Washington Post*) published the story, "Elections
Official Resigns Rather Than Oversee Vote on NC's Amendment One."

The Blend was not cited nor was a link provided to my original story. After I updated my post and noted *The Washington Post* omission, the story has since disappeared. However, as most Internet-savvy people know, the Google cache lives on. I captured a screen shot.[34]

michelangelo

I first became aware of Righthaven after reading Pam Spaulding's blog, *Pam's House Blend,* sometime in 2011 where she described the ongoing battle she found herself thrust into—a battle with a formidable shake-down organization. I've known Pam for years and, although I read her blog as often as I can, I'd obviously missed her initial posts on Righthaven. While the situation with Righthaven that Pam navigated was greatly disturbing, what shocked me most was that I had not read about Righthaven anywhere else. Surely, if I had missed it on Pam's blog, other progressive and LGBT blogs—not to mention media organizations—would have covered it?

Once I read Pam's account of events, I booked her on my radio program on SiriusXM to discuss Righthaven both through her personal experience but also as a larger cultural phenomenon. Only after Pam explained Righthaven's tactics did it become apparent that the organization had induced an incredible amount of fear into the blogosphere, so much fear that self-censorship took hold and a virtual blackout discussing Righthaven's tactics was in place. And, with mainstream news organizations such as The Associated Press implicated in Righthaven's agenda, it wasn't surprising that there'd been little so-called mainstream media coverage about it.

Although Righthaven's primary motive and strategies, such as those experienced by Pam, might have been profit-driven, for the media companies on whose behalf they acted, the organization had the added benefit that they could potentially snuff out a major competitive threat to media—bloggers. In other words, Righthaven's actions (consecrated by major media outlets) were successfully on the road to inhibiting and controlling speech. This is not surprising, since media companies had complained for years about bloggers who used material on their blogs— "aggregating"— that they claimed amounted to taking large portions of stories. Although most bloggers "aggregating" from other news sources amounts to fair use since they provide analysis and discussion about the story, corporate media organizations claimed that readers, once they visited a blogger's site—no longer desired to link back to the original source. However, the media companies made this complaint on the surface knowing full well that it was largely an exaggerated bogus argument, and that it covered up their larger fear of competition.

Ever since the corporate news media's coverage on George W. Bush's "war on terror" and the so-called "weapons of mass destruction"

proved embarrassing for being short on content and stymied by political interests, media companies increasingly lost authority and their ability to frame political debate in the public sphere. While the major news outlets dropped the ball at this time, progressive political blogs and websites grew dramatically. In effect, the media companies had (and, to be sure, have) no one but themselves to blame for the public's refusal to accept their authority on critical political issues. Their tepid reporting on Bush's "war on terror" and his lead-up to the war in Iraq—including the lack of rigorous investigation for the motives behind the war—allowed for alternatives to thrive for a public hungry for real analysis.

The wish for more solid and in-depth reporting soon became true for the vast array of issues that citizens who—both on the right and the left—sought information about issues ranging from the environment to LGBTQ rights. Blogs and sites driven by hot-button political and cultural issues soon discovered they had massive audiences as people— across the globe—more and more turned away from traditional news sources such as *The New York Times* and CNN. For many of the big media companies, the shift in readership happened very rapidly as Internet technology became more readily available. As it turns out, the shift occurred too rapidly for major news organizations to figure out just how to respond. They had maintained authority for so many years and, in the past, they presumed their authority, since it didn't take much to keep other, multiple voices out of the mix. The terms for media hegemony had now changed; it was no longer the domain of the few.

outing the news

Pam's encounter with Righthaven—fully recounted in her notes in the preceding text—got me to thinking about the debates over "outing" in which I played no small role. The term "outing" was introduced in 1989 by *Time* magazine to describe my reporting in the gay weekly *OutWeek* in which I disclosed closeted gay public figures.[35] As part of a new activist edge in the queer movement, and having worked within ACT UP, I— along with my colleagues—decidedly challenged the corporate media's notions around reporting on public figures' homosexuality, particularly closeted politicians who voted antigay on key state and federal legislation. The largely heterocentric media had long before decided the rules about whose sexual orientation gets reported. Hence, heterosexuality was fine to report, while homosexuality was kept hidden. As we viewed it, the media rules about who could write and about what could be written— media authorship—needed challenging. However, how to do this, given the blogosphere didn't yet exist?

At that time, when a gay or alternative weekly was literally distributed by hand to the public, it was easy for *The New York Times*, *Time*, or *The Washington*

51

Post to contain a debate, maintain authority, and inhibit alternative speech. When activists were successful at changing the debate, it was, often, only after enormous and vigorous efforts to control the story by the major media.

In the case of my work at *OutWeek*, the corporate media's first strategy was to, simply, ignore me. With the vast audience-reach they had in place, the most efficient way to censor alternative opinions was not to cover them. However, as our tactics became louder, angrier, and (some argued) offensive, the media soon realized they needed to respond more forcefully. Hence, the media found a new strategy to cover "outing": they demonized us.[36] In fact, by introducing the term "outing" and positioning it as a violent, active verb, they portrayed us as driven by a radical and extreme agenda. Moreover, the major news organizations did not name any of the persons we revealed as gay, again maintaining control and authority of the story. When I wrote a piece in 1991 on the recently deceased multi-millionaire Malcolm Forbes and how he was gay—a cover story that sat quite visibly on New York City newsstands—it took months for many media organizations to report it. And they still covered it up. *The New York Times* reported on my story months after it made the rounds of newspapers such as *The Los Angeles Times* and *The Seattle Times*. Rather humorously, and even though other significant media outlets had named Forbes in their coverage, *The New York Times* only reported that "a recently deceased millionaire" had been "outed." It wasn't until 5 years later that *The New York Times* reported that Malcolm Forbes was gay when they wrote a story about his son, Steve Forbes, running for president.

I retell this history because the kind of media control we witnessed around an issue such as outing during the 1990s is less likely to take hold today, precisely because of the Internet. Even if *The New York Times* chooses to ignore a story, so many alternative media forums exist in which people can access a range of information that a larger media entity might censor. In short, the big and well-funded media companies have lost much control. No longer can they simply ignore public opinion, debate or, critique and hope such discomforting analysis and reporting goes away. No longer can these organizations decide to keep their name as the authority in the public consciousness.

What Righthaven shows—and this new group, NewsRight, which Pam discusses and has the financial and ethical backing of *The New York Times*, The Associated Press, and others—is arguably more aggressive and sinister than Righthaven's strategy to control public debate and who gets to author it. This organization really is no different from the many ways that various media use punitive measures—one thinks of the music industry's legal cases against young people for file-sharing—to maintain control of the mediate message while they try to figure out how to transform in order to stay relevant. Ironically, if not incredibly belligerently, corporate

media are the first to trot out "free-speech" arguments when they believe their rights for journalist expression have been trounced upon. With Internet technology, however, they have stumbled onto something of a double-edged sword since their First Amendment claims necessarily depend on the established concept of fair use. Indeed, the importance of fair use in the Internet age cannot be underestimated, given that so much of the discussion and debates online are dependent on referencing other works in a way that is vital for dialogue and free speech. As such, corporate media turns to exactly the same legal standards on which bloggers depend. It appears that the conundrum news-media organizations face is whether or not they can have it both ways. If so, who decides?

notes

1. *Pam's House Blend*, accessed January 23, 2012, http://pamshouseblend.firedoglake.com/.
2. *Righthaven LLC v. Spaulding*, Justia Federal District Court Filings & Dockets site, accessed January 23, 2012, http://dockets.justia.com/docket/colorado/codce/1:2011cv00537/124642/.
3. "March 2011 Righthaven Victims," *Righthaven Victims*, accessed January 23, 2012, http://righthavenvictims.blogspot.com/2011/03/march-2011-righthaven-victims.html.
4. *The Drudge Report*, accessed January 23, 2012, http://drudgereport.com; *The Raw Story*, accessed January 23, 2012, http://rawstory.com.
5. "Prayer for Relief," *Righthaven, LLC, v. Spaulding*, accessed January 23, 2012, http://goo.gl/X4UNc.
6. Eric Gardner, "Copyright Troll Righthaven Sues for Control of *Drudge Report* Domain," *Ars Technica*, accessed January 23, 2012, http://arstechnica.com/tech-policy/news/2010/12/copyright-troll-righthaven-sues-for-control-of-drudge-report-domain.ars.
7. Nate Anderson, "Copyright Troll Righthaven's Epic Blunder: A Lawsuit Targeting *Ars*," *Ars Technica*, accessed January 23, 2012, http://arstechnica.com/tech-policy/news/2011/03/copyright-troll-righthavens-epic-blunder-a-lawsuit-targeting-ars.ars.
8. *Righthaven Victims*, accessed January 23, 2012, http://righthavenvictims.blogspot.com/.
9. "Some Firms Representing Righthaven Victims," *Righthaven Victims*, accessed January 23, 2012, http://righthavenvictims.blogspot.com/p/victim-help.html.
10. Steve Green, "Defense Attorneys Claim 'Key Evidence' in Undermining Copyright Lawsuits," *The Las Vegas Sun*, March 4, 2011, accessed May 20, 2012, http://www.lasvegassun.com/news/2011/mar/04/defense-attorneys-claim-key-evidence-undermining-c/.
11. David Kravets, "Copyright Troll Righthaven Goes on Life Support." *Wired* (September 7, 2011), accessed January 27, 2012, http://www.wired.com/threatlevel/2011/09/righthaven-on-life-support/; on Gibson, see Kravets. "Newspaper Chain's New Business Plan: Copyright Suits." *Wired*, July 22, 2010, accessed January 27, 2012, http://www.wired.com/threatlevel/2010/07/copyright-trolling-for-dollars/.

12. Richard Esguerra, "Righthaven's Brand of Copyright Trolling." *Electronic Freedom Foundation*, September 2, 2010, accessed January 23, 2012, https://www.eff.org/deeplinks/2010/09/righthavens-own-brand-copyright-trolling.

13. Steve Green, "Some Targets of Righthaven Lawsuits Fighting Back." *The Las Vegas Sun*, August 4, 2010, accessed January 27, 2012, http://www.lasvegassun.com/news/2010/aug/04/some-targets-righthaven-lawsuits-fighting-back.

14. *Randazza Legal Group*, J. Malcolm DeVoy, accessed January 23, 2012, http://www.randazza.com/attorneys/DeVoy.html.

15. *The LLC Company*, accessed January 23, 2012, http://the-llc-company.com/form-llc/who-can-own-an-llc.

16. "Newspaper Blacklist," *Righthaven Victims*, accessed January 27, 2012, http://righthavenvictims.blogspot.com/p/participating-newspapers.html.

17. Michael Roberts, "Brian Hill: Chronically Ill, Autistic Blogger's Lawyer Blasts *Denver Post* for Righthaven Suit," *Denver Westword Blogs*, February 28, 2011, accessed January 23, 2012, http://blogs.westword.com/latestword/2011/02/brian_hill_autistic_blogger_denver_post_righthaven_lawyer.php.

18. Pam Spaulding, "Is This the End of Predator Copyright Troll Righthaven's Flight Under the Media Radar?" *Pam's House Blend*, April 19, 2011, accessed January 23, 2012, http://pamshouseblend.firedoglake.com/2011/04/19/is-this-the-end-of-predator-copyright-troll-righthavens-flight-under-the-media-radar.

19. *Righthaven Lawsuits*, accessed January 23, 2012, http://www.righthavenlawsuits.com.

20. Andrew Goldberg, "Right(haven) Is Wrong, Rules Judge." *Law.com* (Corporate Counsel), March 24, 2011, accessed January 23, 2012.

21. "AP Board Approves Independent Agency to License Digital News," The Associated Press, February 3, 2011, accessed April 20, 2012, http://www.ap.org/Content/Press-Release/2011/AP-board-approves-agency-to-sell-digital-news-020311.

22. "Nicole Sandler's Radio or Not!" Podcast, April 21, 2011), accessed January 27, 2012, http://radioornot.libsyn.com/webpage/20110421-nicole-sandler-show-.

23. Pam Spaulding, "The Visual Guide to the Business Model of Copyright Troll Righthaven, LLC," *Pam's House Blend*, April 21, 2011, accessed January 23, 2012, http://pamshouseblend.firedoglake.com/2011/04/21/the-visual-guide-to-the-business-model-of-copyright-troll-righthaven-llc.

24. David Kravets, "Judge Fines Righthaven $5,000," *Wired*, July 15, 2011, accessed January 27, 2012, http://www.wired.com/threatlevel/2011/07/judge-fines-righthaven-5000/-.

25. David Kravets, "Copyright Troll Righthaven Goes on Life Support," *Wired*, September 7, 2011, accessed January 27, 2012, http://www.wired.com/threatlevel/2011/09/righthaven-on-life-support/.

26. Steve Green, "Music, Book Industries May Intervene on Behalf of Righthaven," December 4, 2011, accessed May 20, 2012, http://www.vegasinc.com/news/2011/dec/04/music-book-industries-may-back-righthaven/.

27. "Righthaven Case Ends in Victory for Fair Use," *Electronic Freedom Foundation*, press release, November 18, 2011, accessed January 27, 2012, http://www.eff.org/press/releases/righthaven-case-ends-victory-fair-use.

28. David Kravets, "Nevada State Bar Investigating Copyright-Troll Righthaven," *Wired,* January 13, 2012, accessed January 27, 2012, http://www.wired.com/threatlevel/2012/01/bar-eyeing-righthaven/.

29. Pam Spaulding, "So what's the big PHB news? Here you go ...," *Pam's House Blend,* June 17, 2011, accessed January 27, 2012, http://pamshouseblend.firedoglake.com/2011/06/17/so-whats-the-big-phb-news-here-you-go/.

30. Andrew Phelps, "Remember the Beacon? Newly Formed NewsRight is the Evolution of *AP*'s News Registry," *The Neiman Journalism Lab,* January 5, 2012, accessed January 27, 2012, http://www.niemanlab.org/2012/01/remember-the-beacon-newly-formed-newsright-is-the-evolution-of-aps-news-registry/.

31. Mike Masnick, "AP Finally Launches NewsRight ... And It's Righthaven Lite?," *Techdirt,* January 10, 2012, accessed February 5, 2012, http://www.techdirt.com/articles/20120110/03124117363/ap-finally-launches-news-right-its-righthaven-lite.shtml.

32. Phelps, "Remember the Beacon?"

33. Pam Spaulding, "NC Elections Official Resigns Rather Than Facilitate the Marriage Discrimination Amendment," *Pam's House Blend,* January 10, 2012, accessed January 27, 2012, http://pamshouseblend.firedoglake.com/2012/01/10/nc-elections-official-resigns-rather-than-facilitate-the-marriage-discrimination-amendment/.

34. "Elections Official Resigns Rather Than Oversee Vote on NC's Amendment One," *The Washington Post-Associated Press,* January 11, 2012: screen capture of Google Cache uploaded to Photobucket, accessed January 27, 2012, http://i2.photobucket.com/albums/y49/pspauld/BlogPix/Safe%20Pix/screen-cap011112.png.

35. William A. Henry III, "Forcing Gays Out of the Closet," *Time,* January 29, 1990, 67; see further, Larry Gross's *Contested Closets: The Politics and Ethics of Outing* (Minneapolis: University of Minnesota Press, 1993), 61.

36. For full coverage about and references to these articles described here, see Michelangelo Signorile, *Queer in America: Sex, the Media and the Closets of Power* (New York: Anchor, 1993), 67–93.

appropriation art,

subjectivism, crisis

the battle for fair uses

three

nate harrison

a tale of two decades

United States District Court Judge Deborah Batts's March 2011 ruling that
artist Richard Prince had infringed photographer Patrick Cariou's copy-
rights threw the art world into a frenzy.[1] Rigorous debate over Prince's
appropriation of Cariou's images for a series of paintings titled *Canal Zone*
had been mounting since Cariou filed his claim at the end of 2008, but
it was Judge Batts's decision that really prompted the punditry.[2] Critics,
curators, gallerists, artists, and other commentators, writing in print
publications, press reports, and the blogosphere, all—for the most
part—decried the verdict, claiming that it would have a "chilling effect"
on appropriation-based practices, which would likewise stifle creativity
and free expression in the long-term.[3] And with serious concern over
Cariou's suit also naming Prince's exhibition organizer, Gagosian Gallery,
as an accomplice, no fewer than ten distinguished museums and arts
foundations, as well as—indeed—Google, filed briefs in support of
Prince's appeal, which is, as of this writing, pending.[4]

Yet, surprise at the verdict and the subsequent bleak prognoses for the future of appropriation art come as something of surprises themselves, given that we've encountered the narrative before: well-known, controversial artist appropriates the imagery of a relatively unknown lifestyle photographer, producing works of art that command very high prices; photographer in turn sues the artist for breach of copyright; artists defends his work on the grounds that it falls under copyright's fair use doctrine; the court finds in favor of the photographer. The last time a lawsuit as seemingly consequential for the art world came before the same court was just over 20 years prior, with the involved photographer Art Rogers accusing artist Jeff Koons of copyright infringement for the latter's use of the former's picture as the basis for a sculpture in Koons's 1988 *Banality* series. Koons lost the case both in the New York District Court and the Second Circuit Court of Appeals.[5] And like Prince's loss, the rulings against Koons brought out the art community, which predicted an ominous future for appropriation art.[6]

However, that future didn't happen. Far from fearfully fading away into the dustbin of legal history, appropriation-based practices in the visual arts have increased dramatically over the last two decades. Within painting and sculpture, photography and film and video, "new genres" and "tactical media," appropriation has become such an ubiquitous artistic strategy that any backlash against it almost seems quaint, as if to deny that the media-saturated condition to which postmodern artists reacted in the 1980s has today become the very DNA out of which, to a significant degree, artistic subjectivity swells.[7]

In how much of a precarious position, then, do "post-Prince" appropriation artists find themselves, and what, if any, constraints might hinder them? Perhaps the situation is better assessed precisely by first revisiting the authorial claims, rationale for legal judgment, and art historical context surrounding *Rogers v. Koons*, and then setting them in relation to *Cariou v. Prince*. Analyzing the similarities as well as differences between the two cases may aid in determining the extent to which Prince's loss is a harbinger of infringement problems for appropriation art (and the institutions that support it) to come.

Comparing and contrasting *Koons* and *Prince*, this essay posits that while both artists ultimately relied on the same fundamental argument— claiming legitimacy by aligning themselves with a tradition of appropriation in modern art, each felt they should have been issued a creative license granting unrestricted subjective expression—Koons's fair use defense was more specific in approach (arguing his art work should have been read as parody). This had the effect of keeping the court's decision within a hermeneutics of parody itself (and its difference from satire). So while the ruling may have unsettled some in the art world at the time, its application was in a sense delimited by its particularity, and

thus deferred until another day the question of appropriation art's general legal fitness within the intellectual property regimes of our image-intensive culture.

In the ensuing years between *Koons* and *Prince*, we witness not just an increase of appropriation techniques in art, but perhaps more importantly, a swing further away from practices based on the critical impulses characteristic of late 1970s Pictures generation, towards a "new subjectivism" in appropriation at the outset of the twenty-first century. It is within the context of this type of appropriation that we might read Prince's fair use defense: his argument is much less specific, and rather than argue parody (a critical strategy associated with corrective ridicule), he instead claims his work is sufficiently "transformative."[8] Not merely derivatives of already-copyrighted material, Prince's appropriations are original expressions themselves, containing "new information, new aesthetics, new insights and understandings" likewise deserving fair use protection because they fulfill copyright's objective of enriching society.[9]

With Prince's District Court loss, however, the determination in the Koons case (that for a work of appropriation art to be considered parody, it must by definition comment directly upon the original expression) becomes much broader and more fundamental: according to Judge Batts's decision, to be considered as fair use, *any work that borrows from another must necessarily refer back, in some way, to its source.* Given the proliferation not only of subjectivist strains of appropriation art in recent years but also the larger, "remix culture" that marks our current moment—one in which aesthetic transformation, more than overt critique, often constitutes the kernel of the creative act—Batts's ruling may indeed trigger yet another shift in appropriation art. However, before we reach any such conclusions, let us examine the case that initially tested the fair use capacities of appropriation art.

string of lawsuits

In 1986, artist Jeff Koons began production on a series of 20 sculptures he titled *Banality*.[10] It marked the first time Koons would realize a set of works without depending entirely on ready-made objects.[11] Instead, the artist commissioned Italian and German artisans to fabricate a set of porcelain and wood sculptures that, while referencing the disposable kitsch trinkets of modern consumer society, displayed handiwork reminiscent of yesteryear's guild systems of production. Through the *Banality* series, Koons seemed to, on the one hand, align himself with the Duchampian legacy of injecting the low-brow aesthetics of mass culture into the domain of high art, while on the other, problematize the efficacy of such a strategy by foregrounding production values associated with beauty, preciousness, and scarcity. For Koons, the series was uplifting, even spiritual.[12]

It represented, as scholar Katy Siegel states, the "dimming of an old definition of culture, and its replacement by an unashamed, affirmative vulgarity, an opulent populism."[13]

Yet the critical messaging within Koons's work had been a point of continued debate, and nowhere was it more put to the test than in a salvo of copyright infringement lawsuits launched against the artist after he exhibited the *Banality* series in 1988.[14] In each case, plaintiffs accused Koons of blatantly exploiting their intellectual property without permission in order to realize his series of sculptures. And it was the first suit, filed by Art Rogers in late 1989, that set the tone for the others.[15] Rogers, a photographer, claimed that Koons had unlawfully used his 1980 black-and-white photograph of a married couple posing with a litter of eight German Shepherd puppies—Rogers titled it simply *Puppies*— as the basis for a life-sized polychromed wood sculpture depicting the same subject, which Koons titled *String of Puppies*. Indeed, in the discovery phase of the case, it was revealed that Koons had purchased a postcard of Rogers's photo in 1987 at a "tourist-like card shop"; that he had torn Rogers's copyright notice off the card before forwarding it on to his fabricators; that during the production process, Koons repeatedly instructed them to craft the sculpture exactly "as per the photo"; that he sold all three *String of Puppies* sculptures in the edition for a total of $367,000.[16]

Despite the acknowledgment of copying and seeming audacity of his actions, Koons argued in testimony that *String of Puppies* exemplified the venerated avant-gardist position that "the mass production of commodities and media images has caused a deterioration in the quality of society [and] proposes through incorporating these images into works of art to comment critically both on the incorporated object and the political and economic system that created it."[17] Koons's lawyers thus defended *String of Puppies*'s tongue-in-cheek garishness as a parody of a society overwhelmed with kitsch consumerism, which was exactly the type of expression for which copyright's fair use doctrine was designed; that is, as a form of social commentary.[18] In essence, *String of Puppies* demonstrated Koons's right to free speech.

The courts, however, did not agree. In their view, *String of Puppies* failed to satisfy the basic definition of parody.[19] According to his own explanation, the courts pointed out, Koons used Rogers's image as the vehicle for a satire of consumer society in general but did not specifically criticize *Puppies* itself. Parodies are typically recognized and appreciated precisely when their viewers are able to differentiate between the source expression and its ridiculing copy. Because Rogers's photograph was not the clear target of Koons's attempted parody, there was no need to conjure it in the first place; any arbitrarily chosen "commodity object" refashioned in Koons's absurdist style could have sufficed. As the Circuit Court concluded, "If an infringement of copyrightable expression could

be justified as fair use solely on the basis of the infringer's claim to a higher or different artistic use—without insuring public awareness of the original work there would be no practicable boundary to the fair use defense."[20] *String of Puppies* was ruled a derivative work; Koons's other lawsuits resulted in the same decision.

It is worth considering here the disparity between the positive, self-actualizing "philosophy of kitsch" that Koons espoused in his promotion of the *Banality* series upon its public exhibition, and the sober, critical rhetoric his defense team employed to justify the artist's appropriation of Rogers's photograph.[21] Such a variance can connote disingenuousness, which is apparently the impression the Circuit Court had as it formed its opinion.[22] Yet, even after his appeal loss, Koons maintained his ambiguous defense: "It was only a postcard photo and I gave it spirituality, animation and took it to another vocabulary."[23] Setting aside Koons's ethical positioning or sense of self-importance, we can, at the very least, note that his "doublespeak"—the seeming simultaneous celebration and critique of commodity fetishism—typifies the slipperiness of determinate meaning that has been the hallmark of postmodern aesthetic theory. It is also an instability that has frustrated a legal system based on "objective," bright-line rules. Yet, Koons's parody claim allowed the courts entrance into the murky territory of artistic subjectivity, supplying them with a set of "stable" parameters (i.e., parody and satire as they are classically defined) against which artistic intention could be measured. Because of the specificity of Koons's defense strategy, the courts did not (indeed had no obligation to) provide any further guidance that might help delineate the contours of fair use as it applies to appropriation art beyond the scope of parody, thus leaving unanswered the question as to whether appropriation—in all its contemporary permutations—is a legally viable aesthetic practice. This question would rise once again in 2008 with Richard Prince's *Canal Zone* series of paintings.

from puppies to a prince

In moving now to *Cariou v. Prince*, situating both Jeff Koons and Richard Prince within the art-historical record will help provide a context for the legal issues at stake in contemporary appropriation art. Prince and Koons both rose to prominence in 1980s New York, the former associated with the Pictures generation of artists who used photography as a means to critically examine the "structures of signification" within a visually dominated culture, the latter, as noted earlier, aligned with the legacy of Duchamp's ready-made and equivocal relationship with the commodification of art.[24] Both artists have come to embody postmodernist art practice, yet it is important to recognize that by the time Koons had embarked on the *Banality* series, artists as well as critics had begun to reassess the

efficacy of the critical posturing seemingly inherent in appropriation strategies. As scholar Hal Foster notes, the poststructuralist critique of authorial originality as well as the Marxist-infused ideology critique of mass media—both impulses attributed to early Pictures practices (such as Sherrie Levine, Cindy Sherman, Sarah Charlesworth)—had often yielded only a "political resignation" to and "fetishistic fascination" of image consumption.[25] To repeat the image through the gesture of appropriation, even in the service of critique, was necessarily to put it back into circulation in the service of advanced capitalism's spectacle culture.

Such a "crisis of critique" did not diminish appropriation practices, however; rather, it began a process of "subjectivizing" them, which is to say appropriation art entered a new phase in which artists treated the found images of mass culture as so many detached signs available for reconfiguration according to creative inclination and, as scholar Lucy Soutter describes, a revived bid for authenticity.[26] This tendency did not simply displace the overtly critical authorial voice (e.g., see the continued work of Barbara Kruger or Hans Haacke), but instead enlarged appropriation art's formal possibilities as well as its readings. Yet, Foster and other critics remained focused upon the capitulation and cynicism within much subjectivist appropriation art, whose producers sometimes calculatingly cloaked practices otherwise complicitous in the commodity status of art with a jargon of critique (Koons would be the model here; see also David Salle).

As insightful as Foster's accounts of 1980s appropriation art are, however, their inability to expand analysis beyond a dialectic of critique/complicity leaves little room for a theoretical articulation of practices that have emerged in the two decades since, practices very much responding to social and technological developments during that time. How do we, for example, assess Jason Salavon's radical data manipulations (*The Grand Unification Theory*, 1997), Candice Breitz's pop song re-performances by die-hard fans (*Queen [A Portrait of Madonna]*, 2005), Jennifer and Kevin McCoy's TV program indexing (*Every Anvil*, 2002), or Christian Marclay's ambitiously edited videos (*Video Quartet*, 2002, or *The Clock*, 2010)?[27] All rely not only on the wide availability of cultural texts but also on audience's familiarity with them; in this sense, they indeed begin from the default condition of our acquiescence to the pervasiveness of advanced capitalism's spectacularity. More specifically, there seems to be a hoarding of popular culture, an "aesthetics of collection," in all of these examples; each operates through the re-presentation of a bevy of media products—films, television, magazines, pop songs, cartoons. Yet, through showcasing the collection, the works in question can also precipitate further consideration. For example, Salavon, "the code" at micro and macro levels of cognition; Breitz, the agency and intimacy of otherwise passive consumers; the McCoys, the formularizing of knowledge production in television; and

Marclay, musical performance and time-keeping as cinema trope. The complexities of formal technique and interpretation in today's appropriation art are matched only by an equally complex set of social and semiotic relations between texts and audiences operating within a twenty-first-century world.

If we ascribe a "collector's tendency" to subjectivist strains of contemporary appropriation practices, then Richard Prince ranks as our *collecteur extraordinaire*. Throughout his career, Prince has consistently re-presented his own gatherings of magazine advertisements, cowboys, comics, jokes, muscle cars, pulp fiction, celebrity memorabilia, and cancelled checks as his art.[28] "[Prince] has always gravitated towards repetition, groupings and categories," curator Nancy Spector writes; "[his move from Manhattan to upstate New York] has allowed him to ramp up his activities as a collector to the point that they have merged with and become indistinct from his artistic pursuits."[29]

Just as important as his tendency to collect, by the mid-1980s Prince had expanded his practice beyond the singular, clinical "rephotographs" that initially gave him notoriety, to encompass more of the artist's expressive hand. Large-scale, gestural paintings that are collages of appropriated photographic elements and pop ephemera have played a significant part in Prince's practice since then. Given his initial association with the poststructuralist discourse affixed to much Pictures generation work by academia in the late 1970s, Prince's turn to painting can be read as the desire to establish distance from theoretical dead-ends and to reclaim an almost modernist authorial subjectivity while retaining a decidedly postmodernist practice. As Prince related during his deposition: "And there was that essay by Roland Barthes called Death of an Author [sic] ... and I think I got caught up in it ... you know, it's academic ... it's something that takes place in October Magazine [sic], which I don't particularly like ... I'm much more interested in trying to make art that stands up next to Picasso, De Kooning, and Warhol..."[30]

It was from such an authorial subjectivity that Prince developed the *Canal Zone* series. During further questioning in *Cariou v. Prince*, the artist explained that the 30 paintings evolved primarily from two events between 2005 and 2007: a trip to his birth place, that region of Panama which in 1949 was an unorganized US territory called the Panama Canal Zone, and Prince's work on a film screenplay recounting the tale of survivors of a nuclear holocaust stranded in a tropical setting. Drawing from these inspirations as well as his love of punk rock, "Prince imagined a make-believe, post-apocalyptic enclave, the Canal Zone, in which bands and music are the only things to survive."[31] Prince used appropriated imagery culled from his collections of books and magazines to portray each of the characters in his narrative. Finally, the artist's own recent *de Kooning* paintings—tributes to the abstract expressionist painter—were

the sources from which much of the *Canal Zone* series' brushwork borrowed stylistically.[32]

However Prince explained his creative process to the court, the record shows that this much is also clear: the images constituting the core of Prince's series came from one "collection" in particular, that of French photographer Patrick Cariou's 2000 *Yes Rasta*, a book of "classical" black-and-white portraits depicting Jamaica's Rastafarian culture.[33] In 29 of the 30 paintings, Prince used Cariou's pictures at least 41 times; some were heavily abstracted through the artist's layered painting process, while others were kept virtually identical to the reproductions in Cariou's book. None were used with Cariou's permission. So much of *Yes Rasta* was incorporated into the *Canal Zone* series, and so prominently, that the gallery with whom Cariou had begun discussing a possible exhibition of *Yes Rasta* prints declined upon learning that Prince was exhibiting the photos at another venue. Indeed, Prince's fall 2008 show *Canal Zone* at New York's Gagosian Gallery featured 22 of the Cariou appropriation paintings. Gagosian sold eight of them for a total of over $10 million, while seven more were traded for other artworks with an estimated worth of $7 million.[34]

Figure 3.1

Patrick Cariou, untitled photograph from *YES RASTA* (2000).

Figure 3.2

Richard Prince, *It's All Over* (2008).

Whatever questions still lingering as to the status of a new sub-jectivism in contemporary appropriation art are put to rest when one pairs the financial figures cited in the preceding with Prince's defense testimony. Unlike Koons's steadfast, if somewhat skewed, claim to the use of Art Rogers's photo through parody, Prince justified his appro-priation of Cariou's images purely on the grounds of the artist's personal taste:

> It's just a question of whether I like the image … my intentions were always to make great art … I liked the [*Yes Rasta*] pictures … I don't have any real interest in what the original intent is because … what I do is I try to … change it into something else that's completely different … I'm trying to make a kind of fantastic, absolutely hip, up to date, contemporary take on the music scene … in any artwork I don't think there is any one message. I'm not a political artist.[35]

During questioning, Prince was adamant that his intention in creating the *Canal Zone* paintings was not to comment on Cariou's photos specifically but to use them simply as raw materials toward a wider artistic vision. His uses were fair, Prince argued, because they belonged to a tradition of art using found imagery in order to convey "new insights with a wholly new expressive … message" altogether different in purpose and character from the appropriated originals.[36]

Ultimately, however, Prince's imagination seems to have gotten the better of him. His explanation did not satisfy the District Court, which

found that the artist took Cariou's photos primarily for commercial gain without "paying the customary price" (i.e., licensing them).[37] And, as Judge Batts further explained:

> The illustrative fair uses listed in the [copyright law]— "criticism, comment, news reporting, teaching [...], scholarship, [and] research"—all have at their core a focus on the original works or their historical context, and all of the precedent this Court can identify imposes a requirement that the new work in some way comment on, relate to the historical context of, or critically refer back to the original works... Prince's Paintings are transformative only to the extent that they comment on the Photos; to the extent they merely recast, transform, or adapt the Photos, Prince's Paintings are instead infringing derivative works.[38]

conclusion: a subjectivity of censorship?

We might understand Prince's loss as merely just deserts for a member of the art world elite so ensconced in his own subjectivity, which is to say so out of touch with the realities of not only image production but also *regulation* that he thought—no doubt aided by his reputation as a celebrated appropriation artist—that he was above the law.[39] Thus, it might be argued, *Cariou v. Prince* won't have much of a long-term impact on appropriation practices, just as Koons's high-profile losses didn't prevent artists from continuing to take from the mass media images around them. If anything, the case might push artists to further critically reflect on their use of pre-existing images, thus making for "smarter" appropriation art.

However, another reality also looms on the horizon—one of authorial self-censorship. With the District Court's ruling, a new, bright-line rule is in the process of being established: fair uses of copyrighted materials cannot simply be aesthetic transformations but must necessarily refer back to their originals. The decision thus explodes the parody argument in *Rogers v. Koons*, which raises concern because it might not only impact artists such as Salavon, Breitz, the McCoys, or Marclay, but also have negative repercussions on potential fair uses beyond appropriation art. In a moment so permeated by the concept of copying—omnipresent in the everyday acts of recording, downloading, sampling, parsing, forwarding—the court's decision risks arresting the very creative innovation that copyright law was designed to foster. Installing such a flat-footed requirement that ultimately intimidates authors with the threat of lengthy (and expensive) legal battles seems incompatible with the fluidity with which information today is transformed (and is transformative).

At this writing, *Cariou v. Prince* is in the hands of the Second Circuit Court of Appeals. Its precedent-setting decision will at least partially determine the boundaries of creative agency going forward. Yet, even now, *Cariou v. Prince* is affecting artists who appropriate. As at least one commentator notes, they are expressing real alarm over the viability of their practices.[40] One hopes that, in its analysis of the issues, the appeals court will map out a fair use territory that allows space for appropriation-based art practices and our culture of the copy, bearing in mind that authors of varying subjectivities today are increasingly incorporating pre-existing media into their expressions without necessarily intending to comment on their sources directly, but who nonetheless generate novel meanings and ways of comprehending the world.

Of more immediate concern perhaps is the prospect of censorship by the institutions that support appropriation art. While artists may "no longer live in an era in which [they] can borrow imagery without thinking carefully about the law,"[41] the museums, galleries, and other exhibition spaces that display appropriation art may have no choice but to altogether restrict public access to works that are deemed too risky. Such a culture of fear gauges the value of appropriation works not according to any artistic quality but according to their likelihood of being deemed infringements.[42] Conversely, the court's recognition of the inherent social benefits of a tolerant copyright system would fulfill its goal of the enrichment of society in the long term. Any revision of fair use need not necessarily trample on the derivative rights of photographers such as Patrick Cariou (or Art Rogers) who, in many instances, depend on the licensing of images for their livelihood. In this sense, amending copyright law to specifically address the practice of appropriation seems especially urgent for both sides of the debate. However, such a revision should recognize that privileging the derivative right—a right tied to the logic of commodity production—might maintain the quantity of cultural output, but not its quality.

notes

1. See Judge Batts's ruling, *Cariou v. Prince*, 784 F. Supp. 2d 337 (2011) at http://www.scribd.com/doc/51214313/Cariou-v-Richard-Prince (accessed January 15, 2012).

2. Prince's exhibition *Canal Zone* at Gagosian Gallery in New York ran from November 8 to December 20, 2008. Cariou filed suit on December 30, 2008. Reactions to the 2011 verdict have been plentiful. See, for instance, Charlie Finch, "Richard Prince: Slippery Slope," *Artnet*, March 21, 2011, accessed March 23, 2011, http://www.artnet.com/magazineus/features/finch/richard-prince-copyright-3-21-11.asp; Edward Winkleman, "Appropriation Prohibition (or Why I Think Judge Batts Is Wrong)," accessed March 23, 2011, http://www.edwardwinkleman.com/2011/03/appropriation-prohibition-or-why-i.html; "Fair Use Doctrine Dead? A Fair Use Fridays

Moment of Silence for Richard Prince," *Copyright Litigation Blog*, accessed March 25, 2011, http://copyrightlitigation.blogspot.com/2011/03/fair-use-doctrine-dead-fair-use-fridays.html.

3. Not all in the art community have defended Prince. For example, curator Dan Cameron and Artnet editor Walter Robinson both lauded Judge Batts's ruling in favor of Cariou. See Brian Boucher, "Experts Debate Richard Prince Copyright Suit," *Art in America*, December 16, 2011, accessed May 20, 2012, http://www.artinamericamagazine.com/news-opinion/news/2011-12-16/art-and-law-panel/. I designate "appropriation-based practices" or "appropriation art" in this chapter as visual art works that take pre-existing materials (usually products of mass culture—advertisements, cartoons, films, commodities generally) as their starting point. With a legacy extending back to Marcel Duchamp's ready-mades at the outset of the twentieth century, appropriation art as an art-historical category is often associated with the rise of postmodernism in the 1970s and early 1980s. Today, appropriation art might be understood as one phenomenon within a now-much-larger "remix culture" that includes turntablism, "Photoshopping," mashups, and so on.

4. The Art Institute of Chicago, the Indianapolis Museum of Art, the Metropolitan Museum of Art, the Museum of Modern Art, the Los Angeles County Museum of Art, the New Museum, the Walker Art Center, and the Whitney Museum of American Art, along with the Guggenheim Foundation, filed a joint "Brief for Amici Curiae the Association of Art Museum Directors," http://articles.law360.s3.amazonaws.com/0283000/283044/museum%20brief.pdf (accessed January 14, 2012). The Andy Warhol Foundation filed its own Amicus Curiae brief, accessed January 14, 2012, http://articles.law360.s3.amazonaws.com/0283000/283044/Warhol%20Foundation%20Brief.pdf; for the Google Amicus Curiae brief, accessed January 14, 2012, see http://articles.law360.s3.amazonaws.com/0283000/283044/google%20brief.pdf. Prince's appeal, "Joint Brief and Special Appendix for Defendants-Appellants," filed October 2011, accessed January 14, 2012, can be found here: http://dl.dropbox.com/u/13848678/rp_lg_appeal_appendix.pdf.

5. On the ruling handed down by the United States Court of Appeals, Second Circuit, see *Rogers v. Koons*, 960 F.2d 301 (2nd Cir. 1992), http://www.ncac.org/art-law/op-rog.cfm (accessed January 14, 2012). The "String of Puppies" case was one of three copyright suits against Koons at the time, all of which sprang from sculptures he exhibited in 1988 as part of his *Banality* series. The other two suits, *Campbell v. Koons* and *United Feature Syndicate v. Koons* (both from 1993) were heard after the ruling in *Rogers v. Koons*; they are largely patterned after the same legal rationale and reach the same verdict.

6. For example: "In a decision rife with ominous implications for the practice of artistic appropriation, the U.S. Court of Appeals ... denied Jeff Koons's attempt to overturn a lower court verdict of copyright infringement. ... If ... the judge rules that Koons's use of the familiar Odie also fails to function as a form of criticism or commentary, the limitations on artists who wish to make works that respond to the contemporary world of existing mass-media images will be very confining indeed." Martha Buskirk, "Appropriation Under the Gun," *Art in America* 80, no. 6 (June 1992), 37–41. And curator Barry Rosenberg writes, "The legal situation looks questionable for appropriation artists and one must wonder

if acceptable boundaries can be drawn considering both the direction of art and that of the present Supreme Court." Quoted in Michael Kimmelman, "Art in Review," *The New York Times*, August 21, 1992.

7. Martha Buskirk would later go on to write of the "extensive and pervasive reach" of practices in contemporary art based on copying. See Martha Buskirk, *The Contingent Object of Contemporary Art* (Cambridge, MA: The MIT Press, 2003), 95. Any list of recent examples of appropriation artists here would be woefully inadequate. In painting: Eric Doeringer; sculpture: Tom Friedman; photography: Elad Lassry; film and video: Christian Marclay; new genres: Eva and Franco Mattes; tactical media: the Yes Men.

8. Pierre N. Leval, "Toward a Fair Use Standard," *Harvard Law Review* 103, no. 5 (March, 1990), 1111. Although the term "transformative" is not in the US Code, its concept as developed by Judge Leval has been very influential in several federal court cases involving fair use defenses, with judges citing Neval's essay as part of their rulings.

9. Leval, "Toward a Fair Use Standard," 1111. "A 'derivative work' is a work based upon one or more preexisting works, such as a translation, musical arrangement, dramatization, fictionalization, motion picture version, sound recording, art reproduction, abridgment, condensation, or any other form in which a work may be recast, *transformed*, or adapted." United States Code, Title 17, Section 101, http://www.copyright.gov/title17/circ92.pdf (accessed January 29, 2012). My emphasis. "The owner of copyright ... has the exclusive rights to ... prepare derivative works based upon the copyrighted work." United States Code, Title 17, Section 106. The reader is advised to note the subtle but important difference between a transformed derivative and a work that is transformative.

10. See *Rogers v. Koons*, 751 F. Supp. 474 (Dist. Court, SD New York 1990), http://scholar.google.com/scholar_case?q=ROGERS+v.+KOONS&hl=en&as_sdt=2,5&as_vis=1&case=9116893010009845497&scilh=0 (accessed February 4, 2012).

11. Katy Siegel, "Banality 1988," in *Jeff Koons*, ed. Hans Werner Holzwarth (Köln: Taschen GmbH, 2009), 258.

12. "In Koons's perception, 'the subject for the show would be banality but the message would be a spiritual one.'" Judge Haight, quoting Koons's testimony, in *Rogers v. Koons* (1990).

13. Siegel, "Banality 1988," 260.

14. "His objects are simultaneously pure and perverse, innocent and irritating, thought-provoking and mind-boggling, and have understandably been accused of celebrating as much as critiquing consumer culture." Roberta Smith, "Rituals of Consumption," *Art in America* 76, no. 5 (May 1988), 164. Others were less balanced: "Mr. Koons delivers an unabashedly cynical message. His works continue to celebrate the emptiness, meaninglessness and Disneylike unreality of contemporary life ... the hollowness the artist reveals seems fundamentally his own." Michael Kimmelman, "Art in Review," *The New York Times*, November 29, 1991; "His work is totally trivial and a pure product of the market. He's considered to be an heir to Duchamp, but I think it's a trivialization of all that. I think he's kind of a commercial artist." Yves-Alain Bois, quoted in Constance L. Hays, "A Picture, a Sculpture and a Lawsuit," *The New York Times*, September 19, 1991.

15. See note 5.
16. *Rogers v. Koons* (1992). There was a fourth, "artist proof" of *String of Puppies* that Koons kept for himself.
17. *Rogers v. Koons* (1992).
18. "Notwithstanding the provisions of sections 106 and 106A, the fair use of a copyrighted work, including such use by reproduction in copies or phonorecords or by any other means specified by that section, for purposes such as criticism, comment, news reporting, teaching (including multiple copies for classroom use), scholarship, or research, is not an infringement of copyright." United States Code, Title 17, Section 107.
19. There are subtle but important differences between parody and satire. Parody "targets" an original source in order to mock it (e.g., *Saturday Night Live*'s parodies of politicians), while satire employs humor, often through irony or exaggeration, to constructively criticize a state, condition, or society in general (e.g., *The Daily Show*'s "investigative journalism" lampooning the American political system). We might interpret Koons's *String of Puppies* less as parody of Art Rogers's photo than as ironic satire of an insatiable art world perfectly willing to indulge in high-priced objects of bad-taste. On irony, see generally Wayne C. Booth, *A Rhetoric of Irony* (Chicago: University of Chicago Press, 1974).
20. *Rogers v. Koons* (1992).
21. Contrasted against a voice critical of the banal-kitsch commodity form responsible for the "deterioration of society," Jeff Koons stated, at the initial launch of the *Banality* series, "I do not start with an ideal that is elevated above everybody. I start with an ideal down below and give everybody the opportunity to participate and move together... It's about embracing guilt and shame and moving forward instead of letting this negative society always thwart us." Jeff Koons, quoted in Burke and Hare, "From Full Fathom Five," *Parkett* 19 (1989), 45.
22. "The copying was so deliberate," Judge Cardamine declared in the appeal ruling, "as to suggest that defendants resolved so long as they were significant players in the art business, and the copies they produced bettered the price of the copied work by a thousand to one, their piracy of a less well-known artist's work would escape being sullied by an accusation of plagiarism." *Rogers v. Koons* (1992).
23. Jeff Koons, quoted in Ronald Sullivan, "Appeals Court Rules Artist Pirated Picture of Puppies," *The New York Times*, April 3, 1992. Notably, while Koons never credited Rogers as the source of *String of Puppies*, he nevertheless insisted his Italian fabricators inscribe their names on the bases of the sculptures they crafted, which would verify their "authenticity." See Burke and Hare, "From Full Fathom Five," 47.
24. On "structures of signification" and the Pictures artists, see Douglas Crimp, "Pictures," *October* 8 (Spring, 1979), 75–88.
25. Hal Foster, "The Passion of the Sign," in *The Return of the Real: the Avant-Garde at the End of the Century* (Cambridge, MA: The MIT Press, 1996), 91. The reader will notice that the artists mentioned here are women; feminist critique comprised a significant component in early appropriation art. For one read on the Pictures generation in this vein, see Craig Owens, "The Discourse of Others: Feminists and Postmodernism," in *Beyond Recognition: Representation, Power and Culture* (Berkeley: University of California Press, 1992).

26. "Appropriation has become the dominant trend in contemporary art practice … no longer [signifying] anything in particular; not the death of the author, not a critique of mass-media representations, not a comment on consumer capitalism. On the contrary, it seems that appropriation is a tool of the new subjectivism, with the artist's choice of pre-existing images or references representing a bid for authenticity (my record collection, my childhood snaps, my favorite supermodel)." Lucy Soutter, "The Collapsed Archive: Idris Khan," in *Appropriation*, ed. David Evans (London: Whitechapel; Cambridge, MA: The MIT Press, 2009), 166.

27. See Betsy Stirratt and Eugene Tan, eds., *Jason Salavon: Brainstem Still Life* (Bloomington: School of Fine Arts Gallery, Indiana University, 2004). On Candice Breitz's pop song video installations, see http://www.mfa.org/exhibitions/contemporary-outlook (accessed February 14, 2012). On Jennifer and Kevin McCoy's cartoon indexing, see http://www.flickr.com/photos/mccoyspace/sets/327770/ (accessed February 14, 2012.) On Christian Marclay, see http://www.nasher.duke.edu/exhibitions_marclay.php; http://www.lacma.org/art/installation/christian-marclays-clock (accessed February 14, 2012).

28. See generally Nancy Spector and Richard Prince, *Richard Prince* (New York: Guggenheim Museum, 2007).

29. Spector and Prince, *Richard Prince*, 40–45.

30. "Videotaped Deposition of Richard Prince," in Greg Allen, *Canal Zone Richard Prince YES RASTA: Selected Court Documents &c., &c.* (New York: greg. org, 2011), 298–99. See also Roland Barthes, "The Death of the Author," in *Image, Music, Text* (New York: Hill and Wang, 1977). For more on Prince seeking to distinguish himself from the critical reception of his work, see Douglas Eklund and Metropolitan Museum of Art, *The Pictures Generation: 1974–1984* (New York: Metropolitan Museum of Art; New Haven, CT: Yale University Press, 2009), 166.

31. "Memorandum of Law in Support of Defendants' Joint Motion for Summary Judgment," Allen, *Canal Zone Richard Prince YES RASTA*, 5.

32. "Joint Brief and Special Appendix for Defendants-Appellants," 30.

33. See Patrick Cariou, *Yes Rasta* (New York: powerHouse Book, 2000). From the inside cover of *Yes Rasta*: "Cariou's direct, classical photographs reveal a strong, simple people whose style and attitude are as distinctive as their dreadlocks." During the production of *Canal Zone*, Prince purchased several copies of *Yes Rasta* in order to tear out their pages for use in his paintings. Not once did Prince ever acknowledge Cariou's copyright notice printed in the back of each book. See "Videotaped Deposition of Richard Prince," Allen, *Canal Zone Richard Prince YES RASTA*, 240–241.

34. *Cariou v. Prince* (2011).

35. "Videotaped Deposition of Richard Prince," Allen, *Canal Zone Richard Prince YES RASTA*, 100–339.

36. "Memorandum of Law in Support of Defendants' Joint Motion for Summary Judgment," Allen, *Canal Zone Richard Prince YES RASTA*, 1.

37. On "paying the customary price" for the use of copyrighted materials, see E. Kenly Ames, "Beyond *Rogers v. Koons*: A Fair Use Standard for Appropriation," *Columbia Law Review* 93 no. 6 (October 1993), 1490–99.

38. *Cariou v. Prince* (2011).

39. Given Prince's position in the art world, it's a shame that the fair use of appropriation art has been tested in *Cariou v. Prince* the way it has, for a "David and Goliath" narrative emerges too easily. Against both sides, I would simply, if crudely, state there is something embarrassing about two white men arguing over whose representations of black men are the more sincere or "authentic" expressions. However, that is for another essay.

40. Julia Halperin, "Is *Prince v. Cariou* Already Having a Chilling Effect? Contemporary Artists Speak," *Artinfo*, February 1, 2012, accessed May 20, 2012, http://artinfo.com/print/node/758352.

41. Halperin, "Is *Prince v. Cariou* Already Having a Chilling Effect?"

42. "Prior to displaying any works of Appropriation Art in current or future collections or exhibitions, museums might have to conduct significant due diligence, including seeking documentation that permission was obtained, requesting indemnification from the artist, seeking expensive legal opinions, or purchasing liability insurance. Rather than judging and acquiring works on their perceived artistic merit, museums might be forced to limit their offerings if they cannot determine a work's precise legal status under the Copyright Act, particularly under the sweeping and ill-defined standard in the district court's approach." "Brief for Amici Curiae the Association of Art Museum Directors," 22.

authorship versus

ownership

the case of socialist china

four

l a i k w a n p a n g

It is reported that Guo Jingming, a 28-year-old popular writer in China, has accumulated royalty fees worth more than 100 million RMB ($16 million), while hundreds of thousands of other professional writers are barely able to earn enough to survive.[1] A major challenge for contemporary media and digital authorship, both in China and the rest of the world, is to overcome the fetishism of the author, who is understood to be the one who "owns" the creative works credited to him or her. This fetishism of the author is both a result and a cause of the rise of creative economy, which submits creativity to the capitalist machine to generate capital.[2] In order to maintain a certain autonomy of the cultural sphere from the encroachment of the market, we must reconsider an authorship which is not understood in terms of ownership. Can we conceptualize an author who has no intrinsic or exclusive rights to her works, allowing the process of creativity to be regenerated and the natural relationship between creativity and everyday life to be reconnected from the ground up? Many of the current copyright debates address tensions between author and distributor, but relatively fewer discussions are devoted to the dissociation of authorship and ownership.

We can take the debates around moral rights as an example. The exercise of copyright according to Anglo-American common law is often criticized for depriving the author of the rights and privileges of ownership of the work; instead, they are granted to the author's employer. Many critics view the Continental practice of *droit d'auteur* (author's rights or author's moral rights) as being more respectful to authors, since it allows the transfer only of certain economic rights, rather than the entirety of the work, to the employer or distributor through contractual means.[3] In the Continental tradition, the work is an extension of the personality of the author, and cannot be altered without the consent of the author. However, upholding the natural rights of the author to her work, this tradition does little to expand the public domain. Although the Continental practice differentiates property rights and moral rights, and rejects the idea of property as a basis for copyright protection, the protection of authors' moral rights is still based on the concept of "ownership"; thus, communal access to the work is hindered.

To my mind, what needs to be deliberated is not who owns which rights, but the possessive nature of the individual author. As contemporary copyright is conceived, the author cannot be defined and discussed unless she is considered the proprietor of the works she "created." It is under this assumption of possessive individualism that the concept of authors' rights is based; under the same assumption, creative products can be understood as private properties. However, as many have already argued, creativity can never be completely separated from copying, so this privatization of creativity leads to the inevitable barring of the circulation of creative drives.

Instead of resorting to copyright alternatives such as Creative Commons, which I believe still stems from the conceptual system of "rights," in this chapter I explore whether an author can be understood to be beyond concepts of ownership.[4] The practices of socialist China (1949–1979) are my focus here, largely because discussion of copyright was almost absent there. I demonstrate how, in socialist China, the identity of the author was both acknowledged and negated without resorting to concepts of rights and ownership. The Chinese hegemony of the collective dictates that the ultimate author is the people, rather than an individual. This ideological structure poses as many problems as it solves, but it does help us deliberate the possibilities and limitations of conceptualizing the author as being beyond copyright and beyond individualism.

copyright versus remuneration

Naturally, one looks to existing socialist states to locate alternative copyright practices, since socialism supports the collectivization of human production, which includes both material and nonmaterial products. However, most of these states actually legalized copyright in ways similar

to their Western counterparts. For example, the socialist copyright law passed by the Soviet Union in 1925 derives largely from the Continental tradition. The law stipulates that, once a creative work is produced, its author owns the rights without registration, and it also prohibits any unauthorized modification of an author's work.[5] Although this socialist copyright emphasizes the abolition of property-based theory of copyright law, the basic ownership concept is not challenged. The Copyright Act of 1928, a refined version of the 1925 law, was to govern author's rights in the Soviet Union for more than three decades, and it also served as a basic reference to most other socialist states.[6]

Many socialist states in Europe also exercised and respected author's rights to a large extent. With the exception of Albania, all European social-ist states that had earned their Berne Union membership before their socialist liberations continued to honor the Convention, and all socialist states in Europe protected authors' rights to their works by developing a comprehensive legal system of authors' contracts.[7] In their discussion of the various versions of the Author's Rights Law passed in Yugoslavia, Grgorinić and Rađen argue that the socialist state relied on the same rhetoric of ownership and individualism that marked their use in the capitalist West.[8] We can say that moral rights of the authors were protected as much by the Eastern Bloc countries as their capitalist counterparts in the West. Although the profit-driven dimension of cultural production was repressed, these socialist states did not challenge the basic concepts of ownership.

A real alternative to copyright can be found in the People's Republic of China (hereafter PRC), where authors' rights have never been pro-moted wholeheartedly. The first modern copyright law in China was enacted in 1910 by the Qing imperial government, and it was revised and updated thereafter by the Republican government to meet interna-tional standards.[9] Immediately after the 1949 socialist liberation, the PRC government had to revamp national intellectual property rights laws to match its new socialist governance. Patent was the first kind of intellec-tual property rights recognized in the new PRC law in 1950, but the coun-try's first copyright law was not passed until 1990. In 1957, the Ministry of Culture offered a proposal entitled "Baozhang chubanwu zhuzuoquan zhanxin guiding (caoan)" ("temporary provisions for protecting authors' rights of publication [draft]") for public consultation, in order to pave the way for the first copyright law in the PRC. The draft was modeled primarily after the Soviet Union's 1928 copyright act, but the scope of pro-tection was drastically reduced, and it did not specify the rights an author was granted.[10] Even this watered-down version was not accepted, and the consultation dissolved silently amid the radicalization of leftist politics when, in 1958, the Chinese Communist Party (hereafter CCP) launched the extremist Great Leap Forward campaign; private ownership was

entirely abolished and households all over China were forced into state-operated communes to promote national production. The individualist dimension of copyright law clearly runs counter to the collectivist ideology promoted during the Great Leap Forward and the even more radical Cultural Revolution that was to follow.

However, this does not mean that socialist China was never concerned about economic issues related to cultural production. Instead of defining an author's rights legislatively, the government focused on regulating the remuneration system. The first such copyright-related regulation is found in a 1950 Ministry of Culture policy paper released after the new republic's first National Publication Meeting. "Guanyu gaijin he fazhan chuban gongzuo de jueyi" ("decisions regarding the improvement and development of publication projects") clearly stated that publishers must respect the author's rights of writing and publication, and they may not conduct activities related to counterfeit, piracy, and alternations without the consent of the authors.[11] However, the authors' actual rights were not made clear in the policy paper, and the most important outcome of this meeting was a relatively concrete formula for the calculation of the author's remuneration, which was determined by a set of criteria that included the publication's nature (scientific publication was ranked higher than humanistic publication, and translators were paid less than writers of original works), quality (a select few publications deemed to have special value yielded greater remuneration), word count, and number of copies.[12] This formula was quickly adopted nationally.

How authors' payments should be calculated has been a matter of constant debate ever since. These discussions comprise nearly all ideological discussion of the author in the PRC, and neglect copyright concepts altogether. A most controversial aspect of the remuneration practice relates to the number of copies published, since there is some question as to whether the socialist state should reward popularity. In the original 1950 system, the honorarium per copy paid to the author decreased as the number of copies printed increased, so that an author's income was not directly proportional to sales; this was meant to prevent grave financial inequality between writers who produced popular works and those who did not. In the 1956 version, which was released in a more liberated political era, this practice was loosened, and the tariff decrease did not go into effect until the sixth printing.[13] The idea was to encourage authors to produce works that had broad impacts, but handsome payments inevitably went to authors of popular writings. Quickly, this practice was heavily criticized when collectivism intensified, and remunerations were markedly reduced in 1958 and 1959, and the payment of honorarium per copy in inverse proportion to the number of copies printed was also exercised more stringently.[14] In 1961, when the Great Leap Forward was officially aborted,

the reformists who had gained the upper hand in party leadership reversed the 1958 and 1959 policies in order to promote publication and artistic production.[15] However, by 1964, when the Cultural Revolution was incubating, the Ministry of Culture separated author payments from the number of copies printed altogether—each author was paid only once.[16]

Although the remuneration system was not officially abolished during the Cultural Revolution, the standard payment was reduced further, and the government encouraged authors to refuse payment from publishers.[17] The 1966 Ministry of Culture report stated that most authors, artists, and scientists were already full-time employees of government institutions and provided a basic monthly salary, and so their publications need not bring them additional financial rewards. Furthermore, ordinary citizens should be encouraged to publish, but also should not be rewarded financially because they have full-time jobs of their own. Remuneration was to be given only to those few freelance authors and translators who still needed financial support.[18] Cultural production and economic incentive were completely detached. Instead, according to the report, publishers and distributors should be more proactive in collaborating with authors, caring about their works and their lives, and providing them necessary information and feedback, in order to help them elevate their works to a higher standard.[19] Authors and artists create not for financial gain, but out of their own passions and responsibilities, which would be appreciated by—and intellectually benefit—the people and the nation.

The concept of individual authorship was also suppressed. Instead, collective authorship was promoted—most literary or artistic works created at that time were credited to a work unit, a political organization, or a study group. In the original versions of many films made during the Cultural Revolution, even the performers were not credited, and audiences struggled to learn the names of their favorite actresses via word of mouth. Most of the official model performances were credited to work units created specifically for these projects in designated national troupes. Artists and authors of literatures were more often named publicly, but almost always in connection with their work units, thereby emphasizing their amateur status. An unspoken rule was that only amateur authors could be named, for the purpose of celebrating cultural democracy; professional authors were not to be identified. Occasionally, professional artists were promoted for political reasons. A case in point was the overnight celebrity status achieved by Liu Chunhua; the art student's 1967 painting of young Mao going to Anyuan to lead the monumental workers' strike in 1922 was strategically promoted by the Mao clique in order to criticize a classic oil painting by veteran painter Hou Yimin that depicts Liu Shaoqi, Mao's primary political enemy during the dawn of the

Cultural Revolution, as the leader of this strike.[20] These individual incidents were exceptions motivated by specific political intentions rather than respect for particular artists.

Although the Chinese socialist remuneration system was based on Soviet practices,[21] and many socialist states also developed tariff systems that took into account the nature, extent, quality, and print run of a work, socialist China never developed copyright legislation as the Soviet and many other socialist governments had done. The remuneration system made up almost the entirety of the Chinese copyright system. In socialist China, copyright debates were not philosophical discussions of the kinds of rights an author should have. Their focus was the actual financial reward given to an author to keep her creating and publishing. The economic motivation for intellectual production was not theorized up to the level of the intrinsic rights of the authors; the state focused on actual practices and outcomes. Although there seemed to be drastic policy changes concerning the remuneration system throughout the socialist period, debates never shifted to the nature of authorship. Other concepts were developed to replace copyrights; one of these was "cultural labor," which was consistently endorsed throughout the turbulent period. The People's Literature Press clearly noted in its 1955 remuneration regulations that the regulations might not fairly compensate authors of valuable original creations and translations that required long-term research and preparation, and stated its belief that remuneration for such works should not be bound by these regulations.[22] In 1966, although the 1955 and 1956 practices were harshly criticized and the standard remuneration continued to be reduced, it was still clearly stated in official policy papers that those very few cultural workers who expended an extremely large amount of labor in the production of their works should receive considerably higher remuneration.[23] The basic remuneration principle was the guarantee of basic livelihood, which was still linked to the labor of the cultural workers rather than the intrinsic quality of the work.

Despite clear Soviet influences, the concept of authors' rights never took hold in socialist China, thus demonstrating major cultural differences between the two states in spite of their common socialist commitment. In the Soviet Union, particularly before the Stalinist era, the arts and literature were still conceptualized as being relatively autonomous from the political realm. The artistic freedom found in the Soviet Union in the 1920s was largely conditioned by the modernist, or romanticist, ideas that still prevailed. Leon Trotsky, whose influences on Soviet cultural policy and artistic development in the 1920s were enormous, clearly held a faith in aesthetics as an autonomous force. He criticized those who read great literature, such as *The Divine Comedy*, as mere historical documents to reflect the psychology of a certain class at a certain time. Instead,

he believed that there are direct aesthetic relationships between readers of different periods: "Works of art developed in a medieval Italian city can, we find, affect us too. What does this require? A small thing: it requires that these feelings and moods shall have received such broad, intense, powerful expression as to have raised them above the limitations of the life of those days. Dante was, of course, the product of a certain social milieu. But Dante was a genius. He raised the experience of his epoch to a tremendous artistic height."[24] This promotion of the "genius" discourse strikes a chord with Martha Woodmansee's study of the intrinsic relationship between copyright discourse and the romanticist view of the author as a genius whose special contribution to humankind must be protected.[25] A major problem with today's copyright regime is the aggrandizement of this Romanticist vision of the author to justify and precipitate broader and broader protections for the owner. The discourse of genius did not find an audience in socialist China, as art and literature had to serve the people and politics—authors did not earn an autonomous social position based on genius status.

William Alford explains the lack of copyright awareness in contemporary China by referring to the absence of the consciousness of individualism in traditional Chinese culture and philosophy. Alford argues that originality in terms of creating something entirely new or innovative was foreign to Chinese culture, and that Confucian ideology—which respects traditional knowledge and protects common resources of use by all prospective authors—did not promulgate any system of intellectual property rights.[26] One can argue for or against Alford's position, but I am not interested in viewing the absence of copyright discussion in socialist China from a culturally essentialist perspective. Instead, I would point out that the CCP utilized a different approach to condition cultural workers' identification with the collective. I think the CCP was sensitive to the identity and self-perceptions of authors and artists in a way. However, instead of theorizing what an author is and articulating the confinement of authorship, the CCP invited authors to surrender whatever they had to the collective—which would explain the absence of authors' rights discussions in socialist China. This practice also sealed the fate of the author during the Cultural Revolution.

authors' identity and identification

This collective ideological system can be traced back to the roots of the PRC's cultural governance during the Yan'an period (1936–1945), when the CCP resettled in the rural Yan'an area to shield itself from the attacks of the ruling republican Guomindang (hereafter GMD) party, as well as the Japanese army. In 1940—when the rival parties joined forces against the Japanese invasion—the CCP Central Committee issued a directive,

penned by Mao Zedong, on concrete policies for CCP-controlled areas. Mao's overall concern was consolidating the party's rule in these areas and securing an Anti-Japanese National United Front with the GMD. Although cultural issues made up a very small part of the overall document, this directive was CCP's first cultural policy and has instrumental significance in this regard.

The document states clearly that culture was to play the propaganda role in the overall United Front policy, so culture should see itself as subsidiary to larger political tasks. Most importantly, it was the "people" instead of the "works" who were the primary concern of the document, showing the party's respect for and hidden anxiety about cultural workers. Mao advocated accepting all intellectuals and students who showed enthusiasm for resisting Japan into CCP schools, giving them short-term training, and then assigning them to work in the army, the government, or mass organizations. The CCP was to boldly draw them in, give them work, and promote them, and should not be overly cautious or too fearful about reactionaries sneaking in.[27] The directive instructed the CCP to embrace as many cultural workers—communist or not—as possible in the War of Resistance, but indicated that these workers should first be admitted to the party's art school, the Lu Xun Academy of Arts.

The CCP established a few official departments in Yan'an to deal with policy design and implementation, which, unsurprisingly, did not include a corresponding department of culture. What was unique about early CCP governance was its decision to put together an art academy, the Lu Xun Academy of Arts, with an eye to training future artists to serve the party.[28] During 1937 to 1945, when China was at war with Japan, artists throughout China voluntarily came to Yan'an. They might have shared some socialist idealism, but many of them mistook Yan'an as the cultural haven that would give them artistic freedom not available in GMD-controlled China. Precisely because of their "incorrect" expectations, these cultural workers had to be admitted to the Academy to be re-educated. The Academy's curriculum was constantly debated, and it became the locus of the CCP's first experimentation in cultural governance. In the Academy, the party's power over culture was exercised by shaping and directing the artists so that they would prove loyal and, therefore, useful. In other words, cultural workers were first and foremost understood to be autonomous subjects, and they had to be contained and controlled. However, this was not done coercively; individual artists voluntarily relinquished their earlier rebellious and individualist attitudes in order to submit to the political project they believed in.

The party's first elaborate cultural statement was Mao Zedong's 1942 "Talks at the Yan'an Conference on Literature and Art." The conference was a party reaction against the bohemian culture developing among the sojourned cultural workers in Yan'an.[29] Mao discussed the nature of

literature and art, and he articulated the political roles they could play in serving contemporary needs. Following the 1940 directive, in which the wartime rhetoric reigned, the talks clearly spelled out the doctrine of *wenyi wei dazhong* (literature and art are for the masses), and emphasized the political functions of art and literature.[30] Once again, cultural workers were called upon to be retrained. Folk cultures were to be respected, and cultural workers were to go to the people and simultaneously learn from them and agitate them. If the Yan'an Talks were the prototype of CCP's later cultural policies, the ideas delivered in the talks resemble less a policy presentation than a pedagogical statement seeking the identification of cultural workers. It is as much the ideas contained in the talks as this direct address to the cultural workers that characterize CCP's cultural governance thereafter.

The Yan'an Talks were to become the most widely studied and influential cultural policy document in China. It is important to note that this document reflects Mao's, or his cultural comrades', philosophical reflections on the relationship between art and politics as a contingent and utilitarian approach to handling culture. The talks emphasized the subsidiary position of cultural workers to the people, which was the result of both Mao's political philosophy and wartime exigencies. In other words, cultural workers had to submit themselves to a totalitarian regime in the name of both ideological commitment and the nation's survival. Such mutual conditionings among theory and practice, and individuals and collective, gave cultural workers no responsibilities other than serving the people.

In 1945, Zhou Yang, perhaps *the* most important party leader in the cultural domain from the Yan'an period to the advent of the Cultural Revolution, offered a more elaborate follow-up cultural policy statement after the 1942 Yan'an Talks, which revealed more clearly how the CCP understood its relationship with culture.[31] Zhou demanded that writers and artists comprehend the new policies introduced by the party in the Liberated Area:

> Since the [Yan'an] Conference on Literature and Art, artistic creations have been marked by a new feature, which is their marriage with all kinds of revolutionary experimental policies. This is one of the most important signposts of the new direction for art and literature. Art should reflect politics. In the liberated area, this principle is realized through *art's reflection of the processes and results of all kinds of policies being practiced among the people*. ... In order to reflect the life of the people in the new era, artists need to understand the various revolutionary policies being practiced, because these policies are changing the face of this era.[32]

According to Zhou, the role of artists and authors was to follow and understand all kinds of new policies introduced by the party, so that these policies could be promoted among the masses. Zhou did not use the term "cultural policy" to represent the party's view on the function of culture, but the two terms are used separately, and it is clear that he advocated the service of culture to policy. Culture was understood not as being subject to government restriction, but rather as a manifestation of practitioners' autonomy. What the party needed to do was to shape and manipulate their voluntary submission—or their self-negation, which was exercised under the promise of their re-empowerment by the people.

This submission mechanism was most blatantly employed during the Cultural Revolution, when authors and artists were among the first to be purged. They were victimized precisely because of their capacity for intellectual "autonomy," which had to be subdued before a new classless society could be realized. In spite of their overall anger and condemnation of the Cultural Revolution, some authors and artists confess in their memoirs about their voluntary submission to their own re-education, and some of them were convinced that the intellectual as an identity had to disappear.[33] The Cultural Revolution presented an extreme case of collective authorship, which made no room for an individual to claim her works under her own name.

I believe that the most important ideological aspect of CCP's cultural policy was to recognize the individual autonomous agency of cultural workers—who, however, were to be submitted to the people for education. The embodiment of the people was first the Lu Xun Academy of Arts and later the entire ideological state apparatus, which first embraced these autonomous subjects before it confined and harnessed their plurality. Recognizing cultural workers' ability to raise alternative views, the party then subdued these views in the name of the people, so that the cultural workers' autonomy was first endorsed and then negated. Naoki Sakai posits that a similar mechanism was at work in imperial Japanese nationalism in the 1930s.[34] Sakai demonstrates that the Japanese state allowed ethnic identity to be brought into the national subject's self-awareness only insofar as the subject negates it and is free from it. Awareness of one's different identity became enormously important in this operation of social formation, because it is the subject's freedom of recognition and negation of one's difference that characterize the success of the hegemony: "[T]he individual's identification with the State ... would be inconceivable unless the nation-state for the individual is primarily and essentially something to which the individual chooses to belong."[35] PRC cultural policy operates along similar lines, in that the autonomous agency of an author or an artist was first endorsed before it could be negated willingly by the author or artist herself.

beyond individualism

Although it was the wartime machine and difficult everyday conditions that engineered the submission and obedience of the cultural workers back in the Yan'an period, this mechanism continued well into the 1950s before reaching its apex during the Cultural Revolution, when the identity of the individual author had to be completely negated in order to reassign authorship to the entire people. The author was always understood to be a temporary category, ultimately to be replaced and deleted. This historical revisit allows us to understand the PRC's reluctance to establish authors' rights from a sociohistorical point of view, and it also prevents us from essentializing a "Chinese" conceptualizing of authorship. The negation of rights given to authors is probably more a political decision than a cultural inevitability.

A major foundation of Mao's political philosophy is the dialectical relationship between the individuals and the collective, which mutually condition each other. The status of the party is therefore ambiguous: it relies so much on the endorsement of the people that the CCP was not truly a Leninist vanguard party—the people as a collective reigns. However, in Mao's philosophy, the people also need constant guidance from the party, because each one of them is naïve and prone to backwardness. As such, the cultural workers, or intellectuals in general, are part of and not part of the people: their autonomy is recognized because they are considered more intellectually advanced than the people in general, but they are also cursed by this status. They are largely residues of the old society, and they must refute themselves and allow themselves to be absorbed into the people. Ultimately, literary and artistic productions are part of people's everyday life, and all can write and participate in the production of culture freely and adequately in the communist utopia. In such a context of cultural democracy, discussion of copyright becomes irrelevant; the public domain is all encompassing— and everyone is free to respond to, appropriate, and even copy works by other people. Such situations actually existed during the Cultural Revolution, when big-character posters, propaganda posters, and comic strips were produced and posted by ordinary citizens in every public place; some of these works were quickly copied and redistributed. It was a radical period of collectivism, which purged all "private" ownership as a ramification of capitalism. It was also a utopia of enlightenment, in which all the people became autonomous and had no need to be guided by intellectuals.

The problems with this debasement of the "private" are several: the individual is not permitted to opt out of the collective, individual freedom is jeopardized, and creativity cannot be attributed to any individual. In fact, this aggrandizement of the public can be maintained only in an extremely politicized environment in which everyone is scrutinized

ideologically by everyone else. However, the nonexistence of copyright concepts during the Cultural Revolution does shed light on an interesting situation to be contrasted with the present situation. It is in our current depoliticized late-capitalist society that copyright and intellectual property rights are most ardently promoted; the concepts of rights are compatible with, and much needed in, a privatized and individuated society. However, in a radically politicized society, these discussions about rights, which focus primarily on the protection of individuals, are superseded by collective interests.[36]

This chapter's central question is whether an author can be defined without attaching rights to her works. In socialist China, the relationship between an author and her works is not defined by ownership, but by the author's membership in a society, which, in turn, owns the works. In the end, the ultimate author was the people as a collective. The people were expected to generate works by relying heavily on the Marxist or Maoist canon, and they would create a body of texts pointing back to the legitimacy of the party, its ideology, and, most importantly, the people themselves who endorse and support the party and its ideology, thus achieving an organic whole between culture and politics.[37] As such, the people as a collective and individual authors cannot be differentiated, and this mutual conditioning is made possible by the dialectics of the individual author's self-affirmation and self-negation. Today, very few people, even the fiercest anti-capitalist critics, would go so far to commit to this socialist idealism, but this idealism seems to me to be a legitimate basis on which to imagine alternative approaches to more egalitarian practices of cultural productions, such as those of the new media, whose authorship is usually collective and fleeting. Socialist China offers the historical lesson that we should not allow collective authorship to completely usurp the individual author, but we can still explore how the collective could be conceptualized and practiced without resorting to hegemonic means or negating the individual. Our urgent task—precisely the major challenge within contemporary, digital media—is to formulate a new mode of authorship beyond the discourse of rights, and to reinvestigate a dialectical relationship between individuals and the collective that takes both seriously. The real reason for the failure of Maoist authorship is precisely the party's inability to realize a dialectic it truly believes in.

notes

1. "Zhongguo wentan pinfu xuanshu—Zuojia fuhao Guo Jinming deng bangshou" [A rich gap between rich and poor in China's literary circles: Magnate–writer Guo Jingming reaches the top] *Sin Chew Daily*, November 22, 2011.

2. Laikwan Pang, *Creativity and Its Discontents: China's Creative Industries and Intellectual Property Rights Offenses* (Durham, NC: Duke University Press, 2012), 67–85.

3. See, for example, Pamela Samuelson, "Economic and Constitutional Influences on Copyright Law in the U.S.," in *U.S. Intellectual Property Law and Policy*, ed. Hugh Hansen (Cheltenham, UK: Edward Elgar, 2006), 164–203.

4. Pang, *Creativity and Its Discontents*, 74–80.

5. Mira T. Sundara Rajan, *Copyright and Creative Freedom: A Study of Post-Socialist Law Reform* (London: Routledge, 2006), 89–97.

6. Moral rights were actually further strengthened by the 1961 Soviet copyright laws. Sundara Rajan, *Copyright and Creative Freedom*, 98.

7. György Boytha, "The Berne Convention and the Socialist Countries with Particular Reference to Hungary," *Columbia-VLA Journal of Law & the Arts* 11, no. 73 (1986), 57–72.

8. Natalija Grgorinić and Ognjen Rađen, "Authors' Rights as an Instrument of Control: An Overview of the Ideas of Authorship and Authors' Rights in Socialist Yugoslavia, and How These Ideas Did Not Change to Reflect the Ideals of The Socialist Revolution," *Law and Critique* 19, no. 1 (April 26, 2008), 35–63.

9. Li Mingshan, *Zhongguo jindai banquan shi* [History of modern copyright in China] (Kaifeng: Henan Daxue chubanshe, 2003), 100–27, 165–69, 174–83.

10. Li Yufeng, *Qiangkouxia de falü: Zhongguo banquanshi yanjiu* [Law under the gun: A study of Chinese copyright history] (Beijing: Zhishi chanquan chubanshe, 2006), 149–50.

11. Li Yufeng, *Qiangkouxia de falü*, 147.

12. For the actual details, see Xinhua Shudian [New China Bookstore], "Xinhua Shudian zongguanlichu shugao baochou zhanxin banfa caoan (1950 nian)" [1950 Draft of the method of remuneration for book manuscripts by Xinhua Bookstore management headquarters], in *Zhongguo banquanshi yanjiu wenxian* [Collected research documents on Chinese copyright history], ed. Zhou Lin and Li Mingshan (Beijing: Zhongguo fangzheng chubanshe, 1999), 264–66.

13. Hao Fuqiang, "'Shiqi nian' wenyi gaochou zhidu yanjiu" [A study of the Seventeen Years' art and literature remuneration system], *Jianghai xuekan* [Jianghai academic journal] (2006), no. 4: 201.

14. Li Yufeng, *Qiangkouxia de falü*, 151–53.

15. Li Yufeng, *Qiangkouxia de falü*, 154.

16. Zhonghua Renmin Gongheguo Wenhuabu [Minstry of Culture, PRC], "Guanyu gaige gaochou zhidu de tongzhi" [Notice regarding the reformation of the remuneration system], in Zhou and Li, *Zhongguo banquanshi yanjiu wenxian,* 328.

17. Hao, "Shiqi nian' wenyi gaochou zhidu yanjiu," 204.

18. Zhonghua Renmin Gongheguo Wenhuabu, "Wenhuabu dangwei guanyu jinyibu jiandi baokan tushu gaochou de qingshi baogao" [Report from the Party Committee of the Ministry of Culture regarding further reductions in remunerations for newspaper, journal, and book publications], in Zhou and Li, *Zhongguo banquanshi yanjiu wenxian,* 331.

19. Zhonghua Renmin Gongheguo Wenhuabu, "Wenhuabu dangwei guanyu jinyibu jiandi baokan tushu gaochou de qingshi baogao," 331.

20. For a more extensive historical account of this painting, *Chairman Mao to Anyuan*, and Liu Chunhua's experiences, see Wu Jijing, "Youhua *Mao Zhuxi qu Anyuan* de fengfengyuyu" [The debates and disturbances around the

oil painting *Chairman Mao to Anyuan*], *Dangshi zongheng* [Over the history of the party], no. 2 (2008), 27–33.

21. Hao, "Shiqi nian wenyi gaochou zhidu yanjiu," 200.

22. Renmin wenxue chubanshe [People's Literature Press], "Renmin wenxue chubanshe chuban hetong, yugaohetong ji gaochou banfa" [The publication contract, commission contract, and remuneration methods of People's Literature Press], in Zhou and Li, *Zhongguo banquanshi yanjiu wenxian,* 281.

23. Zhonghua Renmin Gongheguo Wenhuabu, "Wenhuabu dangwei," 329.

24. Leon Trotsky, "Class and Art," in *Art and Revolution: Writings on Literature, Politics, and Culture,* ed. Paul N. Siegel (New York: Pathfinder, 2008), 70.

25. Martha Woodmansee, "The Genius and the Copyright: Economic and Legal Conditions of the Emergence of the 'Author'," *Eighteenth-Century Studies* 17, no. 4 (Summer 1984), 425–28.

26. William Alford, *To Steal a Book Is an Elegant Offense: Intellectual Property Law in Chinese Civilization* (Stanford, CA: Stanford University Press, 1995).

27. Mao Zedong, "Lun zhengce" [On policy], in *Mao Zedong xuanji* [Selected works by Mao Zedong] (Beijing: Renmin chubanshe, 1964), 2:759–67.

28. The Propaganda Department was one of the first official organs set up in Yan'an right after the Long March, but at that point it was not tasked with formulating cultural policy; its primary duties were economic planning and ideological dissemination.

29. For a comprehensive introduction to the talks, see Bonnie S. McDougall, *Mao Zedong's "Talks at the Yan'an Conference on Literature and Art": A Translation of the 1943 Text with Commentary* (Ann Arbor: Center for Chinese Studies, University of Michigan, 1980).

30. McDougall, *Mao Zedong's "Talks at the Yan'an Conference on Literature and Art",* 14–17.

31. Having engaged in fierce debates on the social role of literature in 1930s Shanghai with major left-wing figures such as Lu Xun and Hu Feng, Zhou Yang was summoned to Yan'an by the CCP to head the newly established Lu Xun Academy of Arts in 1937. Zhou's cultural philosophy became even more politicized after he arrived in Yan'an, and he advocated art in the service of politics.

32. Zhou Yang, "Guanyu zhengce yu yishu: *Tongzhi, ni zoucuo liao lu* xuyan" [On policy and art: Foreword to *Tongzhi, ni zoucuo liaolu*], in *Zhou Yang xuba ji* [Forewords and afterwords by Zhou Yang], ed. Miao Junjie and Jiang Yin'an (Changsha: Hunan renmin chubanshe, 1985), 65. Translation and italics mine.

33. For example, in their 1966 suicide note, renowned translator Fu Lei and his wife explained that they were debris from an old society, and should exit the historical stage. This statement may be read either as sarcasm or as an internalization of the accusations from the Red Guards; I would say it is both. The note is available online, "Fu Lei Yishu" [The Death Note of Fu Lei], September 2, 1966, accessed March 3, 2012, http://www.cclawnet.com/ fuleijiashu/fl0191.htm.

34. Naoki Sakai, "Subject and Substratum: On Japanese Imperial Nationalism," *Cultural Studies* 14, nos. 3/4 (July 2000), 462–530.

35. Sakai, "Subject and Substratum," 469.

36. In a neoliberalist late-capitalist society, there is almost nothing in the public domain; rights are products that stem from confrontations between individuals. In an ideal communist society, on the other hand, the private sphere disappears entirely, so there is no need for discussion of rights at all.

<p>
</p>

authorship versus ownership

Hannah Arendt's understanding of rights as results of individuals' negotiations within a public domain can be seen as occupying a middle ground between these two extremes. See Arendt, *The Origins of Totalitarianism* (London: André Deutsch, 1986), 301.

37. See the parallel discussion by Grgorinić and Raden, who regard the nation as the author, in "Authors' Rights as an Instrument of Control," 49–50.

authoring cloth

the copyright protection of fabric

designs in ghana and the united states

b o a t e m a b o a t e n g

"Laurel Burch's art continues to celebrate the happy, colorful blessings of nature with Flying Things. Gorgeous butterflies, dragonflies and hummingbirds flutter in a variety of settings." This reference to the work of the late artist, Laurel Burch, comes from the Hancock's of Paducah Winter 2012 catalog, and is interesting for its identification of a line of fabrics with the name of a specific artist.[1] This practice is not unique to quilting fabrics, and textiles are marketed to the fashion and furnishing industries based on the appeal of specific designers. It is, however, striking in the context of quilting and marks this realm as one more site where we can see Michel Foucault's "author function" at work.

In his discussion of the ways that the idea and name of an author serve to organize texts for a range of different purposes, Foucault argues that one way the author's name functions is to signal those texts' legitimacy as part of the body of work produced by the author. In other words, it serves to lend authority to those texts—to *authorize* them. This process of authorization has its legal equivalent in intellectual property law, which

links creative work with clearly specified authors in order to regulate the commodification and circulation of that work. The law protects the creations of those authors, and criminalizes the production of any copies made without their permission. In effect, the separation of the work from the author's name renders it illegitimate.

In this chapter, I use the medium of fabric to compare two different systems of authorization of creative work. While fabric bears little apparent relation to the literary and theoretical texts discussed by Foucault, it is an important medium of communication. Fabric bears meaning depending on a range of factors that include the fibers and dyes used in its manufacture, the degree of complexity of the manufacturing process, the identity of the manufacturer, and the uses to which the finished product is applied. For example, a piece of fabric may communicate utility or luxury depending on whether it is woven from wool or silk. In the hands of a celebrated artist who turns it into clothing or furnishing, the added element of the designer's identity may transform the meaning of a piece of wool from utility to luxury. This communicative quality is routinely assigned to the fabrics of indigenous peoples and local communities in Third World nations, which is also true of the fabrics of the global North.[2] Although this medium does not figure prominently in debates on intellectual property law either in the global North or South, calls by a range of actors including quilters, fashion designers, Third World nations, and indigenous peoples for the protection of their cultural production promise to make the medium of fabric increasingly important in debates on authorship and the law.

Fabric is, therefore, a cultural medium or text, and one of the systems of authorization that I examine through this medium works through a combination of factors including history and political authority, while the other works through the name of the author.[3] The first system diverges from the authorization norms of intellectual property law, while the second maps neatly onto those norms. I argue that both systems point in different ways to the contingency of the construction of authorship in intellectual property law. While one system is an example of the intensification of the author function in a sphere where it was historically absent, the other reveals some of the factors at work in any process of authorization. Both systems are important for the ways in which they illuminate and extend Foucault's author function. I also argue that these systems reflect different ways of conceptualizing time and space in relation to creative work.[4]

I situate this examination within the context of broader questions of gender and globalization, and argue that these help to explain the location of different kinds of cultural texts within and outside intellectual property law as well as their relation to the author function. Gender operates in both physical and symbolic ways to assign or withhold significance

to cultural production and does so in harmony with intellectual property law. As I apply it here, globalization operates in two main ways. Historically, one of its most pervasive effects has been to rank different peoples and their cultural production in relation to each other in ways similar to the operation of gender. In its current phase, globalization has also intensified the circulation of cultural goods due to advances in digital technology. Such flows are especially harmful for cultural forms that are located outside intellectual property law since they often occur with little benefit to their producers.

The fabrics that are my focus in this study are the adinkra and kente textiles made by the Asante ethnic group of Ghana in West Africa, on the one hand, and cotton prints produced for quilters in the United States on the other. Adinkra and kente fabrics are important elements of both (ethnic) Asante and (national) Ghanaian culture. Adinkra cloth is made by using a black vegetable dye to stencil designs onto cloth. Each design has a specific meaning, making adinkra not just a decorative art, but also a symbolic system. For this reason, some have argued that adinkra cloth is a form of writing that undermines claims of pre-colonial African illiteracy.[5] Adinkra cloth is most strongly associated with mourning and is worn at funerals. However, when the designs are stenciled onto white cloth, adinkra can also be used for celebration. Kente cloth is a form of strip weaving. While this kind of weaving is done in many parts of Africa and while there are two kente-producing ethnic groups in Ghana, Asante kente is distinctive for its use of vivid colors and relatively abstract designs. In contrast to adinkra, it is associated mainly with wealth and celebration. However, as with adinkra, the designs used in kente also have symbolic value.

The cotton prints discussed here are mass-produced for, and marketed to, quilters. Where they are sold in stores that also sell fashion and furnishing fabrics, there is a clear distinction made between them. While the norms of authorization that I explore in relation to quilting fabrics also apply to these other fabrics and to products such as books and music recordings, I focus on quilting fabrics because these seldom enter into discussions of intellectual property law. In addition, quilting is an activity that is often viewed as occurring outside the realm of formal property relations as enshrined in intellectual property law. Ann Bartow sums up this view very well when she states, "quilting ... is not a good fit with intellectual property law. Quilting isn't typically recognized as an art form because it is often the product of an indefinite group, such as a ... quilting club in which at each monthly meeting, the entire membership works on one member's quilting project."[6]

Despite this assertion, and as has happened with adinkra, kente, and other forms of so-called "folklore," there has been an increasing overlap in the worlds of quilting and intellectual property law over the past

few decades. This is evident in the publication of quilting books and patterns and quilters' active use of copyright law to protect these publications. Digital technology and the Internet have extended the spheres within which this overlap occurs, since they provide new arenas and capabilities for the circulation and appropriation of these publications. As the Internet has become important to the circulation of designs and products that quilters use, it has also become a potential site of increased appropriation. Therefore, for quilters concerned with the protection of their designs, the expansion of the quilting world into the Internet presents an additional challenge.

In the case of adinkra and kente, a number of factors combine to temper the threat posed to producers by the Internet and digital technology. These include the specialized skills needed for cloth production, and the importance of the medium of fabric to the significance of these textiles. While adinkra and kente designs may circulate widely on the Internet, that circulation poses the greatest threat to producers when designs are converted into textile form. Therefore, in the case of these fabrics, increased circulation of the designs does not necessarily mean increased appropriation in ways that have a direct impact on cloth producers. Nonetheless, digital technology and the Internet have the potential for facilitating appropriation by those who can convert adinkra designs into textiles that compete with the handmade versions. Ghanaian law seems to anticipate this in not distinguishing between textile and other forms of appropriation. Thus, the office responsible for overseeing copyright protection of folklore was very critical of a CD of adinkra designs produced in 2004 by the organization Aid to Artisans in Ghana, or ATAG.[7]

To return to quilting, one can locate the author function at different points—in the production of fabrics, patterns and equipment for use by quilters, and in the production of quilts. My focus here is on the copyright protection of fabrics produced for quilters because of my interest in comparing and interrogating authorship practices around the design of different kinds of fabric. In the discussion that follows, I first briefly outline Foucault's concept of the author function and its relation to intellectual property law. I then discuss the relation between cultural products such as adinkra, kente, and quilts to the law as that relation is commonly understood, and I argue that that relation is a function of structural inequalities in gender and globalization. Next, I discuss, in turn, the authorizing practices around adinkra, kente, and quilting fabrics. Finally, I discuss what those authorizing practices reveal about standard conceptualizations of these cultural products in relation to intellectual property law, and what insights they might offer for alternative ways of regulating the reproduction and circulation of these fabrics.

the author function, gender, and globalization

In his essay "What Is an Author?," Michel Foucault challenges the view in literary criticism that the author is "dead." He states:

> Criticism and philosophy took note of the disappearance—or death—of the author some time ago. But the consequences of their discovery of it have not been sufficiently examined, nor has its import been accurately measured. A certain number of notions that are intended to replace the privileged position of the author actually seem to preserve that privilege and suppress the real meaning of his disappearance.[8]

In this view, the importance of the author is diminished (not eliminated) because the meaning of a text is not solely a function of what its creator intended to say. Foucault argues that, far from being dead, the author is alive as ever and, as evidence for this, he points to the importance of the name of the author as a means of organizing texts. The author's name is not applied to everything he writes, but only to certain kinds of texts that he produces. Foucault highlights this in his discussion of what constitutes a "work" when he asks whether a laundry list found in one of Nietzsche's workbooks could be considered a work, and also when he refers to the author as "the principle of a certain unity in writing."[9] In addition, it is the fact of being written by that particular author that makes texts organized in this way worthy of attention. In this way, the author's name serves to mark off and authorize the boundaries of a particular set of discursive texts, and this is what Foucault terms "the author function."[10] This function legitimizes texts and makes the author's work amenable to a range of claims, including property claims.

An important point that Foucault makes in his analysis of the author function is that it does not affect all texts in the same way or at all times. Thus, texts that are organized by the author function at one point in time cease to be so organized in other periods. As an example of this, Foucault points to scientific principles, which went from being authorized by the names of individual authors to being authorized by their replicability. With the emergence of modern science, the most important basis for legitimizing a discovery was not only, in other words, the person who made the discovery, but also the ability of the discovery to stand up to testing by other scientists.

Foucault notes that literary texts, on the other hand, traveled in the opposite direction—especially with the invention of the printing press and the mass reproduction of texts. Prior to these developments, when the circulation of texts was relatively limited and the reproduction

of texts relied on hand copying, little emphasis was placed on the work of individual writers. With the invention of the printing press and the resulting emergence of a lucrative book trade, publishers sought exclusive rights over the texts they produced, resulting in the first copyright laws in Britain in the eighteenth century.[11]

With the codification of publishers' rights into law, the authorization of texts gained legal force. This authorization was initially on the basis of who published a work, but publishers were superseded when writers successfully argued, based on the idea of individual creative genius, that the right to make proprietary claims over creative work belonged not to those who published such works but to those who created them. Thus, while the name of the author diminished in importance in relation to scientific discoveries, its significance increased in relation to literary texts. These developments in the authorization of literary and scientific texts point to the contingency of both the author function and its legal backing in intellectual property law.

That contingency is not only evident in the origins of intellectual property law as a shifting response to the interests of publishers and authors. Over the last four decades, intellectual property protection has changed significantly as new interests and forms of creativity have emerged. For example, in the area of scientific inventions covered by patent law, biological material is now included in works that can be patented, leading to claims and debates over the patenting of life itself.[12] With the rise of digital technology, computer software is now protected under intellectual property law. Further, copyright law has expanded to include technological restraints on the unauthorized use of protected work.[13] These developments illustrate the point that shifts in intellectual property law occur with changes in technology, and in ideas about what can and cannot be protected.[14]

Responses to the increased appropriation made possible by digital technology and the Internet reflect a heightened tension between the right of creators to protect their work, and the right of the public to have access to that work for a range of purposes that include education, participation in democratic governance, and the creation of new works. This tension is rather different in a North–South context, where the people of the global South may claim the right to protected work for purposes that are often couched in terms of economic development and humanitarianism. For example, patent law includes provisions for the transfer of technology for development. Further, Third World nations have demanded the right to produce generic versions of patented drugs in order to treat HIV/AIDS.[15] Third World nations and indigenous peoples have also become increasingly vocal in demanding the right to protect their cultural production from appropriation by industrialized nations.

The challenge for the South, in making these demands, is that much of the knowledge and culture of the global South is relegated to the "public domain." This is the term in intellectual property law for works that do not meet the criteria for assigning ownership claims. Those criteria include originality and clearly defined individual or corporate creators. Cultural products that do not meet these criteria are viewed as part of the public domain and therefore as available for exploitation. Rights-claims over works that are considered to belong in this area are unrecognized in the dominant international regulatory framework of the 1994 Agreement on Trade-Related Aspects of Intellectual Property Rights (TRIPS). As a result, nations such as Ghana currently have little redress in challenging the expanded scope that digital technology provides for the unauthorized use of works such as adinkra and kente designs.

Foucault's analysis of the author function as both legitimizing and contingent can be extended to cultural products other than scientific theories and literary texts. For example, it can be applied to the cultural productions of women, indigenous peoples, and local communities in Third-World nations. Or, if we adopt the term "Fourth World," in reference to indigenous peoples, we may say that Foucault's analysis of the author function is applicable to the cultural production of women, and of Third- *and* Fourth-World people.[16] The key in extending the author function to these cultural forms is to separate the figure and name of the author from strategies of authorization. This separation permits a focus on the ways in which these groups authorize their cultural texts even where the literary and legal idea of an author may be absent. It also makes it possible to compare the creative practices around different kinds of production on the basis of a feature that they have in common in order to better understand the nature and extent of the differences between them. That common feature is authorization; whether collective or individual in their creation, different kinds of cultural production involve strategies of authorization analogous to the author function discussed by Foucault.

The cultural production of women, and of that within Third and Fourth Worlds, is often regarded as "folk art" or "folk knowledge" and is described using terms such as "traditional knowledge" or "traditional cultural expressions." These terms and changes in their use can be traced through the documents that have emerged from activism sponsored by United Nations organizations such as the United Nations Educational, Scientific and Cultural Organization (UNESCO) and the World Intellectual Property Organization (WIPO).[17] From the standpoint of intellectual property law, these kinds of cultural production, while varying widely, are produced under conditions that make it impossible to determine authorship. They are viewed as communal rather than individual, as adaptations of what already exists, and therefore as *unoriginal*. This is in contrast to the

association of individual authorship with creative work that is "original," setting it apart from mere adaptations of what already exists. Although several commentators have pointed to the adaptation inherent in *all* creative work, this view of originality persists and is institutionalized in intellectual property law.[18]

Unlike individualistic proprietary claims over cultural production in spheres such as literature, women's textiles arts in Europe and North America have historically been characterized by sharing of patterns and techniques. As reflected in the earlier quote from Ann Bartow, quilting, in particular, has the reputation of being a collective activity. In reality, quilting combines both individual and collective work. As Victoria Phillips notes in her discussion of the quilts of Gee's Bend, "in the Bend, *as in other quilting traditions*, the process of 'piecing' the quilt 'top', the side that faces up on the bed, was almost always done by a quilter working alone. *It reflected her individual artistic expression.*"[19]

Despite the individual creativity involved, the emphasis has been on the practices of sharing and communal production in activities such as quilting, and these are incompatible with authorship norms that empha-size the individual over the collective. Such sharing is more in keeping with a "commons" of cultural production with no clear owners—a com-mons that intellectual property law declares to be the public domain. In the second wave of European and North-American feminism during the 1960s and 1970s, radical feminists made a virtue of this sharing and claimed that while men's work was characterized by competition, wom-en's work was collaborative.[20] As this feminist response suggests, the use of the purportedly communal nature of women's textile arts to relegate activities such as quilting to the public domain should also be understood as a function of the structural devaluation of female labor.

In European and North American traditions of knowledge and cul-tural production, the creative work of women has long been held to occur outside those cultural activities legitimized by the author function in its original form. Along with being conceptualized as a sphere of individual creative genius, authorship was also conceptualized as a male activity. In collaborative work between women and men, women's contributions were often characterized as "help" and subsumed under men's work, which was viewed as authorship. As a result, the author who emerged in Europe, when individual authorship was legally recognized, was male.[21] Here, the author function operated to render women's work invisible in dominant forms of cultural production. Those forms of female cultural production that were recognized were also regarded as being outside the sphere of individual authorship and, as noted earlier, those forms included textile arts such as quilting.

When judged by the standard of individual authorship, the creative work of the people of the Third and Fourth Worlds, including adinkra and

kente, also appears to be communal in its production. Like women's work, this seems to place cultural products such as adinkra and kente beyond the norms of authorship within intellectual property law. Many of those works that are dismissed as communally produced adaptations are also artisanal because of the time-consuming and labor-intensive methods used. Yet, this labor is not accorded the same value as the labor of individual creators. These spheres of handmade textile production are also strongly gendered in being carried out either by women or men, although there are some instances where both sexes are involved. In the case of adinkra and kente where the main producers are male, women often play auxiliary roles. Similarly, although quilting in the United States is predominantly a female sphere, several quilters are male.[22]

Regardless of who produces them, it can be argued that forms of male-dominated cultural production such as adinkra stenciling and kente weaving are feminized in the encounter with norms of Western cultural production that define creativity as the result of individual and predominantly male genius and originality. Under conditions where it represents marginalization, such feminization devalues the cultural production of both women and men because of the location of their work outside the legitimizing definition of authorship as individual.[23] This devaluing also occurs discursively in the relegation of the cultural production of women and Third and Fourth World people to categories such as "folklore" and "traditional knowledge." These are the categories used and circulated by international organizations such as UNESCO and WIPO, and while there has been a shift in these organizations (and especially in WIPO) from the term "folklore" to "traditional knowledge" and, now, "traditional cultural expressions," they retain their discursive function as markers of marginalized knowledges.

As it operates in intellectual property law, the author function organizes cultural texts for the purpose of making certain kinds of claims—not only about legitimacy, but also about the rewards that accrue from cultural production. When the author function is based on the view that creativity is individual rather than collective, it diminishes the ability of women and Third and Fourth World peoples to make similar claims over their work. Furthermore, in relegating the work of such groups to the public domain, intellectual property law organizes the cultural production of women and of Third and Fourth World people for appropriation in the same way that other kinds of cultural products are organized for protection by the author function.

Since the work of these groups is held to reside in the public domain, anyone may use it in their own creations, and claim individual authorship over those creations. The work of women and other groups is thus reduced to raw material for "real" creative work—real because it conforms to legal norms of authorship. As suggested by critical and gender studies

of the law, the convergence between the cultural production of women and people of color, on the one hand, and the categories of folklore and traditional knowledge, on the other, is no coincidence but a function of the ways in which the conceptualization of authorship is bound up with the exercise of power.[24] The location of female and Third- and Fourth-World cultural production outside authorship is closely aligned, therefore, with the location of these groups outside dominant power structures.

If we separate the authorization affected by the author function from the figure of the individual author, it becomes possible to see how forms of cultural production that are viewed as occurring in the public domain are in fact governed by systems of authorization. Seen through the lens of authorization, it becomes clear that the real differences between forms of cultural production have to do with the strategies by which they are authorized. When the figure of the author is separated from the function of authorization, it becomes possible to compare different kinds of cultural production in ways that are closed off when they are compared on the basis of whether or not they have an author. It becomes possible, moreover, to identify different kinds of authorizing strategies beyond those that operate through appeals to the individual author's name. The case of adinkra and kente suggests that the simple fact that cultural products are not legitimized by an individual author's name does not mean that they are not legitimized at all, and therefore does not mean that they can be relegated to a sphere that marks them as available for appropriation.

authorizing adinkra and kente

Adinkra and kente production is concentrated in a few towns in the Asante (or Ashanti) region of Ghana. It is important to note, however, that these towns are not sites of exclusively communal cultural production. Rather, individual and communal productions interact with each other and contribute to an expanding pool of designs that includes the designs of deceased cloth producers. While cloth producers distinguish their work from each other and can identify the work of individual designers, they do not authorize their work by appeal to their individual creativity, but rather by emphasizing the connection between their individual creations and those of the community. Adinkra and kente producers also insist on linking their work with that of deceased cloth makers, making the communities in which they work not only spatial but also temporal.

In addition to these spatial and temporal communities, cloth producers signal the distinctiveness of their work by appeal to the Asante state, a former imperial power that continues to exercise considerable influence

within the modern nation-state of Ghana. As I have previously argued, these appeals constitute a form of authorization.[25] However, this authorization does not operate on the basis of individual cloth makers' names. Rather, adinkra and kente designs are authorized by the history and political systems in which they are embedded and, instead of being tied to one individual in one temporal and physical space, their authorization spans time, since it operates partly by appeal to deceased cloth makers and not only living ones. In the same way that authorization through the name of an individual author translates into claims over cultural production, these strategies of authorization also enable adinkra and kente producers to make certain claims over their work. For example, they can claim that their work is more prestigious, has more historical significance, and is more authentic than mass-produced textiles. Clients confirm these claims when they demonstrate a willingness to pay more for adinkra and kente than for other fabrics.

In Ghana, textile designs intended for mass-production were protected from 1973 to 2003 under a *sui generis* industrial property law rather than copyright law. This law excluded indigenous fabric designs (including adinkra and kente designs) from ownership claims by those using the law to protect their textile designs. This exclusion from ownership claims was reinforced by active protection in 1985, when Ghana revised its copyright laws and, for the first time in the nation's history, included "folklore" in the works protected under the law. The law defined folklore broadly to include elements of both material and oral culture, from kente and adinkra designs to proverbs and songs.

Since folklore is viewed through the authorship norms of intellectual property law as communal rather than individual in its production, and therefore as having no clear authors and residing in commons, this copyright protection of adinkra and kente designs raised challenges for their protection under copyright law. The government of Ghana resolved this by reposing the rights to folklore in the state on behalf of its "unknown" creators. This was contested by cultural experts and by musicians, and when the law was revised in 2005, state custodianship was limited to designs whose authors were unknown. The definition of folklore to include adinkra and kente designs brought this area of textile production into copyright law in contrast with the protection of mass-produced textiles under industrial property law. In the United States, such copyright protection of textile designs is the norm, not the exception, and includes the designs of cotton prints targeted at the quilting market.

quilting and copyright

The second wave of feminism in the United States and the country's 1976 bicentennial are reported to have created a resurgence of interest in

traditional quilting.[26] This, in turn, created an important market for textile companies, and the fortunes of at least one company, Robert Kaufman, were revived in the 1980s with the renewed popularity of quilting. An examination of the fabrics in quilt stores shows that the designers of these fabrics are often identified by name. Some designers are so popular that their designs are sold under their names. For example, in the store, Rosie's Calico Cupboard, in San Diego, fabrics are organized according to a range of schemes that include color, pattern, and theme. In a few instances, fabrics are also organized by designer, and at Rosie's there is a section devoted to the fabrics of Kaffe Fassett, a prominent fiber artist who is noted for his use of color.[27] The Fall 2011 catalog of Hancock's of Paducah notes, "Kaffe Fassett has long been a favorite designer. Kaffe boldly designs in color and pattern. Those who make the leap of faith are always eager to try the next generation of prints."[28] In another example, the Jo-Ann chain of stores showcases the designs of Debbie Mumm.

In addition to individual designers, certain textile companies are prominent in the quilting world and the popularity of their products among quilters is an indication of successful branding that also animates the concept of a legal person—a concept that grants corporate entities the legal status of individual persons and the ability to assert the same rights. Examples of such high-profile brands are Hoffman, Robert Kaufman, Michael Miller, and Moda. In addition to their corporate identities, these companies rely on, and serve as conduits for, the work of individual designers. This interaction between companies and individual designers can be observed in the marketing of quilt fabrics, as illustrated in the following examples from Hancock's of Paducah's Fall 2011 catalog: "Sarah Jane creates simple and sophisticated fabrics in her debut collection for Michael Miller"; "Joanna Figueroa captures the essence of fall in California in Butterscotch and Roses for Moda"; "Peggy Toole revisits the grandeur of Florence with her luxurious Florentine collection by Robert Kaufman"; "Kashmir by Jinny Beyer for RJR Fabrics. Jinny Beyer captures the exotic beauty of paisley shawls from Kashmir."[29]

A designer who is associated with a particular textile company may also enjoy a high profile in her or his own right. The reference to Kaffe Fassett, in the preceding text, indicates his prominence and popularity as an individual fabric designer. In addition to this, Fassett is one of the designers of the Westminster Fibers fabric company. Another is Caryl Bryer Fallert, a prominent art quilter who is famous for her use of hand-dyed fabrics in vibrant colors.[30] Bryer Fallert has cut back on her own production of her popular hand-dyed fabrics. While continuing to produce some fabric for her own use, she also designs them for mass production by the Benartex company in order to keep up with demand.[31] The designs of these companies and individuals are protected by copyright law.

The late Laurel Burch is yet another artist whose designs attract a strong following in a number of areas including quilting fabrics. At the website for Laurel Burch Artworks (the company dedicated to the artist's life and work), one can find products for sale that range from clothing to accessories and gifts. These are produced in collaboration with licensing partners that include a textile company. The continued popularity of Burch's designs after her death is a striking example of the power of the author's name in the terms described by Foucault. That is to say, power is reinforced by current intellectual property law that extends the rights of authorship for 70 years beyond the author's physical death. Unlike the arrangements in adinkra and kente where deceased cloth makers collectively authorize the work of living ones, the temporal extension of authorization under intellectual property law is specific to individual authors for a finite period and not indicative of a temporally indefinite authorizing community.

The renewed interest in quilting since the 1970s has been accompanied by popular demand for the designs of specific individual and corporate designers such as those described in the preceding text. This demand for fabric seems strange, given the popular view of quilting as a practice that relies on scraps left over from other uses. However, the use of scraps occurs alongside the purchase of new fabric. Furthermore, while scrap use is certainly a longstanding part of the practice of quilting, it can also be linked to class and racial differences among quilters. The use of scraps occurs alongside the purchase of new fabric. Within the consumer culture of the late twentieth and early twenty-first centuries, the use of new fabric is even more prevalent among quilters, and the appeal of designers such as those mentioned earlier gives their work distinction in relation to the wide range of cotton fabrics available to quilters. These designers' names, therefore, reinforce Foucault's concept of the author function, which is to say, most significantly for this chapter, that they are structurally reinforced by copyright law. While this is also true for fabrics produced for other purposes such as furnishing and fashion, the relatively recent development of this trend (of high-profile fabric designers) in quilting fabrics, and the general perception of quilting as a sphere outside authorship combine to make it particularly striking.

The trend is evidence of the commodification that has accompanied the resurgence of quilting, and the rise of a celebrity culture that intensifies both commodification and the importance of individual and corporate brands. These have transformed this sphere into a significant industry that includes an explosion of published work, from books to quilting designs, as well as the invention of an abundance of tools for quilters—most of which are protected by copyright and patent laws. Not surprisingly, therefore, the prominence of individual fabric designers is supported by quilters who increasingly base their fabric choices on the designer and not

only on elements such as color and pattern.[32] In this way, quilters underscore the importance of the author's name in setting some fabrics apart from others. With the rise of a highly commodified celebrity quilting culture, then, fabrics designed by key figures such as Mumm and Fassett are authorized by their designers' names.

conclusion

The last few decades have witnessed increased commodification in several areas of cultural production, including female and Third World spheres such as quilting and adinkra and kente production. In the case of quilting, this commodification has combined with consumer and celebrity cultures, along with a resurgence of interest in the practice, to create an expanded market for quilt fabrics. In the case of adinkra and kente, the result of accelerated commodification and consumer demand has been the appropriation of fabric designs in mass-produced forms—including some targeted at quilters in the United States! The copyright protection of fabric designs in the United States has created an opportunity for individual and corporate designers to benefit from the increased demand for quilt fabric. In Ghana, however, producers of hand-made adinkra and kente cloth have seen relatively little benefit from the mass local and global demand for their fabrics, and from the copyright protection of their designs under national copyright law.

As the preceding discussion has shown, adinkra and kente fabrics are made under authorship norms that are markedly different from the celebrity culture of quilt fabrics designed by figures such as Laurel Burch and Jinny Beyer. On the one hand, the rise in celebrity quilt fabrics has simply intensified the author function in the copyright protection that is routine in fabric production in the United States. On the other hand, the government of Ghana's use of copyright law as a means of regulating the appropriation of adinkra and kente fabrics does not fully resolve the problems this causes for protecting adinkra and kente designs under authorship norms that are at variance with the authorizing practices in the production of these fabrics. In effect, the Ghanaian legislation emphasizes the dominant form of authorization in order to protect adinkra and kente while obscuring those forms of authorization inherent in cloth producers' practices. The approach taken so far makes these fabrics into a problem for Ghanaian copyright law specifically, and intellectual property law in general, and it leaves the authorship norms of intellectual property law unchallenged.

When one compares adinkra and kente with the fabrics of Kaffe Fassett and Debbie Mumm, it is evident that their differing modes of authoriza-tion do not only locate these fabrics in intellectual property law or the public domain, but also in different ways of conceptualizing space and

time in relation to intellectual property law. Rather than posing the question of their suitability for protection from the standpoint of intellectual property law and its relegation of certain kinds of cultural production to the public domain, a more fruitful starting point would be to pose the question on the basis of the strategies of authorization attendant on different kinds of cultural production. Since, as noted earlier, all created work borrows from previous creations, the line between the public domain and protected works is an artificial and somewhat arbitrary one. Instead, starting from authorizing practices would highlight the differing temporal and spatial points that cultural producers emphasize in authorizing their work. This could provide a basis for a pluralistic system for regulating cultural commodification and circulation that does not privilege one contingent and culturally specific concept of authorship, as is currently the case in intellectual property law.

An alternative approach that focused on systems of authorization could help in moving away from the marginal status of cultural products such as adinkra and kente in the space of intellectual property law. Such a focus could provide a basis for expanding standard norms of authorship to include legitimation of the authorizing practices of adinkra and kente producers. The contingent nature of intellectual property law, the ways it has changed over time to accommodate new ideas about what can be protected and the principles that should guide such protection, these all suggest that there is scope for also changing conceptions of what constitutes authorship and expanding those conceptions to include systems of authorization that are not based solely on the name of the author. In such a scheme, it would not matter that quilting fabrics are authorized by appeal to the names of individual designers while adinkra and kente fabrics are authorized by appeal to temporal and spatial communities. What would matter most would be the extent to which intellectual property laws respect the plurality of authorizing practices and undermine the hegemony of a system that insists on ranking those practices in line with historical patterns of dominance.

notes

1. Hancock's of Paducah is a leading supplier of quilting fabrics and accessories.
2. For discussions of fabric as communication media see, for example, Fiona Kerlogue, "Interpreting Textiles as a Medium of Communication: Cloth and Community in Malay Sumatra," *Asian Studies Review* 24, no. 3 (2000), 335–347; Ruth Barnes and Joanne B. Eicher, eds., *Dress and Gender: Making and Meaning in Cultural Contexts* (New York: Berg, 1992); and Susan Prendergast Schoelwer, "Form, Function, and Meaning in the Use of Fabric Furnishings: A Philadelphia Case Study, 1700–1775," *Winterthur Portfolio* 14, no. 1 (Spring 1979), 25–40.

3. In undertaking this comparison, I build on an earlier discussion of authorization in my book, *The Copyright Thing Doesn't Work Here: Adinkra and Kente and Intellectual Property in Ghana* (Minneapolis: University of Minnesota Press, 2011).

4. I provide an extensive discussion of time, space, and cultural production in *The Copyright Thing Doesn't Work Here.*

5. G. F. Kojo Arthur, *Cloth as Metaphor: (Re)-reading the Adinkra Cloth Symbols of the Akan of Ghana* (Legon, Ghana: Centre For Indigenous Knowledge Systems, 1999–2001).

6. Ann Bartow, "Women in the Web of Secondary Copyright Liability and Internet Filtering," *Northern Kentucky Law Review* 32 (2005), 492.

7. Interview in 2004 with the Executive Secretary of the National Folklore Board responsible for overseeing the copyright protection of folklore in Ghana.

8. Michel Foucault, "What Is an Author?" In *The Foucault Reader*, ed, Paul Rabinow (New York: Pantheon Books, 1984), 103.

9. Foucault, "What Is an Author?," 103, 111.

10. As used here, "discourse" refers to a set of texts. However, it is important to also keep in mind discourse in the second sense that has become one of Foucault's most important concepts. In that second sense, discourse operates in the mode of theoretical frameworks such as those developed by Freud and Marx; they set the conditions for understanding the world. This second kind of discourse applies to intellectual property law as discussed in this essay, since it sets the conditions of being for different forms of culture.

11. Mark Rose, *Authors and Owners: The Invention of Copyright* (Cambridge, MA: Harvard University Press, 1993).

12. See for example, Martin Teitel and Hope Shand's *The Ownership of Life: When Patents and Values Clash* (Freeston, CA: The CS Fund/New York: The HKH Foundation, 1997, and Kenbrew McLeod's provocatively titled chapter, "The Private Ownership of People: Genetics, Consumer Databases and Celebrities" in his book *Owning Culture: Authorship, Ownership, and Intellectual Property Law* (New York: Peter Lang, 2001).

13. See James Boyle's discussion of this protection, known as Digital Rights Management (or DRM), under the Digital Millennium Copyright Act of 1998, in his *The Public Domain: Enclosing the Commons of the Mind* (New Haven, CT: Yale University Press, 2008).

14. A point made, for example, by Susan Sell and Christopher May, "Moments in Law: Contestation and Settlement in the History of Intellectual Property Law," *Review of International Political Economy* 8, no. 3 (2001), 467–500.

15. Peter Drahos and John Braithwaite, *Information Feudalism: Who Owns the Knowledge Economy?* (New York: The New Press, 2002).

16. In using the terms Third World and Fourth World, I seek to signal these parts of the world's location in global structures of power rather than endorsing the hierarchical ranking implied by the terms. See Ella Shohat and Robert Stam, *Unthinking Eurocentrism: Multiculturalism and the Media* (New York: Routledge, 1994).

17. See, for example, the shift in terminology from the 1982 "UNESCO/WIPO Model Provisions for National Laws on Protection of Expressions of

Folklore Against Illicit Exploitation and Other Prejudicial Actions" to the draft provisions currently under review at WIPO for "the Protection of Traditional Knowledge and Traditional Cultural Expressions (Expressions of Folklore)" and "Genetic Resources." WIPO defines these terms as follows: "Traditional Cultural Expressions (also referred to as expressions of folklore), refer to tangible and intangible forms in which traditional knowledge and cultures are expressed, appear, or are communicated. Traditional Knowledge refers to the content or substance of knowledge resulting from intellectual activity in a traditional context. Genetic resources refers to genetic material of actual or potential value." (http://wipo.int/tk/en/laws/index.html, accessed, April 22, 2012). The reference to "a traditional context" makes the point that these are forms of culture and knowledge associated with groups and societies that are viewed as not only non-modern, but also non-Western.

18. Such commentators include James Boyle, *The Public Domain*; Peter Jaszi and Martha Woodmansee, "Beyond Authorship: Refiguring Rights in Traditional Culture and Bioknowledge," in *Scientific Authorship: Credit and Intellectual Property in Science,* ed. Mario Biagioli and Peter Galison (New York: Routledge, 2003), 195–223; and McLeod, *Owning Culture.*

19. Victoria F. Phillips, "Commodification, Intellectual Property and the Quilters of Gee's Bend," *American University Journal of Gender, Social Policy and the Law* 15, no. 2 (2007), 362 (emphases added).

20. Alison M. Jaggar, *Feminist Politics and Human Nature* (Lanham, MD: Rowman & Littlefield, 1983). Debra J. Halbert, "Feminist Interpretations of Intellectual Property Law," *American University Journal of Gender, Social Policy and the Law* 14, no. 3 (2006), 431–60.

21. Halbert, "Feminist Interpretations of Intellectual Property Law."

22. Prominent male contemporary quilters include Tim Harding and Jim Smoote.

23. I discuss this feminization at length in *The Copyright Thing Doesn't Work Here.*

24. Halbert, "Feminist Interpretations of Intellectual Property Law"; Rosemary Coombe, *The Cultural Life of Properties: Authorship, Appropriation and the Law* (Durham, NC: Duke University Press, 1998); McLeod, *Owning Culture*; Jaszi and Woodmansee, "Beyond Authorship"; Anthony Seeger, "Who Got Left Out of The Property Grab Again: Oral Traditions, Indigenous Rights, and Valuable Old Knowledge," in *CODE: Collaborative Ownership and the Digital Economy,* ed. Rishab Ayer Ghosh (Cambridge, MA: The MIT Press, 2005), 75–84; and Boateng, *The Copyright Thing Doesn't Work Here.*

25. Boateng, *The Copyright Thing Doesn't Work Here.*

26. Robert Shaw, *Quilts: A Living Tradition* (New York: Beaux Arts Editions/ Southport, CT: Hugh Lauter Levin Associates, 1995; Martha Sielman, *Masters: Art Quilts* (New York/London: Lark Books/Sterling, 2008); and Carolyn Mazloomi, *Spirits of the Cloth: Contemporary African American Quilts* (New York: Clarkson Potter, 1998).

27. Personal observation on several occasions in 2010 and 2011.

28. Hancock's of Paducah Catalog (Fall 2011), 37.

29. Hancock's of Paducah Catalog (Fall 2011), 62, 92, 108, 112.

30. Art quilts constitute an important strand in the revival of interest in quilting and are produced primarily as a form of artistic expression.

After some initial resistance, they have gained legitimacy in the art world.

31. Personal communication, September 9, 2011. I am grateful to Caryl Bryer Fallert for granting me permission to cite this communication.
32. Personal observation, confirmed by Janice Smith, owner of *Inspirations Quilt Shop*, Valley Center, California.

sufi homoerotic

authorship and its

heterosexualization

in pakistan

u s m a n s h a u k a t

This essay revisits the "desi-queer" who has been disguised, erased, and heterosexualized for decades, most recently through new-media platforms. I use the term "desi-queer" to denote a gay South Asian understanding of homosexuality. Desi-queers have their own variations and differences, but, in general, I define them as individuals who experience same-sex love and desire in ways that are culturally specific to South Asian history and culture.[1] A desi-queer can trace back the genesis of her heritage to the love story of the emperor Mahmoud and his slave Ayaz, and to the thousands of homoerotic love poems written in Persian, Punjabi, and Urdu.[2]

Here, however, I use a more blasphemous turn on the desi-queer, "queer Sufis (saints)." By doing so, I refer to the two major Sufi saints, Bulleh Shah and Madhu Lal Hussein, who wrote poems about love between men. These poems are the intellectual heritage of hundreds of thousands of queer desis, especially Pakistanis. Sufi poets wrote extensively about the beauty and divine love of the male figure. This queer writing

was once largely a well-accepted tradition in the Muslim–Indian sub-continent. And yet, while the present-day so-called liberal Pakistani media uses the same Sufi poetry as a counterbalance against orthodox Islam, it completely ignores, reinscribes, reinterprets, and silences traditional Sufi homoerotic authorship. The Sufi narratives are thus sanitized and thus heterosexualized by participants in new Pakistani media.

This essay is divided into three parts. First, I trace the Muslim homoerotic to the genesis of Islam itself, since Quranic authorship is tied with sensual sacredness in its first moments of inspiration and revelation. Sexual/sensual affinity between men continues to be part of the Islamic sensibility through the mystic practices of Sufism. Therefore, I address the history of homoerotic authorship in medieval India by shedding light on Punjabi homoerotic Sufi poetry. Second, I argue that these sensual, mystic poems—now an integral part of the popular culture of Pakistan— have been heterosexualized in Pakistani mass media (e.g., television and YouTube videos).

Third, in order to resituate these poems within a queer aesthetic and resist the heterocentric impulse behind Sufi digitization, I turn to calligraphy as a means to induce a Sufi-like experience by engaging with portions of the original Punjabi poems and translating them into English. I seek a return to a traditional form of mediated writing— authorship—*as queer* in which the tactility between hand and paper conjures Sufi-queer erotics. Although one might argue that the digital experience—an engagement by hand with contemporary technology— may similarly allow for a queer Sufi writing as well, my calligraphic handiwork challenges the homophobia this very media currently facili-tates. Knowing that this essay, once published, will disseminate digitally, I reclaim centuries-old love-offerings through a traditional mode of writing for myself and for my community. As my traditional form of writing intermingles with newer forms of media, my calligraphic gesture—*if only for a moment*—rewrites queer Sufi authorship as part of my, and many other queer Pakistanis', Islamic desiness.

quran and its authorship

First, let us examine the story in Islamic tradition of the moment of Quranic revelation. The author of the most sacred book for Muslims is said to be Allah himself, and he conveyed his message to the believers through two intermediaries, an angel and Muhammad, the man of Arabia, the "last prophet" of the Abrahamic faiths. The tradition narrates that when Muhammad was 40 years of age, he was visited by Jabra'il, the most divine angel of Allah. Jabra'il was a fiery soul of awe-inducing beauty. The sight of Jabra'il made Muhammad shudder in a mix of euphoria, joy, fear, and paranoia. Jabra'il approached Muhammad and told him

that he had been chosen by Allah to be the messenger. Muhammad could not stop his trembling in his ecstasy. Jabra'il said to Muhammad, "Iqra! Read! Recite!" Muhammad told the angel that he could not read. Jabra'il repeated twice the question for which Muhammad's answer was the same, "I cannot read, for I am illiterate." Jabra'il embraced Muhammad with fervor and Muhammad was engulfed in Jabra'il's body. Allah, as he had done before for the Virgin Mary, transferred his seed of knowledge through Jabra'il's body into Muhammad's soul.[3]

The man of Arabia thus became the prophet of Islam. Jabra'il recited the first verses of the Quran (Koran) and Muhammad repeated and memorized them:

> In the name of Allah, the Merciful, the Compassionate
> Recite: In the name of thy Lord who Created,
> Created Man of a blood-clot.
> Recite: And thy Lord is the Most Generous
> Who taught by the Pen,
> Taught Man that he know not.[4]

Thus, Islam was established as a religion in the instant that knowledge was transferred through touch. In the first verses of the Islamic holy book, Allah teaches man through the act of sensual recitation and writing; it is clear that knowledge is revealed "by the pen." The coordinator of that knowledge, the harbinger of sacred Islamic wisdom, is the angel Jabra'il, who clasped God's prophet in loving embrace in order to convey the divine message. Thus, this first transference of divine knowledge—the first revelation of Islam—was achieved through a sensual embrace that transmitted knowledge from one body to another.

sufi authorship

One defies *Tasawuff* (Sufism) if one describes *Tasawuff*. For the purposes of this essay, I describe Sufism in a particular way, but the word "Sufism" is applicable both to a philosophical scholar such as Ibn-e-Arabi or to the naked lover of boys, Sarmad.[5] Following the first revelation noted in the preceding text, the Sufis base their mysticism on the logic of a blessed touch. If Allah touched Muhammad in love, if Muhammad was embraced by Jabra'il in holy passion, then, Sufis ask, why shouldn't their love of the divine be expressed through bodily love? If God is the beloved and identified as male, why shouldn't their beloveds, creatures of God, be male? "Since all beauty is derived from God, it could not be a sin to admire it."[6]

Sufis re-invoke the divine touch in the form of sensuous poems. To understand how this divine tactility is rendered, it is important to consider the common traits that link Sufis. A Sufi is an Islamic mystic,

a seeker of the inner knowledge, the hidden wisdom that informs Islam. He is also immersed in God's Divine love, *Ishq*. He can be a follower of *Sharia* (Islamic law and edicts) or he may choose to resist it. However, seeking holy love is *sine qua non* for his religion. He focuses on Allah's *Jamal* (his beauty) rather than his *Jalal* (wrathfulness).

The Sufi tradition of Punjab (land of five rivers, a historic region now divided between India and Pakistan) derives from Turkic–Persian influences and is touched by the Krishna mysticism associated with Hinduism. Two of the most prominent poets of Punjab are "Madhu Lal" Hussein (*nom de plume* of Shah Hussein, 1538–1599) and Bulleh Shah (*nom de plume* of Abdullah Shah, 1680–1757), the queer Sufi saints of this essay. Their writings are key to the way the sensual divine experience is rehearsed, preserved, and transmitted through music, dance, and poetry.[7] The most important aspect of this poetry, utilized by the Punjabi Sufis, is the image of the beloved *as* male. According to Kidwai, the Sufi poetry of the Turks and the Persians is poetry of homoerotic touch.[8] As Kidwai tells us, "In Sufi literature the relationship between divine and human was often expressed in homoerotic metaphors. Many Sufis insisted that only same-gender love could transcend sex and therefore not distract the seeker from his ultimate aim of gnosis—nevertheless, the recognition of the beloved as a male in mystic poetry was established and was to have a profound impact on later Urdu and Punjabi poetry. Mystical poetry acquired the status of sacred literature for Indian Muslims."[9] The Punjabi poets of Sufi tradition, however, went further with the concept of the divine as a beloved male youth, who they praised in both masculine and feminine voices.

The malleability of gender in Punjabi Sufi poetry can be grasped through the relationship of the literary figures Ranjha and Heer. Ranjha is a male folk hero who serves metaphorically for a perfect beloved— and also for God. Heer, a woman who is the symbol of the ideal lover and seeks the divine, loved Ranjha. The Sufis adopted Heer as a symbolic figure for themselves; they often narrated their longing and desire *through* Heer's voice. Both Hussein and Bulleh Shah turn to Ranjha as their ideal beloved and Heer as their ideal lover, allowing themselves to embody either gender, calling themselves at times the "wife" or "mistress" of Ranjha. The gender play at work here is made even more complex and blasphemous because Ranjha, a Muslim folk hero, is in fact a veiled representation of a Hindu god.[10]

According to Islam, however, the ideal beloved is recognized as one Islamic God, Allah. Ranjha, according to the Sufi poets, also stands for Allah. So accepted and naturalized into Sufi couplets and poems is this erotic dynamic that sometimes these poets do not even refer to the legend of Heer and Ranjha when expressing homoeroticism as divine love. Hence, while many poems do not mention Heer, the

poets describe their beloveds as male, while they refer to themselves as female.

Another reason exists for Bulleh Shah and Lal Hussein to address their beloveds as male: their beloveds *were* male. Bulleh Shah was eternally devoted to his *Pir*, his master Shah Inayat. Lal Hussein was enamored by a Hindu youth, Madhu. Shah Hussein (1538–1599) was born in Lahore during the period of the Mogul dynasty. At the age of 36, Shah Hussein, a Muslim devoted to Sharia, had a transformative experience. He came upon a verse in the Quran (6:32), in which he discovered the following: "The life of the world is nothing but play and pleasurable distraction." He said to himself, "No Quranic verse can contradict itself, every Quranic verse is true, if the world is a playground full of pleasures, then Allah gives me the permission to be like a mischievous child." Hussein then left his studies of Islamic jurisprudence and became a Sufi. He drank wine (forbidden in Islam), danced in womanly red garb, and criticized the Imams and Mullahs, and even the emperor.[11]

When Hussein was 40 years of age, he fell in love with an 18-year-old Hindu, named Madhu Lal. Hussein, and, in order to initiate Madhu into the tradition of Sufism, made love to him. Hussein gave Madhu wine through his lips. Madhu reciprocated by sipping wine from the goblet and transferring it to Hussein's mouth. Hussein kissed and touched Madhu's body while Madhu replied through his embraces and kisses.[12] The hidden knowledge of divine love, in which Allah is witnessed as a beautiful youth, was made visible through a demonstration of male-to-male love-making. Transference of knowledge henceforward became erotic. Hussein's critics chastised him for being corrupt with his disciple. Hussein replied that the burden of divine knowledge cannot and must not only be shared through pedagogical tradition. According to Hussein, touch is the surest means through which mystic wisdom is transferred; divine knowledge is incommunicable by language alone.

Bulleh Shah (1680–1757), like Hussein, was a Sufi of the highest order who devoted his life to loving his master, Shah Inayat. And, like Hussein, Shah wrote sensuous Punjabi poetry, using female pronouns to show devotion to and extol his beloved master. Bulleh Shah was a high-caste Muslim, whereas Inayat belonged to the caste of gardeners; Bulleh Shah, because of this relationship, was an early opponent of the oppressive caste system in subcontinental India.[13] Indeed, Muslims were more scandalized by Bulleh's lower-caste spiritual master than the gender he and his lover shared.[14] Because of this, Bulleh rejected his family, friends, and the society from which he was born but discriminated against various castes and creeds in which he was intimately engaged. Nevertheless, and with the blessings of Shah Inayat, Bulleh wrote poems that proclaimed he was affiliated with no religion and no caste. Instead, he perceived himself an agnostic humanist. It should be clear by now that

the Pakistani queer community can claim with confidence that there are antecedents for same-sex love and desire that are incontrovertibly located within their indigenous culture.

re-appropriating sufi authorship in new media

Until recently, Sufi Islam and the poetry related to it were not fashionable for the Pakistani elite (i.e., the educated upper class and governmental, military, and bureaucratic officials). Since Sufi poetry is primarily written in Punjabi and Sindhi, it is largely shunned in educational institutions and intellectual circles because the language is viewed as lower class.[15] Middle-class Pakistanis prefer, instead, to educate their children in Urdu and English. To counter the rise of Islamic extremism in Pakistan, however, the intelligentsia and politicians find themselves reversing this point of view and actively supporting Sufism because it is seen as homegrown and as a much more tolerant version of Islam. In fact, Sufism in Pakistan has been under constant attack by Islamic fundamentalist forces. Different factions of upper- and upper-middle-class Pakistani society—including politicians, intellectuals, filmmakers, and celebrities— have joined together to raise their voices in opposition to the extremist threat by reaffirming Sufism.[16]

The following example illustrates the embrace of Sufi by Pakistani intellectuals.[17] On July 20, 2010, the first Sufi music festival was held in New York's Union Square. In light of recent attacks on Sufi shrines in Pakistan, the concert, which was organized by the Embassy of Pakistan to the United States and Pakistan International Airlines (PIA), was viewed as a response to Islamic fundamentalism.[18] In his introduction to the event, the Pakistani ambassador to the United Nations, Syed Abdullah Hussein Haroon, said, "Individual acts of violence espoused by any minority cannot be allowed to define us all. There was the great need to give voice to the true Pakistan by showing our peaceful human face and culture to demonstrate the tolerant moderate Islam practiced by the overwhelming majority."[19] Many Pakistani folk stars, including the legendary Sufi singer Abida Parveen, performed in the festival. As expected, the centerpiece of the event was the poetry of queer Sufi saints such as Lal Hussein and Bulleh Shah.[20] However, any homoerotic interpretation of the poems by these revered queer Sufis would be considered blasphemous.

Though the new media made enormous economic and industrial strides under the relatively liberal dictator Pervez Musharraf, and development in these areas continued after his departure, the expression of sexual and religious freedoms online was, and remains, taboo.[21] Numerous times, the Pakistani establishment, assisted by various conservative pressure groups, has severely curtailed access to websites such as Facebook,

Twitter, YouTube, Wikipedia, and Flickr, among others.[22] The Pakistani government's response was in reaction to the Jyllands-Posten newspaper cartoon controversy and the subsequent "Draw Muhammad Day" movement that had so incensed devout Muslims, including many extremist elements.[23] Similarly, the government's response to sexual content on the Internet and other media was to ban it or censor it. In 2011, the Pakistan Telecommunication Authority, PTA, unsuccessfully tried to ban the use of some 1,600 words considered either pornographic or blasphemous to Islam in text messages ("gay pride" was number 459 on that list).[24]

To be sure, "gay" is a highly charged and problematic term in Pakistan. The main argument made by the national media against homosexuality is that it threatens the founding principles that secure Pakistani culture and civilization—this is to say that homosexuality dangerously conflicts with Islamic tenets. Consider, for example, rhetoric used against an unusual gay-pride event in Islamabad, the capital of Pakistan. On July 26, 2011, the US embassy in Pakistan hosted the first-ever Pakistani gay, lesbian, bisexual, and transgender pride celebration. The public and media reaction against the celebration was vocal and vitriolic. The event was declared "the worst social and cultural terrorism against Pakistan."[25] The protestors claimed that the pride celebration was as severe an outrage as US drone strikes ("A conspiracy to promote homosexuality in Pakistan," proclaimed a protest banner). Various protestors and media pundits claimed that, under the pretext of human rights, America was promoting vulgarity and, as one speaker from Islami Jamiat Taliba, a fundamentalist political party, said, "Under the guise of human rights, the [United States] wants to promote unnatural, and abnormal behavior … it's like stabbing the Muslim civilization in the chest."[26]

A television talk show host, Absar Alam from Aaj Ki Khabar at Aaj TV, invited Marvi Sirmed (human rights activist), Mohsin Syed (journalist), and Ibtisam Elahi Zaheer (religious scholar) to comment on the event at the embassy. This show, as well, was posted on YouTube.[27] Sirmed and Syed tried to defend the United States Embassy's decision to invite members of the LGBT community to the event. It was the first instance in my research where I came across a Pakistani—Syed—who pointed out that Sufi and folk poetry is rich with homoeroticism and thus contrary to the view that homosexuality is against Pakistani culture. The comment section for this YouTube video was brief but filled with hatred against Sirmed and Syed. Syed was called a "gandu" (a derogatory term used for a gay man), and Sirmed was called a "randi" (a prostitute) for defending gays and distorting the image of Islam.

Later, yet another television show was posted on YouTube whose topic was about the pride event. *Frontline* on Pakistan's television channel, Express News, invited religious scholars and journalists to

converse about the issue. In the program, Mufti Abdul-Qawi, a religious scholar, said that the event was dangerous for Pakistan because "the American homosexuals destroyed the American family system" and "homosexuality is considered deviation from normal life in every religion." The show's climax, however, was when Abdul-Qawi stated, "These gays are worse than animals."[28] Another participant on the same show, Dr. Momina Malik, was of the opinion that she did not understand the logic of coming out and being proud of a sin: "One doesn't revel in announcement and proclamation when one commits murder." Again, Sirmed, participating in the debate on this show, bravely defended LGBT rights. The online comment section clearly showed how unpopular Sirmed's opinions were. Anonymous comments threatened her with death and rape, marking her as an infidel and conspirator who worked for India and the United States.

In the Pakistani political and cultural milieu in which these discussions occur, it would be surprising, to say the least, if anything remotely positive about homosexuality was presented in a positive or celebratory way. Even poetry is severely condemned. The closet door on queer Sufi poetry, in other words, remains firmly shut. Pakistani public sensibilities cannot deal with the inherent deviance and homoerotic experiences that make up medieval Sufi poetry; instead, they have devised three approaches to re-authoring and silencing the homoeroticism of these poems.

Scott Kugle succinctly explains the first approach. In his discussion about another famous trope in Muslim poetry—the same-sex couple (the emperor Mahmud and his beloved slave Ayaz)—Kugle references Moulana Altaf Hussein Hali, a nineteenth-century literary critic. Hali recommended, "a radical ethical cleansing" of unnatural homoeroticism from poetry. Kugle argues that, "[Hali] felt the poet should never specify the gender of the beloved, especially in ways that imply the male gender."[29]

In the second approach, somewhat more tolerant intellectuals ignore the erotic impulses of these poems and, instead, inscribe them with platonic symbolism.[30] For example, wine and the male cupbearer are rendered as the intoxication of divine love while the handsomely seductive cupbearer stands in for the Sufi master who is the vessel for that platonic love. The male beloved associated with these poems is thus only a mere symbol of either Allah or the spiritual master, devoid of any erotic charge.

In the third and, to my mind, the most contrived justification for solving the "problem," the use of male pronouns is less erotic than fine etiquette: The medieval poets wrote their poetry during a time in which sexual decorum was strictly adhered to and segregation between sexes was more pronounced than today.[31] It was considered uncouth and socially unacceptable to address one's female beloved with her gender pronoun.

Moreover, it was taboo to write poems about her beauty, and to describe the poet's devotion to the beloved. To solve this problem, the poet disguised the female pronouns of his object of affection by replacing them with male pronouns and thus respecting the restriction against using female pronouns in his poetry.[32]

With these justifications in place that insist on a re-authored, de-gendered, transcendent, and de-homosexualized Sufi poetics, a new generation of Pakistani viewers come to YouTube to witness the traditional singing of the poems. Via the Internet, millions of young Pakistanis, nationally and internationally, are introduced to de-eroticized Sufism. Although these poems have found a new life on the Internet, they have been sanitized and heterosexualized. For example, followers of Punjabi Sufi music have created hundreds of fan videos that juxtapose images of the holy sites Mecca and Medina with Muslims praying while performing ritualistic whirling dances as the sensual homoerotic poetry is sung by popular singers.[33] In effect, the pious imagery censors the inherent sensuality of these poems.

In another instance, the same poems are given a heterosexual and melodramatic framework when juxtaposed with mini love stories. For example, in a YouTube user-made video based on a poem named "Jo Rang Rangaya" by Bulleh Shah, the poem is sung by a famous singer, Abida Parveen. In "Jo Rang Rangaya," the poet proclaims that his master has dyed him a dark shade of red. The poem is transgressive in several ways: Shah announces love for his master (Shah Inayat) and, in doing so, he evokes a non-Muslim ritual of Holi, a Hindu festival in which the participants throw colors at each other, dyeing their clothes in the process. Moreover, Shah compounds his poetic symbols. He mixes the Quranic description of the miracle of the "white hand" (it was the hand of Moses that shone like the sun) with the red and black colors of his master's garb, proclaiming that they are as bright as the white hand of Moses.[34] At the same time, the video defies the homoerotic meaning the poem makes available.[35] Throughout this video, references to traditional Islamic motifs abound. We see, for example, pages of the Quran, beautiful shots of different mosques, a girl in hijab wearing a headscarf with the proclamation to Islamic faith written on it, and a youth wearing a kafiya praying with her hands raised. However, the image that is repeated in the video and carries significant religious currency is that of the whirling dervishes. This image, as we shall see further, is something of a cliché in the Sufi videos found on YouTube and provides an iconic representation that has proven useful for these user-generated montage videos.

Other YouTube videos that de-homosexualize and de-eroticize Sufi poetics include Nusrat Fateh Ali Khan's (a popular Sufi Qawwali singer) appearance in a 1995 music video in which he sings one of Madhu Lal Hussein's poems. The video is made up of a young woman's dream where she envisions a soldier's arrival from the battlefield. A Pakistani

soldier returns home after being injured in a war. The video thus presents the singer, the poet, as a man but the desires expressed visually are filtered through those of a woman and her longing for her heterosexual companion.[36]

In another video, divine Sufi poetry is used to advertise tea through the music video genre. The video was an instant success in Pakistan on television in 2002 and now resides on YouTube and elsewhere. It is a strange mélange of consumerism, Sufism, and heterosexuality. The poem featured in the video "Ishq Nachaya" ("Love Made Me Dance," my translation) is by Bulleh Shah. The story the poem tells is about an incident in Bulleh's life that demonstrates his devotion to his master Inayat. Bulleh Shah, at first, was not an apt student of Inayat. On one occasion, Bulleh's relative made fun of Inayat's lower status and Bulleh didn't stop him from doing so. In response, Shah Inayat rejected Bulleh Shah as his student-beloved. Bulleh Shah then went to live with a female prostitute. He cleaned her house, cooked for her, and became her servant. The prostitute, in return, taught Bulleh how to dance, sing, and how to be beautiful for one's beloved. Once Bulleh Shah was well versed in the secrets of seduction, he wore red garments, braided his hair like a woman, put on ankle bells and danced as a courtesan in front of Shah Inayat's door until his master forgave him and embraced him in love.[37]

The poem's first line "Love Made Me Dance," refers to the story explained in the preceding text. However, as an advertisement, the video begins by displaying the tea's brand, "Supreme" (written in English), alongside the word "Ishq" (written in Arabic, together meaning ecstatic love). The video bizarrely mixes tropes that depict a story between a man and a woman. In it, a shepherd dreams himself a whirling dervish. He dances and searches for his love, depicted as an ascetic woman. This woman is shown mourning an unknown loss. Other dervishes then surround our protagonist shepherd/whirling dervish; they dance through different locations such as mosques and Sufi shrines. In the last shot of the video, the whirling dervish literally dissolves into a cup of tea in which the steam pouring from the cup follows a couple as they walk side-by-side.[38]

re-authoring the homoerotic in sufi poetics

In their numerous incarnations, contemporary renditions of these poems make no mention of the male-to-male love and desire that the original writings offer. For this essay, I had hoped to include a section about a counter-heterosexist interpretation of these poems. However, apart from a few instances of cursory acknowledgment on the Internet and academic work in the West, there remains no significant material that positively reclaims— nay, *reauthors across media platforms*—the homophobia and heteronormative insistence that inscribes these writings. Therefore, I offer this intervention.

Figure 6.1

Still taken from video titled *Supreme Ishq* (Director: Shoaib Mansoor, 2002), inspired by Bulleh Shah's poem "The Shepherd".

Figure 6.2

Supreme Ishq. Shepherd's female beloved.

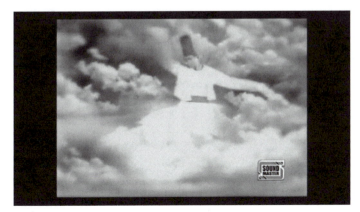

115

Figure 6.3

Supreme Ishq. The Shepherd becomes a Sufi and dances in the clouds.

My reauthoring returns homoerotics to Sufi poetry, and begins with paper and pen.

Figure 6.4

Poem By Bulleh Shah, "My friends of girlhood and of play, Come over to my garden".

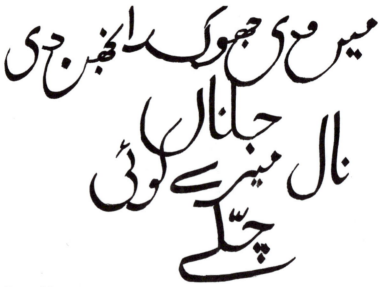

Figure 6.5

Poem by Shah Hussein, "I yearn to go to Ranjha's abode, Let someone come with me".

Just as the disciple soaks up and is marked by the wisdom transmitted by the master, the paper on which I wrote soaked up and was marked by the wisdom of the poems. Just as the disciple is the vessel of the divine knowledge, the paper is a container of these poems. The physical paper serves as a sensual extension of the spiritual content that the writing enables. The handwriting itself is cursive; it is like the locks of the beloved of Sufi poems. The translator is someone in between. He at once erases and produces his own voice. The translator is like Jabra'il. He is a *media*tor who moves between sources of knowledge and those who receive it.

As translator of these mystic poems, I perform the act of writing with my hands, making direct contact with the instruments designed for writing—pen and ink. These poems, touched by my pen and hands, are then touched by the reader. This shared sensuous experience is a symbolic imitation, an iteration, of the act in which knowledge is transferred through touch.

Translations of untitled Sufi poems (excerpts):

> My friends of girlhood and of play,
> Come over to my garden
> And celebrate,
> My husband, my Ranjha,
> Has just arrived today.
> O! what blessed day,
> My Ranjha has entered
> My courtyard,
> Carrying a yogurt bowl,
> His head covered in a shawl
> He would just steal me away.
> My Ranjha had suffered harsh,
> In the forest, in the marsh;
> O, blasphemers, look at him
> You will see Allah in him.
> Bulleh Shah made a good deal,
> He has gulped a poison cup
> The dowry of precious stones,
> I have thrown away.
> I've taken a bale of sorrow,
> But who cares about tomorrow
> Congratulate, celebrate,
> Today, just for today.
>
> —Bulleh Shah

> I yearn to go to Ranjha's abode
> Let someone come with me

I beg on your feet, and I implore
Let someone come with me
Lest I risk the journey alone
The river deep, the boat has holes,
And lions roam the shore.
If someone brings my lover's news,
I will give him my bridal gold.
Ranjha, I hear, is a medicine man
I will show him my raw wounds;
My inner pain.
"My lover should me letters"
shouts the miserable man Hussein in vain.

—Shah Hussein[39]

notes

1. Ruth Vanita, Introduction to *Queering India: Same-Sex Love and Eroticism in Indian Culture and Society* (New York: Routledge, 2002), 8.
2. Vanita, *Queering India*, 9.
3. Imam Al-Bukhari, *Sahih Al Bukhari*, vol. 1, trans. Muhammad Muhsin Khan (Riyadh: Darussalam, 1997), 46–50.
4. A. J. Arberry, *The Koran Interpreted* (New York: Collier/Macmillan, 1986), 344.
5. Sarmad was an Armenian Jew who converted to Islam. He fell in love with a Hindu boy and, inspired by his love, intermingled the tenets of Islam, Judaism, and Hinduism. It is said that, in his ecstatic mood, he would disrobe and dance. Saleem Kidwai and Ruth Vanita, *Same-Sex Love in India: Readings from Literature and History* (New York: St. Martin's Press, 2000), 157.
6. This quote is attributed to a famous Sufi Al-Ghazzali, in Kidwai and Vanita, *Same-Sex Love*, 146.
7. Annemarie Schimmel, *I Am Wind You Are Fire: The Life and Works of Rumi* (Boston: Shambala, 1992), 177.
8. Kidwai and Vanita, *Same-Sex Love*, 114.
9. Kidwai and Vanita, *Same-Sex Love*, 116.
10. Ranjha may be viewed as a Punjabi version of Krishna, avatar of the Hindu god Vishnu, with Heer as the goddess Radha, Krishna's beloved consort. Like Krishna, Ranjha is ostracized by his relatives and banished from his land, although he is the rightful heir to his homeland. Like Krishna, Ranjha is flirtatious towards other women, but his only pure love is Heer. Krishna's true consort is the goddess Radha. Like Krishna, Ranjha is a cowherd, he is of dark color, and he plays the shepherd's flute (Ejaz, "Krishna and Ranjha: symbols of changing societies").
11. Kidwai and Vanita, *Same-Sex Love*, 154.
12. Kidwai and Vanita, *Same-Sex Love*, 156.
13. Shingari and Puri in *Saaien Bulleh Shah* (Lahore: Fiction House, 2004), 14–25 detail Bulleh's aversion towards the caste system. They link him with the Bhagti movement in India as the reason to why he assumed his unusual stance on religious and caste divisions.

14. Manzur Ejaz, "Bullah, How Do You Know Yourself?," *The Friday Times Online* XXIII, no. 33, October 6, 2011, accessed April 15, 2012, http://www.thefridaytimes.com/beta2/tft/article.php?issue=20110930&page=16.

15. During my school years in Pakistan, it was strictly forbidden for students to speak in Punjabi during school hours. Only Urdu and English were permitted. Students were and still are educated in English and in Urdu (author's note).

16. "Sufism Can Bridge Gap Between Islam, West: Shujaat" *Pak Tribune*, February 9, 2007, accessed May 20, 2012, http://paktribune.com/news/Sufism-can-bridge-gap-between-Islam-West-Shujaat-168465.html.

17. Sabrina Tavernise and Waqar Gillani, "Suicide Bombers Strike Sufi Shrine in Pakistan," *New York Times*, July 1, 2010, accessed May 20, 2012, http://www.nytimes.com/2010/07/03/world/asia/03pstan.html.

18. Jon Pareles, "Songs of the Saints, With Love, From Pakistan," *New York Times*, July 21, 2010, accessed May 20, 2012, http://www.nytimes.com/2010/07/22/arts/music/22sufi.html

19. "PR No. 242 PRESS RELEASE SUFI MUSIC MESMERIZED NEW YORK AUDIANCE [sic] Islamabad 21 July, 2010," accessed April 16, 2012, Government of Pakistan—Press Information Department, accessed April 16, 2012, http://www.pid.gov.pk/press21-07-2010.htm.

20. Pareles, "Songs of the Saints, With Love, From Pakistan."

21. Until the early twenty-first century, Pakistan had only one state-owned television network and a short-lived privately owned station called STN (Shalimar Television Network). In 2002, the Pakistani authorities ended the government monopoly on television (as well as radio) and established a regulatory licensing authority, PEMRA (Pakistan Electronic Media Regulatory Authority). This was necessary in order to regulate the mostly *laissez-faire* entrepreneurial satellite and later cable television sector, which would provide Western and Indian television entertainment to the Pakistani public. The nascent Internet market benefited from the new openness and, supported by the upper- and middle-class urbanites, established itself all across the country. For further reading: Abdul Syed Siraj, "Critical Analysis of Press Freedom in Pakistan," *Global Media Journal* Vol. 1 (2008), 44, accessed March 29, 2012, http://www.aiou.edu.pk/gmj/artical1(b).asp; and "Govt Abolished Musharraf's Black Laws," *The News*, February 27, 2012, accessed March 29, 2012, http://www.thenews.com.pk/article-37316-Govt-abolished-Musharrafs-black-laws.

22. "First Facebook, Now Pakistan Bans YouTube over 'Un-Islamic' Content," *Mail Online* May 21, 2010, accessed May 20, 2012, http://www.dailymail.co.uk/news/article-1279889/YouTube-Facebook-banned-Pakistan.html.

23. Andrew Malcolm, "Creators of 'Everybody Draw Muhammad Day' Drop Gag After Everybody Gets Angry," *Los Angeles Times*, April 26, 2010, accessed May 12, 2012, http://latimesblogs.latimes.com/washington/2010/04/creators-of-everybody-draw-muhammad-day-abandon-effort-after-it-becomes-controversial.html.

24. Duncan Geere, "Pakistan Bans 1,695 Naughty Words from Text Messages," *Wired.Co.UK*, November 21, 2011, accessed May 12, 2012, http://www.wired.co.uk/news/archive/2011-11/21/pakistan-sms-ban-list.

25. "US Commits 'Cultural Terrorism' by Sponsoring Gay Pride Event in Pakistan," *Albawaba,* July 5, 2012, accessed April 16, 2012, http://www.albawaba.com/us-commits-cultural-terrorism-sponsoring-gay-pride-event-pakistan-381751.

26. Patrick Goodenough, "Pakistani Islamists Protest U.S. Embassy's 'Gay Pride' Event," *CNS News*, July 5, 2011, accessed May 20, 2012, http://cnsnews.com/news/article/pakistani-islamists-protest-us-embassy-s-gay-pride-event.

27. "Aaj TV (Business Recorder) Promoted Gay Culture in Pakistan – 1 (Aaj Ki Khabar 5 July 2011)," YouTube video, posted by TEJIKHAN, July 7, 2011, accessed March 10, 2012, http://www.youtube.com/watch?v=20E70AkxkFQ.

28. "Express News Front Line with Kamran Shahid – 6 Sep 2011," video clip, accessed March 9, 2012, link expired, ZemTV.

29. Scott Kugle, "Sultan Mahmud's Makeover: Colonial Homophobia and the Persian-Urdu Literary Tradition," in *Queering India*, 40.

30. See, for example, Ibrahim Gamard's discussion on Moulana Jalaluddin Rumi and his relation with his mentor Shams. "A Reply to Misunderstandings about Rumi and Shams" *Dar-Al-Masnavi.org*, January 2001, accessed April 16, 2012, http://www.dar-al-masnavi.org/rumi-shams.html.

31. Emma Duncan, *Breaking the Curfew: A Political Journey Through Pakistan* (London: Penguin, 1989), 28.

32. Duncan, *Breaking the Curfew*, 29.

33. A search for Pakistani Sufi singers such as Nusrat Fateh Ali Khan and Abida Parveen on YouTube will bring you numerous fan videos; most of them involve the imagery described earlier (author's note).

34. There is a description of miracles performed by Moses in the Qur'an. For example, Moses showed one of his hands to the monarch and it was "white" (as if radiant like the sun). For further reading, see "What is Meant by the White Hand of Musa(A)," accessed March 12, 2012, http://www.al-islam.org/hidden-truths-in-gods-word-musavi-lari/5.htm.

35. "Abida Parveen – jo rang rangaya," YouTube video, posted by jdabab, November 11, 2009, accessed March 10, 2012, http://www.youtube.com/watch?v=NepLzmv3VZ8.

36. "Mera Piya Ghar Aaya—Nusrat Fateh Ali Khan 1948–1997," YouTube video, posted by spsyed, July 15, 2009, accessed March 10, 2012, http://www.youtube.com/watch?v=cPVTNmkFJwk.

37. Shingari and Puri, *Saaien Bulleh Shah*, 10–15.

38. "Supreme ishq tere ishq nachaya sufi song," YouTube video, posted by zameeruddin, July 16, 2011, accessed March 10, 2012, http://www.youtube.com/watch?v=9x5JhHxDfO4.

39. The first poem can be identified as "Aao Ni Saayion Ral Diyo Wadahi" by Bulleh Shah, the first line of the poem written in English alphabet. The second poem can be identified as "Mein Vi Jhok Ranjhan Di Jana" by Madhu Lal Hussein, the first line of the poem written in English alphabet. Unfortunately, books consisting of Shah Hussein and Bulleh Shah's original poems are not available, but a Punjabi literature site, Academy of the Punjab in North America, accessed May 21, 2012, http://www.apnaorg.com, has an extensive collection of Punjabi Sufi poems.

event

authoring

user-generated content

s e v e n

m a r k a n d r e j e v i c

In his public response to the Stop Online Piracy Act, new media guru Jaron Lanier identified disrespect for intellectual property as the culprit in emerging forms of commercial surveillance. A culture of online sharing, he argued, goes hand-in-hand with the erosion of online privacy. He scolded what he called "the 'open' Internet movement" (complete with scare quotes) for helping usher in the hyper-commodified era of personal data-mining in the Facebook era.[1] Those who thought information should be free—as in both free beer *and* free speech (which doesn't include the open source movement, though it's not clear what Lanier means by the "open Internet movement")—should expect that their own data will be freely collected and traded. What happens to music and movies will also, necessarily, happen to personal information, he argued. As he put it, "We in Silicon Valley undermined copyright to make commerce become more about services instead of content. ... The inevitable endgame was always that we would lose control of our own personal content, our own files."[2]

Lanier got it wrong. We do not actually have an intellectual property right in our transactional data (and creating one probably wouldn't help matters much)—but the confusion is understandable: privacy and private property have an apparently natural affinity. We are learning, however, that the connection is more complex than the simple equation proposed by Lanier. The capture and use of personal data have little to do with a culture of openness, but are all about new forms of privatization that allow companies to make money by creating proprietary databases accessible only to those who are willing to pay. The story of data collection in the digital era is not a simple story about the end of privacy and private property, but about the creation of new forms of private property based on the collection and aggregation of personal data. Far from undermining the development of private databases, file sharing contributes to it, as illustrated by companies such as Big Champagne that capture and sell data about file-sharing activity.

Lanier's broader point is that we have *forced* companies to develop a commercial model based on detailed monitoring and tracking by our reluctance to pay directly for online content. This is a somewhat more coherent argument, but the notion that companies would forswear creating secondary markets in personal information if we would simply agree to pay directly for online content is suspect, both historically and practically. Marketers working on behalf of commercial entities gathered all kinds of detailed demographic information about paying consumers long before the development of a targeting-based online advertising model. Rather than buying into Lanier's argument, it might make more sense to point out that, to the extent that we rely on a private, for-profit, commercial model for the provision of online content, we are committing ourselves to a world characterized by increasingly comprehensive and sophisticated forms of consumer monitoring, tracking, and manipulation.

However, Lanier's confusion is also suggestive. Why *shouldn't* our personal information be considered a form of intellectual property subject to copyright protection? If, indeed, we are entering a world in which consumers are providing important inputs into the creation of economic value—and, if these inputs are framed by those who elicit them as creative forms of participation, why not afford the products of this participation some form of protection? Clearly, some user-generated content is copyright protected in the United States—including, for example, original videos, music, photos, or text (including email). However, what about other forms of user-generated content, such as the details of our activity online, our expressed preferences, even our time–space paths throughout the course of the day? These may not meet conventional understandings regarding the expenditure of effort or the creation of expressive content, but they have surely become an important source of value and information about the world.

It is one of the paradoxes of the digital era that the aggressive assertion of intellectual property rights coincides with the rampant appropriation of tremendous amounts of information generated by consumers, users, and "interactors" of all sorts. On the one hand, legal protections are secured for a widening sweep of so-called intellectual property (from new genetic strains of corn to traditional medicines), while on the other, a vast data terrain is opened up for commercial exploitation. If it seems as though intellectual property lies at the heart of the data-driven economy, this economy also comes to rely heavily on carving out a space for what might be described in legal terms as non-authored information—information that is subject to capture, collection, mining, and sorting. The capture and use of this information is predicated precisely on the claim that this information is not "authored" in the conventional sense, and therefore does not deserve the type of copyright protection mobilized for original and creative works—at least until it is deliberatively collected and stored— at which point it becomes the intellectual property not of those who have created it, but of those who have captured it. We may author our emails, but we do not in the same sense "author" the information about when we send them, how often we check our messages, where we are when we do so, and so on. The notion of authorship, in this regard, persists in part to designate what is *not* authored—and therefore what remains beyond the reach of copyright protections and control. If popular and scholarly discourses have, in the postmodern era, called into question the authority of the author, economic, commercial, and legal discourses are working hard to secure the notion of authorship as a bulwark against the affordances of digital media.

These developments need to be situated within the larger context of the relationship between interactivity and authorship in the digital era. Much has been made of the de-differentiating force of interactive technologies and the ways in which these purportedly collapse hitherto rigid distinctions between consumer and producer, creator and audience, writer and reader, and so on. Suggestively, this ostensible collapse licenses the claim to authorship of activities hitherto excluded from the realm of production or creation. If consumption is a form of production, precisely because it is participatory—in the sense that it requires some inputs generated by the consumer—then it can lay claim to aspects of authorship. Thus, for example, the decisions made by users as they navigate or contribute to interactive works are treated as forms of collaboration or participation: important contributions to the structure and experience of a work.

By the same token, the contribution of users has become a key component of the emerging online economy, foreshadowed in important ways by explorations in digital creativity in the 1990s. If, in the aesthetic realm, user feedback and participation was greeted as a form of collaboration,

in the economic realm the exploitation of its value relies on excluding it from the realm of authorship. The goal of this chapter, then, is to explore one of the paradoxes of authorship in the digital era: the way in which the generation of personal information remains excluded from the realm of authorship proper for all practical purposes, even as its generation is greeted as a form of self-expression, participation, and empowerment—as well as a source of value.

the promise of participation

The advent of so-called interactive or hypertext literature in the 1990s serves as both a literal and metaphorical example of claims about the changing nature of the relationship between creators and audiences in the digital era. At the heart of claims of the digital impact on authorship is the way in which interactive capabilities change both the nature of authorship and the ability of audiences to participate. Thus, for example, Robert Lanham claims that digital art challenges the reification of taste cultures into timeless canons and truths: "This insistence on art as process rather than product, interactive temporal event rather than timeless masterpiece, I take to stand at the center of contemporary thinking about art, and about more than art."[3] Alongside this change, George Landow argues, the relationship between author and reader is also transformed: "Within a hypertext environment, all writing becomes collaborative writing."[4] Douglas Robertson summarizes the effect this shift has on traditional notions of authorship: "Both 'author' and 'authority' become softened and diffused as the reading event moves from a one-time exchange to a continuing conversation."[5]

Such claims can be expanded to encompass other forms of art and, significantly, other forms of production. In the new millennium, interactivity has become one of the hallmarks of digital art, as evidenced by works that incorporate audience participation and feedback of all kinds—textual, audio-visual, and data. Back in the 1990s, artists, for example, created collaborative poems that allowed Internet users to add a line to the ever-growing poem when they visited its website. The idea of a collaborative poem has since been updated by the creators of "The Longest Poem in the World," a project that captures rhyming lines from Twitter and compiles them into a poem that grows by thousands of lines a day.[6] The poem starts out as follows (and continues to write itself by piggybacking on the volubility of Twitter members): "even though you're singing and thinking how well you've got it made. I just looked at this week's calendar and I'm very afraid."[7] This ongoing production gives new meaning to the concept of "automatic writing," literally automating the process of what Roland Barthes called "writing as fast as possible what the head itself ignores"[8] In the case of the automated poem, however, it is not so

much that the head is ignoring what it is writing, but that it is ignorant of how this writing is appropriated by the algorithm that scans Twitter feeds for promising additional lines. Moreover, the collaborative character of the poem makes it an automated *cadavre exquis*—a digital mash-up of surrealist strategies.

Such experiments bear a marked similarity to much more practical forms of interactive production whereby part of the work of crafting products or advertising campaigns is offloaded onto consumers. Consider, for example, the marketing algorithm that sorts through the cookies installed on someone's web browser in order to target advertising to them. Much like the software that governs "The Longest Poem in the World," these cookies capture user activity and use it to shape the content to which they are exposed. Interactivity-enhanced forms of production provide an automated analogue of interactive works that respond to user activity. They model the shift in consumer–producer relations that work to enlist consumer productivity and establish a relationship that is more an ongoing process than a unique transaction. Perhaps the paradigmatic example would be a hypertext novel that allows users to create a unique path for themselves through a series of interlinked pages. Thus, as Séverine Dusollier observes, if Stéphane Mallarmé wanted the audience to "produce the book," hypertext artists similarly invite audiences to take an active role in constructing the works they experience.[9] This shift aligns itself with the move from work to text in the "open text" theories described by Dusollier: "The distance between the writing and the reading is abolished, and they are tied together 'into one and the same signifying practice'. ... As Barthes writes: 'The Text is very much a score of this new kind: it solicits from the reader a practical collaboration.'"[10] This shift is generally greeted as a positive one, insofar as it challenges the hierarchical relationship between production and consumption, opening new avenues for audience creativity and engagement. "The reduction of reading to consumption is clearly responsible for the 'boredom' many feel in the presence of the modem ('unreadable') text, the avant-garde film or painting: to be bored means one cannot produce the text."[11]

It might seem perverse to line up examples from art and commerce in this way, but this is precisely the alignment suggested by the claims that promoters of interactive forms of marketing and mass customization make when they frame customer interaction as a form of creative collaboration and participation. Moreover, it is the implicit equation adopted by theoretical approaches that highlight the de-differentiation the between realms of production and consumption in the digital era. The promise that consumers can overcome the depredations of mass society through their interactive participation is the utopian theme that underlies what might be described as the dis-alienating promise of the interactive era: that they will start to recognize their own contributions to the commodities

and services they purchase, from custom-designed clothing to "smart" applications that select video clips and news stories tailored to their interests.

Janet Murray's description of the fate of narrative in the era of hypertext provides an analogy for just such a process. For Murray, hypertext promotes the interactive aspect of the digital aesthetic described by Robert Lanham, although she describes the viewer not as a collaborator or participant, but as an "interactor": "The interactor, whether as navigator, protagonist, explorer, or builder, makes use of this repertoire of possible steps and rhythms to improvise a particular dance among the many, many possible dances the author has enabled. We could perhaps say that the interactor is the author of a particular performance within an electronic story system..."[12] Even in this formulation, there is an air of creativity to the reader's activity as performance.

The result, according to Murray, is that the nature of authorship changes: "Authorship in electronic media is procedural. Procedural authorship means writing the rules by which the texts appear as well as writing the texts themselves. It means writing the rules for the interactor's involvement. ... It means establishing the properties of the objects and potential objects in the virtual world and the formulas for how they will relate to one another."[13] The text is no longer fixed, but the rules whereby it operates are. The *process* becomes the author-supplied content. In many ways, this stands as an apt metaphor for the post-Fordist digital economy: people will design and shape their own products, but in so doing will reinforce the procedural logic whereby they do so. What is important for the replication of the digital economy is not the nature of any particular product, but rather the adherence to a given set of rules supplied by the logic of the market. The author, per function, migrates from the level of a fixed text to that of fixed set of rules that govern the "collaborative" production of the text.

consumption as co-creation

The equation of interaction with creative participation, engagement, and self-expression resonates across the divide between art and commerce not least because, as Nicholas Negroponte notes, the tools for the two forms of practice converge, and to this extent everything becomes more "creative" or participatory for the user as it becomes more interactive. It is this line of thought that leads Negroponte to claim that the computer ushers in an age of widespread and democratized creativity accompanied by "a new era of opportunity and respect for creative avocations—lifelong making, doing, and expressing."[14] No longer will creative practice be limited to the fortunate few, for computers turn the "tools to work with" into the tools of creativity: "there will be a more

common palette for … self-expression and group work."[15] The universal medium of the bit brings together formerly dispersed forms of social practice that rely on one shared tool: the computer, which can be used for graphic design and music composition as well as for accounting and engineering. Understood as a convergence device, the computer bridges the realms of labour and leisure for those workers who come home from a day spent staring at the screen only to engage in forms of socialization or leisure that rely on the same—or a very similar—screen. Familiar ads for portable laptops and tablets highlight these forms of de-differentiation, suggesting that the machines can maximize both their users' productivity and their creative, personal, and social lives.

Transposed into the economic realm, this logic of de-differentiation takes on a somewhat different cast: if consumption is increasingly participatory and interactive, it simultaneously becomes more productive. The process of consumption is, as David Harvey notes, a necessary complement to that of production: "production and consumption relate to each other so that 'each of them creates the other in completing itself, and creates itself as the other.'"[16] Thanks to forms of interactive production, consumption can become literally productive, providing inputs into the production of the very goods being consumed. What counted as creative participation in the aesthetic realm becomes a potential source of value in the economic one. Hence the development of the portmanteau term "prosumption" (from Alvin Toffler's "prosumer").[17] Consumers do not write a line of poetry, rather they provide detailed information about their preferences, their past behavior, their anticipated future activity, their demographic and biometric characteristics, their locations, and so on. Such contributions are useful to producers who provide new and innovative ways of facilitating them so as to harvest as much information as possible. Thanks to interactive technologies, data that used to be costly and difficult to come by can now be collected from users via techniques for capturing publicly available data, or by applications that collect data automatically as a by-product of services and transactions. Think, for example, of smart phone applications that ask for user permission to collect location information—and of the applications that collect this automatically, often without users' knowledge, as illustrated by the 2012 controversy about the data-snooping Carrier IQ software used on many mobile phones.

Perhaps unsurprisingly, companies inadvertently draw upon the analogy to the artistic realm to encourage consumers to provide as much data as possible—a process that they frame as a form of self-expression, participation, and, ultimately, empowerment. Consider, for example, Nike's interactive "Nike iD" campaign that allows users to "design" their own sneaker by selecting a customized color scheme and adding a custom ID (such as their own name). As part of the campaign's launch,

it was featured on a 23-story-high interactive billboard in New York City's Time Square. Passersby could call a toll-free number advertised on the billboard, allowing them to "take control" of part of the display to custom-design a pair of athletic shoes, by picking the colors and watching the image on the billboard respond to their choices. Passersby could watch the giant shoe change colors in real time in response to the commands of whoever had managed to phone in and take control of the billboard. The Nike iD website treats consumer participation as a form of artistic "inspiration," providing users with the ability to share their designs online, to contribute them to the Nike iD "gallery," and to make posters of their original creations.

The marketing world greeted the Nike promotion with predictable techno-hype, describing the interactive billboard with headlines including "Nike Empowers Mobile Users with Design Capabilities."[18] The Nike iD website promised users access—if only momentarily and symbolically— to the hallowed halls of a corporate icon: "NIKE iD is your chance to be a NIKE designer."[19] The site addressed consumers as apprentice producers, authors of their own designs seizing the drawing board from those who have too long monopolized it, "You begin with a blank item—or an inspiration—and express your individuality by adding color and a personal iD."[20] The president of an interactive marketing company that worked on the Nike iD campaign linked the interactive technology to new forms of empowerment and creativity: "The Web gives the consumer empowerment and control. ... Consumers own the brands, not the companies. The Internet allows the brand to adjust or adapt to fit the individual, not the other way around."[21] The power shift is purportedly in the direction of democratization, despite the fact that any consumer who tries to use the brand for his or her own purposes would learn imme-diately that Nike is still very much the legal owner of the brand. Nevertheless, as one newspaper commentary put it, "Some see a political dimension to all of this, in that it points to a new market-based democratic egalitarianism."[22] Customization via interactivity represents, on this account, evidence of "a democratic desire": "Every person wants to say this is more them, and they're not part of mass culture."[23]

For Nike, the interactive design application was a form of market multi-tasking. It served as a promotional vehicle (a means of getting plenty of free media coverage), a strategy for building customer loyalty, and a way of gathering information about consumer preferences. As one news account put it, "Profitable or not, the sneaker sites have one very practical application: They open up a wealth of market research possibilities. Thousands of shoppers logging their preferences on the minutiae of laces, tongues, and soles amounts to a free focus group."[24]

The business literature has described the information gathered through interactive marketing as a technique for saving money "by offloading

some of the duties of consumer interactions onto consumers them-selves."[25] Market research "duties" once assigned to producers are being reconfigured as the responsibility of consumers. This use of interactivity as a technique for turning audiences into focus groups is apparent across a variety of industries and products, ranging from online shopping to reality TV. The producers of the *American Idol/Pop Star* franchise are probably kicking themselves for not having thought of it sooner. Now they can make money from the market-testing process instead of paying for it. Interactive marketing is, as one retail consultant put it, "a great way to insert the consumer into the process of product deve-lopment."[26] It is truly a cybernetic process in the sense described by Wiener, one in which the manufacturing process is modified by consumer feedback.

Interactive customization creates two products: in the case of Nike, not just an athletic shoe, but also detailed information about consumer preferences. Moreover, the Nike iD website's terms of use make it clear that the company has the right to use any of the contributions made by users of its site any way they want—the legalese is quite blunt: "You grant, and warrant that you have the right to grant, to NIKE a non-exclusive, non-revocable, worldwide, transferable, royalty-free, perpetual right to use your User Generated Content in any manner or media now or later developed, for any purpose, commercial, advertising, or otherwise, includ-ing the right to translate, display, reproduce, change, create derivative works, sublicense, distribute, assign and commercialize without any payment due to you."[27] Individual designs may be unique, creative, and original "performances" in the sense described by Murray, but the value accruing to such performances has been captured in advance by the terms of access stipulated by those who own and control the interac-tive platforms.

We can distinguish between two categories of so-called "user-generated content": that which is consciously and deliberately crafted by users, such as an original color scheme for a sneaker and an original review (Nike iD also includes a space for user reviews), and that captured by applications that monitor user activity, such as details about users' computers, their location, the sites they visit, the links they click on, and so on. The second category of harvested data is not intentionally created by users, and they are often unaware that they are generating it. For the purposes of market research, however, both categories are useful content that can be merged and mined for correlations. Both get treated the same way: as material that can be used by websites for commercial purposes. Thus, for example, Facebook describes this second category of data as information that it "receives" from users "in connection with the services and features we pro-vide to you and other users."[28] It stipulates that by using the site, Facebook members permit the company to use this information (free of charge)

for a range of purposes including marketing, security, and the creation of new services and capabilities.

Viewed from the perspective of authorship, there is an apparent distinction between these two types of data. Facebook status updates, blog posts, email messages, and so on require varying degrees of creative effort and constitute forms of personal expression. The transactional information generated in posting these messages, however, requires little intentional effort on the part of the user and is unlikely to meet conventional expectations of expressive content. For the purposes of market research, however, the distinction between these two types of data dissolves. In the database, information about web browsing activity rubs shoulders with details of email messages and stated preferences.

Viewed as raw material for, say, an epistolary novel or the rough draft of a book chapter, user-generated content can be construed as a form of intellectual property. However, viewed as raw data to be mined for the purposes of crafting more effective advertising, it falls into the same category as demographic information. Twitter, for example, archives users "tweets" and then sells them to companies interested in data-mining them.[29] Given their terms of use, Twitter could actually craft a novel or poem out of user's contributions and resell it without their permission, but that would be likely to upset users. Treated as data, however, there seems to be little public opposition to Twitter repackaging and reselling users' posts indefinitely. Perhaps because, for the purposes of data mining, expressive content is treated, in a sense, as non-expressive content: pure meaningless data whose value lies in establishing patterns and correlations. Google does not want to read our email for the purposes of understanding the nuances of our thoughts. Rather it machine-scans our postings for keywords and correlations. It is telling, that in its explanation of how Gmail works, Google emphasizes that no actual humans read users' mail. In other words, it is not being read for *meaning*, but for patterns of correlation with statistical significance and predictive power. Privacy policies such as Facebook's and Nike iD's ensure that users have turned over control of both types of information—both their intentionally and unintentionally created content—for the purposes of marketing.

the author is dead; long live the rights holder

The exploitation of user-generated content by commercial websites provides a nutshell summary of the two faces of interactive marketing in the digital era: on the one hand, user contributions to the creation of customized goods and services are portrayed as unique forms of personal expression that constitute active participation in the production process; on the other, users are required to relinquish control over the information they have provided and how it is used. For commercial purposes, the

distinction between creative, authored, and therefore protected content on the one hand and unintentional, captured, and unprotected content is rendered moot by the development of commercial platforms such as Google and Facebook, that make access to their services contingent on the surrender of control over both types of data. It is not a cavalier attitude toward privacy that leads to the wholesale exploitation of this data, but rather the privatization of popular platforms for information sharing, socializing, and searching.

If the traditional notion of the individual genius/author/creator comes under pressure in an era in which the collaborative, networked character of creation—and its reliance on previous creations—comes to the fore, it is noteworthy that, from the perspective of e-commerce, the work of authorship is, in a sense, transferred from the individual creator to that of the application of platform. In legal terms, Facebook can claim both the right to use—and sell—information it has harvested from users. It can do so based on the so-called contract users enter into when they sign up for Facebook. However, the agricultural metaphor is deliberate in the sense that the legal right to use this information is implicitly legitimated by the work that Facebook has invested in collecting this data. Viewed from this perspective, users do not do any "extra" work to generate the transactional data collected by Facebook. Rather, it is the company that writes the code that collects the data; that pays for the servers that store it; and develops the algorithms that sort it. The legal regime that licenses Facebook's claim to this data as its own intellectual property, which it is free to dispose of according to its wishes, hearkens back to what Fukumoto describes as a Lockean conception of property in which mixing one's labor with an object provides an ownership right in the results. It is in this way that Facebook might be construed as the "author" of the transactional data it generates and that it is, "natural to conclude that authors should reap the benefits of their labors."[30]

For commercial purposes, even those forms of user-generated content that clearly reflect the intentional productive activity of users are redoubled. Documents stored online, email archives, blog posts, and photos, can be mined for information and plugged into algorithms to generate useful data for commercial purposes. Thus, for example, as Facebook becomes the most popular site for hosting photos online, it can draw on this database to develop more sophisticated facial recognition algorithms. Similarly, cloud-hosting sites for consumers can scan music files, documents, and other stored data to discern robust correlational patterns. The goal of amassing as much data as possible for this purpose is part of the "big data" business model, which relies upon as broad an array of data as possible to fish for correlations (do preferences in music or movies correlate with tendencies to vote for certain types of candidates? Are particular browsing behaviors correlated with vulnerability to certain

types of marketing appeals, and so on). Anything that can be subsumed to the universal medium of the bit is grist for the database. If personal blogs or email messages were republished, intellectual property rights could be invoked (although sites such as Nike iD anticipate this by requiring users to provide Nike with permission to make use of user-generated content). The same forms of content, however, can also be treated as raw material for data mining—which does not, as of yet, trigger intellectual property protections for those from whom the data is captured. Like people, creative works have their own data doubles: information about them (patterns of language use, incidence of selected key words, metadata, and so on) that can be recorded, stored, and sorted. It is at this level that the distinction between intentional and involuntary production by the user disappears and the data-miner-as-author emerges.

Something odd also happens to user-generated content at this level— it no longer treated as signifying content with underlying meaning (someone's passionately held political beliefs, witty observations, haunting poetry, or revealing photographs). This is why its use by data miners does not look like infringement or intrusion—the goal is not to understand or replicate the sentiment expressed or the audience impact, not to steal someone's unique form of expression and take it as one's own. Still less is the goal to absorb and understand the personal details of someone's daily life. Rather the re-processing of this data takes place at the level of depthless pattern recognition. Individual behavior is "black-boxed," and, in a certain sense, anonymized—data miners do not care why a particular pattern correlates with a higher or lower probability of response; they do not develop underlying theories for why people who drive Mercurys are more likely to vote for Republican candidates. Nor do they care which particular Mercury drivers follow this pattern—all they want to know is the percentage, the probable return on their investment. This apparent rejection of depth recalls the logic of the text outlined by Barthes, though with a very different valence: "Succeeding the author, the writer no longer contains within himself passions, humors, sentiments, impressions, but that enormous dictionary, from which he derives a writing which can know no end or halt: life can only imitate the book, and the book itself is only a tissue of signs."[31]

From the perspective of aesthetic interpretation, there is something potentially liberating about this opening up of meaning—the refusal of those forms of closure visited upon a text by authoritative interpretation. From the perspective of digital capitalism, on the other hand, the logic is a relentlessly productive one—as the database grows, there are always more patterns to be unearthed and liberated from the constraints of interpretation. Thanks to the search algorithms these patterns come to seem self-generating, based on the flow of raw material supplied by the streams of data cast off by users. The capture and "valorization" of

this information results from an approach to data that might be described as a form of "non-reading." The data does not constitute an original form of expressive or creative activity, because, taken as such, there is nothing to express: the goal is not to extract an underlying desire, a hidden feeling, or presumed intention. So-called predictive analytics—the practice of sifting through huge amounts of data for robust correlations—is agnostic in these matters. The only "sense" to be had is that which emerges after the data is captured, sorted, stored, and processed, and this is the reconstituted work of authorship, insofar as it is the activity that adds value to the raw material captured by interactive platforms. As I write, the value of Facebook, for example, is estimated to be somewhere around $100 billion: a value that far outstrips the company's physical assets, but reflects, rather, its data assets—the huge amounts of information it has collected and will continue to collect from users, and the business model that puts this data to work.[32] In a sense, Facebook is a procedural author, crafting the rules that users follow as they participate in creating the site's content. At regular intervals, the company tweaks these rules in order to further its imperatives: creating more interactions that generate more data, which can in turn be used for tailoring advertising and services to users.

Companies such as Facebook trade on the originality of these procedural rules and thus the novelty of the services they offer—the rules and not the content are what have made sites such as Facebook, Google, YouTube, and Twitter powerful forces in the interactive economy. All of them—and many more in the social web world—rely on the ability to capture content created by users, and thus on the creation of a class of content creators who have no claim to the value generated and captured by their activity. Even further, it relies on a commercial media infrastructure that creates an asymmetry of control over information based on who owns and operates the database and who simply contributes to it. If authorship, in this regard, has indeed become collaborative, it is by no means an equal partnership.

notes

1. Jaron Lanier, "The False Ideals of the Web," *New York Times*, January 18, 2012, accessed February 10, 2012, http://www.nytimes.com/2012/01/19/opinion/sopa-boycotts-and-the-false-ideals-of-the-web.html.
2. Lanier, "The False Ideals of the Web."
3. Robert Lanham, *The Electronic Word: Democracy, Technology, and the Arts* (Chicago: University of Chicago Press, 1993), 49.
4. George Landow, *Hypertext 3.0: critical theory and new media in an era of globalization* (Baltimore: Johns Hopkins University Press, 2003), 136.
5. Douglas Robertson, *The New Renaissance: Computers and the Next Level of Civilization* (Oxford, UK: Oxford University Press, 1998), 49.

6. "The Longest Poem in the World," accessed February 10, 2012, http://www. longestpoemintheworld.com.

7. "The Longest Poem in the World."

8. Roland Barthes, "The Death of the Author," in *Image, Music, Text* (New York: Fontana Press, 1977), 144.

9. Séverine Dusollier, "Open Source and Copyleft: Authorship Reconsidered?" *Columbia Journal of Law and the Arts*, 26 (2003), 289.

10. Dusollier, "Open Source and Copyleft," 289.

11. Dusollier, "Open Source and Copyleft," 289.

12. Janet Murray, *Hamlet on the Holodeck: The Future of Narrative in Cyberspace* (New York: The Free Press, 1997), 153.

13. Murray, *Hamlet on the Holodeck*, 152–53.

14. Nicholas Negroponte, *Being Digital* (New York: Knopf, 1995), 229.

15. Negroponte, *Being Digital*, 221.

16. David Harvey, *Limits to Capital* (London: Verso, 1999), 80.

17. Alvin Toffler, *The Third Wave* (New York: Pan Books, 1980).

18. "Nike Retailing Innovation," at Retail Systems (official webpage), accessed March 2, 2009, http://www.retailsystems.com/index.cfm?PageName=PublicationsTONHomeNew&CartoonArticleID=4394.

19. *NikeID.com*, accessed February 10, 2010, http://nikeid.nike.com/nikeid/index.jhtml?_requestid=2357796#home.

20. *NikeID.com*, accessed February 10, 2010, http://nikeid.nike.com/nikeid/index.jhtml?_requestid=2357796#home.

21. Ann Mack, "Power to the People," *Critical Mass*, 2000, accessed March 10, 2011, http://www.criticalmass.com/about/news/ view.do?article=cm_110100&year=2000.

22. "My Logo: Are We the New Brand Bullies? Hijacking the Brand," *Toronto Star*, July 10, 2005, D4.

23. Reuters, "Nike Designs Get Personal," *Los Angeles Times*, May 30, 2005, C5.

24. Suzanne D'Amato, "Custom Sites Let Users Cobble Their Own Shoes," *Washington Post*, July 17, 2005, F1.

25. Walid Mougayar, *Opening Digital Markets: Battle Plans and Business Strategies for Internet Commerce* (New York: McGraw-Hill, 1998), 29.

26. D'Amato, "Custom Sites Let Users Cobble Their Own Shoes," F1.

27. "Terms of Use," Nike.com, accessed February 10, 2012, http://help-us.nike.com/app/answers/detail/article/terms/a_id/16379.

28. Terms of Use, Facebook.com, accessed February 10, 2012, http://www.facebook.com/legal/terms.

29. Todd Wasserman, "Twitter is Selling Your Old Tweets," Mashable.com, accessed February 29, 2012, http://mashable.com/2012/02/28/twitter-is-selling-old-tweets/.

30. Elton Fukumoto, "The Author Effect After the 'Death of the Author': Copyright in a Postmodern Age." *Washington Law Review* 72.3 (1997), 905.

31. Barthes, "The Death of the Author," 145.

32. Lee Spears, "Facebook Tops $100 Billion in Private Market Trading," *Bloomsburg Business Week*, February 13, 2012, accessed March 2, 2012, http://www.businessweek.com/news/2012-02-13/facebook-value-tops-100-billion-in-private-market-trading.html.

invention, authorship,

and massively

collaborative media

eight

judd ethan ruggill and
ken s. mcallister

> Art is an invention of aesthetics, which in turn is an inven-
> tion of philosophers. ... What we call art is a game.
>
> —Octavio Paz[1]

Of all the media through which to pursue the question of what consti-
tutes authorship in the twenty-first century, computer games are probably
the most fun. The medium is play-based, pleasure-driven, and almost
hyperactive in the evolutions, transformations, and transmutations of its
political, cultural, and ludic economies and ecologies. Like the intumes-
cent black snake fireworks of childhood, even as certain elements within
the medium rigidify and reduplicate, something daring and unpredictable
is always happening at its frontiers.

Of course, such frenzy problematizes understandings of how author-
ship is embodied and practiced. The computer game medium is always
already wickedly complex, thanks to its *raison d'être* of turning machines
into playmates, and humans into machine-readable sets of behaviors.[2]

Add incessant tumult to the mix in the form of the game market's constant innovation, maddening faddishness, and fungible material conditions, and the leading edge of the medium looks much like a kindergarten soccer game: a mass of squirming, collaborative, and conflictive energies with seemingly no discernible logic or direction.

In the interest of making some inroads into this mass, we offer the following exploration of several of the principal authorial forces involved in contemporary computer game development. Some of these forces are obvious, even commonsensical in terms of traditional notions of authorship: level designers, concept artists, 3D modelers, scriptwriters, programmers, and other well-placed industry personnel. These are the people who invent games, whose intentional and focused labor produces a particular finished product. In an age of obsessive market testing, it is important to note that players themselves now number among computer games' inventor ranks. Through their play during both the production (e.g., play testing) and post-production (e.g., consumer feedback) phases of development—not to mention post-release when many developers make available tools that allow players to build their own new game levels for sharing and even resale—players constitute a vital authorial force. As in other emerging massively collaborative media, however, this inventive talent is significant but small compared to the sum of authorial forces brought to bear on the full game production process. These peripheral but determinative forces generally come to mind less readily than inventive ones, but they are equally—and in certain cases more—definitive than, for example, a game's graphic artist or sound engineer. This is because it is these peripheral forces that determine what is *possible* within the inventive sphere itself.

For instance, computer operating systems determine how game software communicates with game hardware, and programming languages enable developers to write—within certain strict parameters—computer code that generates game logics and content. A step deeper into game machinery reveals central and graphical processing units, network interface cards, and other hardware that realize game audiovisuals and ludic possibilities. This hardware quite literally defines the parameters within which a story can unfold or an interactive experience be composed, and it also then generates that experience through the precise manipulation of information and electricity. Even software ratings groups (such as the Entertainment Software Rating Board [ESRB] in the United States and Pan European Game Information [PEGI] in Europe), which act as gatekeepers for commercially sanctioned and available content, make authorial (and certainly authoritative) contributions to the computer games people play.[3]

This chapter is meant as an entrée into these forces and the manifold articulations among them. Our goal is not to provide a definitive

answer to the question of game authorship, but rather a set of cairns for navigating the different and changing landscapes of game invention and production. Apprehending the nuance of these landscapes is essential to the field of game studies, as well as to fields that study other massively collaborative media and even to general understandings of authorship. Games and their authors—the manifest and hidden ones both—make the computers that have come to structure everyday life work in all kinds of fascinating and unusual ways, many of which are subsequently adapted for use in other media, such as multi-user network protocols. These ways, in turn, make authors themselves work differently, creating a mutually constitutive and synthetic circuit of meaning-making that influences human understanding, storytelling, and culture. Unfortunately, game authorship is not particularly well understood, either as process or progenitor, even less so in the context of mass collaboration. It is still largely a sorcery that produces an effect, albeit a surprisingly grand one. It is our hope that, through this chapter, we can help in beginning to demystify this sorcery—or at least demarcate sorcery's rightful place within the study of media authorship—and it is toward that end that we begin with a brief description of mass collaboration, then tour some of the super- and subterranean machinery of game authorship in particular.

mass collaboration

A buzz term popularized by Internet strategists Don Tapscott and Anthony D. Williams, "mass collaboration" has come to refer to the organizational practice by which many loosely organized individuals work independently but collectively on a single project.[4] Luminary examples of this kind of mass collaboration include Wikipedia, YouTube, and Flickr, programmable web technologies that allow people to make small, even idiosyncratic contributions to a project that thereby takes shape—that is, it is authored—in such a way that the outcome is both inventive and determinative. For Tapscott and Williams, this model of authorship, which they call "wikinomics" because such mass collaborations can be readily exploited for capital development, introduces a new way of doing business that is able to erase the division between producer and consumer. This "prosumption" is one of the primary dynamos of mass collaboration, empowering as it does the conversion of the consumer into the producer.[5] In the case of Wikipedia, for example, the open source framework that underlies that site allows users to also be contributors. In the case of software, the idea of the prosumer can be seen in everything from the amateur use of commercial-grade audio software such as Pro Tools, to the use of Vectorworks Landmark—a professional landscape visualization tool—to redesign one's backyard.[6]

This particular understanding of mass collaboration is increasingly applicable to the game industry. *World of Warcraft* (Blizzard Entertainment, 2004), *FarmVille* (Zynga Game Network, 2009), and *Lineage II: The Chaotic Chronicle* (NCsoft, 2004), for example, all depend to some degree on this business model. The mass collaboration we mean to invoke in this chapter is a broader one that acknowledges both the recent trends in prosumerism and the less visible but much older phenomenon that erases people's significant contributions to production processes; that is, the conjoined mechanisms of the alienation of labor and commodity fetishism. From this perspective, mass collaboration is simultaneously generative and arresting, both opening up possibilities for invention and closing down certain developmental directions. This is always the nature of authorship, of course: each decision that builds is also a decision about what not to build. In a medium as multi-modal as that of the computer game, such authorial decisions are made on innumerable fronts and in ways that directly contribute not only to the invisible framework that supports any given game title, but also to those elements of a game that are most readily apprehended: its look, sound, responsiveness, playability, mode of distribution, and so on. Thus, mass collaboration as an inescapable feature of the computer game medium means that game authorship must always be understood as highly complex, chance impacted (if not chance driven), and semi-organized. In the next section, we survey the most accessible authors of computer games, the agents who most overtly construct the specific products available for sale at game retailers. From there, we part the curtains to look at how less visible forces also author computer games quite directly, although in ways that are generally mystified by the cover of computation, industry politics, and legal obfuscation.

invention

As we noted in the preceding text, the most visible authorial force in computer games are inventors. These are the agents responsible for the design and programming of a game. Typically, inventors are human, but not always. Indeed, games have long relied on random number generators built into their software to respond to player input and produce and vary content. While such response and production are not designs or programs per se, they are nonetheless creative acts—"creative" in the sense that they create, not necessarily that they are artful—that shape the game world and its possibilities. In other words, computer games are often partly self-authored.

Not surprisingly, this type of auto-invention has expanded along with the medium, and today games contribute to their own architecture and playful possibilities in a variety of ways including the use of highly

recursive algorithms and the implementation of extra-gamic data. *Black & White* (Lionhead Studios/Electronic Arts, 2001), for example, could not only be set to fetch and respond to real-time and local weather information with in-game weather events, but the game learned from player action over time and responded accordingly by modifying the behavior of the player's familiar and the landscape of the game itself.[7] Such personalization and adaptation are part of a larger design approach that encompasses avatar and interface customization tools, configurable input devices, and user-selectable difficulty, an approach that is both inveterate and highlights the importance of player authorship to the medium.[8] We take up the concept of player authorship more fully in the following text, but mention it here as a way to emphasize the medium's tendency toward baked-in multivalent authoriality. Computer games seem meant to be changeable—by themselves, players, or even by designers, who make modifications or expansions after a game has been released—something developers and publishers are keenly aware of and use to foster intimate and inviting connections between their products and the players who engage with them.

Given this range of game inventors, then, it should be clear that computer games are never single-authored works. While a game (e.g., *Hunt the Wumpus*, by Gregory Yob, 1972) may have a principle designer/developer, as a piece of software it is inherently multi-authorial. There is no ludic experience without the software and hardware to generate it. Thus, game invention is always team-based, with development teams made up with as small as three or four people—designers, game software developers, and hardware/software producers who enable the game to compile and run on a given machine (we discuss this in detail in the next section)—or as large as hundreds. Premier, big-budget titles commonly deploy an army of artists, writers, level designers, voice actors, sound engineers, programmers, supervisors, localization experts, play testers, outside contractors, and other creative and technical workers.

This set of authors is joined by another set—players—once the game is released.[9] Like the readers, watchers, and listeners of other media whose engagement helps produce meaning in books, television shows, and radio broadcasts, players activate, modify, and create games through their play. This authorship can be as simple as starting a new game, or as involved as modifying an extant one through the use of cheats and exploits, the building of new levels and other in-game content, or the extension of a game world to other media through the creation of unofficial fora, homebrew sequels, fan art and fan fiction, handicrafts, and other game-derived DIY projects. Regardless of complexity, the act is the same: the co-authoring of a game and its play. Moreover, play in this instance is mimetic, replicating the multi-authoriality of game development in

the co-creation of play through the synthetic dialogue among players, developers, and machines. Just as there is no such thing as a single-authored computer game, there is no such thing as a single-player computer game. The computer-mediated play act is always collaborative.

If these various collaborations appear obvious, the authorial forces they partner with beyond the sphere of invention tend to be less so. And yet, the determinative energies of computer componentry and content regulation are no less important to the question of authorship than those of developer, game, and player. It is to these energies and their influence on game creation that we now attend.

determination

One of the primary determinative forces in computer game development is the software used to produce a game. Programming languages such as C++, asset development tools including Autodesk's Maya, and game engines such as Valve's Source enable what is possible in a game world, from graphical type and resolution to narrativity and artificial intelligence behaviors to network connectivity and more.[10] Such software programs are not merely creative tools, but organizational ones, mediating and shaping the desire, agency, and artfulness of the various inventors (including tool authors). Havok Physics, for example, is a tool designed to provide developers with a sophisticated collision detection system for their game worlds.[11] In so doing, the engine determines the range of potential physical interactions of objects in these worlds, and therefore effectively authors the limits of what can happen visually (assuming the game does not malfunction and transgress those limitations). In other words, like oil pastels or a fan brush, Havok Physics is an expressive technology. It structures how the creative act flows between inventor and medium in a fundamental way. It circumscribes the authorial processes that unfolds at both the initial moment of creation (how well the Hanzo FX350 drifts on a wet tarmac in *Split/Second*) and over the course of a game's development and life cycle (how the drift characteristics of all the cars in *Split/Second* [Black Rock Studio/Disney Interactive Studios, 2010] impact the overall feel of the game).

The same is true for programming languages, which transmute human interest into machine logic. As this logic is inherently binary and electrical—essentially on or off—every language must produce the same broad end result, or else there is a disconnect between the programmer's requests and the computer's ability to understand and heed them. However, there are many different programming languages to choose from, each with its own strengths and weaknesses, from small-environment optimization to web-based delivery and the ability to efficiently handle high-polygon-count models. More than mere

idiosyncrasies, these strengths and weaknesses are authorial, delimiting the dimension, direction, and delivery of design. Programming languages are carefully chosen for what they can and cannot do, that is, for what they have to contribute to the creative process. They, too, are prominent agents—that is, they have authorial agency—in the construction of the computer game medium and its messages.

At an even deeper level, computer operating systems and hardware function similarly, acting as both structuring and generative forces. Programming languages, game software, and design ideas stagnate without an environment in which to run, and this environment exerts creative pressures and offers affordances that form expressive patterns and possibilities for games and their developers. The relationship between games and their technical environments is not unlike that of driver and car, where the power train and control system both enable and prohibit certain kinds of uses (consider the ability to accelerate past a slow-moving sightseer on a winding mountain road or navigate a rutted four-wheel-drive track without destroying the oil pan). In fact, operating systems and hardware are arguably more influential in game authorship than game designers. Designers are free to imagine anything they choose, to be sure, but their imaginations must be filtered through what the machine can and cannot do. These capabilities are determined by other inventors: the people, software, and machines that design and build the graphical processing units, hard drives, memory chips, and other musculoskeletal organs that make up the computer on which a game is played. When considered from this angle, games are shaped by a raft of authors before they even reach the invention stage.

Finally to be counted among computer games' authors are those agents who contribute to the creative process through non-technical, non-gamic forces. Chief among these are the institutional organizations built to moderate and commoditize content. We mean here organizations such as the ESRB, PEGI, and the ACB (Australian Classification Board), which in determining the social acceptability of game sights, sounds, and stories also determine what is available for play and by whom.[12] In many instances, games cannot reach store shelves without the imprimatur of these agencies, and can sometimes be banned because of it. Wal-Mart, for example, does not stock games that have an AO (Adults Only) ESRB rating, a significant deterrent given that the retail chain is responsible for an estimated 20–30 percent of all US computer game sales.[13] As a result, few games are released with such a rating, meaning that the ESRB powerfully influences the aesthetic and iconographic decision-making and production processes of game developers, as well as the experiences of players.[14] In Australia, such determinative authorial forces have been even more influential. For example, it was not until August 2011 that games rated more explicit than

"MA15+"—the equivalent of "T for Teen" in the ESRB system—could get a rating other than "Refused Classification." Not only did this system effectively ban dozens of major release games each year throughout the country, but it also shaped what Australian developers would let themselves imagine lest they invent something that would never reach the marketplace.[15] Consequently, the collective authorship of the medium itself was stunted nationwide due to the blockage of globalization's homogenizing influence. Rather than engage such suicidal barriers to entry, Australian developers worked within the imposed organizational constraints and produced very few titles with mature content. And, rather than lose a place at the table entirely, international developers such as Konami, Activision, Acclaim Entertainment, and Sierra Entertainment self-censored and re-released their games for the Australian market, in essence re-authoring their completed works. Thus, much like the Motion Picture Association of America, whose rating system helped all but eliminate NC-17-rated Hollywood films, game ratings organizations speak with a profound authorial voice, even though it is not an expressly inventive one.[16]

more than a medium

While some may be willing to grant that the determinative forces noted in the preceding text—hardware, operating systems, programming languages, industry watchdogs, and so on—are key to computer game development, others may argue that, despite this fact, such forces are only peripheral and mediumic, and not authorial. Indeed, to say that NVIDIA's engineers deserve author credit for every game ever designed and played using their graphics cards, or that Brad Cox and Tom Love—the developers of Objective-C, the language that drives Apple's iOS—should be listed as co-authors on the next Godzilab iPhone game, would seem impractical if not preposterous to many. The cult of celebrity and the drive to elevate cultural and financial uniqueness above the riffraff are strong motives in mainstream media, from the reduction of movie production labor to the director and marquee headliners, to the lead singer who absorbs the limelight that might more fittingly fall on the band, the song writer, and the audio engineer.

144 This is the nature of authorial designation in the early twenty-first century. Curiously, however, almost every popular mediated expression today that pretends to art or artfulness acknowledges the interdependence of the artist and her/his influences: books that could not have been written were it not for friends, colleagues, and editors; Oscar winners who thank agents and family members; and radio hosts who acknowledge their debt to sponsors and guests. It is perhaps a sign of computer games' relative newness and innate transdisciplinary complexity

that, with rare exceptions such as Roberta Williams, Sid Meier, Will Wright, and American McGee, the computer game industry has not yet fully succumbed to such metonymies of media authorship. Instead, the game industry seems to have plateaued at the level of corporate brand: Electronic Arts, Valve, Nintendo, and so on. This is the model of industrial authorship and corporate personhood that are common in heavy industries—bulldozer manufacturing and bridge construction, for example.

Why, then, should the determinative forces of the computer game industry be considered authorial when other comparable industries do not extend that recognition to their workforces? First of all, we are not suggesting that the game industry abandon its current authorship practices. Rather, we are promoting the idea that media scholars recognize and account for the full scope of authorship upon which computer game development depends. Notably, game developers themselves routinely acknowledge this fact within the confines of their profession. *Game Developer Magazine*, one of the industry's primary trade publications, prints a monthly column by an invited developer who offers a "postmortem" of a recently completed title. Organized around a common organizational framework that includes "What Went Right" and "What Went Wrong," developers reflect on the processes of their projects, from hiring practices and development schedules to art styles and programming decisions. As an exercise that requires the modesty of the confessional combined with the sacrificial leadership skills of a soldier—*mea culpa, mea culpa, mea máxima culpa*—the postmortem showcases developers willing to acknowledge that as all the authorial voices of game development are brought together, the game itself takes a shape that none of the individuals could have accurately foretold.

Consider, for example, Bill Muehl's December 2011 "Postmortem" of the Xbox 360 Kinect game *The Gunstringer* (Twisted Pixel Games/Microsoft Game Studios, 2011).[17] In the "What Went Right" section, Muehl describes the initial thrill and subsequent stress when Microsoft decided to shift the game from an Xbox Live download to a retail release, that is, from a low-profile digital-only game to one that would receive the full force of Microsoft's marketing might, including the Kinect's signature purple game case and an international publicity campaign. With this decision came more development time, more personnel, and more money, all of which meant that the development team was able to "make more stuff and polish what had already been made, including enemy behaviors, animations, and level design content."[18] In addition to this assortment of new resources that rapidly altered the authorship of the game mid-development, Muehl also notes that a number of personnel gaps—such as not having an environment artist whose job would be to seamlessly connect the graphical assets produced by internal and external artists—meant that the team had to depend on Chief Technology

145

Officer Frank Wilson to develop on-the-fly computational solutions that would allow art assets to be quickly integrated into the game's core programming. According to Muehl, "Frank can shape the engine and toolset like putty in his soft hands, and he rapidly wrote a script that the outsourcers could run to make each asset [game engine] ready."[19] In other words, according to *The Gunstringer*'s project director, the game was authored not only by the lead developer and designer (Josh Bear and Mike Wilford), but also by an engineer who could write a custom script that would process digital images for the game engine, as well as by the external artists who had been tasked with developing some of the game's visual effects.

In an even more illustrative example of how determinative and not just inventive forces participate in the authorship of a computer game, Muehl writes in the "What Went Wrong" section of the *Gunstringer* Postmortem:

> When we're developing our games, the level that comes out of the prototyping period is functional. Under the surface, however, it's pretty much cobbled together because it's the test bed that helps us figure out what the hell we're doing. The art, design, tech systems, and features that rise to the top during prototyping are built on earlier experiments and carry the baggage of iteration. ... [We realized too late] that we'd either have to live with the [prototype's] legacy issues or rebuild it in the new system. Time was not on our side, so we decided we'd live with it, knowing full well it would give us the most headaches when we needed to change anything or started pushing it hard during QA.[20]

Here, Muehl acknowledges that not only do all the personnel and technologies have an authorial role in game development, but so too do timing and serendipity. Muehl goes so far as to suggest that because that prototype level was locked into the game due to time constraints, the entire game was affected. Ultimately, Muehl writes that "we all poured everything we had into *The Gunstringer*" and that because so many talented people had contributed to the project "the game was a lot better for it."[21] Taken as a case study, then, Muehl's postmortem makes it unassailably clear that computer games are poly-authorial in the extreme. Each contribution—large or small, simple or complex, technical or artistic—adds directly (though not always visibly) to a game's look and feel, its distinctive anatomy skinned over with a network of poly-authored textures, sounds, and story elements. In short, when it comes to game development, technologies, labor practices, and organizations write the stories just as much as the inventors do.

revelation

In this chapter, we have argued that there are always multiple authorial forces at play in computer games, and that they provide both direct and indirect influence on the creative processes. Designers, developers, and players, of course, are among a game's most direct inventors; that is, they are the agents primarily responsible for the generation of game content and play. We also showed, however, that game hardware, programming and scripting languages, operating systems, and content evaluation organizations contribute in powerful ways to the authorship of computer games, structuring, pressuring, and molding the invention and development processes to so great an extent that it is impossible not to recognize their contributions. Game authorship, then, is as much a determinative act as it is an inventive one.

That said, there are many other authorial forces at work in computer games, which is in part why the medium is so diverse. We have chosen to focus on the inventive and determinative elements, because they provide prominent landmarks for plunging into the question of authorship. These elements also nicely illuminate the mutually constitutive and thoroughly imbricated nature of game creation, which is a network of aesthetic, technological, and industrial agents and ideologies that move in concert and contestation to produce a game.

Importantly, we are not arguing that game authorship is unique or distinct from other kinds of media authorship. On the contrary, mass-mediated artifacts share all sorts of productive techniques and ideologies, as in fact they long have.[22] Rather, we have focused on games here as a way to get at what it means to author in the twenty-first century. It is to be creative, to be sure, but it is also to be collaborative and regulatory, to structure and determine as well as invent. True, authorship has always been so, with editor, press, studio, and patron influencing and at times even serving as the principal creative voice in both mass- and popular-mediated meaning-making. There are just now so many more voices that crowd the mix—especially those that are computational and recursive—that the act seems different.

The epigraph that heads this chapter speaks of this complexity quite pointedly, though from a different time and place. In an essay about André Breton's treatment of language as both magical and scientific, Octavio Paz further reminisces about an evening stroll he took with Breton in Paris, in 1964:

> That night, as the two of us strolled through Les Halles together, the conversation turned to a subject that was worrying him: the future of the Surrealist movement. I remember what I told him, more or less: that to me

Surrealism was the sacred malady of the world, like lep-
rosy in the Middle Ages or the state of possession of the
Spanish Illuminati in the sixteenth century; since it is a
necessary negation in the West, it would remain alive as
long as modern civilization remained alive, whatever
political systems and ideologies might prevail in the
future. My elation moved him, but he answered: "Negation
is a function of affirmation and vice versa; I doubt very
much whether the world that is now dawning can be
defined in terms of affirmation or negation: we are enter-
ing a neutral zone…"[23]

To Paz, close attention to a new dialectic, one emerging in Breton's
"neutral zone," where politics and ideologies are muddled and contradic-
tory, progressive and regressive, mercurial in the extreme, meant seeing
the constant maneuvering of authorship as a game. In seeing media—
for Paz and Breton, art and poetry; for us, computer games—as the
ground upon which people negotiate meanings synchronously and
asynchronously in order to author a story into being, a necessary recog-
nition emerges: authorship is always on the run. To Breton's anxiety
about the emergence of a neutral zone where Surrealism's tactics no
longer apply, Paz proposes that, viewed from the perspective of a game—
specifically, a game designed to undermine reason with play and laugh-
ter—art's ashen tail would always be headed by a fiery chaotic head
"revealing what is hidden, bringing the buried word back to life, calling
forth our double, that Other which is us but which we never allow to
exist—our suppressed half."[24] Thus, to understand the art of computer
game authorship requires more than an examination of the final product,
the realized, manifest story of creation within this new medium; it neces-
sitates what Paz and Breton tellingly call "revelation," an unearthing of the
marvels previously hidden by the automata of commerce, the crush of
law, and the frenzy of desire. Under the edict of revelation, then, if art is a
game, then the game—including the computer game—must by defini-
tion number among its multitude of authors, inventors, and determiners
alike.

notes

1. Octavio Paz, *Alternating Current* (New York: Arcade Publishing, 1990), 55.
2. The idea of the "wicked problem" originates with designer Horst Rittel and
 urban planner Melvin Webber. In a 1973 article in *Policy Sciences*, they pro-
 posed that certain kinds of social policy issues are "wicked," that is, they
 have no right answer but can only be solved and resolved based on the latest
 needs, innovations, and exigencies. See Horst W. J. Rittel and Melvin M.
 Webber, "Dilemmas in a General Theory of Planning," *Policy Sciences* 4 (1973),
 155–69.

judd ethan ruggill and ken s. mcallister

3. For more on the ESRB and PEGI, see http://www.esrb.org and http://www.pegi.info, respectively.

4. Don Tapscott and Anthony D. Williams, *Wikinomics: How Mass Collaboration Changes Everything* (New York: Portfolio, 2006).

5. Tapscott dubiously takes credit for this concept. In their chapter "The Prosumers: Hack This Product Please!," Tapscott and Williams write, "In his 1996 book, *The Digital Economy*, Don introduced the term 'prosumption' to describe how the gap between producers and consumers is blurring" (125). They acknowledge in a note that Alvin Toffler had in fact coined the term nearly 20 years earlier, but they miss that this concept had become central to Marshall McLuhan's work by the early 1970s. See, for example, Marshall McLuhan and Barrington Nevitt, *Take Today: The Executive as Dropout* (New York: Harcourt Brace Jovanovitch, 1972).

6. For more about *Pro Tools*, see http://www.avid.com/US/products/family/pro-tools. For information about Vectorworks Landmark, see http://www.vectorworks.net/landmark/index.php.

7. In *Black & White*, the player acts as a deity, and is given an animal—the Creature—as a familiar and underling. The Creature can be taught all manner of tasks, as well as be rewarded for good behavior and castigated for bad. The Creature learns from these interactions, and modifies its behavior over time in response. Similarly, the player's acts, as they average out over a continuum of good and evil, and cause the game environment—ground, sky, vegetation, architecture, and so on—to change. The more "good" the player does, the brighter and greener the environment; the more "evil," the darker and more desolate the game world becomes.

8. The computer game medium has been personalizable since it was first commercialized, and likely even before. Atari's *Tempest* (1980), for example, included the Skill-Step play system, whereby the player could select the opening level and thus the difficulty of the game. For details on Skill-Step, see: Atari, *Tempest: Operation, Maintenance and Service Manual* (Sunnyvale, CA: Atari Inc., 1981).

9. Games tend to be heavily played during their development, as well. This play is done by workers—often called play testers—whose job it is to make their ways through the game and report on its strengths and weaknesses. These reports are then used to help improve the game prior to its commercial release. Sometimes, a game's development period will include an "open beta," whereby the game is made available for a limited time to the general public for play testing.

10. For more information about C++, Maya, and Source, see http://www2.research.att.com/~bs/C++.html, http://usa.autodesk.com/maya, and http://source.valvesoftware.com, respectively.

11. Details on Havok Physics can be found at http://www.havok.com/products/physics.

12. Information about the ESRB can be found at http://esrb.org. Information about the PEGI system can be found at http://www.pegi.info. Information about the ACB can be found at http://www.classification.gov.au/www/cob/classification.nsf.

13. Although Wal-Mart only agreed to provide point-of-sales data to market research firm NPD in February 2012, respected industry analysts such as Michael Pachter, as well as NPD estimates from previous years, have fairly consistently estimated that Wal-Mart is currently in the range of

20–30 percent. See Eric Caoili, "Walmart Provides Coveted Sales Data to NPD's Retail Reports," February 3, 2012, accessed May 20, 2012, http://www.gamasutra.com/view/news/40092/Walmart_provides_coveted_sales_data_to_NPDs_retail_reports.php; and Harold L. Vogel, "Playing the Game: The Economics of the Computer Game Industry," n.d., accessed May 20, 2012, http://www.fathom.com/course/21701761/session1.html.

14. The ESRB lists 24 games in total that have received an AO rating, accessed May 20, 2012, http://www.esrb.org/ratings/search.jsp?titleOrPublisher=&rating=AO&ratingsCriteria=AO&platforms=&platformsCriteria=&searchVersion=compact&content=&searchType=title&contentCriteria=&newSearch.x=30&newSearch.y=6.

15. For details, see "Final Report: On the Public Consultation on the Possible Introduction of an R18+ Classification for Computer Games" (Commonwealth of Australia, 2010). According to this report, "Computer games that are unsuitable for a person under 15 to see, must therefore be classified Refused Classification (RC). These games may not be sold, hired, exhibited, displayed, demonstrated or advertised in Australia" (4).

16. For a detailed explication of the MPAA's role in the decline of NC-17 offerings, see Kevin S. Sandler, *The Naked Truth: Why Hollywood Doesn't Make X-rated Movies* (New Brunswick, NJ: Rutgers University Press, 2007).

17. Bill Muehl, "Postmortem: *Gunstringer*," *Game Developer Magazine* 18.11 (December 2011), 18–24.

18. Muehl, "Postmortem: *Gunstringer*," 21.

19. Muehl, "Postmortem: *Gunstringer*," 22.

20. Muehl, "Postmortem: *Gunstringer*," 24.

21. Muehl, "Postmortem: *Gunstringer*," 24, 21.

22. In *Hollywood and Broadcasting: From Radio to Cable* (Urbana: University of Illinois Press, 1990), for example, Michele Hilmes describes the even, free-flowing, and longstanding exchange of talent and technique between the US film and broadcasting industries as they developed over the course of the twentieth century. As a result of this cross-pollination, the industries grew to have a great deal in common.

23. Octavio Paz, "André Breton or the Quest of the Beginning," *Alternating Current* (New York: Viking Press), 47–59.

24. Paz, "André Breton or the Quest of the Beginning," 51.

abductive authorship of

the new media artifact

n i n e

g r e g o r y t u r n e r - r a h m a n

Digital productions can take a plethora of forms that defy simple classifi-
cation. Stories, formal aesthetic efforts, and even ideas and data can be
and often are presented as an inter-mediatory experience extending
well beyond the confines of an original product. To complicate matters
further, original concepts quickly evolve as subsequent contributors
remix them. Theorist Lev Manovich describes new media authorship as
a result of various types of collaboration.[1] I will augment this key notion
of collaboration by invoking additional attributes: auto-theoretical reflec-
tion and trial-and-error as technoetic exploration. Situating these personal
actions in a networked system re-centers the individual, yet reveals
nothing less than "abductive authorship" marked by one's distinct explor-
atory interactions with seemingly limitless digital toolsets and the sponta-
neity of communal discourse.[2] In networked environments, creative
dynamics challenge notions of authorship by moving away from a final-
ized, packaged commodity fixed for consumption. Authorship is not

just a concerted effort to produce a particular mediated product, but a conglomeration of interactions.

Many new media texts, then, exist as evidence of their production, as explorations of expression, or merely as a record of events, and thus may only have significance to their creator or a particular community. Consider how most of the 60 hours of video uploaded to YouTube every minute will have a limited audience. While those productions may only have meaning for the authors, subsequent sharing and remixing allows others to derive their own meanings. The reworking of auto-theoretical texts reveals conditions that are ephemeral, at times unpolished and of a process-oriented nature.

A review of the Demoscene, an early creative community known for procedural motion graphics, reveals how their interactions—both in the physical and virtual worlds—along with exploratory efforts produce work that is largely outside of commercial interest. The practices of Demoscene participants culminate in expressive visual presentations that are more than mere programming or aesthetics; they are complex assemblages of interactions. The following sections will explain how experimentation, play, dialogue, and even error define not finished products of capital but instead individual expressions of experience and subjectivity.

from product to ecology

"New media" is a blanket term describing creative works that use digital tools—generally referred to as information and communication technologies (ICT)—for both production and distribution. Interactive electronic artworks, animations, and procedural computer graphics are but a few types of projects that fall under this domain of digital productions. These projects can also be the very spaces of interaction (websites, blogs, portals), and can include any creative work digitized and presented electronically. Digital works are incredibly diverse in their relationships between authors, audiences, software interfaces, production methods, various included media, and even material artifacts.

These creations are, therefore, complex expressions of both personal and collective interactions with and through a mediated set of tools.[3] Remixing, sampling, selection, and synthesis of a variety of media are key aspects of production facilitated by the technology.[4] An individual's creative process is, therefore, tied to the work of others. The technological is explicitly socio-cultural and political; collaborations between people, people and technology, and the resulting collection of intermediated experiences reveal that the dynamic nature of interactions across the network have the potential to define nothing less than fluid, alternative

subjectivities. If exploration and experimentation are dominant modes of making meaning or even of defining the self, the entire ecology has transformative qualities. To engage with the process is to explore what it means to be in the broader mediated environment, and with that comes a de-emphasis on a final product as the individual experience becomes more valuable. At its most elemental, creative personal expression is a record of interactions—both mediated and otherwise—across a number of independent spaces that extend beyond a corporate model or influence. Parallel or alternative environments such as personal websites, peer-to-peer sharing, real-world maker labs, and creative collectives provide venues for interactions.

Gilles Deleuze and Félix Guattari explored the role of the autonomous individual as creative producer in an expanded field of politically charged potentialities using the rhizome as a way of conceptualizing alternative power relationships. Arguably, the dynamic nature of networked ICT mirrors the rhizome. Thus, a multiplicity of interactions potentially allow for the *de-territorialization* or refiguring of relations defining the subject.[5] Matthew Fuller's media ecologies take Deleuze and Guattari's notions further by allowing for the subject to emerge from actions within the network.[6] Individual expressions and constantly emerging alternative subjectivities are the sum of interactions. Fuller sees the political ramifications and outlines the instances wherein the individual and collective expressions create alternatives to repressive or restrictive systems.

Recent efforts have built upon these notions to include media ecologies as creative assemblages of concepts, practices, material environments, and individuals.[7] I am relying on Fuller's concept of media ecology to trace the varying transformative forces marking the multivariate means of engaging with and creating a work so as to highlight how the reading of that product now extends beyond the actual story, image, or interactive experience. Included is all the work on the periphery including interactions between creators, audiences, and even the broader physical environment. Far from de-centering the individual, new media ecologies maintain networks between constituents that may be in a constant state of becoming.[8] As one explores the range of available media for inspiration or remixing and begins to craft one's own story, the media ecology expands to include all interactions and technological tools. New combinations of devices and situations and the subsequent mediated interactions help the creative producer to construct some alternative self-representation or give relevance to a personal aesthetic approach. Exploration through open-ended methods, such as trial-and-error, allow one to better understand creative action and expression within these dynamic systems.

trial-and-error as discursive, creative, and technoetic action

A significant factor in any human production is error. In terms of aesthetic exploration, error is often considered an indicator of amateurism. Perfection, therefore, masks years of training and is used to define a type of aesthetic autonomy.[9] Error is often something to be mitigated. However, Alan Singer, in the essay "Beautiful Errors," argues that error makes explicit the rationality of an artwork's expressive powers. Singer posits that error is always in tension with canons of aesthetic perfection, and thus a possible "salutary link between the aesthetic and rational cognition."[10]

Like Singer, I maintain that error, in its cognitive role, makes explicit alternative potentialities. Similarly, digital tools enable constant creative re-evaluation. As Petran Kockelkoren describes, the conditions for *technoesis*—meaning-making through technologically enabled interactions—require more than just a consumptive engagement.[11] Playful exploration demarcates limitations. In terms of digital production, the act of continually revisiting potential solutions gives a more sophisticated and nuanced understanding of one's own work and the how the machine might facilitate achieving a particular result. Kockelkoren, for instance, argues that, as artists "domesticate" technologies, the individual is re-centered after an initial technological de-centering.[12] I'd take this argument further: The act of engaging in creative trial and error facilitates an individualized account of the expressive potentialities of sophisticated combinations of tools.[13] Implicit here are all the political ramifications of such expression. To make meaning requires an open environment that may be in conflict with intellectual property regimes, for instance. While sharing appropriated popular media as personal expression has become a political gesture, remixing offers individualized meaning-making. In terms of structural references, prior media provides models of how one can utilize and personalize expressive technologies.

The first generation of web designers and multimedia producers, in particular, strove to define and make sense of expression in the new media environment.[14] Designers employed the book, the graphic design artifact, film, and prior technological interfaces as cultural references, yet there was a sense of the uniqueness of the early web. New contexts, capabilities, and opportunities required exploration through trial and error. This meant "zooming" from code (such as HTML, the language used to construct web pages) out to visual interfaces and then out again to a more abstracted level of cultural interaction.[15] The connections and communities that were, in turn, fostered by this early generation's products (threaded discussions, forums, listserves, inspirational websites) further augmented production processes. Connecting through those networked environments and tools, media producers shared their

open-ended experimentation and established a feedback loop, perhaps enabling a deeper engagement with the technology and one another. The resulting set of experiences quickly defined the individual's understanding of limitations and possibilities of the mediated expression and, more importantly, of one's interactions. Early web design is marked by a period of intense experimentation that ended with the codification of design practices brought on primarily by the interest in website usability. What remains of those early interactions are tools that enable sharing of inspirational work.[16]

Appropriating prior media and experimenting with it, as opposed to creating from scratch, shifts one's view or understanding by tying it to the work of others. Online forums and even casual conversation serve the broader creative community by potentially extending the work beyond the original producers. Discussions of errors and solutions can become extensions of the projects themselves and provide additional recognition for the creator. Communal discourse alone can also influence a production. For example, in an online forum dedicated to a particular programming language, a discussion may prompt someone to contribute a bit of code. Like media, lines of code can be shared, modified, and tested once placed in a project, thus programming never happens in a vacuum. Trial and error relies, in part, on the abundance of accessible, manipulatable, existing media, including that relating to individual production processes. Snippets of another's work or even personal methodologies can be borrowed. Authorship, whether cited as such or not, is more often than not casually collaborative.[17]

In terms of off-the-shelf technology, the average end-user rarely considers errors as tools or, more directly, how the machine makes a significant contribution to any digital production. Younger generations of digital producers often begin working with new applications through play and experimentation before relying on help-forums and related support discussion lists. In interviews I conducted, many young web designers, for instance, described a need to get a general understanding of the software and hardware (such as graphics tablets, digital cameras, sound recording devices) before beginning to work with them in earnest.[18] Loaded with options, modern interfaces require a mode of exploration based on constant re-evaluation.[19]

The use of error in this way is, of course, not a novelty or a byproduct of new media alone. What is unique about this type of environment is how facile error correction also alters the author's understanding of the potentialities of the work. A feedback loop of production supports casual yet expansive search for alternative modes of reference. By this, I mean that any prior product or shared methodology can be brought into a production, tested, easily evaluated, and, if need be, disposed of without destroying the previous iteration. Interactions with software, for example,

are through an interface often designed on the principle that the user experience should be simple, and yet provide powerful options. More importantly, software allows the project to be manipulated in an open-ended manner. There is no single solution to any given problem. The result is an overwhelming number of possible combinations of tools. The digital author is apt to be in a consistent mode of engagement with tool combinations and possible overall solutions including the incorporation of glitches or more experimentation to work around an error. Constant re-evaluation is facilitated by the software tool options, including something as mundane as the "undo" button.

While the "undo" feature is often taken for granted, it is arguably the most significant instrument in the creative toolkit.[20] Undo is more than mere negation of prior action; it is a re-opening of an immeasurable number of options—aesthetic or otherwise. This allows for fluidity and consistent indecisiveness to be hardwired into the workflow.[21] The author is constantly making micro tweaks to a product because the play of options affords an endless variety of results and tantalizing hope for a uniquely beautiful or innovative solution. Combinations of processes—again a product of engaging an error or limitation and playing with possible results—encourage instances when unplanned effects begin to change the formal qualities of a work. If error is an unintended result that, more often than not, will be discarded, then production processes are now mitigated by a mode of authorship in which the creator engages in a re-iterative dialogue with the products and the toolset. Established production techniques themselves are subject to re-evaluation.

While workflows and processes have become more or less codified in, say, mainstream film and television, error and experimentation, in the most radical way, become what gives form and meaning to the digital artifact. Many creative forums offer communal critiques and tutorials allowing anyone to share their different methodologies. Expanded behind-the-scenes explanations become as valuable as the actual work. Tutorials often open dialogue between the professional and the novice; yet, in many instances, shared solutions and high-quality-deemed experiments blur or make such distinctions meaningless. One person's error is another's potential solution. Thus, exploration and its resultant effects can be and often are shared products in themselves. For example, *datamoshing* is a technique that uses video compression artifacts as visual effects. Compression artifacts are visual symptoms of technical problems. Datamoshing is an example of an error made an active element, a key visual quality.

Errors that provide new and unintended creative openings also obliterate the distinction between professional and amateur, because control is given over to the technology itself. Glitches, for instance, have received some recent attention for their surprising aesthetic potential.[22]

Unplanned and often the unintended result of complex systems, glitches are perhaps the purest form of abductive design. Glitches are traces of procedural malfunction, and the resulting digital artifact is a reflection of all the processes, intentional or otherwise, that constructed it.[23] When the digital producer incorporates a glitch or even merely acknowledges its aesthetic function, one is creating a work that does not follow a prescribed mode of production or prior reference and thus the work is a trace of her experiences. The auto-theoretical work is both an indexical sign of its own production and an indicator of the author's understanding and appreciation of her own interactions and production methods.

in and of itself: the auto-theoretical text

Auto-theoretical works provide evidence of their creation and are dynamic forms revealing traces of the author's experiences within the broader new media ecology. Auto-theoretical texts require that the producer or community of producers engage in some sort of individual or shared theoretical reflection.[24] Theory, in this instance, is a set of ideas circumscribing one's actions in the new media environment. As we have outlined in the preceding text, new media products are often playful conglomerations of shared interactions and spontaneous creative acts, including the incorporation of glitches or errors. Auto-theoretical texts may or may not be designed for an external audience, as play is the force that gives this work its significance. Play is freedom to create something out of the ordinary,

Figure 9.1

New media artist Robert Overweg captures the surreal beauty of video game glitches as seen in his work *Facade* (2010).

and yet, along with trial and error, creates order.[25] If trial and error is the standard mode of technoetic interaction, play is a broader, more expansive expression and as such the text may not be presented in traditional narrative structure or even as cogent visual presentation. The auto-theoretical project can take any form, including those that mimic well-established media types. Returning to the discussion of YouTube, it is safe to say that many of the videos shared online have some qualities of traditional filmic narrative, yet may not resonate with larger audiences because they are more or less personal expressions. Perhaps the shared product is capturing a moment, an event, or a performance. Regardless, that video becomes part of the broader community as a trace of both social and technological interaction. It can be ignored or received as an object to be studied or as piece of re-mixable media to be made personally relevant. Either way, it does not matter. The media object is thrown into the broader ecosystem, but its significance varies for each viewer and its meanings are fluid.

If the creative ecology is composed of many evolving and reworked auto-theoretical texts, dynamic exploratory acts help to re-center the individual or to make sense of that ever-shifting environment. Play enables a consistent mode of becoming. While the auto-theoretical text may only give evidence of the author's past actions or intentions, as a trajectory of change, the only way to truly understand the work is to make it something of one's own. There are no fixed rules, and each text exists in its own self-contained identity. In play, the networked product can function simultaneously as a learning tool, social nexus, and living document.

It makes sense, then, that the dynamic nature of the shared visual projects, methods, and ideas are difficult to commodify. The creative product in the digital production ecosystem becomes a reflection of the processes and principles shared among producers. Communal aesthetic explorations can take a host of forms, often highlighting their ephemerality. One such example is *layer tennis*, a game that pairs designers in a "competition" of creating and re-interpreting an image in a reiterative manner. A layer tennis match begins when one designer creates an image or very short film or animation. After completing this draft, the artifact is shared with another designer, who alters it, eventually returning it to the original designer. The various iterations show the creative act as a trace of an individual's methodology and expression. For the audience and the designers, the experience of participation, the communal dialogue, is revealed in the resulting collection of baroque visual improvisations. Other older digital creative communities, such as the Demoscene, have similarly used improvisational creation as a method of exploring the technology and community building in both virtual and physical gatherings.

the demoscene

The Demoscene is an early creative community defined by its real-time motion graphics. *Demos* (or *intros*) were initially small introductory animations that displayed the pseudonyms of individuals or teams who had bypassed the security of software applications. The Demoscene evolved throughout the 1980s and 1990s to the point that demos became unique cultural objects. Demoscene teams—composed of a computer programmer, musician, and designer or "graphician"—meet in large gatherings called Demoparties to compete by fashioning lines of code into lavish motion graphics set to equally elaborate music. Demoparty participants engage in a friendly competition, eventually sharing and ferreting out work that is either the most visually resplendent or contains the quickest code compacted to a particular file size.[26] Although the goal is to have one's work recognized, Demoparties are social gatherings where participants share knowledge and their works-in-progress. Demoparties' competitive yet cooperative creative production happens in small communities that resist, to a fair degree, commercial influence or outright co-optation.[27]

As a prototypical creative community, the Demoscene thrives in and mirrors an ecosystem centering on "collective improvisation" and "public collaboration" among other attributes.[28] The Demoscene's practices are, however, derived from other longstanding technology-oriented subcultures. There is a direct connection to prior hacker cultures and academic computing before that. The notion that information can be shared or that one is judged on his or her skills are key principles in the hacker's code.[29] Like early hacker communities, Demoscene participants are networks of tinkerers. This historical connection makes explicit new media authorship as a result of playful exploration and perpetual engagement with the myriad options provided by digital tools and the collaborative environment.

Although over 30 years old, the Demoscene remains important to the discussion of new media authorship as the work shows an overlap of information technologies and filmic media in an auto-theoretical manner. Contemporary demos often tout the programming and artistic skills of their creators while at the same time referencing scientific visualization, video game cinematics, and movie trailers. Regardless of the visual pastiche and glossiness of the visuals, they maintain a character of their own. Demos are often the result of shared dialogue and private explorations, yet become traces of the collective set of experiences or the visual remnant of reiterative production processes. Abductive authorship, as I argue at the outset of this chapter (and the Demoscene as exemplary for the way I understand this concept), centers on the loss of control to the discourse, the toolset, and the experimental play.

It is the new media ecology that delineates a Demo's auto-theoretical conceptual–aesthetic framework.

conclusion

The Demoscene's auto-theoretical projects are not commodities, nor may they make much sense to a viewer outside the community. Demos do not often follow traditional narrative but are their own unique form of documentation. As expressions of programming and artistic skill, they are a beautiful record of experiences. Yet, Demos are put together by teams of individual producers who are themselves dynamic traces of interactions. The new media environment, as exemplified in the Demoscene, runs counter to capital. Expression and artistic production are part of a complex dynamic of technical and material interactions, social sentiment, and shared information. A remarkable aspect of the Demoscene is that it retains its uniqueness. While highly skilled participants have gone on to work in the video game industry, for instance, the communities seem to respect the demo as a unique artifact. In some ways, the goal of competitions at demoparties, to create beautiful, small, and fast-running motion pieces, is only a smaller part of larger motivations centering on social exchange, experimentation, and play.

Early web design worked in a similar fashion. As mentioned earlier, some experimentation resulted in the very online spaces and tools that helped disparate communities connect and interact. This included communal projects that encouraged sharing of techniques and aesthetic approaches. As the web became more a marketplace during the boom of the 1990s, exploration and play came into conflict with corporatized efforts to manage the user's web experience. What resulted was a bifurcation of practices. Web design has, for the most part, become a codified practice, while more experimental work has become the domain of net artists or, as I have argued here, been absorbed into the broader creative field in the new media ecology.

notes

1. Lev Manovich, "Who Is the Author? Sampling/Remixing/Open Source," http://www.manovich.net/DOCS/models_of_authorship.doc, accessed July 30, 2011.
2. I am borrowing and modifying the term "abductive" from Charles Sanders Peirce. Abductive reasoning is tantamount to judgment based on inference from data. For my argument, abduction is a result of understanding the environment in which one works. Abductive authorship is a mode of creating work that is dependent on and inseparable from the dynamic qualities of the system within which the text was created.

gregory turner-rahman

3. Lev Manovich, *The Language of New Media* (Cambridge, MA: The MIT Press, 2002); Mariano Longo and Stefano Magnolo, "The Author and Authorship in the Internet Society," *Current Sociology* 57, no. 6 (November 1, 2009), 829–50.

4. Manovich, *The Language of New Media.*

5. Gilles Deleuze and Félix Guattari, *A Thousand Plateaus: Capitalism and Schizophrenia* (Minneapolis: University of Minnesota Press, 1987).

6. Matthew Fuller, *Media Ecologies: Materialist Energies in Art and Technoculture* (Cambridge, MA: The MIT Press, 2005).

7. Phoebe Moore, "Subjectivity in the Ecologies of Peer to Peer Production," *The Fibreculture Journal* 17 (2011), 82–95, accessed May 23, 2012, http://seventeen.fibreculturejournal.org.

8. Moore, "Subjectivity in the Ecologies of P2P Production," 85.

9. Alan Singer, "Beautiful Errors: Aesthetics and the Art of Contextualization," *boundary 2*, vol. 25, no. 1 (1998), 7–34.

10. Singer, "Beautiful Errors," 9.

11. Petran Kockelkoren, *Technology: Art, Fairground and Theatre* (Rotterdam: NAi Publishers, 2003), 31–35.

12. Kockelkoren, *Technology*, 31.

13. Gregory Turner-Rahman, "Doing-Making-Meaning: Processual Visual Literacy in Recent Digital Cultures," in *From Power 2 Empowerment: Critical Literacy in Visual Culture. Proceedings of the 2008 International Conference on the Critical Examination of Visual Literacy, Dallas, Texas, USA, June 6 and 7, 2008* (Dallas: University of North Texas, 2009), 50–61.

14. Turner-Rahman, "Doing-Making-Meaning," 54.

15. Turner-Rahman, "Doing-Making-Meaning," 53.

16. Gregory Turner-Rahman, "Parallel Practices and the Dialectics of Open Creative Production," *Journal of Design History*, 21, no. 4 (2008): 371–86.

17. Manovich, *The Language of New Media.*

18. From 1999 until 2003, I conducted a number of interviews and surveys of designers and digital artists. For additional information about this virtual ethnography project, see http://www.webpages.uidaho.edu/~gtrahman/aboutbaroque.html.

19. Peter Lunenfeld, *Snap to Grid: A User's Guide to Digital Arts, Media, and Cultures* (Cambridge, MA: The MIT Press, 2000); Turner-Rahman, "Parallel Practices," 378.

20. Turner-Rahman, "Parallel Practices," 378.

21. Rick Poynor, *No More Rules: Graphic Design and Postmodernism* (New Haven, CT: Yale University Press, 2003), 96.

22. For instance, Robert Overweg, new media artist and virtual photographer, captures video game glitches resulting in surreal scenes of floating staircases, empty scenery, and characters walking while embedded in virtual cement. Another artist, Yoshi Sodeoka, uses static and distortion as the primary aesthetic elements in his video works. In both instances, these glitches are errors wholly outside of the author's influence. Overweg and Sodeoka have two different approaches to using glitches in their productions, but they share an appreciation of the glitch aesthetic and a willingness to give control over to the machine.

23. For a comprehensive review of error as a characteristic of contemporary new media aesthetics, see Mark Nunes, ed., *Error: Glitch, Noise, and Jam in New Media Cultures* (New York: Continuum, 2011).

24. I am appropriating the term "auto-theoretical" from Stacey Young. Young defines auto-theoretical text as those advanced by marginalized women wherein the author engages in theoretical reflection, thus advancing a personal account of her struggle. See Young, *Changing the Wor(l)d* (New York: Routledge, 1997).

25. Johan Huizinga, *Homo ludens; A Study of the Play-element in Culture* (Boston: Beacon Press, 1950). See also Paul Rand, "Design and the Play Instinct," accessed April 20, 2012, http://www.paul-rand.com/foundation/thoughts_designAndthePlayInstinct/#.T5GhLphuHzJ.

26. George Borzyskowski, "The Hacker Demo Scene and Its Cultural Artifacts by George Borzyskowski." Vincent Scheib—Homepages. http://www.scheib.net/play/demos/what/borzyskowski (accessed July 25, 2006).

27. Some Demosceners claim, however, that the Demoscene is no longer a vital community, and that commercial sponsors of *compos* (competitions) have corrupted the community's original ethos.

28. John Sobol, "Demoscene and Digital Culture," in *The Sharpest Point: Animation at the End of Cinema*, ed. Chris Gehman and Steve Reinke (Toronto: YYZ Books/Ottawa International Animation Festival/Images Festival, 2005), 206–208, 225–26.

29. Steven Levy, *Hackers: Heroes of the Computer Revolution* (Garden City, NY: Anchor Press/Doubleday, 1984).

creative authorship

self-actualizing individuals and

the self-brand

s a r a h b a n e t - w e i s e r a n d
i n n a a r z u m a n o v a

In 2008, a *New York Times* article, titled "Sorry, Boys, This is Our Domain," proclaimed that, according to a Pew Internet and American Life Project study, "among Web users ages 12 to 17," girls blog and create their own web pages significantly more than boys.[1] Reporter Stephanie Rosenbloom declared that "the cyberpioneers of the moment are digitally effusive teenage girls." The terrain conquered by these cyberpioneers? The blogosphere (and its videostreaming complement, the vlogosphere). The number of teenage bloggers nearly doubled from 2004 to 2006, and almost all the growth was because of the increased activity of girls. The article speculated as to why this may be so, citing academic Pat Gill, who argued that "Girls are trained to make stories about themselves." As Gill continued, from a young age, girls learn "that they are objects … so they learn how to describe themselves. Historically, girls and women have been expected to be social, communal and skilled in decorative arts."

Unlike boys, Gill asserts, girls are more confessional and emotional, and these personality traits carry through in online activity, leading to what she calls "the feminization of the Internet."

Yet, the feminization of the Internet is not simply a mapping of gender onto an already established technological framework. "Sorry, Boys" appeared in the Fashion and Style pages of *The New York Times*, not the Technology section (where it might have seemed more appropriate, given it was based on a study about technology usage). The idea of girls using the web more than boys as a site for creative authorship is already bound by conventional notions of what, and who, girls *are*—fashionistas, make-up artists, stylists, and most of all, shoppers. So while this may be a "new" moment of girls using technology more than boys, the increasing use of the web by girls also preserves a historical discourse that understands girls as "objects," and thus positions them as knowing "how to describe themselves." However, this "new" moment is, nonetheless, a shifting concept of gender arrangements where visibility and self-description are understood as conduits for empowerment. In this chapter, we examine this kind of online authorship by girls where confessional culture provides a backdrop for a version of authorship of the self. In this context, we understand gendered authorship as the practice of curating the self through a commoditized confessional, in order to produce a branded self that is evermore normalized and compliant with the conditions of post-feminist visibility. That is, we are primarily interested in the ways in which authorship is articulated though post-feminist consumption and its attendant normative femininity, both of which are functions of a neoliberal cultural ethics of individualism, and entrepreneurial visibility.

For the purposes of this discussion, we understand neoliberalism as the increasing marketization of all aspects of public and private domains, which reduces most interactions to the principles of the free market and works to eliminate financial and cultural investments in the social body. Without rehearsing all the tenets of this prevailing economic philosophy in the contemporary moment, we focus here primarily on neoliberalism's mobilization of competitive individualism in conjunction with what is often imagined as freedom. As David Harvey, among others, has pointed out, the notion of individual freedom, however vague and variably deployed, is fundamental to the set of ideas that comprises neoliberal thought.[2] This philosophy stipulates "that the individual in competition with other individuals for resources is the irreducible unit of human experience," making property accumulation a fundamental right.[3] While there are varied definitions of neoliberalism (and it certainly doesn't mean the same thing in all contexts), here we focus on the features of a neoliberal culture that privilege individualism and construct citizenship as a subjectivity founded in allegiance to consumption as the primary mode of democracy.

Contemporary gendered authorship, as we understand it, is thus enabled by this neoliberal context. More specifically, it operates and inevitably competes in a media landscape where the conditions of gendered visibility are governed by an ethos of post-feminism. Post-feminism can be seen as many things: as ideologies, a set of practices, consumption habits, and strategies. Post-feminist culture engages feminist values, and then re-routes these values as trendy style politics, as a way of repudiating feminism's pursuits of social justice. Post-feminism is also what Rosalind Gill calls a "sensibility" that shapes everything from products to media representation to digital media by privileging the individual entrepreneur and personal consumption practices, thus providing the ethos for specific women to be "empowered" through their own visibility, individual choices, and self-promotion.[4] Angela McRobbie calls this engagement of feminism by contemporary culture "feminism taken into account" because it is a process in which feminist values and ideologies are initially considered but only to be found passé, and thus renounced.[5] McRobbie characterizes this dynamic—acknowledging feminism only to discount it—as a "double-movement," noting the paradox of how the dissemination of discourses about freedom and equality provides the context for the retrenchment of gender and gendered relations. Importantly, post-feminism relies on the visibility of (specific) women, thus trading on the politics of visibility historically fought for in feminisms. Post-feminist visibility, however, is about privileging the individual entrepreneur and a conventionally feminine body.

Following Gill, we see a fit between a post-feminist subject and a neoliberal subject: "At the heart of both is the notion of the 'choice biography' and the contemporary injunction to render one's life knowable and meaningful through a narrative of free choice and autonomy—however constrained one might actually be."[6] Additionally, the "choice biography," or what we are calling post-feminist authorship, is enabled in the contemporary moment by the presumed freedom of digital spaces. The increasing normativity, and even championing of interactivity in online spaces, has provided the mechanism through which female authors speak, hone, and stage their identities in a post-feminist context. Consequently, feminine subjects are at once neoliberal entrepreneurs, reliant on the ethos of competitive individualism, compulsive managers of a self-brand, and subjects who rely on post-feminism to claim empowerment through visibility. Through these intersecting dynamics, divisions between authorship as critical practice and authorship as self-branding are increasingly blurred, calling for a closer exploration of what is at stake in this relationship.

To illuminate these dynamics, we examine "hauler" videos and the community these videos cultivate online. Haul videos are homemade videos posted on YouTube, where young (mostly white) women film

themselves displaying their "hauls" of various consumer items they have purchased, all having to do with crafting a feminine self: clothes, make-up, jewelry. The haulers position themselves as particular kinds of experts, and offer advice to viewers, a sort of authored guidebook on what to buy.

authoring the (post-feminist) self

What, really, does it mean to author the self as post-feminist in the context of digital interactivity? This kind of authorship requires a shift away from understanding autobiographical creative activity through exclusively traditional practices, where creative activity is usually couched within writing practices—the author of a novel, of a film, or a song. While these practices remain central, other definitions of authorship are animated and enabled by new technological platforms. The "writing" component of authorship is thus not obsolete, but rather expanded in the contemporary digital context. Indeed, we retain some of the conventional terms associated with authorship as a way to demonstrate how the terrain upon which these terms rest has shifted with new technological formats and shifted understandings of gender "empowerment."

The "digitally effusive teenage girls" about whom Rosenbloom wrote in 2008 have established themselves, five years later, as "cyberpioneers." Creating make-up YouTube tutorials and producing haul videos are routine activities for many girls aged 13–18 (within particular class parameters), and reading or watching these productions is even more normative. Not only a habit or a form of entertainment, however, these online activities are understood as lucrative career choices. Crafting one's personal identity in front of a web-cam by applying make-up and displaying fashion purchases is not positioned as narcissistic, but rather empowering, precisely because these activities nurture the promise of an entrepreneurial future that may include corporate partnership and sponsorship, fashion blogging, and paid product reviews. The notion of empowerment authorized inside these spaces is constitutively and exclusively linked to feminine consumption and the subsequent branding of that consumption on one's body. The girls who participate in these activities are "empowered" to use their creative voices—indeed, to articulate their "authorship"—as a way to establish themselves as particular kinds of cultural experts. That is, they are authorized as arbitrators of "girl-next-door" tastes, experts of efficient mall-shopping and bargain prices, and approachable adjudicators of the vagaries of the fashion world. This context is structured doubly by post-feminism and the culture of interactivity, both of which are normalized under the logics of neoliberalism.[7] The cultural scripts of these media productions, authored by young, media-savvy girls, are written through the

sarah banet-weiser and inna arzumanova

vocabulary of visibility, made legible through practices of narrative and autobiography.

Considerations of authorship and autobiographical articulation have a history with particular purchase among feminist scholars and writers, many of whom have cited these practices as important challenges to the silence typically imposed on female subjects.[8] Within different iterations of feminism, the concept of authorship has been crucial; "voice" and authority over one's voice have been historically denied women, especially working-class women and women of color. Authoring a creative production—whether writing or filmmaking or, now, authoring within digital media—is about claiming a space to express oneself, and through that claiming, establishing oneself as an expert of a particular field of knowledge. Feminist autobiography is thus not simply about expressing oneself, but about claiming power, resolutely declaring oneself to be a particular kind of subject, an "I," that claims subjectivity by rejecting objectivity. However, in a neoliberal digital culture, the ground of feminist authorship's "I" has shifted. The "I," situated within the contemporary moment, or the "I" of *post-feminist* authorship, is also tethered to voice, but what a voice is, and how it empowers, is inextricable from the current economy of recognition and visibility. The "I" in feminism, in other words, has shapeshifted in the contemporary era, to become the "I" in post-feminism. Contrary to historical versions of feminism, in post-feminism, "I" claims objectivity by rejecting (feminist) subjectivity. In this context, the empowered feminist voice shifts to the confessional post-feminist voice, seeking out visibility through consumption and a continually normalized feminine subjectivity.

authoring the body

So how is this body "authored" in digital culture, and specifically among haulers? How does post-feminism implicate authorship as a kind of creative, communicative, and commodity-driven act? We have argued that a dimension of compulsive visibility is critical to our definition of post-feminist practice. Following Angela McRobbie's assertion that post-feminist practice lays out "a new gender settlement" where choice is deemed plentiful and entering the space of visibility (what she calls Deleuzian "luminosity") is the goal, we yoke this context to digital autobiography, exploring how the digital facilitates and expands post-feminist authorship.[9] Our definition of post-feminist digital authorship grapples with the idea of visibility, in part, by examining the role of the body inside these digital narratives.[10]

Historically for many feminisms, authorship and claiming ownership over bodies of knowledge have meant explicitly undermining a focus on the corporeal, the actual body, which was routinely objectified in all

realms of culture. However, as McRobbie, Gill, and others point out, a defining characteristic of post-feminism is, in contrast, an obsessive preoccupation with the body—a shift of a feminist "I" articulated through voice to a post-feminist "I" expressed through the body, in a sense. As Gill argues, within post-feminism, "it appears that femininity is defined as a bodily property rather than a social, structural or psychological one."[11] Thus, possessing a sexually desirable body is offered as a woman's key source of identity as well as her vehicle to achieving the sought-after form of visibility. Becoming visible through the deployment of one's body is the linchpin in achieving successful post-feminist subjectivity, a practice that is both adapted to and expanded by hauler culture in digital spaces.

Part of the way post-femininity imagines authorship in the contemporary era is through a shifted iteration and experience of "empowerment" and "agency," both buzzwords appropriated from feminist rhetoric and mobilized for consumer capitalist ends.[12] Furthermore, visibility in a post-feminist sensibility is positioned as the ultimate objective of the entrepreneurial, autonomous female subject. In the contemporary moment, post-feminist sensibilities dictate which bodies become visible and available for validation in a mediascape. This manifests in a kind of required female subjectivity that is not only self-monitoring but also beholden to the compulsory consumption of fashion and beauty products.[13] The feminine body, in this sense, becomes not only a vehicle for the curated display of commodities, but also a brand unto itself, testifying to the newly disciplined post-feminist subject's ability to manage the "anxiety" that plagues perceived endless consumer choice. The branded products purchased and displayed by the post-feminist author work to stitch together a self-brand, which in turn authors and makes visible the body. That is, displaying the products on the body is at once displaying the authored body—the products and the actual female body are overlaid. Involved in a deep interrelation, the body of the post-feminist author in hauler videos cannot be visible—indeed, is not legible—without commodity goods, and commodity goods take on new meaning through their display on the body.

Online post-feminist media production, such as hauler videos and vlogging, present their self-narratives to audiences as intimate monologues. Authors in these cases speak directly to their primarily peer audiences, using language that is casual, often steeped in slang terminology, and always personal. Not only does this form of address implicitly invite viewer/user feedback, it also does so directly through the comments section that accompanies all of these online productions. Speaking specifically about entrepreneurial vloggers, Jean Burgess and Joshua Green remind us that this "emblematic form of YouTube participation ... has antecedents in webcam culture, personal blogging and the more widespread 'confessional culture'."[14]

sarah banet-weiser and inna arzumanova

168

Indeed, vlogging often invokes the confessional, a model of self-narrative and autobiography that, as scholars such as Michel Foucault, Anthony Giddens, and Nikolas Rose have observed, leads to a specific modern experience of the self.[15] Foucault, in *The History of Sexuality*, argues that Western societies have established confession as one of the main rituals relied upon for the production of truth, resulting in the obligation to confess as a process of identification and a construction of subjectivity. As a function of modern governmentality, this autobiographical self-narrative encourages the compulsory definition of oneself through confession by positioning the practice as "freedom." The confession is perceived on the part of the subject, argues Foucault, as a form of liberation from repressive powers that try to silence us. In exercising what we understand as the "freedom" to confess, we become "subjects in both senses of the word."[16] That is, the practice of confession does not "free" us, but rather embeds us even more deeply in contemporary power relations.

In the contemporary digital era, we see confessional practices manifest in the interactive practices of video uploading and blogging. The feedback loop that is so central to media interactivity—where users post comments and critiques on media productions—functions as a technologized form of confession. This confession is in turn packaged as a product that is resold to the very laborers who produce it. As in Foucault's model, perceived freedom and empowerment are critical dimensions in this dynamic. The media producer understands herself to be empowered through telling her own story of herself. Conversely, users and viewers view themselves as equally empowered to comment and critique such performances of the self. The idea that confession—the authoring of oneself that allows others to really know us as part of subject formation—is a conduit to empowerment thus emerges in social media, where a telling of oneself interpellates consumers as empowered individuals. Here, though, empowerment is both legible and experienced in consumption practices, where the individual is an entrepreneur of the self, constantly employing disciplinary regimens and developing strategies to control its production.

Following Foucault's concept, we see vlog viewers as standing in judgment of the confession, providing the author with both corroboration and feedback and establishing a power relationship between the confessing author and critical audience. Yet, the feedback given by users to the post-feminist author is positioned not as judgment, but rather an important element in the crafting of the author's self-narrative. As examples from the haul community demonstrate, the change that is encouraged in the confessing author is one that constantly strives toward a perfected post-feminist subjectivity. Interactivity becomes the method by which compliance with post-feminist principles is produced, as viewers and

commenters constantly police and evaluate compliance. Here, the post-feminist author's body is disciplined through the incorporation and negotiation of user interactivity that at once makes available a post-feminist authorship while reaffirming the ways in which contemporary media culture packages this embodied authorship as a commodity. It is this kind of authorship with which we are concerned: a post-feminist autobiographical performance of the self within social media. The body in this case is both the physical body and the body of "texts" or products, and the meaning of the post-feminist narrative of the self is constructed through their intersection.

We consider these intersecting bodies in the autobiographical texts associated with haulers: the specific body of the girl who is in the video, or fashion blogger; the subject body who is the "I" in the narrative; the cultural body which mingles with the material goods referenced in the video, and the fashion in the fashion blogs; and the "body politic" which is post-feminism and new technologies. Sidonie Smith, in her discussion of female autobiography, argues that there are multiple bodies in an autobiographical text, bodies that coalesce in complex and often contradictory ways: "There is the 'specific body' of the autobiographical speaker/narrator. Then there is the 'subject body' of the autobiographical I. There is the 'cultural body' somewhere out there soliciting specific autobiographical orientations to the body. Then there is ... 'the body politic' whose materiality the physical body symbolically represents."[17] These different bodies, however, have varied salience depending on the media platform in which they are embedded; as such, Smith's questions about female autobiography apply to post-feminist authorship as well: "whose body is speaking? What specific body does the autobiographical subject claim in her text? ... How is the body the performative boundary between inner and outer, the subject and the world? What kind of performance is the body allowed to give?"[18]

The context for YouTube vloggers and haulers involves the privileging private property over public resources, as well as the increasing normativity of self-branding that is required inside these wide-reaching processes.[19] The entangled discourses already described here—post-feminism, neoliberalism, online interactivity—are mutually constitutive; "the girl-next-door" subjectivity mitigates the crassness of consumer citizenship through specific modes of confession that feature honesty and positivity.

Two popular haulers, Blaire and Elle Fowler, bring into bold relief the intersections and operations of these three governing principles of post-feminist authorship. According to these two haulers, their requirements are:

> Don't brag or boast.
> Identify trends of the new season.

Offer versatility.

Look for bargains.

Don't duplicate what you already have.

Show off your personal style.

Don't take yourself too seriously.[20]

In the following three sections, we will unpack this "list" as a way to think through the complex and often contradictory elements of digital post-feminist authorship.

the girl next door

In 2010, ABC News featured two articles on their website, "Girls Gone Viral: Online Fame from Shopping" and, a follow-up, "Major Retailers Latch on to 'Hauler' Viral Videos." The articles identified hauler videos as a "phenomenon," stating that in 2010 there were more than 150,000 haul videos on YouTube, and that some of the videos were generating tens of millions of views. The authors of haul videos display their recent purchases in front of a webcam, always mentioning the retail outlet where it was purchased, and often stating the price. She then posts the video on YouTube as a sort of shopping tutorial. The videos are typically 6–20 minutes long, and often have a theme such as Christmas, trips, and "best-ofs." According to Kit Yarrow, a consumer psychologist, "Haul videos are the perfect marriage of two of Generation Y's favorite things: technology and shopping … It's a vicarious pleasure. You don't have to spend the money and you still get the thrill; it's a bit like pornography."[21] While the videos may be "a bit like pornography," where the viewer's pleasure is firmly situated in a safe witnessing of someone else's indulgence in performed excess (excessive purchases, excessive consumerism, excessive description), they are decidedly unlike pornography in the rhetoric of nice-ness that seems required as part of the video (remember the list: "don't boast or brag" and "don't take yourself too seriously").

To achieve this goal of niceness, as McRobbie argues, post-feminist authors need to understand themselves as the "privileged subject[s] of social change" and must refrain from any critique of patriarchy.[22] Post-feminist subjectivity, then, is not just an eschewing of criticism, but also a marked revival of a traditional, compliant, and determinedly pleasant form of feminine performance. In the hauler community, this abandonment of critique manifests in what we call "girl-next-door" culture, with the authors' monologues and users' comments rendering a revolving door of pleasantries: smiles, treacly compliments, endless gratitude, and vague positive attributes.[23] Haulers consistently use ambiguous rhetorical amplifications to communicate the degrees of their delight, adoration, and appreciation about their purchases and the overall shopping experience.

Products are often "sooo pretty" and "sooo cute," with the word "nice" and "really" making frequent appearances in descriptions; stores are "the most favorite ever." Haulers don't just love the products they display; they "absolutely love" or "love so much." Here, we see the haulers exhibiting excessive description, but not excessive expression, as the phrases are stock phrases of adolescent post-feminist culture. In one of her hauls, for example, ChanelBlueSatin showcases the five nail polishes she has purchased, informing the audience that each color she shows to the camera is a "nice baby pink" or a "nice blue."[24] Describing her latest haul (accomplished with the assistance of a personal stylist) JuicyStar07 proclaims: the "personal stylist was awesome … and super stylish herself and I wanted to be wearing what she was wearing."[25] In another haul video, she describes a Lush sales assistant as "honestly the sweetest, nicest girl ever," noting that Lush employees are "just like the kindest people."[26]

This compliance with what McRobbie and others have called the post-feminist return to a traditional, uncritical, and heavily contained femininity can also be seen in their usage of the body. It is the haulers' use of the body to reinforce niceness that differentiates Laura Jeffries' rhetorical analysis of "nice girl" culture from what we position here as "girl-next-door" culture. These post-feminist authors' voices implicate their physical bodies as much as their linguistic structures, offering the post-feminist authors as welcoming and unthreatening "girls next door" in both body and language. Haulers' bodily gestures—indeed, their performances of femininity—speak to the disciplined sexualization that is asked of these kinds of authors. Blair Fowler, who vlogs as JuicyStar07, opens each video with a polite, restrained wave at her audience, swinging her head coquettishly to the side, moving only her palm as she waves, careful to keep her limbs close to the body (and importantly, within the frame). Similarly, Steph of CityandMakeup closes every video by blowing the audience a quick kiss and waving, accompanied by "Bye guys, love you." In their joint haul video, the haulers FleurDeForce and MissGlamorazzi constantly display contained shrieks of excitement, shrinking their shoulders inwards and subduing their expressions of glee.[27] Using their bodies in ways that both gesture toward sexual availability and disingenuously discipline that availability, these authors both maximize their visibility and avoid any kind of critical language.

While hauler videos are intensely focused on the body, the sexuality displayed is that of the "girl next door." For instance, in her haul video with MissGlamorazzi, FleurDeForce mentions that she bought underwear at the chain lingerie store Victoria's Secret, but makes sure to quickly add: "of course, I'm not going to show those on the haul video."[28] Likewise, JuicyStar07 displays a Victoria's Secret bag so that viewers see the evidence of her shopping, but reminds us that she wouldn't show the underwear she bought. Another hauler, ChanelBlueSatin, again after

shopping at Victoria's Secret, pans her webcam down to her shorts, thus displaying her legs—but is clearly uncomfortable with showing her bare legs, saying self-consciously, "I know it is weird to show my legs." The "girl-next-door" haulers are not performing "hotness" in a way that is currently normative in all media, where girls' and young women's bodies are displayed in hypersexual ways. Rather, the haulers perform an embodied femininity, or an embodied female authorship, corresponding to a wholesome form of consumer citizenship.

When critical language is used in the hauler community, it is quickly brought into the fold of a broader, more positive discourse. Jeffries finds these "nervous vacillations" between criticism and positive reinforcement to dominate the subsection of haul videos entitled "Products I Regret Buying."[29] The practice of absorbing—whether through the monologue or the physical movement of the body—any semblance of negativity, however, can be seen frequently across all versions of the haul video, and it is reinforced through language and physical cues.

In her "Birthday Haul:)))" ChanelBlueSatin holds up a new nail polish that she has purchased, observing that "it's chipping now, so it's really ugly." She quickly rescues her comment, smiling and shrugging her shoulders, by adding: "but I still really like it."[30] CityandMakeup, too, realizing that she has taken an inadvertent stab at a beloved brand, immediately retracts it. This hauler, in her "Boxing Day Haul 2011," explains that Aritzia is "pretty much [her] all-time favorite store ever" but that the store does not offer very substantial sales (she even hints that the sales announcements may be misleading). Nevertheless, she salvages the video by reassuring the viewer that she "actually found some pretty good deals there."[31] Jeffries reads these allegiances to positivity as, in part, allegiances to corporate brands. However, while the possibility of obtaining corporate sponsorship may very well be an important objective for these female authors, it is a goal that cannot be examined outside of the wider implications at play in post-feminist culture, a culture that provides an arena for these performances of femininity as commodified post-feminist "niceness."

confession

As we have described, the confessional constitutes a critical dimension of autobiographical vlogging for haulers, including a function for the authors as initiation into subjecthood through the guise of empowerment, thus subjecting her to the judgments and reviews imposed by other users. However, the mechanics of the confessional in post-feminist online authorship also hinge on particular discursive formats and behavioral tropes. The confession appears in a variety of manifestations in hauler videos, but when it comes to content, haulers tend to adhere to specific

and recurring structures. For the most part, the video blogs are intimate shots of the author alone, in her bedroom, confessing details of her recent shopping spree to her audience. Despite the fact that haulers become nervous if they are *too* honest (i.e., complaining about service, or not being satisfied with a product), there is a *kind* of honesty or transparency that is crucial to the videos. In reviewing products they have purchased, haulers often take steps to corroborate their narrative by offering evidence. In her "Boxing Day Haul," for example, the hauler CityandMakeup tells her audience that she has purchased a dress on sale and, after some justification of the purchase, makes sure to show the dress tag (she brings it up to the camera), so that the viewer can authenticate her claims.[32] She does this several times throughout the video, asking the viewer to stand witness to her narrative, demonstrating, on the one hand, that transparency is at a premium in the hauler community. Such transparency also helps build the brand of the retail outlet. This kind of confession thus establishes the authenticity of the post-feminist author as well as the authenticity of the retail outlets she frequents.

These performances of sincerity (a sincerity that labors to enhance the authenticity of the personal and corporate brands in question) also inform the haulers' treatment of corporate sponsorships (retailers ranging from Forever 21 to K-Mart and JC Penney have sponsored haulers). Many haulers begin their vlogs by prefacing that the following review is unencumbered by corporate endorsement. Those who do confess to doing a sponsored vlog go to great pains to authenticate their reviews in light of what might be perceived as contamination. JuicyStar07 in her "Perfect Wash Review" says: "I just want to let you guys know … hands down, being totally upfront and all that type of stuff, this is a sponsored video."[33] This statement is then followed by the hauler's extensive explanation that the sponsorship was a result of her genuine love for the product and not the reverse. These patterns among haulers suggest that an author's sincerity and, indeed, her validity as a trusted hauler rely on a transparency that always hinges on the promise of unpaid labor. Even when the labor of vlogging is sponsored, as JuicyStar07 demonstrates, it must be predicated on unpaid intentions and an upstart entrepreneurialism. The notion of honesty perpetuated by the confession in these videos, then, validates the author as an ideal entrepreneur— self-driven and bending the economies of visibility to her own ends (instead of *being bent* to those economies).

Transparency or earnest honesty is not the only manifestation of confession in these forms of post-feminist authorship. Confession happens on and through the body as well.

For instance, YouTube's haulers often wear the fashion items and makeup they have purchased in order to showcase the product, using

their own bodies as staging areas for promotion. The bodies of these young female authors become critical components of both product exhibition and the author's visibility as trusted consultants. The labor undertaken by these bodies is the precondition to visibility for haulers. To showcase her latest Nordstrom purchase, JuicyStar07 dons the maxi dress, giving viewers close-ups of her body as a way to point out the details of the dress.[34] The audience sees her nearly bare back, her profile and her hips, as she draws our attention to these parts of her body in order to explain how tight the skirt is, how flowy the top is, and to show the strappy back. In a Kmart haul, she describes the romper she is wearing, pointing to the buttons that line the garment's center front, as the camera pans down to a close-up of the hauler's torso, illuminating specific parts of her body as a canvas on which these commodities are made to make sense.[35] This practice is even more common with the displays of accessories, with haulers frequently putting these accessories on during the video. Excited about her rose-gold bangles from Henri Bendel, FleurDeForce puts them on during the video and waves her newly adorned wrist into the camera, drawing intimate attention to her own feminine body as she narrates her own self through consumption.[36] Talking about commodities, for haulers, necessarily implicates the authors' own bodies, wherein using one's own body to display feminine goods is an expected and increasingly normative practice, as well as an opportunity for the women to become visible as authors in the first place.

consumer citizenship

For YouTube's haulers, authoring the self in these online spaces is inseparable from narrativizing their own practices of consumption. Indeed, this narrative is the sign of authorship; it is what engages the post-feminist "I." The products that are displayed by haulers are part of the ongoing "text" of post-feminist authorship; haulers specifically rely on a constantly renewed, intimate sharing of newly purchased products, which emphasizes accumulation as the key to securing continued visibility and relevance on sites such as YouTube, where search engine relevance is sorted by upload date, view count, and rating. The most popular haulers post a new haul video every few days, displaying and reviewing a brand new set of fashion and beauty items from their latest shopping sprees and therefore ensuring their own constant appearance in the search results. This compulsory and entrepreneurial display of commodity goods, alongside the hauler's narrativized commentary, authors the self, which is further reinforced through user comments. As Jeffries has noted about the hauler community's response to criticism, the refrain—summarized by the sentiment, "if you don't like it, then don't watch"—underscores both the haulers' and the commenters' right to

perceived democratic consumption (of both products, for the haulers, and of media, for the commenters).[37] Individual choice and freedom become the only ethics of value here, rendering any criticism illegitimate. Haul videos, and the way they showcase the post-feminist author, offer a narrative that is about her as much as it is about what she buys—indeed, who she is because of what she buys.

The relatively low barriers of entry to YouTube enable amateur videos to be posted, which may become business ventures for the young female authors of these videos. As the ABC News report mentioned earlier continues, "While haul videos are making one girl's shopping treasure into another's online entertainment, they're also transforming these savvy shoppers into young tycoons. Some videos are being viewed millions of times, and the vloggers are cashing in—scoring sponsorships, product deals and magazine spreads."[38] The director of Product Management at YouTube, Shishir Mehrotra, apparently "scours YouTube looking for top talent."[39] When he discovers haul videos with considerable numbers of views, he offers them partnership in the YouTube Partner Program, an official relationship with YouTube that allows the site to feature advertising on vlogger's video (or YouTube channel), and in return shares some of the revenue with the vlogger.[40] As Mehrota notes, "We have hundreds of partners that make over $1,000 a month, and we have several that are making six figures and really are supporting a living off of YouTube."[41] Companies are apparently also taking notice of the haul videos: "major retailers—always eager to find new ways to market to teens and tweens—are giving the haul video makers a commercial makeover by actively recruiting a handful of them for back-to-school marketing campaigns. And it could mean big business."[42] The hauler community represents a new kind of commercial frontier, open for conquering and colonization, taps into a broader ideology about both neoliberal entrepreneurship and post-feminism, where authors, through their own initiative, can profit through their efforts to author their own selves.

conclusion

The unproblematic positioning of haulers as entrepreneurial female authors in the context of a terrain typically occupied by feminist speech forces us to contend with contemporary definitions of feminism and feminine subjectivities. That is, the economy of visibility embraced by haulers is a stark departure from the (albeit problematic) modes of authorship sought by feminist writers in the past. The feminine subject produced in its wake is a post-feminist one, both policed *and* enabled by the technologies of interactivity. However, in the mediascapes illuminated by post-feminist sensibilities, visibility and exhibition are not quite ends

unto themselves. Consumption is both the route to visibility and the reward in this formulation, with the labor of femininity functioning as a prize for the exponentially demanding and more ambiguously dispersed labors of the female subject. Prescribed by neoliberal ideology as cure for feminine anxiety, consumption becomes the conduit to the expression of agency, with both the female author and viewer/reader interpellated as subjects already invested in the tenets of liberal individualism, meritocracy, and the personal responsibility to self-monitor.[43] For online female authors seeking visibility through creative self-branding then, consumption of fashion and beauty products becomes synonymous with an empowered subjectivity, one that simply no longer needs feminism. As we noted at the outset of this chapter, however, the female authors we discuss here are made legible and visible in a specific ideological universe, one that is structured by the imbrication of post-feminist sensibilities and neoliberal principles. This imbrication ensures that continued visibility requires a continued self-monitoring made possible by online interactivity. Haulers invite reader and viewer feedback, constantly incorporating that feedback into their authorship narrative to produce perpetually more calibrated and mediated narratives of the self.

notes

1. The December 2007 study showed that "significantly more girls than boys blog (35 percent of girls compared with 20 percent of boys) and create or work on their own Web pages (32 percent of girls compared with 22 percent of boys)." Stephanie Rosenbloom, "Sorry, Boys, This Is Our Domain," *The New York Times*, February 21, 2008, accessed August 25, 2012, http://www.nytimes.com/2008/02/21/fashion/21webgirls.html?pagewanted=all.
2. David Harvey, *A Brief History of Neoliberalism* (New York: Oxford University Press, 2005).
3. Jeremy Gilbert, *Anticapitalism and Culture: Radical Theory and Popular Politics* (New York: Berg, 2008), 32.
4. Rosalind Gill, "Postfeminist Media Culture: Elements of a Sensibility," *European Journal of Cultural Studies* 10, no. 2 (2007), 147.
5. Angela McRobbie, *The Aftermath of Feminism: Gender, Culture and Social Change* (London: Sage, 2008).
6. Gill, "Postfeminist Media Culture," 154.
7. For discussion of authorship as a "technique of the self," see Janet Staiger's "Authorship Approaches," in *Authorship and Film*, ed. David Gerstner and Janet Staiger (New York: Routledge, 2003).
8. Leigh Gilmore, "Policing Truth: Confession, Gender, and Autobiographical Authority," *Autobiography and Postmodernism*, ed. Kathleen M. Ashley and Leigh Gilmore (Boston: University of Massachusetts Press, 1994), 73.
9. Angela McRobbie, "Postfeminism and Popular Culture: Bridget Jones and the New Gender Regime," in *Interrogating Postfeminism: Gender and the Politics of Popular Culture*, ed. Yvonne Tasker and Diane Negra (Durham, NC: Duke University Press, 2007), 31.

10. Angela McRobbie, "Top Girls? Young Women and the Post-feminist Sexual Contract," *Cultural Studies* 21, nos. 4–5 (2007), 718.

11. Rosalind Gill, *Gender and the Media* (Malden, MA: Polity Press, 2007), 255.

12. Tasker and Negra, Introduction to *Interrogating Postfeminism: Gender and the Politics of Popular Culture*, ed. Yvonne Tasker and Diane Negra (Durham, NC: Duke University Press, 2007).

13. See Sarah Banet-Weiser's *Authentic*™: *Political Possibility in a Brand Culture* (New York: New York University Press, 2012).

14. Jean Burgess and Joshua Green, "The Entrepreneurial Vlogger: Participatory Culture Beyond the Professional-Amateur Divide," in *The YouTube Reader*, ed. Pelle Snickars and Patrick Vondereau (Stockholm: National Library of Sweden, 2009), 94.

15. See Michel Foucault, *The History of Sexuality, Volume I: An Introduction* (New York: Random House, 1978); Anthony Giddens, *Modernity and Self-Identity: Self and Society in the Late Modern Age* (Stanford, CA: Stanford University Press, 1991); and Nikolas Rose, *Governing the Soul: The Shaping of the Private Self* (London: Routledge, 1990).

16. Foucault, *The History of Sexuality*, 60.

17. Sidonie Smith, "Identity's Body," in *Autobiography and Postmodernism*, eds. Kathleen Ashley, Leigh Gilmore, and Gerald Peters (Boston: University of Massachusetts Press, 1994), 271.

18. Smith, "Identity's Body," 271–72.

19. See Banet-Weiser, *Authentic*™, for more discussion of self-branding.

20. Eric Noll and Lee Ferran, "Major Retailers Latch on to 'Hauler' Viral Videos," ABC News, July 14, 2010, accessed August 25, 2012, http://abcnews.go.com/GMA/jc-penny-forever-21-american-eagle-latch-youtube/story?id=11156574#.T1XTDvUgP3A.

21. Eric Noll, "Girls Gone Viral: Online Fame from Shopping," ABC News, March 21, 2010, accessed August 25, 2012, http://abcnews.go.com/GMA/Weekend/haul-videos-turn-tech-savvy-shoppers-web-stars/story?id=10158339#.T1XTbvUgP3A.

22. McRobbie, "Postfeminism and Popular Culture," 31.

23. This is what Laura Jeffries calls "nice girl" culture in "The Revolution Will Be *Soooo* Cute: YouTube 'Hauls' and the Voice of Young Female Consumers," *Studies in Popular Culture* 33, no. 2 (2011), 59–75.

24. ChanelBlueSatin, "Birthday Haul:))))," April 11, 2011, http://www.youtube.com/watch?v=LnRyc7XHW-8.

25. JuicyStar07, "Nordstrom Haul + OOTD/OOTF (Outfit Of The Day/Outfit Of The Future)," September 5, 2011, http://www.youtube.com/watch?v=lAxQ851ptBk.

26. JuicyStar07, "Lush Haul!" January 1, 2012, http://www.youtube.com/watch?v=enpHUWiiNJY.

27. FleurDeForce, "LA Haul with MissGlamorazzi!" January 10, 2012, http://www.youtube.com/watch?v=Nlv5wzulenc.

28. FleurDeForce, "LA Haul with MissGlamorazzi!"

29. Jeffries, "The Revolution Will Be *Soooo* Cute," 65.

30. ChanelBlueSatin (2011), "Birthday Haul:))))."

31. CityandMakeup, "Boxing Day Haul 2011," December 29, 2011, http://www.youtube.com/watch?v=hvVomUo6VQQ.

32. CityandMakeup, "Boxing Day Haul 2011."

33. JuicyStar07, "Get Rid of Your Acne + PerfectaWash Review!" December 15, 2011, http://www.youtube.com/watch?v=RUjYNlhzh8M.

34. JuicyStar07, "Nordstrom Haul + OOTD/OOTF (Outfit Of The Day/Outfit Of The Future)."

35. JuicyStar07, "Dream Out Loud Clothing Haul + Contest Announcement!" July 14, 2011, http://www.youtube.com/watch?v=Cn_n-7JuDjU.

36. FleurDeForce, "LA Haul with MissGlamorazzi!"

37. Jeffries, "The Revolution Will Be *Soooo* Cute." Jeffries' explanation of the haulers' collective response to criticism often coalesces around the idea that viewership is optional and that, because of this, criticism is unnecessary.

38. Noll, "Girls Gone Viral."

39. Noll, "Girls Gone Viral."

40. Since fans and advertisers are hanging on their every cyber word, the Federal Trade Commission recently enacted rules governing vlogger sponsorship. While they are allowed to accept free merchandise, haul video vloggers must disclose if they are being paid by a company to review a product. Any person with a webcam and an audience can become a professional paid haul video expert. See Noll, "Girls Gone Viral," and the follow-up article "Major Retailers Latch on to 'Hauler' Viral Videos."

41. Noll and Ferran, "Major Retailers Latch on to 'Hauler' Viral Videos."

42. Noll and Ferran, "Major Retailers Latch on to 'Hauler' Viral Videos."

43. McRobbie, "Postfeminism and Popular Culture."

authoring the

occupation

the mic check, the human

microphone, and the loudness of

listening

e d w a r d d . m i l l e r

prelude

In Jorge Luis Borges' story "Tlön, Uqbar, Orbis Tertius," a scholar describes the mysterious planet of Tlön to the reader.[1] Among many seemingly strange customs, this otherworldly realm has radically different practices of authorship than those we wrestle with in the contemporary United States and beyond, which emphasizes contract and copyright law. Contestation over intellectual property and bickering over disciplinary distinctions are nonexistent in Tlön. Borges writes:

> Within the sphere of literature, too, the idea of a single subject is all-powerful. Books are rarely signed, nor does the concept of plagiarism exist: It has been decided that all books are the work of a single author who is timeless and anonymous. Literary criticism often invents authors: It will take two dissimilar works—the *Tao Te Ching* and the *1001 Nights*, for instance—attribute them to a single author,

and then in all good conscience determine the psychology
of that most interesting *homme de lettres*...²

The encampments of the Occupy Wall Street movement during Fall
2011 in the urban centers of United States and elsewhere were not akin
to Tlön, but the discursive strategies they established and sustained were
radically different from those of the larger culture that either ignored,
watched, supported, disapproved, or finally stood by while the police lay
siege to these encampments. In particular, the ways in which occupiers
communicated with others in public meetings appeared to be a radical
break from modes of address that celebrate the speaker and author and
restrict the auditor's participation to clapping (or booing). Listening
became visible and audible and authorship became collectivized, scram-
bled. The manner in which ideas were expressed became more important
than the person who spoke or wrote them. The movement eschewed
leaders, which meant that they also eschewed current constructions of
authorship. Even as many prominent intellectuals, activists, and actors
were welcomed when they came down to lend a hand, they were there to
donate their ideas to reinforce the movement's ideological foundations;
they weren't there to promote books or films. As in Tlön, there was only
one author, yet this author was not solitary or unitary, but multiple.
Seemingly, the promise of intertextuality was realized: no one could claim
ownership over acts of enunciation, and no one claimed originality.
Discourse was not sourced in occupied spaces and texts bore no signature,
yet lending libraries grew within occupied sites. No contracts were signed:
a faraway land indeed, but also accessible by way of public transport.

The Occupation may prove fleeting, and this may have its advantages:
before it became institutionalized and riddled with inevitable infighting,
the form of this particular resistance mutated. Yet, the movement had an
immediate impact upon the political discourse. The importation of the
term "the 99 percent" into mainstream media changed the focus of debates
and forced economic inequality to become an issue front and center, at
least for a few months. Certainly, the movement's enduring impact is not
yet clear. While many are rightly concerned with estimating the political
ramifications of the movement, this essay is primarily invested with com-
menting upon its communications systems by offering a reading of what
became known as the mic check and the human microphone. The essay's
tendency is to acclaim the movement's innovations; hopefully, this is
balanced by a more distanced consideration of the movement's tactics.³

redefining the mic check

The mic check and the human microphone were created in response to
the New York Police Department prohibiting the amplification of the

voices of speakers in Zuccotti Park, the site of Occupy Wall Street. It became the mode of public address throughout the Occupy movement and allowed speakers to be heard without technology in large open spaces during the occupations of Fall 2011. The mic check and human microphone mimic broadcasting formally, but rather than sending out the voice through amplification or by way of media, they rely upon the crowd assembled nearby to repeat the words of the speaker. The occupiers used the practices and terms of analog media to enable communication in occupied spaces, and did so by way of bodies and voices.

As Occupy Wall Street used Livestream and other websites to broadcast their activities, this process was also digitized and made accessible to Internet audiences. Those who watched and listened, via Internet, used Facebook and Twitter to participate and respond. Actual microphones and cameras supplemented the human microphone and allowed reception in disparate locations even as the use of technology to amplify was disallowed in the actual physical site of occupation. Importantly, due to its nonstop use of a panoply of new media, the Occupy movement did not wait for news media coverage; the organization was adjoined to the mediascape from the get-go through their use of Facebook, Twitter, YouTube, and Livestream, as well as their own websites. Perhaps most importantly, voices speaking in near unison and bodies crowding a public space became media for their message. As a result, they generated their own memes expressing unfairness and highlighting economic disparities, alerting Americans from diverse identity formations to the possibilities of imagining a commonality among groups against a redefined elite.

The Occupy movement was thus mediatized from its inception, even as the human microphone and mic check relied upon live performance, similar to much videated theatre in downtown Manhattan these days (such as the Wooster Group or Gob Squad). The process of the mic check/ human microphone begins with a person who wishes to address the crowd declaiming "mic check." This utterance declares the intent to be heard and, like the actual mic check in which a query is addressed to a technician in order to see if the sound system is working and the voice is amplified, it verifies that those assembled are ready to be addressed. Analogous with the "electric" or "original" mic check, the "acoustic" or "unplugged" version of the mic check uttered by an occupier is "phatic communion," as described by anthropologist Bronislaw Malinowski (and elaborated upon by linguists and philosophers of language who substituted the word "communication" for communion): "it serves to establish bonds of personal union between people brought together by the mere need of companionship and does not serve any purpose of communicating ideas."[4] The phatic establishes a connection between speaker and auditor and is used to ensure that a channel is available for further, more meaningful, interaction. Although it is purposeful, it does not convey any information other than

the intent to speak and the willingness to listen. The mic check establishes this affinity.

In establishing this affinity, the mic check becomes a way to measure the dimensions of the communion by way of acoustics. Even as it became a ubiquitous tactic, it is always specific to a locale, and sets in motion a dynamic of "us" and "those who have not realized that they could be part of us" (that is, the rank and file of the police, passersby, and onlookers), and the economically elite whose interests are being catered to by lack of regulations, bail-outs, and the dismantling of occupied sites. The mic check has ramifications spatially: it places a momentary auditory border around the area. Sometimes the mic check has to be repeated twice: once by the crowd nearest to the speaker, and then again by the occupiers who are in the outskirts of the occupied space; the speech act is expansive and inclusive. Voices carry, but the voice is not necessarily carried all the way to the margins. In such cases, repetition steps in to make up for the distance.

The mic check is also a performative utterance, as defined by J. L. Austin.[5] It carries out its intent through the enunciation of the words themselves. Thus, the words are also action, and the audience's response is verification that the utterance has been heard and the act successfully performed. As a performative, it clears a space for the speaker and listener to inhabit simultaneously. Furthermore, the mic check has a performativity that is linked to its innate theatricality and not only its distinctive quality as a speech act—the call and response (or call and repeat) of the mic check and the human-microphone has a ritualistic element to it that enables listeners to become speakers. This ritual became a very audible feature of the makeshift "theatre-state"—to use Clifford Geertz's description of Bali in the nineteenth century—of occupied spaces.[6] Occupied spaces were seemingly governed by way of theatricality, repetition, and procedure, and not by the pronouncements of visible leaders.

Importantly, the mic check is a speech act that is effective and made necessary by the dynamics of certain situations in which one occupier may have information that all present need to hear. At one demonstration in which I participated, after a "mic check," the speaker let everyone know that police were threatening to arrest anyone who did not move from the street to the sidewalk. When we repeated her words using the human microphone, we all knew what was at stake by either moving or remaining in place; as we reiterated her speech with more volume, it also allowed for more people to hear her message. In this instance, the mic check captured everyone's attention immediately; it stepped in and stopped protesters from being needlessly arrested.

This repetition enables collective human voices to serve as a means for broadcasting. It is akin to echolalia, which is a term that describes the immediate and involuntary repetition of words that is sometimes deemed

a symptom of autism or schizophrenia. However, the Occupy movement's echolalia is not pathological. Rather, it solves the problem of how to project voices without technology. It is borne of necessity, it borders on tediousness, and it has repercussions for the creation of group identity and for the use of language in collective expression. The speech that succeeds the mic check is also repeated through the use of the human microphone, and it both encourages brevity on the part of the speaker and allows opportunity for the crowd to comprehend and inhabit the speaker's words through reiteration. It is a crucial component of the direct democracy that insists upon participation and promotes intersubjectivity in occupied spaces. Experiences, and authorial function (or a rejection of how this function is traditionally structured and expressed), become intertwined.

shifting pronouns

The human microphone expands Roman Jakobson's notion of the pronoun as a "shifter," a word that changes meaning depending upon context and user.[7] For Jakobson, the shifter "I" is both a symbol and an index (as is "you"); it represents its object only by convention, yet the "utterer is existentially related to his utterance."[8] In other words, the word "I" bears a temporary connection to a specific speaker/writer, but it is also a word that can represent any speaker or writer. Similarly, for Émile Benveniste, shifting pronouns "exist only insofar as they are actualized in the instance of discourse, in which, by each of their own instances, they mark the process of appropriation by the speaker."[9] Uttering the pronoun brings the subject into discourse and grants the pronoun a specific meaning. The pronouns "I" and "you" are empty, but they become full through utterance, and deflate again when unspoken as they lose any existential connection to a specific speaker.

With the human microphone, the first person pronoun shifts to accommodate the many, through repetition. Simultaneously the crowd utters an "I," bending it toward the first personal plural, providing the opportunity to see if the utterance also articulates the experience of its audience. When the speaker uses "we," the audience gets an opportunity to test out this purported identification with the many—to see if it is valid for collective expression. The sign becomes replete with the presence of multiple "I"s within this rhetorical "we." As a result, the significations of "I" and "we" overlap and intertwine in the group utterance. Distinctions between singularity and plurality dissipate, and the elasticity of the "I" expands even further than it does in other forms of discourse—it becomes especially "full," to use Benveniste's term.

Noted theorist Judith Butler addressed a crowd assembled at Washington Square Park as part of an Occupy Wall Street demonstration on October 23, 2011. Videos of the event have been posted on YouTube;

edward d. miller

184

one video begins with two organizers of the march performing a mic check that gathers together those assembled and brings everyone's attention to a site on the edge of the crowd.[10] In this video, one organizer invites everyone to sit down. Yet, a leather-jacket-clad Butler remains standing, and waits a moment before speaking, perhaps indulging in a theatrical pause, or gathering up her resolve to utilize the human microphone to best advantage. She has a paper in her hand, presumably the words she plans to speak. She begins: "Hello Everybody."[11] The crowd repeats her phatic greeting back to her, but also the greeting is directed to each other, not only the speaker. Butler points her finger toward her auditors in a gesture that accompanies the next utterance. She proclaims, "I'm Judith Butler."[12] The crowd repeats, "I'm Judith Butler." When the crowd echoes this identification, Butler gives a thumbs up, content that she has given them her name, and they have renamed themselves, if for but a moment, Judith Butler, regardless of gender. There is laughter, and "the real" Judith Butler smiles. She is among others who are also "Judith Butler," contingently and temporarily.

Of course, this is impossible and untrue, but this impossibility is within a play frame, which, according to Gregory Bateson, is based on the paradoxical ability for opposites to co-exist within a psychological and actual space, or a frame.[13] Within such frames, metacommunication is necessary in order to maintain the paradoxical nature of communication within the frame.

This structure is one that allows the occupiers to repeat Jim Goodman's declaration that "I am a dairy farmer from Wisconsin" when he addresses a crowd at Zuccotti Park, though most of the people assembled there presumably have never set foot on a farm.[14] The repetition allows for the audience to imagine inhabiting the speaker's experience, even as the actual experience remains distant. Like Jim Goodman and his listeners, Judith Butler and the occupiers have entered into a play frame where paradox is normative and untruths have the value of truth. She remains Judith Butler, and they take on her name in the repetition of her words, so that within the play frame impossibility reigns, though it has a limited duration and claims only a group-designated amount of space (depending upon the volume of those assembled at the site). By extension, one could argue that spaces of occupation are, themselves, play frames from the get-go: time-bound, theatricalized, metacommunicative, and vulnerable to the threat of aggression as well as actual violence, especially from the police. Play ends when a person is injured.

Suitably, the theme of demanding the impossible becomes the subject matter of Butler's remarks (harking back to the French student slogan of 1968 "soyez réaliste, demandez l'impossible"). Such a demand becomes needed and inevitable, she argues, if economic justice and the extension of democracy are deemed impossible. Butler is being generous since a criticism of the movement was, in October 2011, its lack of specific demands;

her speech begins to articulate goals for the movement. She hands them over and is able to hear what they sound like in her auditors' voices—likewise, her auditors are offered a chance to embody her words.

Butler finishes by concluding that bodies in public space are in fact the realization of one of the demands of the group, which "is to enact the phrase We, the People."[15] To have bodies crowd public spaces and to have individuals recast their identity as part of a group through a myriad of fleeting and lasting connections—as was accomplished in the Arab Spring—is itself a victory, a realization of a performative of one of the founding documents of the American nation-state. Such a configuration creates possibilities for multiple authorships, as the event itself produces distinctive pathways for speech acts.

Butler's speech, for example, by way of using the mic check and the human microphone, and importantly by using the first-person singular pronoun "I," entered into the realm of the impossible before the significa-tion of the epistrophic words (she repeats the phrase "and then we demand the impossible" at the end of a series of phrases). Her use of pronouns repeated by her listeners is both accurate and false; hence we know that demanding the impossible is within the realm of possibility. Within this play frame, a crowdsourcing of the physically proximal is utilized, one that brings distal political demands within reach. Butler's emphasis upon impos-sibility (and the imperative to make it possible) matches content to form; she addresses herself, the audience, and the play frame itself, which remains in place. Authorship is thus scrambled, collectivized; utterances are made communal by the form of address itself. Though Butler moves to use the first person plural "we," the "I" she began with already gestured toward the plural, and her use of the plural pronoun insists upon a "'democratic' version of the 'royal' we."[16] This mixing of singular and plural pronouns flickers toward a radical ontology, becoming perhaps an example of what Jean-Luc Nancy names "this singularly plural coexistence."[17]

Butler also encounters the requirements of rhythm and tempo neces-sary for the successful delivery of a speech by way of the human micro-phone. One speaks slower than usual, and one allows for a pause after a phrase (and from my count orators don't usually utter more than six words at a time before waiting for the "echo" of the human microphone). Otherwise, the crowd encounters problems in repeating speech acts—it becomes difficult to remember the order of the words. The result is that one speaks in phrases (or to think more poetically, in verse, utilizing iambic dimeter or trimeter), and not in sentences. When Butler forgets to leave a pause after saying "Either they say" and continues to utter "there are no demands," the crowd intervenes and repeats her first phrase.[18] She nods and in doing so seems to acknowledge that she has not adhered to the rhythm of speech she set up. Corrected, she stops and listens to their repetition. When they are done, she reiterates, "there are no

demands."[19] What this interaction indicates is that the human microphone is a rule-bound event and that those who repeat the words of the speaker are not engaged in pure mimicry; their listening is active and responsive. By way of repetition, the audience gets to try the words on for size. If the words "fit," there is a gestural accompaniment that does not interfere with the soundscape, such as clapping. Those assembled perform a version of Bob Fosse's jazz hands (also the ASL gesture signifying applause), in which the occupier moves the fingers on upright hands to signify agreement, one of the gestures known as temperature checks. One of the unspoken demands of the Occupiers is that speakers/listeners abide by the rules of the human microphone; I've witnessed more than once an occupier correcting another for incorrect behavior—for cheering instead of using the more appropriate "upward twinkle."

playful protest

In his study of queer protest movements, Benjamin Shepard emphasizes the ludic as key to the tactics utilized by gay and lesbian protest movements, and argues that an understanding of play is needed in scholarship about social movements, and in particular scholarship on LGBTQ protest.[20] Influenced by Roger Caillois's study *Man, Play, and Games*, which devises a typology of games, as well as Johann Huizinga's *Homo Ludens*, a text which argues that the play impulse is central to creativity and the development of culture, Shepard "acknowledges the ambiguous often

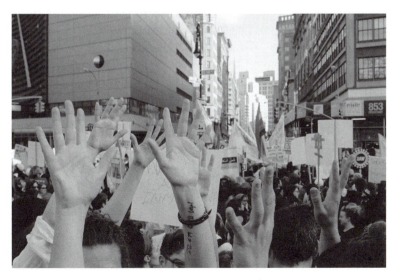

187

Figure 11.1
Marchers leave Union Square in New York City during OWS's 2012 May Day protests. Photo credit: Andrea Geyer.

paradoxical nature of play that vacillates between spontaneity and regula-
tion, work and leisure, logic and madness."[21] As in Bateson's notion of
the frame, for Shepard, the paradox of play is generative, not restrictive.
A sense of freedom is also needed for the ludic, and this sense of freedom
is an affect that the movement provides, but the work of play often
involves creating procedures and rules to conform to in order to be
successfully performed. Thus, playfulness is not necessarily random, it is
often ordered. In Caillois's typology, play falls along a continuum
that ranges on one extreme as ludus (which is highly structured and
rule-bound like a sports game) to paidia (which is spontaneous and
unpredictable like a mêlée).[22] The playfulness of Occupy Wall Street tends
toward ludus, but this does not mean it is less playful; rather, it balances
spontaneity with an adherence to process.

In a video of mic checks recorded on October 7, 2011, one speaker
announces a meeting organized to improve life at the Occupation that is
about to occur at a nearby Church, and the next speech relays information
about taking money out of the bailed-out banks and putting it into "better"
community banks.[23] In a manner, both speakers are serious young men
and the human microphone mirrors their stern mode of delivery. However,
the third speaker in the video has a playfulness to him that matches the
structure of the mic check itself. His mic check is repeated three times,
each time increasing in volume and intensity and the crowd duplicates his
mode of delivery. Importantly, he is holding a blue ball. Then he utters, "If
you want to play."[24] He waits for the reverb of the human microphone. The
reverb repeats his words. He continues: "A game of tax dodger dodge
ball."[25] He holds the ball aloft and once more pauses for the human-made
echo to repeat his phrase. And then finally he utters: "Meet me at the red
cube in three minutes."[26] He gestures toward the painted steel sculpture
across Broadway, a piece by Isamu Noguchi that animates a corporate plaza
through its scale and startling color as well as the unlikely way it is
balanced on a corner of the cube. The sculpture stands in front of the
HSBC building (an area that became a site where police were stationed
when the occupation grew in numbers). The dodge ball player's mic check,
which begins the game itself, lays bare the playfulness of the human micro-
phone structure itself. In other words, he started playing (a kinder version
of) dodge ball in his address, and the game only continues across the street.
His address reveals the ludic quality that is embedded in the form of
the human microphone itself, even if the human microphone is often
burdened with relaying quite serious information.

the loudness of listening

In the essay, "Listening," Roland Barthes distinguishes between listening
and hearing.[27] Hearing is automatic and physiological, whereas listening is

dedicated and psychological. He further delineates three levels of listening: the first is listening that alerts the auditor (to danger with a fire alarm, to the arrival of ice cream with the sound of the ice cream truck, and so forth); the second is the listening that allows the auditor to decipher complicated auditory signs (such as speech acts); and the third is psychoanalytic. In this third level, the listener imagines the particularities of the situation from which the speaker enunciates. This form of listening is itself an utterance. Thus Barthes writes: "Listening Speaks."[28]

This mode of responsive listening makes intersubjectivity a possibility in that it attends to the human voice as its companion; it blurs the distinction between self and other, speaker and auditor. Whereas one cannot make an assumption about all the listeners/repeaters involved at all times in all occupied spaces I assert, nonetheless, that the listening in occupied spaces is structured to promote this third mode of responsive, intensive listening. Each person involved in the human microphone mode listens twice: to the initial utterance and then to its repetition by the group. There is twice the chance for an understanding of motivation and meaning. Each hears one's own voice as well as the voices of those in the environment. The voice itself reverberates and lingers in its uploading from one to many. The responsiveness of listening is activated; listening becomes audible. Proof of the embodied act of listening is in the repetition.

Jean-Luc Nancy lends a different nuance to listening than Roland Barthes who foregrounds listening's spatiality and its expansiveness. In "Listening" he writes:

> The sonorous present is the result of space-time: it spreads through space, or rather it opens a space that is its own, the very spreading out of its resonance, its expansion, and its reverberation. This space is omnidirectional and transversate through all spaces.[29]

Nancy, instead, articulates the ontology of listening in such a space and notes that the act of listening is that which allows for the possibility of a self:

> To listen is to enter that spatiality by which, *at the same time*, *I am* penetrated for it opens up in me as well as around me, and from me as well as toward me. It opens up me inside me as well as outside, and it is through such a double, quadruple, sextuple opening that a "self" can take place. To be listening is to be at the same time outside and inside, to be open *from* without and *from* within, hence from one to the other, and from one in the other.[30]

Listening is interpenetrating; a self is created through a series of openings and not by burrowing into an identity. For Nancy, speaking does

not create the prospect for a self; rather, listening is the defining act. This self is porous, malleable, morphing, and always in response to that which is heard in this expanding space of sound.

In occupied spaces, sightlines were less privileged than acoustics, and listening afforded occupiers the possibility of an articulated sense of self that is defined in relation to other articulating selves. Occupation encouraged individuals not only to define political goals but also to initiate modes in which each could redefine their own place within a new movement and the larger culture. Such definitions are not set in stone, but with the physical proximity of so many others, there could be no way not to settle down without acknowledging—and hearing—the presence of others. No doubt, there were conflicts, but to the extent that there were any interpersonal success stories, it could only be due to the ensuring of an attendance to others' words. Listening was institutionalized in the lands under occupation.

postlude: from noun to verb

This mysterious planet Tlön, which the protagonist realizes in a postscript is a hoax perpetrated by a group of scholars and never actually existed, has more than one language. Yet, the languages share a common root. Borges writes:

> There are no nouns in Tlön's conjectural *Ursprache*, from which the "present-day" languages and the dialects derive: there are impersonal verbs, modified by monosyllabic suffixes (or prefixes), functioning as adverbs. For example: there is no word corresponding to our word "moon," but there is a verb which in English would be "to moonate" or "to enmoote." "The moon rose above the river" is *hlör u fang axaxaxas mlö*, or, as Xul Solar succinctly translates: "Upward, behind the onstreaming it mooned."[31]

Around November 2011, "mic check" also became a verb, almost leaving its status as a noun behind. As occupation sites began to be dismantled by the police in various locations, the term became mobile, matching the morphing of the movement itself as protesters became less affixed to occupying sites and more concerned with staging events. The term "mic check" adapted to this change. It moves from signifying the naming of an event within a space of occupation to becoming an act of intervention within another venue, announcing the presence of protesters.

The verb "to mic check" means now to interrupt the speech acts of political leaders; the politician becomes "mic checked" when an occupier yells "mic check" and others in the audience yell back. With the announced presence of the movement, the narrative of the politician is blocked.

The utterance becomes a way of interfering with mainstream political discourse; it affords mobility to OWS and the ability to be present in various locales simultaneously. The initial responses to being mic checked range from the dumbfounded (Michele Bachmann)[32] to those outraged by the audacity (Karl Rove)[33] to reluctant tolerance (Barack Obama).[34] However, the mic check puts all on notice—address economic disparity in your speeches and activities, or else you may be undermined in public. In authorial terms, to mic check (as a verb) becomes a way to fact-check a speaker's words; it rewrites—and destabilizes—the text of another (usually a mainstream politician). The mic check scrawls the demands of the 99 percent atop the teleprompter and makes them audible.

OWS rebelliousness is thus not only found in the staging of its politics; it also occupied the standard signification of words. An examination of the movement's communication strategies reveals linkages between speech acts and authorial functions. As it encouraged the 99 percent to confront and respond to economic inequities through action, it also forced discourse to accommodate to the specific demands of a newly formed (and constantly re-forming) linguistic community that attempted to author an American story. Perhaps this demand upon language is made even greater because of the nonhierarchical mode in which the Occupy movement operates, either cloaking its organizers, or working without a clear leadership and insisting that process and consensus (or ritual and performance) itself provides guidance and direction.

One of the implicit demands of the movement is to challenge and collectivize notions of authorship, and to trip up those who maintain divisions between speakers and auditors. Redefining terminology is foundational but a term's meaning is also never fixed; users pack up nouns and travel with them as verbs. In Tlön 2.0, a singular pronoun is redolent with plurality, and playfulness provides protocol. In Tlön 2.0, repetition speaks volumes about how authorship becomes attributed to one and many simultaneously.

notes

1. Jorge Luis Borges, "Tlön, Uqbar, Orbis Tertius," in *Collected Fictions*, trans. Andrew Hurley (New York: Penguin Books, 1998), 68–81. Thanks to those who contributed comments to this piece: Nathan Atkinson, Sheila A. Brennan, Sharon M. Leon, Catherine Lavender, and Elspeth Van Veeren. Thanks also to the editors at *In Media Res* and to the students of my seminar in Performance Studies in the Theatre Department of the Graduate Center (CUNY) during Fall 2011 for spirited interchanges on the tactics of the Occupy movement.
2. Borges, "Tlön," 76–77.
3. Many of the ideas—and some of the combination of words that are used— first emerged in a piece I curated at the website *In Media Res*. Edward D. Miller, "How to Occupy a Speech Act: The Mic Check as Performative

Utterance," in *In Media Res*, December 6, 2011, accessed May 20, 2012, http://mediacommons.futureofthebook.org/imr/2011/12/06/how-occupy-speech-act-mic-check-performative-utterance.

4. Bronislaw Malinowski, "The Problem of Meaning in Primitive Language" in *Magic, Science and Religion and Other Essays 1948* (New York: Free Press, 1948), 250.

5. J. L. Austin, *How to Do Things with Words* (Cambridge, MA: Harvard University Press, 1976).

6. Clifford Geertz, *Negara: The Theatre State in Nineteenth-Century Bali* (Princeton, NJ: Princeton University Press, 1980).

7. Roman Jakobson, "Shifters and Verbal Categories," in *The Communications Theory Reader*, ed. Paul Cobley (London: Routledge, 1996), 292–98.

8. Jakobson, "Shifters," 294.

9. Émile Benveniste, "The Nature of Pronouns," in *The Communications Theory Reader*, ed. Paul Cobley (London: Routledge, 1996), 289.

10. "Judith Butler at Occupy WSP," YouTube video, posted by lukegaraitaylor, October 23, 2011, accessed February 10, 2012, http://www.youtube.com/watch?v=rYfLZsb9by4. Judith Butler's work on performativity is greatly informed by her reading of J. L. Austin, most overtly in *Excitable Speech: A Politics of the Performative* (New York: Routledge, 1997), in which she measures the force of hate speech. Critiques of J. L. Austin's work influenced both queer theory and performance theory; see, for example, Andrew Parker and Eve Sedgwick's introductory essay in *Performativity and Performance* (New York: Routledge, 1995). Considering Butler's political affiliations—and her commitment to comprehend the importance of speech acts—one can imagine that making use of the human microphone and supporting the occupy movement are both important involvements for her.

11. "Judith Butler at Occupy WSP," YouTube.

12. "Judith Butler at Occupy WSP," YouTube.

13. Gregory Bateson, "A Theory of Play and Fantasy," in *Steps Toward an Ecology of Mind* (Chicago: University of Chicago Press, 2000), 177–93.

14. "Jim Goodman, Wisconsin Dairy Farmer, at the Farmers March (12/04/2011)," YouTube video posted by OccupyFoodSystem, December 5, 2011, accessed February 10, 2012, http://www.youtube.com/watch?v=7Yuh6II3eqk. Catherine Lavender alerted me to this video.

15. "Judith Butler at Occupy WSP," YouTube.

16. Nathan Atkinson, "The Democratic We," in *In Media Res*, December 6, 2011, accessed February 10, 2012 (comment on Miller, "How to Occupy a Speech Act"), http://mediacommons.futureofthebook.org/imr/2011/12/06/how-occupy-speech-act-mic-check-performative-utterance#comment-3285.

17. Jean-Luc Nancy, "Of Being Singular Plural," in *Being Singular Plural*, trans. Robert D. Richardson and Anne E. O'Byrne (Stanford, CA: Stanford University Press, 2000), 3.

18. "Judith Butler at Occupy WSP," YouTube.

19. "Judith Butler at Occupy WSP," YouTube.

20. Benjamin Shepard, *Queer Political Performance and Protest* (New York: Routledge, 2010).

21. Shepard, *Queer Political Performance and Protest*, 15. See also Johan Huizinga, *Homo Ludens: A Study of the Play Element in Culture* (Boston: Beacon Press, 1955), and Roger Caillois, *Man, Play, and Games*, trans. Meyer Barash (Champaign: University of Illinois Press, 2001).

22. Caillois, *Man, Play, and Games*, 27.

23. "Occupy Wall St.—Mic Check at Zuccotti Park - 10/7/2011," YouTube video posted by BoxOfSteve42, October 7, 2011, accessed May 20, 2012, http://www.youtube.com/watch?v=kZt-mA34xXM&feature=player_embedded.

24. "Occupy Wall St.—Mic Check at Zuccotti Park - 10/7/2011," YouTube.

25. "Occupy Wall St.—Mic Check at Zuccotti Park - 10/7/2011," YouTube.

26. "Occupy Wall St.—Mic Check at Zuccotti Park - 10/7/2011," YouTube.

27. Roland Barthes, "Listening," in *The Responsibility of Forms*, trans. Richard Howard (Berkeley: University of California Press, 1985).

28. Barthes, "Listening," 259.

29. Jean-Luc Nancy, "Listening," in *Listening*, trans. Charlotte Mandell (New York: Fordham University Press, 2007), 29.

30. Nancy, "Listening," 30.

31. Borges, "Tlön," 73.

32. "Michele Bachmann Gets Mic Checked by Occupy Charleston," YouTube video, posted by CharlestonSubterrain, November 10, 2011, http://www.youtube.com/watch?v=Q9e34kHANHs, accessed August 21, 2012.

33. "Karl Rove MIC CHECK in Baltimore," YouTube video, posted by itsbatmansilly on November 16, 2011, http://www.youtube.com/watch?v=fhyG7o0Toxo, accessed August 21, 2012.

34. "Video: OWS protesters interrupt Obama's speech," posted by RussiaToday on November 23, 2011, http://www.youtube.com/watch?v=p7kS3Ic4-lE, accessed August 21, 2012.

context

the myth of

democratizing media

software-specific production cultures

t w e l v e

e l i z a b e t h l o s h

World-making, as a form of authorship, is increasingly procedural and collective in character. As complex media-authoring packages are developed that support new techniques for virtual camerawork, nondestructive editing, digital compositing, 3D modeling and animation, and interactions with and between non-human intelligent agents, fundamental notions about media authorship are changing. Furthermore, real-time massively multi-user participation may involve mobile and ubiquitous computing technologies around the globe. No longer are worlds built by one person using one media technology to create one user experience, as novelists J. R. R. Tolkien and L. Frank Baum may have done with Middle Earth and Oz. Now story spaces constituted by computational media, distributed networks, and global workflows may exceed the capabilities of even the most ambitious and well-equipped polymath laboring alone. "Authoring" has replaced "authorship" in the lexicon of new media criticism.[1] With the rise of "authoring tools," "authoring systems," and "authoring languages," traditional modes of authorship have taken a

profoundly computational turn that both empowers and disempowers software users.

At the same time that DIY media and vernacular forms of in-home production are being celebrated by scholars of participatory culture such as Mimi Ito and Henry Jenkins, new types of expertise are actually hardening knowledge hierarchies and excluding amateurs and newcomers.[2] As extensible software packages acquire more features every year and competence in object-oriented programming becomes the norm, in effect, niche industries develop around customization. Geert Lovink, Rita Raley, and other critics of tactical media may laud the subversive potential of new forms of digital artistry and widespread access to digital platforms and code, but certain kinds of authoring tools remain prohibitively expensive or unusable for the technologically uninitiated.[3] Activists such as The Yes Men may dazzle the public with comically hyperbolic computer-generated graphics that mimic the disingenuous visual rhetorics of the companies that they impersonate, such as when they created a 3D-simulated assembly line in which first-world waste becomes third-world fast food.[4] Yet, the cost of software licenses, storage, bandwidth, graphics work stations, and trained personnel necessarily limits the verisimilitude of their subversive fictions in comparison to the capacities of their much-better-financed corporate counterparts at creating ever more compellingly realistic virtual worlds. The most technically advanced forms of such authoring expertise tend to be exercised for commercial purposes and proprietary corporate interests by parties who create synthetic worlds under contract with Hollywood, the military, the health-care industry, or the legal field.[5]

This chapter explores the distinctive software-specific labor and knowledge practices that manufacture computer-simulated environments and objects. These objects circulate not only in entertainment, but also as legal, scientific, architectural, and journalistic evidence and deliberation; that is, as virtual sites in which public political discourse takes place. Bruno Latour once observed that "making things public" often requires the literal display of "public things" (in Latin, the *res publica*). For Latour, the co-creation of knowledge, the construction of spaces for public assembly, and visual representation are closely interrelated. This is particularly true even if cultural norms are discipline-specific. Latour writes,

> Scientific laboratories, technical institutions, market-places, churches and temples, financial trading rooms, Internet forums, ecological disputes—without forgetting the very shape of the museum inside which we gather all those *membra disjecta*—are just some of the forums and agoras in which we speak, vote, decide, are decided upon, prove, are being convinced. Each has its own architecture,

its own technology of speech, its complex set of procedures, its definition of freedom and domination, its ways of bringing together those who are concerned—and even more important, those who are not concerned—and what concerns them, its expedient way to obtain closure and come to a decision.[6]

Rather than present a relatively unified Habermassian public sphere in which participants inhabit a single lifeworld, Latour imagines a number of simultaneously existing *topoi*, many of which are now rendered computationally.

In *The Language of New Media,* Lev Manovich argues that "the logic of a computer" now shapes many other forms of traditional cultural production.[7] Thus, in a phenomenon that Manovich describes as "transcoding," consumer products and infrastructures such as buildings, furnishings, and vehicles express their specific design properties as well as unintended quirks of particular software algorithms. According to Manovich, the very skylines of our cities now demonstrate the fact that architects and engineers depend on software to create both prototypes and final products. As Matthew Kirschenbaum observes, the software that such designers use executes code in a fashion that expresses both ideals of mathematical perfection and purity of abstraction and the pragmatic facts that code runs on mechanical devices.[8] Thus, "cyberspace" can never exist apart from the material substrates that enable connection, processing, display, and storage, just as it can never exist apart from labor practices and the social roles of production systems.

Of course, software shapes more than our physical environment; it shapes our cultural imaginaries as well. Software creates the digital special effects in movies that depict the violent consequences of warfare, terrorism, global climate change, alien invasions, or apocalyptic endings for the planet. Norman Klein has argued that the massive scale of the cinematic city of the future made possible by digital effects may even propagate conservative ideologies that are opposed to the new urbanism, thereby implicitly defending suburbia and its reactionary political management of gender, race, and class.[9] According to Vivian Sobchack, the morphing of the human subject made possible by digital effects can be understood as part of a longer history of representation, narrative, and mythology in which Ovid and *Terminator 2* may exist on the same continuum of cultural production.[10]

The range of cultural production that involves visual effects artists often extends far beyond conventional Hollywood cinema and traditional audiences for entertainment fare. Help-wanted pages may seek freelance artists for eclectic projects such as a "short film on the cosmos/consciousness/spirituality."[11] One may even see hourly work advertised for

companies that handle defense contracts, such as a listing from a firm that creates digital training materials for negotiators, chaplains, and other military personnel, which needed artists to create simulated human characters "talking to camera, typing, and moving between sitting poses."[12] Those who use job networks for highly trained 3D animators may need to devote their labor to building virtual worlds in many different rhetorical contexts that may be much more complex as knowledge systems than simplistic "infotainment" labels may indicate.

job-seeking for world-making

Lev Manovich's *Software Takes Command* notes that software packages used in world-making fields have become increasingly complex in order to enhance the possibilities of information visualization, and that this complexity in turn fosters collaborative practices around particular global aesthetics. Programs such as Autodesk Maya "can usually display the model in at least a half a dozen different ways" from wireframe to fully rendered versions, while the artist may be manipulating "dozens of separate objects each having dozens of parameters."[13] For example, the list of basic display options in Maya includes Kinematics, Animation, Manipulators, NURBS, Polygons, and Subdivs., and different user interface elements include Shelves, Tool Box, Channel Box, and Attribute Editor. Michael Nitsche argues that the structures of a 3D creation program such as Maya "can evoke certain readings of space" as well as enable certain modes of authoring; literacy in Maya, therefore, allows a user to both read and write richly detailed virtual worlds.[14]

Manovich additionally claims that such software promotes not only a particular relationship with a suite of tools but also a workflow process. The transparency of the workflow—a sequence of rationalized administrative processes through which a piece of work passes from conception to reception—is of critical concern to media authoring industries. However, the non-intuitive (or even counterintuitive) customs of that workflow process may only be shared among initiates in the corporate inner circle who have become acclimated to common labor practices. Tutorials and user manuals may in fact leave aside critical information for novices about how to manage complex projects constructed with elaborate file structures and multiple versions of the same scene or character. However, specific labor cultures only identify a person as a fellow "professional" if they observe certain recognized norms, such as following established naming conventions for digital files.

Given the extreme specialization and levels of gatekeeping that Manovich describes, it has become the case that paying careers for modelers, animators, programmers, or compositors are commonly only established through long resource-intensive apprenticeships in niche areas,

and relatively few entry-level positions are available among employment listings. For example, a 2008 job posting for a compositor at Rainmaker Entertainment, an animation effects studio that describes itself as a place "where worlds are created," specifies that applicants should have at least four years of professional experience. For this listing, a "working knowledge of Maya and Nuke is required," and knowledge of "XSI, Houdini and rendering software such as Shake, Digital Fusion and/or After Effects is considered an asset."[15]

Individual specializations are even narrower, since companies may seek only those who are able to program and write scripts that simulate the behavior of particles, fluids, solids, or gravity itself. Those focusing on virtual "rigging," "lighting," "shading," or camerawork may follow specific career paths, just as those who work in traditional film production may devote a lifetime to working their way up the ladder of apprenticeship in highly selective industry guilds. An advertisement on Creative Cow that recruits a "digital texture artist" seeks someone "responsible for creating photo-real texture and relevant maps" to "be rendered using established industry tested rendered software and proprietary renderers." The company also specifies awareness of "the aesthetics and techniques of photo-realistic effects" and "a strong understanding of real world materials." The listing also notes that this artist should have "successfully completed" a degree program in visual effects or computer animation from a "recognized institution." Furthermore, cross-disciplinary knowledge is required because "3DModeling and Digital Texture Artists work closely with the shading and lighting artists. Therefore, a thorough knowledge of each discipline must be demonstrated."[16]

Digital specialists in muscle, skin, hair, fur, or clothing may only compete for jobs with their highly trained peers. For example, a 2012 listing for a "fur artist" at Reel FX Studios sought a "team player in a high pressure, deadline driven environment." Moreover, the company asked for someone with experience in "one or more dynamic hair packages, such as Maya hair, Shave and a Haircut, or Styleflex hair." Additionally, the applicant was required to have "expertise" in Autodesk Maya, one of the standards for 3D animation, modeling, simulation, visual effects, rendering, matchmoving, and compositing in the animation industry, which is widely used in film, video games, television, print publication, graphic design, and architecture.[17]

The aesthetics of scale and granularity involved in this work then demands photorealistic effects often at a highly trained level of detail in which a single strand of hair or a raindrop must be directed with as much attention as would be devoted to a human actor in conventional cinema. For example, a job posting on the Digital Filmmaker's Resource Site seeks "a RealFlow/Maya savvy 3D artist with experience in fluids and fluid dynamics for upcoming commercial productions" to incorporate "splashes

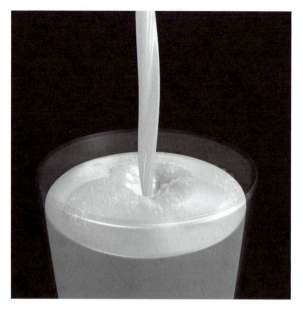

Figure 12.1
Milk (2009), Mel Horan.

and other fluid effects." Like many job advertisements discussed here, this posting specifies "no students or recent grads please."[18] Although such listings prohibit entry to those still learning software in pedagogical rather than professional settings, a circular logic connects educational certification closely to workplace tools. A person seeking more information about the RealFlow software described in this advertisement might find the ad for RealFlow's New Certification Program for Schools and Training Centers from Next Limit Technologies taking up most of the online real estate of the landing page for the company's website.[19]

To the jobseeker seeking entry-level employment on the Animation World Network website, banner ads frequently remind him or her that professional animation schools and art academies offer more training in these specialized areas. Such instruction may be very expensive compared to similar software education at a community college. Recent controversies about for-profit education, financial aid, and student-loan debt suggest that the rapidly growing economic burden of tuition is becoming more difficult to recoup.[20] For example, the Gnomon School of Visual Effects in Hollywood charges over $66,000 in tuition for a two-year program in Digital Production for Entertainment.[21] California residents may be eligible for subsidies from the California Employment Training Panel (ETP) if already working for an entertainment company, and others can apply for financial application through the Free Application For Federal Student Aid (FAFSA), but the debt burden can make early employment choices

even more limited among participants in software-specific production cultures.

Although organizations such as the Mozilla Foundation have sponsored initiatives to recognize design and programming abilities with "badges" rather than with conventional diploma programs, job listings on Animation World Network and Craigslist continue to show preference for traditional forms of education with degrees and certification. Furthermore, despite the fact that examples of Maya Embedded Language Script may be, seemingly, liberally shared and disseminated among communities of artists and designers, deploying individual lines of code from these snippets of MEL Script requires the ability to navigate an extremely complex interface and understand how the code executes and renders a 3D representation of space and time.

beyond entertainment: making law, making science, making news

When the reach of these new media extends beyond entertainment to become a critical part of contemporary legal argument, scientific debate, journalism, public relations, military strategy, land-use planning, and other domains not conventionally associated with media production for public audiences, the need for systems to train and certify ever more targeted digital professionals becomes even more acute. Furthermore, informed users not only need to know how to operate in specialized fields and to navigate complex menus and file structures but also how to find workarounds when onerous user agreements, digital rights management systems, and constant versioning make expensive commercial proprietary software even more difficult to use without access to "cracked" versions that have had their copy-protection removed or to knowledge of common reverse-engineering techniques.

These forms of "procedural literacy" are critical to successful new media production, particularly when digital artists might find it difficult to create their own demo reels for future employment without violating either their employee contracts or copyright law. (One of the conventions of personal demo reels for digital effects artists is that the original source footage from a set with live actors is shown first, then the footage is overlaid with in-process digital elements, such as wireframes, and finally the finished composited shot is shown. This process may also be shown in reverse on a demo reel, but these elements may be fiercely protected by studios that do not allow raw footage to exit the site.) These forms of pragmatic knowledge are thus often delegated to sites of vocational learning and treated as craft, not art. While cinematic and literary models of authorship continue to dominate the education of *auteurs* and authors in traditional Hollywood and publishing parlance, theories about affordances

and constraints that are central to understanding the software that creates such cultural artifacts get relatively little attention.

In legal settings, authoring in 3D animation software may simulate the execution of crimes unseen by witnesses or illustrate shortcomings in the recollections of eyewitnesses. Digital simulations used in courtrooms that are created by third-party artists reconstruct events that range from the kinds of large-scale industrial malfeasance that lead to ecological disasters to small-scale neighborhood traffic accidents. Under US law, this material serves only as "demonstrative evidence" that summarizes other evidence or testimony. In the legal sphere, 3D animation is supposed to serve only as illustration, and its creators labor in even more obscurity and anonymity than their Hollywood world-making counterparts. Nonetheless, video animations have become an important part of litigation discourses, much as charts and diagrams have been traditionally used by both the prosecution and the defense.

Such animations in the courtroom are not without controversy. Legal decisions have affirmed a judge's rights to exclude such evidence in *Clark v. Cantrell*, and have castigated the government for dazzling juries with such evidence in *State v. Farner*.[22] One treatise on new forms of digital evidence from the company DOAR Litigation Consulting notes that software executives may become unwilling parties in courtroom wrangling over who is telling the truth because "the trustworthiness and reliability of a computer simulation depends, to a much greater degree than in the case of computer animation, on the software used to produce it, the authentication of which may require an expert opinion."[23]

> Therefore, courts may tend to be more conservative about what constitutes a proper foundation for presenting computer simulations at trial, at least as long as the nature of the software remains relatively obscure. If the software is proprietary (the underlying code is protected as a trade secret by the designer of the software), the court may compel production of the codes for scrutiny, unless an independent expert can testify to the reliability of the software based on industry standards, acceptance by the relevant scientific or technical community, general availability, or history of producing accurate results. Problems may arise if the court compels production of the code, but the software designer resists—especially when the designer is an entity unrelated to the litigation—on the basis that the code is intellectual property.[24]

Thus, according to DOAR, it is preferable that the simulation software that visualizes the contentions of a particular case also serve as a trade standard for testing conditions, as in the case of the software that reproduced

lighting conditions in a parking garage in *Bray v. Bi-State Development Corp.*[25] Creative license exercised by the individual agency of a designer would be highly undesirable in such cases, and scientific accuracy rather than imaginative interpretation is clearly valued.

In these cases in which video simulations appear in court cases, questions about the ethics of source code itself may become an issue. Scholars in the Critical Code Studies Working Group on Ethics have argued that both "the writing of individual lines of code by programmers for work or play and the reading of code by scholars and archivists working to discern intent or causality" should require attention to the philosophical dimensions of ethical engagement and "awareness of the ethical factors embedded in the writing and reading of code that are in turn impacted by factors in society and culture."[26]

Although articles in law review journals may warn that "television generation viewers" are misled by tantalizing computer simulations, such animated models are increasingly part of the expert discourses of science and thus part of evidentiary conventions in contemporary knowledge more generally.[27] Since the Supreme Court ruled that "testing pursuant to the scientific method" should be more central to distinguishing expert testimony from hearsay in *Daubert v. Merrell Dow Pharmaceuticals*, computer simulations that supposedly try out precisely how objects would interact under different experimental conditions seem to serve as both a testing ground and an increasingly acceptable field of display.[28]

Computer simulations that visualize information from the natural world and the historical past certainly serve important pedagogical and persuasive purposes in fields that range from astronomy to zoology. In the discipline of archeology, members of learned societies have claimed in the recent book *Beyond Illustration* that vivid and interactive 3D simulations may also serve as tools for scientific discovery and the shaping of research questions.[29] Matt Ratto has described such computer simulations in archeology in terms of "epistemic commitments" that may be more contested and more tenuous than the model of conclusive demonstration in which the simulation merely functions as evidence of the scientist's experimental logic played out to its logical conclusion.[30] Furthermore, practices for crediting those who program such simulations in the scientific literature to which they contribute have yet to be regularized, and figuring out the relationship between traditional scientific authorship and newer forms of media authoring is in flux.

In my own institution, researchers at the California Institute for Telecommunications and Information Technology who are part of the Center of Interdisciplinary Science for Art, Architecture, and Archeology are using large-scale 3D simulations and flythroughs to search for a missing Leonardo da Vinci mural, explore the historical truth of the legends of King Solomon's Mines, and seek the remnants of the empire of

Genghis Khan. Although the Genghis Khan project uses crowd-sourcing techniques to encourage fans of *National Geographic* to search for ruins on the vast Eurasian continent where Khan once ruled, most of these projects require extremely expert forms of knowledge. Those who run demonstrations for the public on the HIPerSpace visualization system across 55 high-resolution tiled screens generally have advanced degrees in fields related either to the specific field of exploration, such as archeology or art history, or in computer-science- or informatics-related disciplines, in addition to years of practice on the expert visualization systems they have learned to navigate.

In journalism, 3D simulations may be used to enhance the presentation of journalistic truth in coverage of a given current event or news story. For example, former *Newsweek* correspondent and documentary filmmaker Nonny de la Peña considers herself a pioneer in "immersive journalism."[31] Unlike "citizen journalism" that has a low threshold for entry, since any witness with a cell phone camera can function as a reporter in the contemporary news landscape, "immersive journalism" requires years of experience in creating 3D solids and lifelike animations and familiarity with a number of media authoring platforms and technologies. Using a 3D engine capable of rendering complex virtual scenes, De la Peña created *Hunger in Los Angeles* (2012) in which a user wearing a head-mounted display can walk among computer-generated animated figures (who appear life-sized) waiting in a food line and watch as a helpless bystander when one of the people waiting collapses in a diabetic coma before being rushed away by emergency personnel.

Even online versions of mainstream publications such as *The New York Times* have used 3D computer graphics to illustrate and dramatize everything from collapsing bridges to luge accidents. However, the use of default characters and scenes in media authoring for news might detract from both authenticity and verisimilitude when journalism adopts the virtual camera in lieu of the traditional one. For example, a *Denver Post* graphics editor has shown that the accuracy of the depiction of a school shooting at Platte Canyon High School might have been poorly served by re-creations of the event that were generated by a 3D computer simulation package, which can populate a scene with procedurally constructed human figures to restage events that take place behind police cordons and out of the view of camera crews.[32] Because of the nature of software defaults, one CBS news broadcast actually portrayed the Platte Canyon High rescue scene with military personnel storming into the classroom rather than police officers on the local SWAT team.

When golf star Tiger Woods was involved in what was taken by some to be a domestic altercation with his wife, a Chinese team produced what was called "motion news" that showed a cartoonish recreation of the incident. The clunkiness of these stock figures was later lampooned by MSNBC's

Keith Olbermann, although he opined that such techniques were here to stay in televised news broadcasts, given the difficulty of finding appropriate news footage or b-roll for some stories. Olbermann argued that such reconstructions could offer humorous commentary on tabloid stories, but that it was not acceptable to use such stylized digital stereotypes for events with more gravitas. Specifically, he deplored depicting the ambush of a group of police officers in Seattle in TV news with a similar segment of 3D animation.[33]

machinima and the limits of mastery

Production cultures that are defined by professional and commercial norms may differ substantially from those based on the gift economies and modes of informal learning at work in DIY communities of digital content-creators. For example, the use of much simpler animation engines is characteristic of "machinima," a form of digital filmmaking that often uses video game engines to dramatize action with stock figures that are more easily puppeted on digital sets and backdrops than would be possible with more complex professional programs such as Autodesk Maya. Peter Krapp has argued that machinima privileges gesture and its citability, much as was the case with silent film. However, Krapp also insists that such filmmaking opens up possibilities for political and cultural critique because it can function like "Brechtian epic theater," which alienates as it simulates events. Krapp notes that "moments and sequences of gameplay are interrupted and time-shifted into a different context."[34]

While the expertise of the cognoscenti in programs such as Maya is often applied to making movement more fluid and space more deep, machinima may draw attention to the limitations of a character's movement or the lack of digital assets in a scene. Ironically, some have argued that hyperrealistic computer animation created by programs such as Maya create even more distance and even less empathy than machinima does. This is especially possible if audiences experience what has been called "the uncanny valley" in which realistic animated figures get close enough to recreating living entities that the shortcomings of those digital representations can be apprehended as a disturbing kind of lifelessness.[35]

New media scholars have praised machinima as a venue for "low-floor, high-ceiling" digital cultural production, but there are many other counterexamples of 3D media authoring software programs that support a position of universal access and democratic participatory culture contrary to the one that I am describing in this chapter.[36] For example, building on products already familiar to consumers, such as Google Earth or Google Maps, Google SketchUp promises "3D Modeling to Everyone" with a tagline enthusing about the existence of "a tool available for anyone designing anything from coffee pots to skyscrapers."[37] The accessibility of Adobe

Photoshop to many computer users, the familiarity of the XYZ arrows, and the simple cube that served as a basic building block similarly once made the 3D virtual world Second Life an appealing environment for 3D design for many amateurs during its heyday. However, the relative crudeness of computer simulations created with SketchUp or Second Life has not created production cultures as robust or as lucrative as the ones associated with large digital effects houses and programs such as Maya.

The open-source 3D program Blender presents itself as a potential competitor to Maya, but users still face a steep learning curve in creating content with the software, especially in comparison to the relative ease of puppeting machinima or building in programs such as SketchUp or Second Life. The Blender website acknowledges that the program's "very unusual interface," which is "highly optimized for 3D graphics production," might be "a bit confusing to a new user." [38] Furthermore, some users may be stymied by "cheap graphics cards on the market that only support a basic sub-set of the OpenGL specs."[39]

Maya's real challengers are likely to come from other proprietary visual effects software companies. At this writing, Maya may be an essential competency area for many professional digital effects artists, but in the years to come, Maya may be replaced by new industry standards, just as it replaced older software packages that were once widely in use by digital effects houses. Erkki Huhtamo cautions that critics should not overlook the potential obsolescence of any visualization technology.[40] Indeed, many software-specific production cultures have already become extinct as media production packages are upgraded, renamed, or abandoned. Furthermore, corporate takeovers and failures in an industry that is specialized, competitive, and frequently platform-dependent have consigned certain forms of computer simulation to disuse. What does not change is an organizational structure of labor and sociality based on specialized expertise, apprenticeship training, and high barriers to entry.

As authoring replaces authorship in the cultural landscape, it is important to question the uncritical celebration that has often attended the arrival of what seems to be an era of user-generated content and user-friendly interfaces. Millions may use media-sharing sites such as Facebook and YouTube, create works or art on easily accessible devices such as cell phones or tablets, and feel that the divisions between expert and amateur are breaking down. However, if 3D photorealistic verisimilitude is required in professional entertainment and legal, scientific, or journalistic settings, the rules governing highly specialized and highly trained cadres of expert digital artists must be understood and observed. Software-specific production cultures will continue to develop even as other forms of media democratization take place and as those same specific technologies change along with their cultural practices.

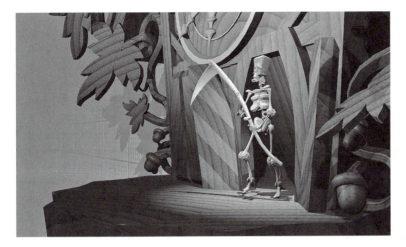

Figure 12.2

Clockworks (2002), Mel Horan.

notes

1. Pat Harrigan and Noah Wardrip-Fruin's *Third Person: Authoring and Exploring Vast Narratives* (Cambridge, MA: The MIT Press, 2009) devotes half its text to modes of "authoring" characterized by narrative extent, world and character continuity, cross-media universes, procedural potential, and multiplayer interaction.
2. Henry Jenkins, *Convergence Culture: Where Old and New Media Collide* (New York: New York University Press, 2006); Mizuko Ito, "Amateur Media Production in a Networked Ecology" (paper presented at the CSCW 2010, Savannah, Georgia, February 10, 2010). http://www.itofisher.com/mito/publications/amateur_media_p_1.html.
3. Geert Lovink, *Zero Comments: Blogging and Critical Internet Culture* (New York: Routledge, 2008); Rita Raley, *Tactical Media* (Minneapolis: University of Minnesota Press, 2009).
4. The Yes Men, "Let Them Eat Hamburger" (2002?), accessed May 21, 2012, http://theyesmen.org/hijinks/plattsburgh.
5. Organizations such as the Association for Computing Machinery's Special Interest Group on Graphics and Interactive Technology (SIGGRAPH) disseminate cutting-edge work among academics developing new animation and simulation programs.
6. Bruno Latour, "From Realpolitik to Dingpolitik," in *Making Things Public: Atmospheres of Democracy*, ed. Bruno Latour and Peter Weibel (Cambridge, MA: The MIT Press, 2005).
7. Lev Manovich, *The Language of New Media* (Cambridge, MA: The MIT Press, 2001), 63.
8. Matthew G. Kirschenbaum, *Mechanisms: New Media and the Forensic Imagination* (Cambridge, MA: The MIT Press, 2008).
9. Norman M. Klein, *The Vatican to Vegas: A History of Special Effects* (New York: New Press/Norton, 2004), 298.
10. Vivian Sobchack, *Meta-morphing: Visual Transformation and the Culture of Quick-change* (Minneapolis: University of Minnesota Press, 2000).

11. "MAYA Particle Fluids VFX - Jobs - Creative COW," February 5, 2012, accessed May 21, 2012, http://jobs.creativecow.net/job/867111.

12. "A Great 3D Animator Needed - Jobs - Creative COW," February 2, 2012, posting expired, http://jobs.creativecow.net/job/866520.

13. Manovich, *Software Takes Command*, November 20, 2008, accessed May 21, 2012, http://lab.softwarestudies.com/2008/11/softbook.html.

14. Michael Nitsche, *Video Game Spaces: Image, Play, and Structure in 3D Game Worlds* (Cambridge, MA: The MIT Press, 2008), 164.

15. "Compositor," *The AWN Career Connections*, February 8, 2012, posting expired, http://jobs.awn.com/jobseeker/job/8997476/Compositor/Rainmaker%20Entertainment/.

16. "3D Modeler / Digital Texture Artist - Jobs - Creative COW," November 23, 2011, accessed May 21, 2012, http://jobs.creativecow.net/job/866125.

17. "Fur Artist Feature Animation," *The AWN Career Connections*, January 27, 2012, posting expired, http://jobs.awn.com/jobseeker/job/9496849/Fur%20Artist%20%20Feature%20Animation/Reel%20FX%20Studios/.

18. "RealFlow / Maya Fluid Dynamics Artist Wanted L.A. - 2-Pop Forums", April 21, 2005, accessed May 21, 2012, http://www.2popforums.com/forums/showthread.php?t=75659.

19. "RealFlow: CertificationProgram," n.d., accessed May 21, 2012, http://www.realflow.com/rf_education.php.

20. See Anya Kamenetz, *Generation Debt* (New York: Riverhead, 2006), and Allan Collinge, *The Student Loan Scam* (Boston: Beacon Press, 2009).

21. Gnomon School of Visual Effects | Digital Production for Entertainment, n.d., accessed February 26, 2012, http://www.gnomonschool.com/programs/digital_production/.

22. *Clark v. Cantrell* 332 S.C. 433, 504 S.E. 2d 605 (Ct. App. 1998); *State v. Farner* 2012-OHIO-317 (January 30, 2012).

23. Suzan Flamm and Samuel H. Solomon, *Admissibility of Digital Exhibits in Litigation* (Lynnbrook, NY: DOAR Litigation Consulting, 2004), accessed May 21, 2012, http://www.epic-photo.org/documents/doar.pdf.

24. Flamm and Solomon, *Admissibility of Digital Exhibits in Litigation*.

25. *Bray v. Bi-State Development Corp.*, 949 SW 2d 93 (Court of Appeals, Eastern Dist., 2nd Div. 1997).

26. Evan Buswell, Scott Dexter, Craig Dietrich, and Elizabeth Losh, "Week 1: Ethics - CCS Working Group 2012," January 31, 2012, http://wg12.criticalcodestudies.com/discussion/10/week-1-ethics#Item_6.

27. Adam T. Berkoff, "Computer Simulations in Litigation: Are Television Generation Jurors Being Misled," *Marquette Law Review* 77 (1993–1994), 829.

28. *Daubert v. Merrell Dow Pharmaceuticals, Inc.*, 509 US 579 (Supreme Court 1993). See Scott S. Katz and Elliot L. Stern, "Daubert in the 21st Century and Computer Simulation," presented at the NASP Annual Conference, New Orleans, LA, 2007, accessed May 21, 2012, http://butlerpappas.com/1432.

29. American Council of Learned Societies, *Beyond Illustration 2d and 3d Digital Technologies as Tools for Discovery in Archaeology*. BAR International Series 1805. (Oxford, UK: Archaeopress, 2008).

30. Matt Ratto, "Epistemic Commitments, Virtual Reality, and Archaeological Representation," in *Technology and Methodology for Archaeological Practice: Practical Applications for the Past Reconstruction (Technologie Et Méthodologie Pour La Pratique En Archéologie: Applications Pratiques Pour La ReconstructionDuPassé)*, ed. Alexandra Velho (Oxford, UK: Archaeopress, 2009).

31. Nonny de la Peña, "Nonnydlp.com | Nonnydelapena.com | Pyedogproduct-ions.com | WELCOME," n.d., accessed May 21, 2012, http://www.nonnydlp.com/.

32. "Covering Shootings: An Infographics Case Study," YouTube video, posted by jonathanberlin, 2007, accessed May 21, 2012, http://www.youtube.com/watch?v=c7a8L1dwLbU&.

33. *Tiger Woods Animation 2.0 Keith Olbermann*, YouTube video, posted by mandydouful, December 11, 2009, accessed May 21, 2012, http://www.youtube.com/watch?v=ctL8fRy9MO4&.

34. Peter Krapp, "Of Games and Gestures: Machinima and the Suspensions of Animation," in *The Machinima Reader*, ed. Henry Lowood and Michael Nitsche (Cambridge, MA: The MIT Press, 2011), 159.

35. Angela Tinwell, Mark Grimshaw, Debbie Abdel Nabi, and Andrew Williams, "Facial Expression of Emotion and Perception of the Uncanny Valley in Virtual Characters," *Computers in Human Behavior* 27, no. 2 (March 2011), 741–49.

36. See, for example, Mizuko Ito, "Machinima in a Fanvid Ecology," *Journal of Visual Culture* 10, no. 1 (April 1, 2011), 51–54.

37. Google SketchUp, n.d., accessed February 21, 2012, http://sketchup.google.com/.

38. Doc:2.6/Manual/Introduction/History – BlenderWiki, n.d., accessed February 27, 2012, http://wiki.blender.org/index.php/Doc:2.6/Manual/Introduction/History.

39. Blender.org—Education & Help, n.d., accessed March 21, 2012 http://www.blender.org/education-help/.

40. Erkki Huhtamo and Jussi Parikka, *Media Archaeology: Approaches, Applications, and Implications* (Berkeley: University of California Press, 2011).

global flows of women's

cinema

nadine labaki and female authorship

p a t r i c i a w h i t e

Young women directors are achieving increasing prominence within the current circulation of world cinema, facilitated by international festival networks, transnational funding agencies, the cinephilic blogosphere, and fan- and diasporic online networks. Though the prestigious category *auteur* remains, undoubtedly, preponderantly male, the fact that women have gained higher profiles and more honors within such taste-making international venues as A-list film festivals stamps the figure of the woman director with new value. In the first decade of the twenty-first century, films by women twice took home top prizes at both Berlin and Venice. The Cannes Grand Prix (its second prize) was conferred on Naomi Kawase's *The Mourning Forest* (Mogari No Mori) in 2007, and that festival's Jury Prize (its third most prestigious) was awarded to films by women six times.[1] Veteran director Kathryn Bigelow closed the decade by winning the first Oscar to be received by a woman in the directing category for *The Hurt Locker* (2008), renewing intermittent debates about the celluloid ceiling.[2] During the same period, in that competition's (admittedly compromised)

foreign-language film category, dozens of films by women directors were submitted by their countries for consideration; while proportionately fewer received nominations, two films won the award.[3]

If this publicity indeed indicates feminist gains in the elite sector of world cinema, where female authorship is articulated with aesthetic value, do these gains matter at the level of global mass culture, where questions of women in cinema seemingly remain constrained by "to-be-looked-at-ness" and the consumerist quandaries of the "chick flick"? Through a case study of a young Lebanese actress–director, Nadine Labaki, I show how discourses around female authorship in cinema intersect with media constructions of national identity, celebrity, and genre as well as with an aesthetic signature validated by the festival circuit. I suggest that the contours of women's cinema—provisionally defined as films by and about women, regardless of a filmmaker's own attitude toward the term or the industrial, artisanal, or political mode of production—have been broadly remapped by shifts in global production, circulation, and evaluation of films.[4]

As Hollywood franchises dominate global film consumption, and new technologies alter distribution and viewing experiences, "world cinema" is presented by international festivals, policies, and critics as a brand or category that preserves film art and national identity. Women directors— whether working in national popular or art cinema or training in film schools or other media industries—are ambivalently recruited to this corrective project, becoming guarantors of "culture" in multiple senses of the term, though not necessarily masters of their own art. Yet, while new understandings of world cinema are the object of growing attention in film studies, questions of gender and authorship have yet significantly to structure such inquiry.[5]

How does globalization affect the concept, content, and address of women's cinema, and how are women's films challenging assumptions about and approaches to world cinema?

Even more pointedly—how are women filmmakers shaping new, transnational formations of feminist film culture within these circuits of production, distribution, and exhibition? Of course, feminist activists, organizations, and scholars have fostered and advocated for women's media since the 1970s, and this work now reaches far beyond the Anglophone contexts in which it principally originated. Encompassing community-based media, documentary, and experimental work, personal filmmaking, and artists' film, women's cinema circulates largely through non-theatrical venues and feminist and academic networks. While not my focus here, this history informs and helps make sense of the twenty-first-century presence of women feature filmmakers in a range of national film industries and transnational media contexts in which categories of cinematic value are adjudicated and distinction conferred.

Women directors are in fact key to the history of political filmmaking in Lebanon. While the country has a rich cinema-going tradition associated with time of French mandate, its national industry has been dominated by Egyptian talent. During the civil war (1975–1990), a true auteur cinema emerged with outspoken women directors such as Randa Chahal Sabbag (1953–2008) and Jocelyne Saab (b. 1948) making political documentaries and, later, feature films while living in exile. Several decades younger than these prominent directors, Labaki (b. 1974) was among the first graduates of Beirut's Saint Joseph University's film school in 1988, where her student film won a prize. In the absence of an infrastructure for Lebanese cinema, both the filmmakers who returned after the civil war, and Labaki and her peers who came of age during the post-civil-war period, are dependent on co-production financing, traditionally from France. Labaki's *Caramel* (Sukkar Banat, 2007) is a French/Lebanese co-production produced in Lebanon with a French producer, Ann-Dominique Toussaint. When *Caramel* debuted in Cannes in the Directors' Fortnight in 2007, it immediately attracted international attention; Labaki returned to the festival with her second film, *Where Do We Go Now?* (Et maintenant, on va où?) in 2011. *Caramel* topped the box office charts in Lebanon, and its success on the festival circuit (including a Gala at Toronto) earned it release in 32 territories and a gross of $14 million (against a budget of under $2 million); it was the first Lebanese film to be released theatrically in the United States. The popular success of Labaki's films coincides with an upturn in feature-filmmaking and film culture in Lebanon and in the Middle East more generally, with newly established film festivals and markets in the United Arab Emirates offering co-financing opportunities and outlets. For my purposes, the high profile of *Caramel* as a film from a peripheral film-producing country by a woman director makes it an exemplary text in any consideration of how so-called third-world women directors are becoming important currency in twenty-first-century global culture.

I focus on *Caramel* in order to map multiple determinants of cross-cultural consumption, competing constructions of feminism and "post-feminism," and shifting politics of prestige, patronage, and taste that inform the reception of female film authorship in a globalized, multi-platform media world. A national and regional celebrity through her work in music videos and commercial campaigns, with a charismatic presence on the international film circuit and as lead actress in her own films, Labaki harnesses the proto-feminism of the global "chick flick" and the energy of Arabic pop fandoms in her compelling performance of authorship.

nadine labaki and the chick flick

Caramel centers on a group of women who frequent and work at a beauty salon and support each other through romantic difficulties, the constraints

214

patricia white

of family and traditional femininity, and conflicts between career and desire. The space, the scenario, the character type—all are recognizable to North American audiences from the generic world of the woman's picture. The film activates familiar dynamics of spectatorial identification through the trope of female friendship and a distinctive, though not exclusive, address to a female audience. In time-honored traditions of film melodrama, political and social conflicts are displaced onto personal and consumerist concerns and resolved (or not) emotionally rather than systemically.

However, this is not a Hollywood women's picture. *Caramel* is set in Beirut and uses its female ensemble-cast formula to bridge social divisions—notably, in the Lebanese context, sectarian ones between Christians and Muslims (evoked here with intentional superficiality—a character name, a cross). On the one hand, the film's enthusiastic international reception credits its "universality"; it is emphatically privatized and consigned to a world of emotional connection. On the other hand, the film's success on the world stage is appropriated to discourses of the nation, "softening" Lebanon's international image of civil war and strife. The film's reception is framed in both populist and auteurist terms. Thus, while making concessions to international viewers in the commodity form of the art-house-friendly "foreign film," *Caramel* frames questions about gendered authorship, genre, and trans/national address that have significant implications for contemporary feminist media studies.

National films for export frequently deploy images of female emancipation as part of an international bid for the nation to be seen as progressive; the figure of the woman director herself often can be seen in this light.[6] Paradoxically, for example, in the case of post-revolutionary Iran, where the profession of cinema is governed, like all public life, by modesty laws, the percentage of women directors is much greater than in most Western nations. A less ideologically mediated example is the international acclaim accorded Tunisian director Moufida Tlatli (who became cultural minister after the January revolution). Ella Shohat cites Tlatli's *Silences of the Palace* (Samt el Qusur, 1994) as a primary example of what she calls "post third worldist" cinema—films that depart from a masculinist "third worldist" emphasis on nation-building and revolutionary violence to foreground gender and sexuality, the private sphere, and feminism.[7] Yet, Tlatli's film, which deals with a servant girl's experience of the transition to independence, is still very much an allegorical intervention in master narratives of Tunisian patrimony. In contrast, the success of *Caramel*, and Labaki's media celebrity, can in part be attributed to the more recent film's affinity with "post-feminist" texts that associate female emancipation with consumerist values and sexual and professional self-definition in a neoliberal frame—to its status as a Beirut *Sex and the City*, consistent with Lebanon's cosmopolitan reputation as the "Switzerland of the Middle East," and its relaxed

215

standards of female dress code. Extradiegetically, Labaki's glamour is consistent with those of the contemporary Lebanese female megastars whose images her music videos have helped cultivate; it is this glamorous image that is received by national, diasporan, and regional audiences. Diegetically, her character is intelligible to transnational audiences in generic terms.

"Chick flick" is, of course, the epithet used to characterize—and dismiss—contemporary women's pictures (romantic comedies and serious dramas that receive limited critical but much fan love). In contrast to the proto-feminism of the classical Hollywood women's picture, the chick flick is a genre of production, and a ritual of consumption, often associated with the post-feminist presumption that the collective goals of feminism have been achieved, leaving the emancipated woman to address her narrowly individualized needs through heterosexual coupling and the commodity form. That this is an often racialized, class-based, and Western narrative is pointed out by Diane Negra and Yvonne Tasker in the introduction to their collection *Interrogating Postfeminism*: "postfeminism is white and middle-class by default," in its focus on leisure and consumption.[8] Their volume characterizes post-feminist culture as transnational-media representations of women that relegate feminism to the past. Because women's autonomy, solidarity, and empowerment are taken as givens and goods, feminism itself—as organized political struggle on behalf of women as a class—is considered passé. When the geopolitical dimensions of this neoliberal narrative are acknowledged at all, it is with the perhaps paradoxical result of displacing active feminism onto the global south. Human rights campaigns and various "click-philanthropy" projects targeted at "women and girls" work for "democracy"—and, one assumes, an attendant level of consumer comfort. There is, of course, profound arrogance in this assumption of a cultural lag time, given that "post-feminist" culture exports the ideologies of individualism that precisely paralyze collective struggle. And in the process, feminisms from other parts of the world are not recognized as such. Like Hollywood "chick flicks," films such as *Caramel* articulate problems of female subjectivity and agency with dimensions of contemporary consumer society. However, the film's embeddedness in a national cinema and a larger world helps bring out a critique of post-feminist culture's complicity with profoundly imbalanced global flows of capital and power.

Caramel embraces both the consumerist "chick flick" present and the affective energies of traditional women's genres while steering clear of overt framing in terms of Arab feminisms. Labaki's film uses a female ensemble-cast formula to articulate changing questions about national identity with the urgency of women's self-realization and the energy of their solidarity in a fractured culture. *Caramel* decisively brackets war and politics to focus on women's everyday lives, and it was largely lauded precisely for its apolitical qualities: critics punned the title, resulting in

216

patricia white

overuse of the epithet "sweet."[9] Yet, the subtext for international audiences is oversaturated media images of the civil war that wracked Lebanon from 1975 to 1990, as well as conflict in the Middle East more generally, especially after the 2006 Israeli-led war with Hezbollah that shattered a fragile but decade-long period of peace and prosperity in the country, in the year before the film's release.

Certainly, a woman's film by a woman director, shaping international reception of Lebanese cinema, marks significant distance from stereotypical associations of the country with war. As Labaki states in the press kit: "I belong to a generation that wants to talk about something different, love stories for instance, something that is closer to the feelings that we know and the experiences that we have than to war."[10] The director's "we" refers to the generation that came of age since the civil war ended, but "feelings" and "love stories" also implicitly gender "we" as female, in opposition to the masculine-coded subject of war. Despite her desire to change the national subject, Labaki's acclaimed second feature, *Where Do We Go Now?*, responds directly to the legacy of war, produced as it was after the 2006 Israeli air strikes and, as the director points out in most interviews, after she gave birth to a son. The film built on *Caramel*'s success and became an even bigger domestic and international hit. Employing many of the same production personnel (producer, costume designer, co-writer, composer), and reprising *Caramel*'s themes of female solidarity, *Where Do We Go Now?* depicts sectarian violence overtly. It is the women of a remote village who unite to heal the community rift (which is seen as national and regional). In this context, the generic elements of the women's film—ensemble cast, central star, romance, costume, even songs—distinguish the film from more direct political critiques. In a commercial directed by her sister for Johnnie Walker's "Keep Walking Lebanon" campaign, Labaki explains: "I felt a responsibility as a mother, a citizen, a director, to convey this message [of coexistence] before it is too late."[11] In Lebanon and the Middle East, the film was cast as a significant public sphere intervention, very much associated with the creative voice (as well as the glamorous lifestyle of its director, as the Scotch campaign's mise-en-scène attests).

Framed by North American reception, the woman director can be seen as carrying out a particular "civilizing" mission. How do "women's films" as a genre align with "women's films" as a question of authorship in these exchanges? An answer can suggest how the politics of genre inform the cultural work of global women's production. Labaki's films are (re-)shaping Lebanon's national cinema and media culture by tapping into the generic formulae and affective power of the women's film, while at the same time accessing international circuits in which these formulae are universalized. While this intelligibility can mean that cultural specificities are downplayed (the country and village remain unnamed in *Where Do We Go Now?*), it can also facilitate what Chandra Mohanty calls transnational

feminist "connectivities."[12] I argue that Labaki's films' feminist impact is tied to the visibility of their "female" subject matter—including the affective bonds between women that their generic form draws upon—as well as to the visibility of their female director. In the reading that follows, I wish to keep in play the tensions between the genre's homosocial sphere of solidarity and critique, populism and affective engagement, and the forms of individualism associated with auteurism, as well as between transnational post/feminism and national/regional celebrity culture.

caramel

Caramel stars Labaki as Layale, charismatic owner of a beauty parlor who is having an affair with a married man. She's surrounded and supported by an assortment of female employees, clients, and neighbors, played by an ensemble cast of nonprofessional actors. The salon is a chick-flick topos *par excellence* and a microcosm of its concerns—at once a homosocial (but, importantly, not domestic) space, it is a site of female "bodywork" and a neighborhood hub. It provides for an intersection of types (here Christian and Muslim, traditional and "modern," successful and struggling, young and old), a focus on female desire, and the sharing of secrets (extending to "cultural" secrets such as the caramel depilatories that give the film its title). As these secrets are shared with the viewer, we are implicitly located as (female) patrons of the beauty parlor.

Other storylines are interwoven with Layale's, involving sex before marriage, aging, divorce, lesbian desire, and family obligations. None is thoroughly resolved, and the romances mostly don't work out, though the film does end conventionally with a wedding—that of one of the stylists, Nisrine, to her fiancé, with the other women fulfilling the chick-flick character function of bridesmaids. While the wedding affirms a traditional female destiny, the celebration and even the structure of married life sustain the homosocial bond so central to the film's spaces, plot, and address. Moreover, the occasion affirms Arabic cultural integrity—while this is a Muslim wedding, it is an occasion for inter-communal song and dance.

On the international cinephile circuit, *Caramel* has been located primarily as an auteurist film and as a harbinger of Lebanon's film renaissance, but neither of these characterizations can disavow the film's overtly "female" subject matter and sensibility. I suggest that this gendering both facilitates the film's circulation and undermines masculinist discourses of nation. At the end of the film, a black title card in French and Arabic displays the dedication: *a mon Beyrouth*. Like a number of other works of Lebanese cinema, this film pays tribute to the city's survival of the ravages of 15 years of civil war and acknowledges Beirut's central place in the Lebanese (and a wider Middle-Eastern) imaginary as a cosmopolitan city.[13] The end credits then

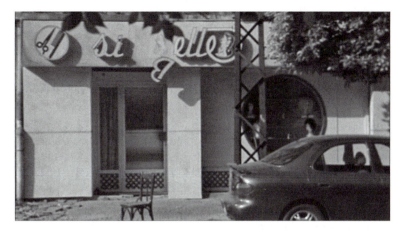

Figure 13.1

A multivalent sign graces the central Beirut hair salon location of Nadine Labaki's global chick flick *Caramel* (2007).

open over a shot of the streets outside the salon, a frequent location of the film, with two older female characters, the salon's laundresses, picking up pieces of paper, as if gathering shreds of communal memory in a shared living space. Thus, the salon stands at the intersection of two discourses: the chick flick (and, more generally, the semi-public sphere of female cultural influence), and the symbolic power of the capital (Beirut as cosmopolitan city). This intersection is inscribed with an authorial—female—signature: to *my* Beirut.

The salon's sign, *Si Belle,* has been damaged, whether by shelling or regular wear and tear, we don't know. However, with the "B" tipped, the sign, while still legible as "so pretty," becomes a conditional phrase: "Si elle ..." (If she ...).

Indeed, the city is not so pretty as it once was, but the initial affirmation of beauty is still present in the conditional assertion of potential. "If she"—that *she* read, perhaps, as the female subject—were in a position of agency, would the city remain a symbol of war? The film's focus on women and everyday life tests this proposition. *Caramel* hangs a question on the salon as "chick flick" topos. It uses its gendered generic affiliation to explore questions of national/cultural specificity and transnational legibility. The dedication "a mon Beyrouth" is at once a modest, feminized claim to particularity *and* an ambitious attempt to redefine the cinema according to a female perspective.

Discourses of beauty and potential also define Labaki's authorial persona. The reflexive association of Labaki's name with the film is not only consistent with the auteurist circuits in which it was launched—it debuted at the Cannes film festival, and La Cinéfondation financed the script through the Cannes Residency—but also to her visibility as its star and as

an actress more generally. At the time of *Caramel's* release, Labaki had already made a name for herself in Lebanon, directing music videos for Arab women singers, notably superstar Nancy Ajram.[14] Her personal details are well known—her sister Caroline designed the costumes for *Caramel*, and after the film wrapped up, Nadine Labaki married the film's celebrity music director Khaled Mouzanar. Labaki's profile—even star status—is achieved in a national and regional context with a relatively high number of women directors, but her music video background and Coca-Cola Lite ad contract locate her squarely in a younger generation tied to more commercial entertainers, and she has accordingly achieved a much higher international profile.

Labaki's insistence on opening the film in Lebanon before France, the use of non-professional actors, and location shooting, all enhanced her authenticity as a national spokeswoman. As a "cultural" rather than a conventionally political film, *Caramel* also spoke to a diasporic population that, despite having been affected by war, by no means defines itself exclusively in those terms. Labaki commented in an interview with *Filmmaker* that "You have a very big sense of guilt because you're a filmmaker and you don't know ... how your art can do something for your country. ... but then I understood that maybe it was my mission to make this film that shows something else ... a new image."[15] A "new image" invokes the makeover trope, the neoliberal post-feminist plot *par excellence*, and it links what *Filmmaker* calls the film's "Hollywood aesthetic" with Labaki's commercial and music video work. And, while some press accounts downplayed just how girly the film is in the interests of serious art cinema coverage, other sources explicitly associated it with the chick flick genre. *New York* magazine's "Culture Vulture" column comments on *Caramel's* beauty parlor setting: "The premise may evoke images of Queen Latifah tossing off one-liners with a blow-dryer in hand, but *Caramel* throws a few curveballs into the chick-flick mix: One woman falls for a female client, another has an affair with a married man, and a third finds love in the last stages of her life."[16] Interestingly, these so-called curveballs have nothing to do with the national context in which the film is made, with civil war, with sectarianism. Yet, these subplots do mediate these key axes of national identification. The homosocial spaces of the film (the salon, the sleazy hotel room where the women party together) are both post-feminist consumer spaces *and* extensions of gendered socializing in the Middle East.

The chick-flick trope of the superficially different group of friends is here used to transcend Christian/Muslim divisions. Themes of consumerism and beauty culture are articulated with those of tradition and modernity. For example, plastic surgery provides the occasion for a "universal" post-feminist storyline: Jamale, a divorced mother of teenagers, competes against younger women for work as an actress in commercials. However, the young Muslim stylist Nisrine turns to plastic surgery as a procedure to

"restore" her virginity before marriage. While so-called virginity recovery is widely practiced in the West, the film uses it to signal a culturally specific conflict—and an accommodation—between modernity and tradition. The scene in which the three friends take Nisrine to the surgeon is comically leavened by Nisrine's adoption of the unmistakably Christian name Magdalene when she signs in for the procedure. The humor seems to mark the film's awareness of its own limited engagement with the parsing of these distinctions.

If discrimination against post-menopausal women and cultural discouragement of sexual activity before marriage feel like heavy-handed "issues facing modern Lebanese women today," the sense of an Oprah-style round-up is mitigated by the film's non-professional cast, and the genuine sense of female community centered on the salon. In the course of the film, several characters at one remove from the core group—a male suitor, the laundress, the boyfriend's wife—come into the salon for services; as each one is beckoned closer to the inner circle so too are we.

In the epilogue to her book *Lebanese Cinema*, Lina Khatib tests Lebanese cinema against standard criteria for defining a national cinema and finds it falls short on every count. Concluding her study, she writes, "one can go [so] far as saying that the Civil War has become the defining feature of Lebanese cinema."[17] In fact, *Caramel*'s press notes brag that is the *only* Lebanese film that doesn't mention the civil war.[18] Yet, the habitual equation of masculine war/feminine home is challenged by the interdependence of public politics and private feeling. If the ensemble female-cast drama has a structural relation to war in Hollywood home front films, no such separation of spheres existed in the reality of the Lebanese civil war. In an English-language interview, Labaki describes being forced to stay indoors as a child during the war, where she grew up on *Dynasty* and *Dallas*, Egyptian films and French ones.[19]

However, the ambition to make a Lebanese film free of connotations of war was crushed by the fact that, just a week after *Caramel* wrapped up in summer 2006, war broke out again, this time between Israel and Hezbollah. The July War lasted 34 days, with a large number of civilian deaths in southern Lebanon resulting from Israeli air strikes in southern Beirut. Retrospectively, war can be seen as a structuring absence of *Caramel*. The younger characters don't mention it; while Lily, the aged, slightly demented sister of the salon's laundress Rose, is troubled by an unassimilatable event in her past. However, releasing the film into this unstable context made the national legacy of war impossible to disavow. Although "it wasn't my intention when I wrote it," Labaki admits, "because of the events, I would say yes [*Caramel* is a political film] … In Lebanon … politics slip into the most intimate areas of our lives. … I thought I could get away from it but the reality of the war caught up with me."[20] However naïve, Labaki's remark makes the feminist claim that the personal is political, and suggests

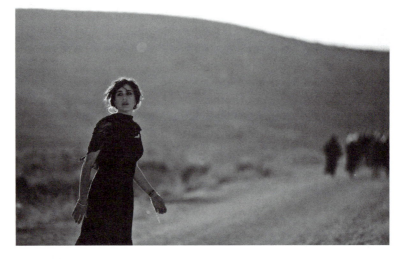

Figure 13.2

Lebanese actor-director Nadine Labaki as Amale in her feminist anti-war musical-comedy blockbuster, *Where Do We Go Now?* (*Maintenant on va ou?*, 2011).

that "apolitical" or "post-feminist" concern with telling love stories might meaningfully mediate this context. *Where Do We Go Now?* takes this approach further; the film's combination of topicality and fable-like storytelling put Labaki into the role of a national mediator, and the film broke domestic box-office records.

If *Caramel* treats Muslim/Christian differences as primarily sartorial—a matter of Layale's cross—*Where Do We Go Now?* addresses the crucial national question of sectarian violence and explicitly posits women's community as the way to address this. Labaki wrote her second film in 2008 during the aftermath of the Israeli invasion and after she had her first child (a son)—a context and catalyst she invokes frequently in interviews. A comic fable reviving aspects of the post-war Lebanese musical—again with songs by Labaki's husband—the film shows the women of an unnamed village banding together across religious lines to keep the men from sectarian violence. The surprise winner of the People's Choice Award at the Toronto Film Festival and Lebanon's pick for the Oscar competition, the film addresses political tensions—both feminist and communal conflict—much more directly than *Caramel*, while again employing the formula of an female ensemble cast of non-professionals with the director in the lead role.

As I noted, in *Caramel*, Islam is primarily a signifier of multiculturalism. Notably, the community ritual of the wedding is sanctioned by another form of difference, through the wedding song offered by the salon's hair washer, Rima. Rima's song is a multivalent performance. Although her

identity is never spoken about, Rima's clothing and stance code her as a lesbian, and the glances exchanged by female coworkers relay our own sense of being in on her secret. On one level, Rima's song sanctions the normative gender roles of the nation. She's been rather forcibly made over to look "femme" for the wedding. On another level, her casting as guardian of culture strengthens the reading of wedding not as ritual of heterosexual closure but rather as one of homosocial solidarity, even desire—after all, her "make over" involved one of the caramel depilatories!

Clearly, lesbianism functions more as thematization of an issue facing modern Lebanese women than it does as a matter of sexual identity or practice. Once again, the gay or lesbian character is used to signify "modernity."[21] At the same time, this "curveball" appeals to the cachet of "the secret," the promise of a female world. Rima is shown as hyperaware of

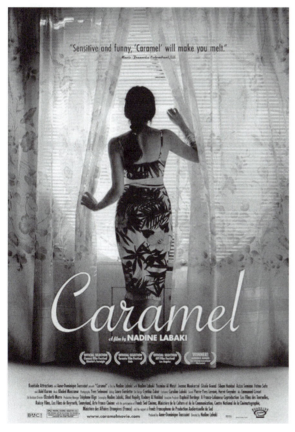

Figure 13.3

Sensuous drapery and the figure of the woman gazing out the window on this poster featuring Nadine Labaki in the lead role of her debut feature *Caramel* (Sukkar banat, 2007) condense orientalist and women's picture tropes.

the girl sitting next to her on the bus and her rather minimal storyline entails her attraction to a beautiful client who enters the salon with trepidation. Labaki discusses the character with *New York* magazine online: "[Homosexuality] is very secret, which is why I decided to write about that. I see a lot of homosexual women and men who just keep it to themselves, and they lead very unhappy lives where they end up hating their bodies and hating themselves. Many people live with it in secret, but there are also many victims and others who have problems dealing with it in public. It's the contradiction of the country."[22]

Elevating homosexuality to "the contradiction of the country" confirms the function of queerness as an emblem of modernity. This adds another twist to the modern chick-flick cliché of the lesbian in the female ensemble cast film. Often, such a character's explicit lesbianism defuses a more generalized homoeroticism; the other women are just (her) friends. However, in an Orientalist iconography of the harem or baths, the lesbian marks the diffusion of erotic possibility within such homosocial spaces. *Caramel*'s very title refers to a culturally specific female ritual, one that not only invites the gaze but also makes the mouth water. The Orientalized poster and marketing imagery beckon the viewer beyond the veil to a mysterious female-only space. In *Caramel*, this nineteenth-century iconography of female homoeroticism is supplemented by a late-twentieth-century one, in which lesbianism is a metonym for feminism itself.

Rima is still sexy; in a deployment illustrative of Eve Kosofsky Sedgwick's concept of the "epistemology of the closet," the salon employee's cryptic identity may even make her *more* appealing, constrained as is her sexual expression within this diegetic reality.[23] Rima's non-disclosure works in another way: For Labaki, the character is a stand-in for closeted Lebanese lesbians. Her "visibility" as an erotic subject—or object—is a marker for the wider cultural recognition entrusted to more explicit, internationalized, and modern media such as this film strives to bring about. Thus, the film has it both ways. It thematizes lesbian identity while not having to be on the line itself as a "gay" film. It is knowing about the need for discretion while remaining ignorant about the lived reality of lesbian life. There is a palpable eroticism in the hair-washing scene (a well-worn trope of grooming as a stand-in for lesbian sex) as well as a failure of imagination; ultimately, erotic desire is translated back into discourses of empowerment.[24]

Rima's beautiful client has no backstory. Although the stylists recognize and whisper about her when she returns to have her lustrous hair cut short, she seems to belong outside the narrative in some transmedial space. While Rima's wedding song could have ended the film, instead we return to the salon setting. As if in a music video, "Mirror Mirror" (Myrete Myrete), composed for the film by Khaled Mouzanar and sung by Racha Rizk, plays on the soundtrack as the woman exits the salon and looks at

her transformed self in a shop window. She smiles and tosses her bobbed hair, embracing a public self that implicitly defies familial, privatized expectations about appropriate femininity. If, occasionally, "Lebanese" is a Western code word for lesbianism (cf. Lady Gaga's "Born This Way"), something else is at stake in this scene. In soft-focus, slow motion, manicured, and wearing heels, this woman is not coded as lesbian; eroticism is consigned to Rima's gaze (and perhaps the viewer's) and siphoned into female solidarity and Lebanese pop. Still, her haircut unmistakably signifies a new identity.

This cryptic figure of the Arab woman in public—to be looked at, perhaps, but by herself—stands in, I suggest, for Labaki as director. Although the role of the mysterious client was evidently too small for a filmmaker who asserts in interviews that acting alongside her non-professional casts yields the better part of her directing success, the role of confident public beauty is one the director plays on the red carpet at Cannes and in the media discourses that surround the marketing of her work in Lebanon and abroad. By linking this mirror scene with Labaki's celebrity status, I suggest that Rima's desire for her client, which catalyzes the latter's transformation, resonates with the affective charge infusing the filmmaker's public persona. Moreover, I believe that this scene of self-assessment figures Labaki's own self-reflexivity about her authorial image as a director within national, regional, and world cinema. She invites the gaze, and it is a gaze that figures possibility. *Si 'elle…*

The beauty-parlor setting of *Caramel* allows all the film's Arab female subjects (lesbian, Muslim, aging, working class) some access to the glamorous self-determination that Labaki embodies on- and off-screen and, as I've indicated, beckons the viewer in as well. Of course, like the classic woman's picture, *Caramel* is circumscribed in its political critique. Chick-flick tropes facilitate liberal inclusiveness (Muslim–Christian female friendship and alliance, crypto-lesbianism), but go further to challenge the gender politics of film authorship. For a woman director from a marginal film-producing country to make a film that draws on popular generic sensibilities and art house protocols and thereby to achieve critical attention and audience approval from national, Arab, diasporic, and "general" audiences is to sustain a complex enunciative performance. Labaki's career to date suggests that feminist film is alive and well in the age of the chick flick, including in the chick flick itself.

As Thomas Elsaesser and others have argued, the international film-festival circuit has long functioned as an alternative distribution network in opposition to Hollywood cinema.[25] Labaki is one example of many women directors in negotiation with the constraints of the globally circulating commodity form of the feature film—signed by an auteur, but recognizably affiliated with a genre and a region. The many media discourses that position her—commercial campaigns, red carpet appearances, her

work as a music video director, her claiming of her maternal role—translate this filmmaker's self-authoring to a world of potential fans.

notes

1. Berlin's Golden Bear winners were Jasmila Zbanic's *Grbavica: The Land of My Dreams* (Bosnia/Herzegovina, 2005) and Claudia Llosa's *Milk of Sorrow* (La teta asustada, Peru, 2006). Indian–American director Mira Nair's *Monsoon Wedding* received Venice's Golden Lion in 2001, and Sofia Coppola's *Somewhere* won the top award in 2011. Cannes Jury Prizes were conferred on two films by Samira Makhmalbaf, *Blackboards* (Takhté siah, Iran, 2000) and *At Five in the Afternoon* (Panj é asr, Iran, 2003); two by Andrea Arnold, *Red Road* (United Kingdom, 2006) and *Fish Tank* (United Kingdom, 2009); *Persepolis* (directed by Vincent Paronnaud and Marjane Satrapi, France, 2007); and Maiwenn's *Poliss* (Polisse, France, 2011). Note that Makmalbaf and Arnold won this prize twice, confirming the festival's association with the anointing of auteurs. The fact that more women are recognized does not mean the culture of festivals—which has always admitted the singular talents of individual women auteurs such as Agnes Varda or Lina Wertmüller—has substantively changed. In 2010, Cannes included no women's films in competition at all, and Jane Campion's 1993 *The Piano* remains the single Palme d'Or winner by a woman director in the festival's history.
2. "The Celluloid Ceiling: Behind-the-Scenes Employment of Women in the Top 250 Films of 2011," Martha Lauzen's annual study of the American film industry for the Center for the Study of Women in Film and Television at San Diego State University, found that "women accounted for 5% of directors, a decrease of 2 percentage points from 2010 and approximately half the percentage of women directors working in 1998." A separate 2009 study entitled "Independent Women: Behind-the-Scenes Representation on Festival Films" found that "Women comprised 22% of directors" of feature-length US films at top US festivals for the year. See Center for the Study of Women in Television and Film: Research, n.d., accessed May 21, 2012, http://womenintvfilm.sdsu.edu/research.html. The Center does not look at global figures.
3. The successful films were Caroline Link's *Nowhere in Africa* (Nirgendwo in Africa, Germany, 2003) and Susanne Bier's *In a Better World* (Hæven, Denmark, 2010); interestingly, both films feature white characters in non-Western settings.
4. For recent contributions to this robust field that emphasize the transnational dimensions of women's cinema, see Alison Butler, *Women's Cinema: The Contested Screen* (London: Wallflower, 2002); and Kathleen McHugh, "The World and the Soup: Historicizing Media Feminisms in Transnational Contexts," *Camera Obscura* 72 (2009): 110–51.
5. Among the many excellent recent works on world cinema, see especially: Natasa Durovicova, and Kathleen Newman, eds., *World Cinemas/Transnational Perspectives* (London: Routledge, 2009); Elizabeth Ezra and Terry Rowden, eds., *Transnational Cinema: The Film Reader* (London: Routledge, 2006); and Rosalind Gault and Karl Schoonover, eds., *Global Art Cinema: New Theories and Histories* (Oxford, UK: Oxford University Press, 2010).
6. See Viola Shafik's discussion of the "feminization of Arab cinema" in *Arab Cinema: History and Culture*, 2nd ed. (Cairo: American University in Cairo Press, 2007), 201–203.

7. Ella Shohat, "Post-Third-Worldist Culture," *Rethinking Third Cinema*, ed. Anthony R. Guneratne and Wimal Dissanayake (London: Routledge, 2003), 51–78.

8. Yvonne Tasker and Diane Negra, "Introduction" to *Interrogating Postfeminism: Gender and the Politics of Popular Culture* (Durham, NC: Duke University Press, 2007), 2.

9. See, for example, Colin Colvert called the film "a bittersweet treat," in "'Caramel' Beauty Shop Teases Out Affairs of the Heart," *Minneapolis Star Tribune*, April 10, 2008; Claudia Puig, "'Caramel' Takes a Sweet Journey," *USA Today*, January 21, 2008 (Puig describes the film thus: "*Caramel* is a sweeter and more believable version of *Steel Magnolias*, Middle Eastern style.").

10. *Caramel* Press Notes. Distributor: Roadside Attractions.

11. Labaki was dramatically unveiled in January 2012 as the new spokesperson for Johnnie Walker's social media campaign "Keep Walking Lebanon," which invites users to select one of three projects to benefit the country. Caroline Labaki's promotional video "Walk with Nadine Labaki" is featured on the homepage (http://www.keepwalkinglebanon.com/main.php), and the Keep Walking Lebanon and official Nadine Labaki YouTube channels (http://www.youtube.com/user/KeepWalkingLebanon/featured; http://www.youtube.com/user/labakinadine?feature=results_main) introduce "Nadine Labaki – Keep Walking Lebanon," the video quoted in the text, thus: "Listen to Nadine Labaki's words of inspiration as she adopts the mantle of mother, citizen, and director to deliver a powerful message to the Lebanese." According to the ad agency responsible for the campaign, Leo Burnett Beirut, "The percentage of female interaction with the brand doubled to 49% versus just 24% last year." See http://www.dubailynx.com/winners/2012/media/entry.cfm?entryid=107&award=99&order=2&direction=1.

12. Chandra Talpade Mohanty, *Feminism Without Borders: Decolonizing Theory, Practicing Solidarity* (Durham, NC: Duke University Press, 2003).

13. For the place of the city in Lebanese cinema, see among other films, Jocelyne Saab's *Once a Time in Beirut* (Kanya Ya Ma Kan, Beyrouth, Germany, 1994).

14. Lebanese female stars are prominent in the Arabic pop recording industry. Labaki directed Ajram's breakthrough video "Akhasmak Ah" and several additional award-winning clips. Their most recent collaboration "Fi Hagat" is the most viewed Arabic video on the Internet. http://www.youtube.com/watch?v=0vxMNY-mNXA. Ajram is Coca-Cola's Middle Eastern spokesperson and a UNICEF Goodwill ambassador. Labaki also directed the video for the Lebanese reality show *Star Academy*. For a discussion of the show, see Marwan Kraidy, *Reality Television and Arab Politics: Contention in Public Life* (Cambridge, UK: Cambridge University Press, 2009).

15. Nick Dawson, "Nadine Labaki: 'Caramel'," *Filmmaker*, February 1, 2008, accessed May 21, 2012, http://www.filmmakermagazine.com/news/2008/02/nadine-labaki-caramel.

16. Annsley Chapman, "'Caramel' Director Nadine Labaki on Remaking the Chick Flick," *New York*, January 30, 2008, accessed May 21, 2012, http://nymag.com/daily/entertainment/2008/01/caramel_director_nadine_labaki.html.

17. Lina Khatib, *Lebanese Cinema: Imagining the Civil War and Beyond* (London: I. B. Taurus, 2008), 288.

18. *Caramel* Press Notes. Roadside Attractions, 2007.

19. Dawson, "Nadine Labaki: 'Caramel'."
20. *Caramel* Press Notes. Roadside Attractions, 2007.
21. See, for example, Gayatri Gopinath, *Impossible Desires: Queer Diasporas and South Asian Public Cultures* (Durham, NC: Duke University Press, 2005).
22. Chapman, "'Caramel' Director Nadine Labaki on Remaking the Chick Flick."
23. Eve Kosofsky Sedgwick, *Epistemology of the Closet* (Berkeley: University of California Press, 1990).
24. Iranian–American director Maryam Keshavarz' *Circumstance* (2011) provides an interesting counterpoint. Much more explicit in its depiction of the erotic entanglements between the two 16-year-old schoolgirls at its center, the film appeals directly to LGBT Western and global gay audiences as well as Iranian diasporan audiences.
25. Thomas Elsaesser, "Film Festival Networks: New Topographies of Cinema in Europe." *European Cinema: Face to Face with Hollywood* (Amsterdam: Amsterdam University Press, 2005), 82–106.

anxieties of authorship

in the colonial archive

f o u r t e e n

j a n e a n d e r s o n

The significant work that has been done on the archive, both before and after Derrida's fevered turn, has greatly expanded understanding of the archive as more than a description of a physical space and location.[1] Through the work of Carolyn Hamilton, Ann Stoler, Alan Sekula, Thomas Osborne, and Nicholas Dirks, it is possible to appreciate archives themselves, as well as the objects assembled within them, as sites of epistemological struggle.[2] For what an archive holds, how knowledge–objects are arranged, as well as what it makes available, are the very subject of politics always refracting colonial/modern power relations.

In 2002, Stoler argued for moving away from analyzing the content of archives, to looking more closely at archives' form and constitution. Considering the way an archive is made and the form that it takes is a significant shift in understanding the archive-as-process, rather than a site to be mined for content to support or refute a particular argument. This archival turn was a radical effort to encourage scholars, particularly anthropologists, to reflect upon archives themselves as sites of interpretation and meaning making. Looking more closely at the way an

archive is made up, and thus making possible and distributing central relationships between knowledge/power, a larger picture about archives as sites of knowledge production emerges. Stoler observes, "[t]hat every document comes layered with the received account of earlier events and the cultural semantics of a political moment makes one point clear. What constitutes the archive, what form it takes, and *what systems of classification signal at specific times* are the very substance of colonial politics."[3]

This chapter contributes to the literature regarding the intricacies of archives as sites of knowledge production by looking closely at one central component that underpins the classificatory logic system of an archive— the author function. My argument is that authorship is an integral component for understanding how archives are constituted, how they distribute certain kinds of authority, and how they circulate meaning. Authorship is foundational to the organizational framework because it operates as a core node in the classification of all materials within the modern archive. Authorship is central to the index of an archive: the archive upholds and endorses the authority of the author and also acts as a prism for making meaning about materials contained within the archive.

Situated within a broader decolonial project articulated by scholars such as Linda Smith and Walter Mignolo, this chapter explores the role of the author within colonial archives as a legal and cultural construct that maintains very specific exclusions and relations of power.[4] As decolonial projects center an appreciation of the mechanisms that enable the coloniality of power, this work considers how the relationship between copyright law and authorship functions as a means for maintaining hierarchies of knowledge production by reducing Indigenous and non-European subjectivity and legitimating the (ongoing) appropriation of Indigenous cultural material by non-indigenous authors.

Authorship is first a legal category made possible and instrumentalized through copyright law. It is copyright which historically and contemporarily makes, maintains, and distributes the figure of the "author" and correspondingly the "work," both of which are folded into the classificatory frameworks of the archive. As an archive depends upon content—and certainly from the nineteenth century when archives really became the central document repositories that they remain today—it is important to see the contributing role of copyright law in facilitating the identification of authors and works. Through this, copyright law becomes institutionalized within the archival classificatory and regulatory framework.

Closer analysis of the author/archive/copyright nexus also reveals how, in conjunction, they work to reinforce the operation of colonial projects of knowledge accumulation. If authors are privileged and recognized in archives, and the people subjected to colonial and colonizing projects are rarely named as authors—never given that status—yet are ostensibly the "subjects" of the documentation, then the archive, through the legal

(and social) entitlements afforded authors, becomes a further site of colonial control and dispossession. This affects not only how historical meaning is made, but also how contemporary readings of the archive can proceed. As a central locus in historical and contemporary projects of coloniality—from which knowledge about certain kinds of peoples was produced and served to justify how they were recognized and treated— reading the colonial archive "along the grain" requires accounting for the form and constitution of the *content*.[5] For the classification of content shapes the organizational rationales of the archive, affecting how the archive itself is made and, through the internal ordering, how it is made accessible and legible to others.

The function of authorship in the archive has not had sustained interrogation, further naturalizing the embedded power relationships between authors, archives, and their subjects. However, as authorship is an outcome of specific legal and cultural developments, emerging in a more stable form from the eighteenth century in Europe, questions about its conditions of emergence show us its cultural particularities and reveal how it became a tool, alongside written text, to erase, appropriate, and delegitimize alternative knowledge practices and forms of knowledge transmission, particularly and especially those that were oral in nature.[6]

I will return more fully to the historical utility of authorship in furthering colonial governing projects because this history is crucial for understanding the current tensions over authorship that are spilling out of archives across the world. These tensions are emerging because the historical subjects of the archive are contesting their status within it, and making forceful demands to be recognized as the legitimate "owners" and "authors" of the materials that document their lives, families, ceremonies, and cultures. With no legal rights to any of this material, the challenge mounted reveals the cultural contingency of the category of authorship and, ironically, how it remains a tool to reinforce earlier exclusions and relations of power. There is no legal option for retroactively reasserting the "correct" authorship, even if in its liberal individual singularity, this was desired or even possible for the millions of works currently held in archives across the globe.

The increased capacity to digitally circulate collections and thus also circulate artifacts of the colonial collecting condition actively re-evoke the author/archive legacy. In the same moment that "subjects" of the archive demand recognition as legitimate "authors" and "owners" of the documents that represent their cultures, the contours of authorship are shifting. The struggle to own and control, the legal entitlements that come with authorship, again evades those "subjects," "informants," and "natives." Even reframing the claim as authorship and ownership, the very paradigm that historically excluded access and control to begin with, the subjects of the archives, predominately the classified, studied, catalogued

"others," are again confronted with the unequal political terrain of authorship. This is because one part of the digitization agenda of archives has increasingly included the "digital repatriation" of Indigenous cultural materials from colonial archives. Digital "repatriation" initially offers the possibility for a renegotiation of the terms of authorship/ownership that historically inscribed the material now offered for return. The very idea of return is itself a critique of the embedded social and legal relationships that fostered and enabled the collection of this material to start with. Yet, for both digitization and digital repatriation projects, legal regimes of authorship are pre-supposed and maintained. Despite considerable effort on behalf of those working in these projects, legal regimes of copyright continue to marginalize Indigenous people from rights to determine culturally appropriate use, access, and control of this material.[7]

For Indigenous people, the colonial archive is a site of considerable anxiety. This is for two reasons. First, most of the material that records the lifestyles, languages, ceremonies, laws, customs, and cultural practices of Indigenous, local, and "traditional" people is legally authored and owned by the person who "made" the sound recording, the film, the photograph, or manuscript. As the "subjects" of the images, recordings, and writings are not the legal copyright owners of this material, not only do they have no control over the life of the material, including in which archive it ends up and how this material is accessed and circulated, but in an ironic twist, they too must secure permission from the "author" in order to reuse material that documents their lives, customs, and cultural practices.

The second anxiety arises precisely and poignantly because these enormous collections that have been amassed are not how Indigenous people would have chosen to represent themselves.[8] Indigenous peoples were not informed that this material was produced and used to fit them into a very specific vision of the world that reduced their cultural practices and justified the dispossession of lands, resources, and cultures. Yet, all this kind of material remains with increased and increasing circulation possibilities well beyond what was originally envisaged (and explained) at the moment it was created. There is no taking it back. The material comes encoded with relations of power and specific entitlements, and continues to position Indigenous peoples, cultures, lifestyles, and practices within a Eurocentric locus of enunciation.

As archives are powerful sites of interpretation and meaning-making, the historic refusal to admit Indigenous people as legitimate authorities of their own cultural practices has had profound effects upon how Indigenous people and Indigenous peoples' issues are contemporarily circulated and understood. Indigenous claims within colonial archives expose both the cultural specificity of the notion of the author and the extent that the archive continues to uphold and endorse very specific logics of what constitutes knowledge production and knowledge circulation. The archive

bears witness to a complex network of power relations and constructions of subjects and memory. While the integral relationship between law, the author, and the archive is foundational, it reveals itself most clearly when authorship itself becomes a site of contest. Contested archives tell us a lot about the people who constructed it and for whom it served.

authority, authorship, archives: the ordering of colonial knowledge

Archives can be conceptualized as centers for interpretation. In providing a way of relating to the past, these places are not innocuous or neutral holders of material but part of socio-political practices that produce their possible existence in the first place. Archives have existed in multiple contexts and over long periods of time. While the content has shifted, their function as repositories to be used by specific social authorities has remained relatively consistent.[9]

Although archives continue to be valuable facilities, the practices and struggles associated with composing, assembling, and controlling access to documents inevitably play a substantive role in the scholarly reconstruction and writing of history.[10] For how the modern archive is composed as well as what content the archive contains, and therefore what histories can be written, are outcomes of documentation as governance and later Enlightenment strategies for making sense of the world and its peoples.[11]

Archives are as much products of historical struggle as they are primary sources for the writing of histories.[12] If archives are sites of authority, then the documents or materials assembled within are working to enhance the legitimacy of those who are charged with the task of accumulation and those privileged with access. The materials reflect the concerns and focus of those governing; they are assembled to serve very particular interests. Within projects of colonization, the modern archive offered itself as one of the most useful tools for the selective and strategic assemblage of critical information informing the rule of specific peoples in varying contexts. According to Nicholas Dirks, "The archive, that primary site of state monumentality, is the very institution that canonizes, crystallizes, and classifies the knowledge required by the state even as it makes this knowledge available to subsequent generations in the cultural form of a neutral repository of the past. ... Colonial conquest was about the production of an archive of (and for) rule."[13]

In India for example, the colonial archives feature two specific kinds of documentation. The first is the predominance of newly imposed land tenure and land tax information, documents crucial for asserting new systems of control and governance over lands and natural resources. Such systems worked to systemically displace original inhabitants and, in doing

so, created new social hierarchies wherein regulatory British property frameworks were imported and imposed into contexts that had never imagined land and land use in such ways.

The second kind of documentation found within Indian colonial archives is equally transformative, but reflects a larger concern with the population itself as a specific subject of governance.[14] The first census in India was conducted in 1871–1872 and provided a new vehicle for counting the population.[15] The census was a technology that became intrinsically involved in producing the modern concept of caste as a category of social organization.[16] By 1891, the census broke over 60 subgroups into six broad categories to which people were asked to identify within. The reduction of multiplicity into simplified categories served a larger governing purpose, and an otherwise diverse population was rendered more manageable through categories of identity and social status.

The archive, developed and elaborated by British colonial agents and administrators, served the colonial apparatus and colonial governmentality to enhance British rule and to transform the Indian subcontinent into a more governable and economically viable site for resource expropriation.[17] The relationship between colonial ideas, ambitions, and strategies for governing their subject populations and archives is in the way in which these strategies produce knowledge. That knowledge is, firstly, documented, stored as accurate, neutral, and apolitical. Secondly, it is redeployed and circulated in ways that uphold the original logic of production. Wherein colonialism is understood as a cultural project of control, archives function as the locus for the cultural technology of rule.

It is important to note that colonial strategies of governance were not only advanced by administrators and bureaucrats, but also by researchers in older and emerging disciplines such as anthropology where the study and documentation, measurement, and classifications of peoples became those disciplines' primary *raison d'être.*[18] All this documentation ended up in archives, sometimes in the context where the data-gathering occurred, such as India or Australia, but most often in archives far from the site and the subjects to which it referred. It is not accompanied by any qualifications or questions about its collection. For longer than a century, such archives have been used to support European ideas of superiority, evolutionary logics, and justifying the dispossession of lands.

In Australia, colonial archives contain extensive information about Indigenous people—not only about specific kinds of Indigenous sociality and praxis, but also details of the birth and death rates, classification of stages of development, conditions of employment, wage negotiations, as well as family records about the removal of children, governmental strategies of assimilation, and even the documentation of massacres. This kind of material offers an interpretation of how the Australian state sought

to manage the lives and futures of Indigenous people and created the bio-political conditions for indigenous governance.[19] The colonial documentation project encoded a certain anxiety that, as Dirks argues, "rule was always dependent upon knowledge, even as it performed that rule through the gathering and application of knowledge."[20]

If colonial rule was dependent upon knowledge, then the legal frameworks that produce the possibilities for knowledge to be considered a form of property, and the consequent entitlements that are folded into those specific knowledge objects, matter considerably. As cross-sections of contested and subjugated knowledges, what constitutes the archive, what form it takes, and what systems of classification signal at specific times, are the very substance of colonial politics.[21] "Colonial archives," Stoler notes, "were both sites of the imaginary *and* institutions that fashioned histories as they concealed, revealed, and reproduced the power of the state."[22]

As political technologies, archives hold a powerful position in how we make meaning of the past, of social organization and representations of relations between ourselves and others. Thus, the political shifts that re-imagine relationships with the archive are critical sites of analysis. Moreover, the legal frameworks that establish the networks of permissible circulation and the conditions of proprietary attribution encoded within this material are not only relevant, but point exactly to where colonial traces and modes of exclusion continue to function.

authoring the archive

The relationship between authorship and copyright has been a site of productive exploration since the late 1980s, especially among critical legal scholars.[23] This interest takes its point of departure from Michel Foucault's "What Is an Author?" which raises questions about how the notion of a "work" as a singular entity comes into existence, the role of this unity in producing the figure of the "author," and especially how this functions differently for the categories of literary and scientific works.[24] Foucault asks what networks of relations are necessary for both the "work" and the "author" to be put in circulation individually and together.[25]

Within copyright law, the two most important categories that were developed through its long history were authorship and originality.[26] While these categories were not developed automatically or as stable entities, the making of the category of the author within copyright law, and by implication within the wider society, begins most clearly with the literary property cases in Great Britain in the seventeenth century.[27]

While constructing the figure of the author was not the primary concern for the law, it was inevitably an *effect* of the law. With the multiplicity of factors influencing law and its relationship with the legal idea of the

"author," an inevitable by-product was the transference of characteristics identifying the "author" within law to the wider society as an individual and as an agent determining status and authority. Defining the category of the "author" was the means for establishing the legitimacy of property in a "work." In authorizing such property relations, the law necessarily affected the functionality of the subject named as the "author." It is the instructive relationship between the emergence of an entity named as an author, and the legal and institutional networks that uphold and endorse that same entity that are important.

The 1774 case *Donaldson v. Becket* is significant because it marks the emergence of the author as a proprietor.[28] Rather than assuming the author as an already existing category of law, this case shows that there was no automatic connection between authors and texts. Instead, there was a range of cultural and legal conditions that were required before the notion of an author could be established. For example, Mark Rose argues that "the concept of an *author* as an *originator* of a literary text rather than as the reproducer of traditional truths" had to be realized in society, before it could be actualized.[29] The notion of the author was also influenced by cultural specificities where writing and documentation was becoming a privileged site for assessing civilization and progress.[30] Thus, authorship became a fulcrum in a developing hierarchy and logic of modernity.

The rise of modern authorship exposes the complexity of the law and the difficulty in locating a specific moment where the law was seen to arrive at a particular definition of the author in relation to a text. Copyright law relies upon an abstract and generic notion of the author and this category is carried into an archive and placed at the center of the organizational apparatus of the index and catalogue. Nevertheless, the subjectivity of the author persists and informs the role, function and effect that the person, with the legitimate and recognizable rights to material within the archive, can exert. While archives center the author, they are also beholden to the legal rights and responsibilities that are present with a work. Archives do not work outside copyright frameworks, except for the exceptions that this regime grants itself an illustration of the way in which an archive is always-already positioned within a network of legal relations.

The crafting of the legal category of the author that evolved through the literary property debates hints at how this category, from the beginning, was constructed as a vehicle for political interests. Foucault's interest in how this category becomes naturalized within the context of new property relations tells us one part of the story. However, this remains part of a Eurocentric narrative that fails to account for the emergence of the author at the expense of other cultural authorities whose histories, narratives, laws, traditions, and cultures were literally written out of the story. The relationship between the rise of modern authorship and colonization is

not just a coincidence. The "author" was also a figure of dispossession, working to legally and socially reduce and exclude other cultural forms of articulation, expression, and association with cultural knowledge products. Authorship furthered the means for knowledge appropriation in a corresponding way to how the imported Lockean property concepts radically altered the colonial contexts in which it was applied, from Hawaii to India, Indonesia to Bolivia.[31] Through the rise of modern authorship, there is a reduction in the capacity for Indigenous people to account for their own histories and practices. Moreover, with the increasing European gaze, these practices become increasingly written and authored by others—predominately "men with letters."[32]

The enormous collections of archived material that relate to Indigenous people have only recently become the focus of more sustained attention, even though they have been repetitively mined by non-indigenous people for important biological, medicinal, and artistic innovations.[33] The inherently political nature of these collections has made institutions that house them increasingly uneasy. This unease manifests not only in accounting for their establishment and collection—and the colonial power relations that enabled such projects—but also the claims of ownership, control, and access that Indigenous people are asserting which the archive has a great deal of trouble accommodating. For in these claims, this material emerges from its apolitical shroud: that is, its conditions of collection exposed. Most importantly, however, it was never expected that this material recording Indigenous lives would actually be accessed and used by Indigenous people themselves.

Over the last 20 years, a shift in access to such collections by Indigenous people has occurred. As the historical subjects of colonial archives start becoming new users, it is inevitable that challenges in terms of representation and access, control and ownership will occur. These challenges constitute a new archival event that disrupts the authority and stability of the archive.[34]

The issues that archives deal with today in relation to the contested ownership of their collections have their genesis in colonial projects of recording Indigenous people's lives, languages, cultures, and histories. These contests can be traced to the unequal and unethical collecting endeavors, which, through the development of new technologies such as photography, sound recordings, and moving pictures, became more elaborate and sophisticated, and provided for the accumulation of knowledge objects at unprecedented levels. For if Margaret Mead, in 1936–37, was able to author 36,000 photographs and 33,000 feet of film footage from her ethnographic inquiry in Bali, Indonesia, by the 1980s, the accumulation of such knowledge objects was possible at a much greater level. While we know none of the names of the people in the 36,000 photographs, we know that they are authored by Mead and that she retains authority over these

images as well as how these can be used. In the American Museum of Natural History in New York where this collection is held and managed, her name is the one recorded as the author in the catalogue, and it is from her estate that permission to use these needs to be granted. The legal entitlements here are explicit, and the exclusions of the "subjects," the "informants," are in perpetuity.

contesting the author(ity) of the archive

In an archive known as the Australian Institute of Aboriginal and Torres Strait Islander Studies (AIATSIS), the world's largest collection of its kind, it is possible to locate the moment when Indigenous people started becoming the primary users of the archive, constituting a new Indigenous public. In the 1990s, the Aboriginal and Torres Strait Islander clientele of the archive constituted a user group of about 1 percent, but this dramatically shifted to over 75 percent in 2004.[35] In a period of roughly 14 years, this is a significant increase in who was using the archive. This increase was due to three related factors that reflected the shifting political terrain for Indigenous rights in Australia. It also was the catalyst for ruptures in long-held rationales and expectations about authorship and knowledge as a specific species of property.[36]

The changes within this archive come from an era of land rights and native title, recognition of the issue of the "stolen generations," and the rise of interest in reviving Indigenous languages.[37] The displacement of Aboriginal people from their land and the fragmentation of their families was a deliberate governmental strategy to try to destroy Aboriginal culture, and it had, and continues to have, profound effects in Australian Aboriginal communities.[38] Land rights, and the later 1993 Native Title Act, produced more Indigenous users of this archive because, quite simply, the possibility of native title rests upon "proving" to the satisfaction of a court "continuity" or ongoing Indigenous connection to particular tracts of land.[39] With the demands of native title, Aboriginal people came to AIATSIS to find the historical texts, written and authored by others, that could "prove" in a court of law (in a way that the courts recognize) their ongoing relationships to land.

Between 1910 and 1970, the Australian government removed multiple generations of Indigenous children from their families (the "stolen generations"), relocating them in institutions thousands of kilometers away from their families and often with no further contact with their parents.[40] In the late 1990s, many Aboriginal people started coming to AIATSIS to try to locate records of family and documents relating to family histories.[41] These documents, however, are authored by the state and the state's bureaucrats, and they record the extreme governmental administration of Indigenous lives. As Stephen Kinnane writes,

When my grandmother's file first arrived it was a bit of a shock. It's one thing to find out there were administrative files kept on the community. It's another thing to realise the extent to which the Department [Department of Aboriginal Affairs] watched and controlled members of your own family. My grandmother's file is as thick as a telephone book. … This is just her personal file. Any one personal file does not exist in isolation but links up to other Aborigines Department files, police files, Health Department files, Crown Law Department files. … The language contained in them about our families and communities does not reflect how we see ourselves. This is how others have seen us. While they give me some details of my grandmother's life, their reading of her tells me more about the people who constructed them than it does about her. In our own community's hands these files are used to link up with lost family and to make steps to reclaim what was taken.[42]

Searching through collections compiled by anthropologists, historians, and linguists, Indigenous visitors to the archive have found photographs of fathers, mothers, brothers, and sisters that no one knew existed. This is because the archive does not necessarily know their names nor record them in the catalogue in any searchable way. In most cases, these names remain hidden behind the non-Indigenous author/owner/collector's name. It takes the time-consuming searching of family members to reconnect those names back into the images, into the recordings.

The reviving of indigenous languages, and the need for the archive in this process, is also tied to the above-mentioned changes in Australia's negotiation of its past of which colonial archives have been central. Aboriginal people seek access to a range of language materials—wordlists, dictionaries, sound recordings, and films—in order to learn or relearn specific languages that relate to their family, their clan, or their country. For instance, it is estimated that prior to colonization there were approximately 250 distinct languages spoken in Australia. That figure is now estimated around 20.[43] While it seems impossible that one person could own a language, the wordlists, dictionaries, sound recordings, and films are owned by individuals because, in their making, copyright asserted its proprietary weave. To gain access within the archive is one thing, but to make the numerous necessary copies in order to facilitate the possibility of revival within ex-situ contexts, to publish word lists for community schools or knowledge centers, a range of copyright issues arise. Still, maintaining the protection of the author, Aboriginal people seeking access to their own language materials must request permission and explain use.

While most owners of this material who remain alive and can be found give permission, this is not the point. The point is that this permission is required in the first place. It illustrates the power of copyright to safeguard very particular interests, and the extent that this protection extends across time, so that even after the death of the author, permission to use these materials still needs to be secured.

Osborne notes that "the archive is there to serve memory, to be useful—but its ultimate ends are necessarily indeterminate. Material is deposited for many purposes, but one of its potentialities is that it waits a constituency or public whose limits are of a necessity unknown."[44] We might then also think about the cultural particularity of this idea of the "public" and ask what happens when there are shifts in the colonial polity—and the people, traditionally the "subjects" of archives, start to become new users and a new "public" is constituted—one that questions not only its status within the archive, but also the authority of the archive as a center of interpretation. What happens to the meaning produced by the archive when the users of the archive shift focus—and what happens when new user groups are constituted, users who have not only been historically excluded from the "public" space but whose lives and histories informed and consequently formed a corpus of material contained within the walls of the archive?

digitizing the archive

The technological changes that have occurred over the last 10 years have facilitated an increase in the range of users to libraries and archives that would not have previously been possible. In an information age, digital technology provides an important opportunity for the further dissemination of material. Archives have capitalized on the potential of new digital mediums for a variety of reasons including better storage capabilities, preservation, better scope for circulation of public-domain material, and sometimes more streamlined processes of ordering and classifying material. As Klaus-Dieter Lehman has noted, "within the framework of a national digital library, the Library of Congress will have digitized five million items of Americana by the year 2000."[45] Like other material, Indigenous cultural material is also being digitized.

240

As in other contexts, the capacity for archives to respond to remote users has generated new copyright challenges alongside the contests made by Indigenous people to the "authorship" of the collections. The new copyright challenges revolve around reproduction and copying and exist because of the way in which digital technology has altered the ways in which accessing and communicating material can be achieved. While archives are not the only organizations effected by changing technology and consequently the changing law, questions about how archives

maintain their core functions of making material available to the public without onerous administrative burdens center again on the dependency between the archive and the author. In situations where copyright owners are difficult to locate or provenance is hard to determine (which is often the case with material relating to Indigenous people), institutions are faced with the limits of the law in this area and are offered the choice of infringing copyright or not facilitating digital access.

With the changing information technologies, material that may once have been difficult to access becomes relatively easier. For colonial archives, this changing technological environment produces a range of new questions about who should be able to access certain kinds of culturally specific material recorded through the legacies of colonial conquest. The questions are an extension of the contested status of authorship raised by those subjugated through this category and affect both copyright materials but also, especially, that which is already in the public domain.[46] The public domain is not some *a priori* state but is in direct relationship with the legal frameworks that create the initial proprietary networks governing material that copyright expiration allows (limited) relief from. Moreover, expiration of copyright and the transition to status as public domain material only provides relief in terms of ownership and to some extent use, but it does nothing to dislodge the authorship that copyright institutes. While copyright creates the legal construct of authorship, in the transition to the public domain, authorship becomes an embedded normative category.

As the public domain status of material does little to dislodge the author from the work, the same Indigenous concerns about the legitimacy of legal authorship carry into the increasingly accessible public-domain material. However, so naturalized have the relationships between the author and work become by the time a work enters the public domain (70 years after the death of the author in most jurisdictions), that Indigenous claims find little traction. The "public" of the public domain is assumed to be neutral, universal, and all-inclusive. Within public-domain advocacy, there is a monumental failure to acknowledge the conditions that produced a culturally specific "somebody" as the author, and the persons documented, those without the technology, without the privilege, without the information to make informed decisions about participating in the first place, as having no legal rights and subsequently no social recognition about what the claim to these knowledge objects entails.

A dilemma is that not all Indigenous cultural material that currently resides in the public domain should actually be there.[47] The public domain is blind to the inequity within the formation of these relationships, and in so doing reveals the coloniality of power wherein certain hierarchical power relations are folded into the present and normalized. Under such

circumstances, it becomes very difficult for recognizing that some material should not be circulated because it remains culturally offensive and inappropriate, or still has contextually driven community rules governing access. For instance, in numerous communities in Australia, photographs of deceased Aboriginal people can cause offence.[48] Other kinds of material can also raise questions about confidentiality relating to who is entitled to "see" it, for instance, a film recording of a ceremony may only be for viewing by one clan or community—it is not necessarily something that is free to be shared and used by others beyond the community.[49]

New capacities for accessing material seldom come with any new accompanying information about what the subjects themselves thought, nor their names—these elements remain peripheral, marginal. Yet, there continues to be important information about who the author is and, in this, authority over the representation is retained. The logics that produced the entitlement to be able to make these representations in the first place are carried into the present. The digital archival event, a turn of promise and potential, does little to address the uncomfortable truths underpinning the creation of such collections and their placement within the organizational archival system.

conclusion

Archives are primary repositories for providing an interpretation of the past. However, what an archive holds is always selective and depends significantly upon the founding logics and rationales from which the archive's constitution and form is derived. Within the archive, what the systems of classification signal at specific times are the very substance of colonial politics, which continue to be refracted in the present.

Law is foundational to an archive. It creates the organizational frameworks for the archive and sets the foundational conditions for identification of works within it. Copyright law establishes the central category of authorship, and this affects how ownership is managed and, consequently, access and use of the works that are crucial for the archive's very existence. Yet, the modern author-function establishes the proprietary trajectory for a work and thus also the conditions for its circulation. In turn, the archive upholds and endorses the authority and legitimacy of copyright law and, inevitably, the notion of the "author."

This chapter suggests that archives are an excellent site for considering the intrinsic operation of copyright in establishing categories and forms of classification that govern the assemblage of certain knowledge objects. Through this framing, the political, social, and cultural effects of copyright as a sophisticated vehicle for colonial projects of knowledge expropriation and extraction become much clearer. This is not only a concern for past practices but how these are carried forward, influencing

how we are able to make meaning and interpret different cultures and cultural practices when these have been authored and set within culturally specific proprietary frameworks.

Digital repatriation within colonial archives does nothing to dislodge the embedded organizational frameworks of the author/owner matrix. If anything, it further normalizes these frameworks, making the interrelations, functions, and effects harder to see and disrupt. The paradigms of colonial control have ongoing legacies in archives where Indigenous people still have to mount arguments for why they also should have rights to access, to copy, and to control material that documents and records their lives and cultures in intimate detail.

Decolonial projects encourage reflection upon the embedded colonial relationships conditioning modernity and in so doing expand the range of available readings of a specific event or site of knowledge production. The current contests in colonial archives for the return of culturally significant material have no easy resolution. The legal category of authorship has very limited capacity for the inclusion of those that it functioned to dispossess. Yet, the anxieties of authorship that pervade colonial archives are only increasing. To find equitable ways of dealing with these requires appreciating the extent that the organizational logic of archives centralized and operationalized relationships of power and privilege between the author and the text. The established hierarchies of colonial control continue to greatly affect Indigenous peoples' lives and their capacity to regain and reclaim what was taken.

notes

My thanks to Cynthia Chris and David Gerstner for their encouragement and wise editorial suggestions. Thanks to the students in my Heritage of Colonialism course for the dialogue that allowed me to nuance old thoughts in new ways. Thanks to Andrea Geyer.

1. Derrida suggests that relationships of power, control, and legal authority have been encoded within the archive through the very etymology of the word. See Jacques Derrida, *Archive Fever: A Freudian Impression* (Chicago: University of Chicago Press, 1995).
2. Carolyn Hamilton et al., *Refiguring the Archive* (Cape Town, South Africa: David Philips Publishers 2002); Ann Laura Stoler, *Race and the Education of Desire: Foucault's History of Sexuality and the Colonial Order of Things* (Durham, NC: Duke University Press, 1995); Ann Laura Stoler, "Colonial Archives and the Arts of Governance," *Archival Science* 2 (2002), 87–109; Alan Sekula, "The Body and the Archive," *October* 39 (1986), 3–64; Thomas Osborne, "The Ordinariness of the Archive," *History of Human Sciences* 12, no. 2 (1999), 51–64; Nicholas Dirks, *Castes of Mind: Colonialism and the Making of Modern India* (Princeton, NJ: Princeton University Press, 2001).
3. Stoler, "Colonial Archives," 92 (emphasis added).
4. Linda Tuhiwai Smith, *Decolonizing Methodologies: Research and Indigenous Peoples* (London: Zed Press, 1999); Walter Mignolo, *The Darker Side of Western*

Modernity: Global Futures, Decolonial Options (Durham, NC: Duke University Press, 2011).

5. Ann Laura Stoler, *Along the Archival Grain: Epistemic Anxieties and Colonial Common Sense* (Princeton, NJ: Princeton University Press, 2009).

6. Walter Mignolo, *The Darker Side of the Renaissance: Literacy, Territoriality, Colonization* (Ann Arbor: University of Michigan Press, 1995).

7. For a project trying to overcome the incommensurabilty between Western norms of authorship and indigenous community practice, see: www. mukurtu.org. Also, Kim Christen, "Gone Digital: Aboriginal Remix and the Cultural Commons," *International Journal of Cultural Property* 12 (2005) 12, 315–45.

8. Stephen Kinnane, *Shadow Lines* (Fremantle, Western Australia: Fremantle Arts Centre Press, 2002).

9. Amitav Ghosh, *In an Antique Land: History in the Guise of a Travel Tale* (New York: Vintage, 1994).

10. Michael Lynch, "Archives in Formation: Privileged Spaces, Popular Archives and Paper Trails," *History of the Human Sciences* 12, no. 2 (1999), 67.

11. Walter Mignolo, *Local Histories/Global Designs: Coloniality, Subaltern Knowledges and Border Thinking* (Princeton, NJ: Princeton University Press, 2000); Benedict Anderson, "The Census, Map, and Museum" in *Imagined Communities* (New York: Verso, 1983).

12. Lynch, "Archives in Formation," 67.

13. Dirks, *Castes of Mind*, 107.

14. Michel Foucault, "Governmentality" in *The Foucault Effect: Studies in Governmentality*, ed. Graham Burchell, Colin Gordon, and Peter Miller (Chicago: Chicago University Press, 1991); Michel Foucault, *Security, Territory, Population: Lectures at the College De France 1977–1978*, trans. Graham Burchell (New York: Picador, 2004).

15. Dirks, *Castes of Mind*, 201.

16. With emerging measuring techniques and a focus on *varna* as the classificatory rubric, the first census recorded the number of castes as 3,208, which in the following census in 1881 went up to 19,044. See Dirks, *Castes of Mind*, 208–209.

17. David Scott, "Colonial Governmentality," *Social Text* 43 (Fall 1995), 191–200.

18. Fredrik Barth et al., *One Discipline: Four Ways: British, German, French and American Anthropology* (Chicago: University of Chicago, 2005); George Stocking, *Victorian Anthropology* (New York: Free Press, 1987).

19. Tim Rowse, "Official Statistics and the Contemporary Politics of Indigeneity" *Australian Journal of Political Science* 44 (2009), 193–211; Tim Rowse and Len Smith, "The Limits of 'Elimination' in the Politics of Population," *Australian Historical Studies* 41 (2010), 90–106; Sally Engle Merry, "Measuring the World: Indicators, Human Rights and Global Governance," *Current Anthropology* 52 (2011): S83–S95.

20. Dirks, *Castes of Mind*, 123.

21. Stoler, "Colonial Archives," 92.

22. Stoler, "Colonial Archives," 97 (emphasis original).

23. Mark Rose, *Authors and Owners: The Invention of Copyright* (Cambridge, MA: Harvard University Press, 1993); and Peter Jaszi and Martha Woodmansee, eds., *The Construction of Authorship: Textual Appropriation in Law and Literature* (Durham, NC: Duke University Press, 1994).

24. Mario Biagioli, Peter Jaszi, and Martha Woodmansee, eds., *Making and Unmaking Intellectual Property: Creative Production in Legal and Cultural Perspective*

(Chicago: University of Chicago Press, 2011); Mario Biagioli and Peter Galison, *Scientific Authorship: Credit and Intellectual Property in Science* (New York: Routledge, 2003).

25. Michel Foucault, "What Is an Author?" in *The Foucault Reader*, ed. Paul Rabinow (Chicago: University of Chicago Press, 1983).

26. Jane Anderson, *Law, Knowledge, Culture: The Production of Indigenous Knowledge in Intellectual Property Law* (Cheltenham, UK: Edward Elgar, 2009).

27. Ronan Deazley, *On the Origin of the Right to Copy: Charting the Movement of Copyright Law in Eighteenth Century Britain (1695–1775)* (Oxford, UK: Hart Publishing, 2004); Brad Sherman and Lionel Bently, *The Making of Modern Intellectual Property: The British Experience 1760–1911* (Cambridge, UK: Cambridge University Press, 1999).

28. *Donaldson v. Becket* (1774) 4 Burr 2408, 98 Eng. Rep. 257.

29. Mark Rose, "The Author as Proprietor: *Donaldson v. Becket* and the Geneaology of Modern Authorship," *Representations* 23 (Summer 1988), 56 (emphasis added).

30. Mignolo, *The Darker Side of the Renaissance*.

31. Sally Engle Merry, *The Colonization of Hawai'i: The Cultural Power of Law* (Durham, NC: Duke University Press, 2000); Dirks, *Castes of Mind*; Patricia Spyer, *The Memory of Trade: Modernity's Entanglements on an Eastern Indonesian Island* (Durham, NC: Duke University Press, 2000); Peter Blackwell, *Miners of the Red Mountain: Indian Labor in Potosi 1545–1650* (Albuquerque: University of New Mexico Press, 1984).

32. Mignolo, *The Darker Side of the Renaissance*.

33. Anderson, *Law, Knowledge, Culture*.

34. Stoler, *Along the Archival Grain*, 51.

35. Conversation between Emily Hudson and Barbara Lewincamp in Jane Anderson, *Intellectual Property and Indigenous Knowledge Project: Access, Ownership and Control of Indigenous Cultural Material* (Preliminary Report AIATSIS/IPRIA Canberra: April 2005).

36. Anderson, *Intellectual Property*.

37. Anderson, *Intellectual Property*.

38. Kinnane, *Shadow Lines*; Anna Haebich, *Broken Circles: Fragmenting Indigenous Families* 1800–2000 (Fremantle, Western Australia: Fremantle Press, 2000).

39. *Native Title Act 1993* (Cth) and *Native Title (Amendment) 1998* (Cth).

40. Human Rights and Equal Opportunity Commission, *Bringing Them Home: Report of the National Inquiry into the Separation of Aboriginal and Torres Strait Islander Children from their Families*, 1997.

41. The Australian Institute of Aboriginal and Torres Strait Islander Studies has a special Family History Unit to manage these requests.

42. Kinnane, *Shadow Lines*, 126–27.

43. Patrick McConvell and Nicholas Thieberger, "State of Indigenous Languages in Australia – 2001," *Australia State of the Environment Technical Paper Series (Natural and Cultural Heritage)*, Department of Environment and Heritage, 2001.

44. Thomas Osborne, "The Ordinariness of the Archive," *History of the Human Sciences* 12, no. 2 (1999), 55.

45. Klaus-Dieter Lehmann, "Making the Transitory Permanent: The Intellectual Heritage in a Digitised World of Knowledge," *Daedalus* 125 (1996), 308.

46. Jane Anderson, *Indigenous/Traditional Knowledge and Intellectual Property Issues Paper* (Centre for Public Domain, Duke University Law School 2010), accessed May 21, 2012, http://www.law.duke.edu/cspd/itkpaper.

47. Kathy Bowrey and Jane Anderson, "The Politics of Global Information Sharing: Whose Cultural Agendas are Being Advanced?," *Social and Legal Studies* 18 (2009), 479–504.
48. It is currently an Australia-wide media industry practice to provide a visible warning when images of deceased Aboriginal people will be featured in any documentaries or televised reports.
49. There were two early confidential information cases in Australia in 1976 and 1983 that illustrated the importance of Indigenous material and the authority of Indigenous people to regulate access. See *Foster v Mountford* (1977) 14 ALR 71 and *Pitjantjatjara Council Inc v Lowe* (1983) Victoria Supreme Court, unreported.

perceptions of place

the nowhere and the somewhere of

al jazeera

f i f t e e n

m a t t h e w t i n k c o m

> Of course, we can define the project of post-modernity
> simply in political terms as an open dialogue between local
> and global, margin and center, minority and majority, con-
> crete and universal—and not only between those but also
> between local and local, margin and margin, minority and
> minority, and further still, between universals of different
> kinds. But there is never surety that a political dialogue,
> even the most open, will not erupt into violence.[1]
>
> —Ihab Hassan

Three moments inaugurate this chapter's discussion of the problems of
media authorship presented by the Arabic news organization Al Jazeera.

First: On December 2, 2010, the tiny country of Qatar on the Arabian
Peninsula was announced to have won its bid to host the World Cup
football games in 2022. The celebrations of this achievement were vividly
displayed on Al Jazeera, the global Arabic news media that makes its home
in Doha, the capital of Qatar. Crowds of Doha's inhabitants danced in the

streets and waved the country's white-and-maroon flag, allowing Al Jazeera to promote the sense that the country was becoming a recognized national actor in global economic, cultural, and political spheres—not least by securing the coveted World Cup hosting, perhaps the most widely viewed sports event in the world. Al Jazeera's "local" coverage of these celebrations came as a surprise to many living in Doha—this author included—because it seemed that these were the first images of events in Doha that anyone could remember appearing on the news channel. As much as Al Jazeera identifies with Qatar as its home, specific news information about Qatar often seems remote from Al Jazeera's agenda, and that December night's coverage of the World Cup festivities drove home the paradox of Al Jazeera's placelessness in its home city.

Second: Beginning in January 2011 and continuing to the present moment, Al Jazeera's website has hosted bloggers in Egypt, Syria, Bahrain, and Yemen who post updates—sometimes on a moment-by-moment basis—regarding the resistance movements that have emerged in the Middle East. These blogs include prominently placed disclaimers such as "We bring you the latest news from various sources" and that "Al Jazeera is not responsible for content derived from external sites."[2] Such "various sources" and "external sites" are often euphemisms for private individuals who post to Al Jazeera's websites and serve as anonymous witnesses to the various regimes' violent actions against their citizens.

Third: Anyone accustomed to the utopian fantasy that the World Wide Web provides access to all information and opinions which the user might seek would be as surprised as myself at the discovery of the following response to a web search: a visual field containing a cartoon figure expressing puzzlement and outrage to the request for access, with a large "OOPS" appearing in a thought-bubble above him.

Elsewhere within the image-field, the recipient is informed that "the web page you are trying to access has been blocked as the content contains prohibited materials" and is offered instructions to contact the relevant government office at a provided email address. Other cartoon figures within the frame stare at the reader and smile benignly, but their presence offers little assurance to the thought that prohibition to this site might be in error.

This image also circulated within Qatar, the very same place that, as mentioned, is home to Al Jazeera. (Thus, the accompanying text also appears in Arabic.) This response by the Qatari Ministry of Information appeared in the web browser after this author's search for a *New York Times* article on same-sex marriage initiatives in the United States in the spring of 2011, and did indeed come as a surprise because such media access had not been the source of such evident censorship on the part of the Qatari government in the nearly two years I had already lived in the region.[3] As much as I was dismayed by the government's intervention into my web surfing,

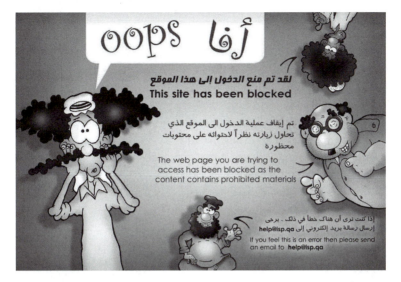

Figure 15.1

A Different Arab Spring: screen capture, Doha, Qatar, May 2010.

I was more surprised that the same entity that was simultaneously playing a key role in the political events being narrated on my television screen was limiting my access to another global media outlet such as *The New York Times*.

That entity is the Qatari government, which indirectly underwrites the global news outlet Al Jazeera and which also coordinates all web and telephone channels available within the country. However, as this article will argue, Al Jazeera's emergence as an important force within the production and dissemination of news, not least about political developments within the Arabic-speaking world, occurs through the frequent omission of a sense that Al Jazeera has a locale—that it is, in fact, based in the Qatari capital city of Doha but has correspondents in nearly 70 news bureaus around the world. As a newly emergent actor in the international news media environment, it has played an important and ongoing role in the various events gathered under the name of the "Arab Spring." Those events include political uprisings in Tunisia, Egypt, Bahrain, Yemen, Syria, and Libya, and herald the appearance of a set of popular political voices demanding the expansion of political enfranchisement by men and women living in those nations.

Al Jazeera presents a remarkable challenge in the global news environment for our understanding of what it means for news to be authored—by a corporation, by a country, by a regional identity such as the open-ended name of "Arab"—and the role that location plays in both stabilizing those authorial names while simultaneously disrupting them. When, as was the case in the spring of 2011, I viewed in Doha on Al Jazeera English

the reportage from Cairo, Tunis, and Damascus regarding the political revolutions taking place there (and at the same time was challenged to get news about events in New York and California), the sense of place—and placelessness—became all the more palpable. In this chapter, then, I consider the way that location matters still to the authorship of news in perhaps a superannuated way. At the same time, this chapter contemplates the effects of how it becomes possible for a media enterprise such as Al Jazeera to develop as an important agent in the political life of one location—such as Egypt or Tunis—while emanating from another place, Qatar, a country whose political life seems hardly to figure within the representational field at hand.

authorship as dislocation: doha and its satellites

In its comparatively brief existence, Al Jazeera has borne a unique status among media scholars for several reasons. First, its brand has further reach to Western audiences than any other Arab-language media outlet, and, second, it is associated with an increasingly liberalized editorial content. Yet, scholars of Arab media have noticed the tendency of making Al Jazeera stand single-handedly—especially among Western commentators—in the place of media and news production in Arabic or within the Gulf region more generally; that is, we are cautioned not to accept accounts about the status of Arab media by focusing too narrowly on Al Jazeera and, indeed, made aware that Al Jazeera is probably anomalous, rather than typical of, Arab-language international news media. As Marwan M. Kraidy and Joe F. Khalil suggest, "al-Jazeera's [sic] status as poster child for Arab media in the post-September 11, 2001 world obscures further rather than enlightens non-experts who are interested in Arab television."[4] That said, it would be difficult to overestimate the importance of Al Jazeera in the post-9/11 global news environment and, more recently, within the stories of the Arab Spring. One important instance, for example: among the most widely reported moments in the Egyptian revolution was the initiative by the Egyptian government, led by the administration of the then-President Hosni Mubarak, to curtail Internet and cellular access by Egyptian citizens to "external" media sources (i.e., non-government-regulated media outlets) and to internal social networks mediated by cellular communications using mobile devices and Twitter messaging. Thus, one of the most significant events to occur during the uprisings centralized in Cairo's Tahrir Square was Al Jazeera's participation in the distribution of information helpful to the protesters. Most notably, after the government's blockade to web and cellular access was reported by Al Jazeera's news broadcasts in the region, the channel began to include a news crawl on its television broadcast and web pages that informed viewers—most pointedly those in Egypt—of the coordinates for satellite access to the channel, thus giving

Al Jazeera's audience information about alternative media channels by which to learn about the events unfolding around them in Cairo and other Egyptian cities.[5]

In this regard, Al Jazeera became a powerful and active agent within the political events occurring in the Arab world by providing information crucial for how the protestors mobilized in response to the violence and resistance offered by the Egyptian government and military. Indeed, many of Al Jazeera's professional correspondents became celebrities for the reporting they offered (frequently from unnamed locations), among them Abdel Fattah Fayed and Ayman Mohyeldin. (Mohyeldin, in fact, was detained briefly by the Egyptian government in February 2011, and became so widely recognized as a news source for the region that he was subsequently recruited to the NBC news organization in the United States.) By contrast, Al Jazeera's local news content—that is, its coverage of events within Qatar—is frequently a source of humor within Doha, with jokes circulating that one could hardly find any news about life in that country. Such commentary, both in its humorous and more serious versions, is commonplace in Al Jazeera's home city and the capital of the country. Thus, when you want to know the weather forecast for Doha, a locally shared joke in Doha is that you will want to check CNN's international weather online—either that, or risk going outside, where local temperatures in the Arabian desert reach 120°F in the summer months.

This absence of news information about the city that a significant news organization calls home is not lost on the people who live there. The irony of not being able to access news about life in Doha is a source of discussion—not because there are no news sources for the city (two newspapers are printed in Doha and local talk radio is available), but because there is a marked disconnection between the local identity of the space and its role in the region and in the larger world. Given that Qatar is a small nation of just over 4,400 square miles—roughly the size of Connecticut—and its primary source of wealth has emerged in the past three decades around its large resources of natural gas (third only to the holdings of Russia and Iran), the country's infrastructure has quickly developed to extract and export its petroleum resources to the global consumer market for energy. The country has developed its industrial sector to convert extracted natural gas into liquefied natural gas (LNG) and, according to the United States government, is now the largest exporter of LNG in the world.[6] Such newfound wealth, concentrated in the hands of the few tribal families who form the ruling elites of the country, most importantly the Al-Thanis, makes possible the country's recent capacity to build institutions both locally and globally. The Qatar Foundation, funded by the ruling Al-Thani family, has become a global philanthropic presence, underwriting activities in humanitarian relief as well as projects in education and medicine. Its latter activities are primarily organized in the

context of the institution of Education City, a 5-square-mile campus located on Doha's western outskirts which is home to campuses housing six US-based universities, as well as graduate programs from France and the United Kingdom. (Starting in 2008, I spent two years at Georgetown University's School of Foreign Service at Qatar serving as a faculty member and administrator.)

The Qatari royal family and, by proxy, the Qatari government, are eager to expand the country's reputation and, indeed, its economy beyond solely that of oil- and gas-extraction wealth, and this emphasis shifts the identity of this part of the Arab world from the more robustly developed antecedents of its older neighbors nearer to the Mediterranean (such as the countries of the Maghreb or of Egypt, Libya, and Tunisia) and its more enclosed neighbors, such as Saudi Arabia and Iran, where economies have historically been tied to the wealth derived from oil extraction. Like its closest neighbor to the east, the United Arab Emirates (UAE), the rapid expansion of Qatar's infrastructure, its ballooning population, and its initiatives to attract and develop "Western" institutions—including universities but also banks, law firms, media and entertainment companies, and museums—demonstrate that the governing impulse in the spaces of Qatar and the UAE is to produce a new Arab social and economic space that rivals those elsewhere and outside the region.

The attempts to foster such innovations within the smaller Gulf countries such as Qatar do not fail to raise suspicion among many, both in the region and elsewhere; at worst, they seek to take on the appearance of institutions characterized by transparency and accountability while it remains difficult to imagine the constituencies and communications modes that would make places such as Doha, Abu Dhabi, and Dubai homes to institutions that foster open and democratic societies. Worth remembering is that all this development is unfolding in spaces whose social organization historically has been through monarchical and tribal identities. However, it would be a mistake to dismiss the impact of the country's developments as solely gratifying the elite's wishes for the appearance of openness within the context of royal political rule. Rather, we should understand the paradoxical situation whereby the effects of the development of entities such as Western-style education and Al Jazeera seem most pronounced in other Arab spaces (such as Egypt or Libya) where the confluence of forces—of political unrest, of economic stagnation, of diasporic movements of populations—shape the historical events that continue to unfold.

Thus, the thrust of this article is that we need to understand Al Jazeera as what Hassan, in the epigraph to this chapter, calls "post-modern," in that the effects of news production and dissemination in one location—i.e., Doha, or New York, or Singapore—can be most acutely felt in other spaces such as Cairo, Tunis, or Tripoli. The unanticipated effects of Al Jazeera's

activities in its location of identity—the Gulf, and Qatar in particular—is that its most powerful constituents reside elsewhere from its space of production. Al Jazeera becomes a local "nowhere" with seemingly few ties to its home city while having, to use Hassan's term, "dialogue" with other parts of the Arab world—the "somewhere" of its impact. Conversely, the local events with which Al Jazeera's news coverage is most intensely identified are not the locale in which it operates.

authorship as media flows: al jazeera and citizen journalism

In an effort to understand Al Jazeera's effects as a media enterprise whose effects are most intensely felt in places besides its home, Mohamed Zayani notes that the study of contemporary Arab media insofar as the scholarship increasingly

> draws attention to the need to move away from the traditional understanding of culture as a place and to go beyond the focus on stable, coherent and localized units of cultural analysis as they are proving to be inadequate for understanding a (real and imagined) world made all the more complex by transnational flows of people, goods, images and information that are embedded less in circum-scribed locations and more in fluidly constructed spaces where influences intersect and networks shift.[7]

Arab media—even that which is not in Arabic, such as Al Jazeera English—has expanded beyond the Gulf to larger audiences, a fact that is not always seen as benign. For example, during the US military incursions in Iraq and Afghanistan, the administration of President George W. Bush accused Al Jazeera of being a mouthpiece for radical Islamists. This perception is not mitigated, but is indeed intensified, by the idea that Al Jazeera's flows of information and opinion move in a markedly different direction: from East to West. This distinguishes Al Jazeera from international news outlets such as the BBC or CNN, whose own flows historically have moved in a counter-direction. In place of seeing Al Jazeera as located in Doha but reporting about other Arab political spaces, Zayani underscores the sense of movement between those two spaces that parallels the flows of humans, capital, and commodities through the Middle East from other parts of the world.

Worth understanding about the history of these flows is the fact that Al Jazeera emerged initially as the product of short-lived collaboration between the Saudi Arabian government and the British Broadcasting Corporation, an alliance that was intended to foster an Arabic-language news outlet, produced in Riyadh and London and staffed by journalists trained by the BBC.[8] This venture proved too restrictive for BBC standards

as to what made for suitable broadcast material. Ultimately, the BBC Arabic channel folded its operations after the Saudi sponsors balked at the prospect of broadcasting a documentary about public executions in Saudi Arabia.[9] It was then that the Emir of Qatar offered a home within Qatar where the journalistic activities of the organization, newly branded as "Al Jazeera" (Arabic for "the island"), would be allowed to proceed without government intervention. The journalistic coverage from the re-invented organization heralded a new vector from "East to West," which more specifically meant from the Gulf to audiences in other spaces. It also marked the development of other flows, not least within the region of the Gulf and North Africa, moving through multiple venues within the Arabic-speaking world. It is hardly the case that all content flows to all spaces, though. For example, access to Al Jazeera has been restricted at different moments in many parts of the Middle East, not least Saudi Arabia and Iran.[10] Such restrictions are the result of news coverage that has proven to be provocative within the historical context of journalistic content within the region, where most of what was available through print broadcast, satellite, and web access was "government-sanctioned" (i.e., vetted by state censorship entities) if not manufactured outright by state-sponsored news organizations. Complicating matters even further is the sense that, within Doha, it hardly matters what Al Jazeera includes in its news coverage if nearly all of its concerns are about spaces other than Qatar.

The fact that Al Jazeera is not a singular entity operating within one medium does not lessen the problem. Over time, it has created new satellite channels and websites for sports, children's programming, and documentaries. Perhaps its most marked innovation in its news programming was the development of Al Jazeera English as a channel for distribution globally and, particularly, in the United States. It is instructive that just prior to the launch of the Al Jazeera English channel in 2006, its name was to have been Al Jazeera International. The last-minute change would seem to herald a shift in focus from a more generalized "global" intention for the channel to the emphasis that Al Jazeera's new media platform was not simply about reaching an ostensibly global audience but that it would do so most centrally by being offered not in Arabic.

More to the point, the manner in which we analyze and theorize Al Jazeera in relation to other models of cultural authorship allows us to discover its anomalous stature as an international news outlet that bears the hallmarks of two parallel but distinct models: the CNN-style American corporate model of news journalism and the BBC-style state-supported version. Al Jazeera's unique status derives from the fact that the channel's attempt to hybridize these two versions is made possible by support from the Emir of Qatar as part of the articulation of a quasi-national identity, and thus what we witness in Al Jazeera is the look-and-feel of a globalized news outlet, which it very much is, with the financial underpinnings of a

royal patronage system. The little advertising revenues garnered by the station do not make it profitable, and the station continues to rely upon the Qatari Emir for its primary sponsorship, a fact that should make its viewers wonder whether the station is able to avoid control by the Qatari elite over its editorial content. Al Jazeera's staff insists upon its ability to operate without such control.[11] Given Al Jazeera's inclusion of voices critical of Arab political regimes—outside Qatar and its context—and its dissemination of debate-format programming about issues within Arab societies, it is not surprising that the organization has fostered the sense among audiences in the Arab world and elsewhere that it is, by comparison, the non-Western news outlet within the region that is most willing to allow for discussion of alternatives to the political formations that have historically organized life in the Arabic-speaking nations.

The question of ownership and its relation to news content, it should be mentioned, is vexed in the Western context as well: it was illuminating to be able to view in Doha the broadcast of the April 2011 Parliamentary hearings of investigations of News Corporation's hacking of phone and email accounts by *News of the World* staff and their affiliates. The experience of watching—on Al Jazeera, no less—Rupert Murdoch and his son, James, testify that they had no knowledge of the surveillance by News Corporation employees of email and mobile phone activities of politicians and celebrities drove home the sense that the larger questions of media consolidation and ostensible independence of the press from corporate oversight can have both negative and positive effects. The sense that the Emir of Qatar maintains an "arm's-length" relation to Al Jazeera can foster the possibility that the Murdochs could, in fact, remain ignorant of their employees' activities.

Furthermore, the fact of Al Jazeera's expansion of its news content to include an English-language channel can be seen as a move not only to garner larger audiences (a move that has, at the date of this writing, met with limited success given the few North American television markets that the channel has been able to access), but to diversify, within the model of corporate news authorship, into other news formats as well. Furthermore, the expansion into English-language programming shapes perceptions about its being transparent in its editorial stance. That is, the viewer who is unable to understand Al Jazeera's content in Arabic might, if he/she assumes an approximate content in English, come to think of Al Jazeera more generally as Westernized, liberal, and more open to critiques of Arab political and social life than those available elsewhere in Arab language news reporting. This assumption would not necessarily be wrong, given that we are discussing perceptions of the channel's branding attempts. However, it is worth emphasizing that this logic would assume that the English and Arabic channels' editorial stances are similar—an assumption that is not necessarily warranted if only because a comparative analysis of the two has yet to be undertaken.

Indeed, within the domain of perception (as opposed to actual content), what if it were the case that Al Jazeera's English-language programming signals new political possibilities within the Middle East to viewers well outside the region while, in practice, its activities most closely linked to the mobilization of dissidence were the effects of its Arabic-language broadcasts? Might we understand a sympathetic and necessary relation between its activities in Arabic and English, each performing a symbolic function apart from the editorial content it offers? In other words, the programming in Arabic and English are not simply the translation of one into the other, but indeed form part of a larger ideological whole.

Be that as it may, the political life of many Arabic countries in 2011 would seem to render such concerns more complicated, given that the forms of dissent that Al Jazeera has fostered and disseminated in Egypt and elsewhere came from its audience as much as from its journalists and commentators. As the channel sought to represent events in Cairo and Tunis, it could not help but discover that its authorial voice was made by its Egyptian and Tunisian viewers and subjects and by their demands for political change. Significantly, they articulated such demands in both Arabic and English. Indeed, the protestors were savvy in their usage of both languages to reach different constituents and affiliations—as an Arabic-speaking friend pointed out to me about the signs and placards that appeared in Tahrir Square, "some of the signs are in Arabic—those talk to the [Egyptian] government and to other Egyptians—and some are in English, and those send a message to the West that they're not terrorists, but serious political dissidents."[12] Of note for this account of Al Jazeera's authorial identity is that these signs of protest—in Arabic and in English—appeared as part of Al Jazeera's coverage on its Arabic- and English-language news outlets. Thus, Al Jazeera's authorial identity has emerged to be one of a transnational news source that articulates the message from political dissidents in Egypt and Tunis to their governments while simultaneously enjoining viewers—not solely those in the Gulf—to hear that protest is possible in these spaces simultaneously and could benefit from its articulation in English as well. This would counter the tendency (discussed previously) to understand the English-language broadcast content of Al Jazeera as the space of dissent—and would usher us to the most historically contingent aspect of the "Arab Spring" protest movements as part of Al Jazeera's coverage: the emergence of the citizen journalist as a central figure in the production of news content.

Even if Al Jazeera's intention could never have been to position the protestors in a harsh and condemning light—not the channel's apparent aim, but not unheard of in the longer history of state-sponsored news programming in many Arab countries—the fact of social networking and SMS message packeting made it nearly impossible to discount the size, intensity, and seriousness of the crowds of protestors, crowds containing

many of Al Jazeera's key news manufacturers: citizens with smart phones. These citizen journalists, using mobile phone cameras and Twitter messaging, became some of the savviest manufacturers of news content. Their articulations of dissent fit so well with Al Jazeera's displaced political interventions that they enhanced the channel's identity as an important actor within the region—but just not at home in Qatar.

This last point suggests the "nowhere" of this chapter's title: Doha and the Gulf more largely. The home of one of the most important new institutions for the fostering of civic cultures within the Arab world has no symbolic home itself to the degree that it seems much more probable that Egypt, Tunisia—and perhaps even Syria and Yemen—will develop public political cultures and institutions before other countries on the Arabian peninsula do. Of course, history has a way of surprising us, and as I write that sentence, I am aware of how unlikely events in Tripoli and Damascus, as well as Cairo or Tunis—would have seemed only a year ago. However, Ihab Hassan's assertion that "there is never surety that a political dialogue, even the most open, will not erupt into violence" becomes all the more poignant when we consider how much our desires for dialogue—that is, for the power of words over the power of force—might tell us of an ideal that we have about the impact that an unhindered news media might have on the world on which it reports if—and this is a large "if"—such media have a relation to the places they represent beyond that of being physically accommodated in them, yet discursively excluded from them. In other words, Hassan's thoughts about post-modern space and violence offer caution about the seeming fact that the flow of news information can move from Tahrir Square to Al Jazeera's studios in Doha and back to Tahrir Square—a crucial loop that helped protestors in Cairo—but with little effect on the site of news production itself.

Set against Hassan's admonition about post-modern spaces—center and margin, margin and margin—we can take some hope from Zayani's account of the flows of news media through which Al Jazeera's content moves. Its flows move against the historical current from the West to the East into previously unaccessed sites of news production (such as the cell phone in the public square) and news reception—those television viewers who re-calibrated their satellite signal, curtailed by the Egyptian government, to receive Al Jazeera's signal. It increasingly becomes untenable to consider all news about developments in the "Arab world" as singular. Indeed, what the name "Arab" means becomes more complicated in national, linguistic, or personal terms given that this umbrella term often mystifies more than it reveals because it poses more questions about precisely what that name consists of: populations that range historically from North Africa to the Middle East; the fact of extensive (but not identical) overlap between many Arabs and Islam; the fact of large-scale migration of Arab communities and self-identified Arabs (many of who might not speak

Arabic as their first language). Furthermore, even those political movements within more Arab countries such as Egypt or Bahrain are hardly the same, given the differences between military-backed authoritarian regimes (as in Tunisia or Egypt) and local governance by royal decree (as in Saudi Arabia, the UAE, or Qatar).

If the events of the Arab Spring and the robust economies of the region help to explain how circumstances in North Africa and on the Arabian peninsula have generated greater interest among viewers outside of those places in what is unfolding, representing them in the name of an "Arab" news source is problematic if, as has until just recently been the case, solely two news outlets have shouldered the task of producing news in the name of the Arab world. While Al Jazeera has attempted to become a global news source, Al Arabiya has maintained a more local identity associated with its home in Saudi Arabia. This situation may change, and quickly. In the fall of 2011, two new entities were announced: Alarab, to be co-sponsored by Saudi prince Walid bin Talal and US-based Bloomberg News, and Sky Arabia, a satellite channel subsidiary of British Sky Broadcasting and Abu Dhabi-based Sheik Mansour bin Zayed al-Nahyan.[13] Initial reports about these two news channels do not specify whether their content will be in Arabic, English, or with outlets for both languages. The decision will be telling and may help focus the challenges faced by Al Jazeera, not least because the development of its English-language news outlets construed, depending on whose critique is at hand, as either re-directing its resources away from its Arabic-language outlets (and thereby neglecting the needs of its Arabic-speaking viewers) or as attempting to propagandize its message on behalf of conservative Arab Gulf nations to English-speaking viewers who somehow would be duped by such news production.

Yet, such perceptions must be framed within the more complicated array of antagonisms toward the channel's activities, which range from the idea that Al Jazeera has been seen, especially prior to the events in the winter and spring of 2011, as too often soft on political issues as they relate to political reform in the Middle East, and to the attitude that, during the Arab Spring, the channel struggled with its sympathies toward protesters in Cairo and Damascus. Compounding matters is the longer-standing sense that, as Marwan M. Kraidy and Joe Khalil argue, "Al-Jazeera's editorial slant combines Arab nationalism, Islamism and Third Worldism ... [whereby] the channel is scolding of pro-US Arab states like Egypt, Jordan and Saudi Arabia, and supportive of radical movements like the Palestinian Hamas and the Lebanese Hezbollah."[14] Their account helps to illuminate how Al Jazeera's sympathetic coverage of the protesters in Egypt makes sense within the channel's longer-standing antagonism toward the Mubarak regime's sympathies toward the United States. The protests, in other words, were not solely framed within the advocacy for reform

internally within Egypt, but also by proxy toward rethinking the forms of influence that the United States has wielded within the larger region.

authorship as legacy: al jazeera and the arab spring's effects

By way of conclusion, it is significant that the Occupy Wall Street movement that emerged in September 2011 heralded a moment whereby many of the social-media techniques of the Arab Spring were adopted by protestors in the United States and around the world. The insightful use of social networking technologies, for example, included mobilizing participants with the symbolic co-opting of physical space in many cities. Some Occupy participants have paid homage to the protests in Egypt, Tunisia, and Syria, movements based on the ideal of a "horizontal" political organization that uses social media to mobilize dissidence and to secure representation in the more traditional media channels of television and print media. As a measure of what we may want to believe about the relation between news media in the West and dissidence, it is worth contemplating whether—in some dystopian version of political life—a government such as that of the United States might seek to curtail access to information by attempting, as the Mubarak government did, to block Internet and cellular access. What might we expect of CNN, the BBC, NHK, or France 24 in their responses to such an event? Would we expect their relation to their own citizen-journalists and bloggers to be similar to that which Al Jazeera has maintained with its own? And what would be the national security considerations for media enterprises that were perceived to be aiding dissidents in a country not of their self-identification? The answers to this question lead us to understanding that the authorship of news—not just that of Al Jazeera—within the current global mediascape still ties global news production to spaces of cultural production in remarkably "modernist" ways. In this regard, Al Jazeera and its symbolic home (and its symbolic homelessness) in Qatar offer a lesson to us about articulating our own expectations about how political engagement—be it in Cairo or New York—can be represented, to whom, by whom, and under what circumstances.

notes

1. Ihab Hassan, "From Postmodernism to Postmodernity: The Local/Global Context," *Philosophy and Literature* 25, no. 1 (2001), 13.
2. Al Jazeera Blogs, accessed April 23, 2012, http://blogs.aljazeera.com/ middle-east.
3. Many institutions and those individuals working in them rely on the use of virtual private networks, or VPNs, which allow users to log on to a web portal whose IP address is that associated with a location outside the country. The monitoring of these devices is a source of debate among local users. While no one reports interference or even evidence of scrutiny by

third parties, it would seem naïve not to consider the possibility of surveillance in one of the most politically fraught and economically productive regions on the planet.

4. Marwan M. Kraidy and Joe F. Khalil, *Arab Television Industries* (London: Palgrave MacMillan, 2009), 2.

5. Robert F. Worth and David D. Kirkpatrick, "Seizing a Moment, Al Jazeera Galvanizes Arab Frustration," *New York Times*, January 28, 2011, accessed December 15, 2011, http://www.nytimes.com/2011/01/28/world/middleeast/ 28jazeera.html?scp=2&sq=al+jazeera&st=nyt; Robert F. Worth, "Al Jazeera Covers Protests Despite Hurdles," *New York Times*, January 29, 2011, accessed December 15, 2011, http://www.nytimes.com/2011/01/29/world/ middleeast/29jazeera.html?_r=1&scp=5&sq=al+jazeera&st=nyt.

6. United States Energy Information Administration country report on Qatar, sourced February 6, 2012, http://205.254.135.7/countries/country-data.cfm?fips=QA.

7. Mohamed Zayani, "Toward a Cultural Anthropology of Arab Media: Reflections on the Codification of Everyday Life," *History and Anthropology* 22, no. 1 (2011), 39.

8. Kraidy and Khalil, *Arab Television Industries*, 80.

9. Muhammad I. Ayish, *Arab World Television in the Age of Globalization: An Analysis of Emerging Political, Economic, Cultural and Technological Patterns* (Hamburg: Deutsches Orient-Institut, 2003), 45.

10. Kraidy and Khalil, *Arab Television Industries*, 82.

11. Ayish, *Arab World Television in the Age of Globalization*, 45–50.

12. Personal correspondence with author, February 11, 2011.

13. Eric Pfanner, "Arab Spring Reshapes Market for TV News," *New York Times*, October 30, 2011, B11.

14. Kraidy and Khalil, *Arab Television Industries*, 81.

matthew tinkcom

amateur auteurs?

the cultivation of online video partners

and creators

sixteen

susan murray

Much of the press coverage of YouTube users in recent years has focused on
the type of user uploads that quickly travel through social media as a viral
video while generating a surprisingly substantial amount of income for the
creator. One of the most widely reported examples of this is "David After
Dentist," a less-than-two-minute-long video taken by a father of his son's
loopy, high on anesthesia, ride home after a tooth extraction. First posted
on YouTube in the summer of 2008, the video generated more than
$100,000 by 2011 for David's parents through the company's revenue shar-
ing Partner Program. (The family also earned money by selling t-shirts and
stickers on their site, davidafterdentist.com.[1]) Other videos that have
reached this level of success include "Talking Twin Babies" and "Lily's
Disneyland Surprise." Despite these highly publicized (and kid-centered)
examples, most YouTube partners do not earn hundreds of thousands for
each video they post. Many successful partners post video series, most
commonly instructional (such as massage or make-up techniques) or
music videos. In these cases, the video creators or performers gain a small
level of Internet celebrity status, along with somewhat regular income

while providing YouTube with relatively predictable programming. The position as authors or creative producers is minimal, as they are promoting a service or another type of talent or event, often unrelated to the actual production of the videos themselves.

YouTube's Partner Program, which enables producers of video with high view counts to earn revenue, was first announced in 2007 and initially included mostly professional content providers although it quickly opened up to amateurs. It was conceived soon after Google's purchase of YouTube and at a time when competition between video sharing sites had begun to intensify. By 2011, the 20,000 channel operators who were part of the program generated 100 billion views and millions of dollars in ad revenue. The company told *The New York Times* in May of that year that there were several hundred former amateurs who were now making over $100,000 a year.[2] George Stompolos, the partner development manager at YouTube, told a reporter in 2010, "Folks who 10 years ago couldn't even get their content shared to friends across the street are now connecting with audiences around the world. We see that not only as a cute thing, where someone has a viral hit; we see these people as the next content creators, the next brand in original programming. It's where our roots have always been, and we are doubling down on that type of programming."[3]

In the summer of 2010, YouTube unveiled its $5 million Partner Grants Program, created to provide financial backing for the most promising members of the Partner Program. The grant program—renamed after the company's 2011 acquisition of Next New Networks—was set up with the intention of cultivating new semi-professional video makers who would hopefully help rebrand YouTube as an original premium content producer. NextUp aims to take partners to yet another level, promising to act as an instructor, networking source, financer, promoter, and distributor of their work. YouTube stated in 2010 that it planned to give its "creators" (a category decidedly distinct from "partner") anywhere from a few thousand to a couple of hundred thousand dollars to help support and improve their productions. By the following year, the company had set up two distinct initiatives related to this funding. The first was The YouTube Creator Institute: A New School for Content Creators, which admitted a select number of applicants based on how many viewer-votes their two-minute (or under) video submission acquired. They were then offered a month-long training camp at either the University of Southern California's School of Cinematic Arts or Columbia College Chicago's Television department where they would "learn from a unique new media curriculum, apply new media tools, find out how to build their audiences, be promoted globally on the YouTube platform, and engage with industry leaders and experts. Participants will learn everything from story arcing to cinematography, money-making strategies to social media tactics."[4] And the entire institute experience would, of course, be recorded and posted on

YouTube so that "the wider YouTube community [would] be able to learn along the way too."[5] The second was the UpNext Creators contest, which was open to YouTube members with under 300,000 subscribers. Submissions were first reviewed by YouTube and then a selection of finalists were put to viewer vote. In May of 2011, the 25 winners were awarded $35,000 and an invitation to attend a four-day-long Creators Camp in New York City. The winning creators ranged from "musicians to comedians to a trick basketball shooters [sic], a makeup artist, a skateboarder and a screencasting Final Cut wizard."[6]

The creators program developed out of a larger initiative to alter YouTube's brand—to move it beyond being largely known as a repository of home videos and grainy clips of film and television dubs. Google, YouTube's parent company, announced its plan to retool the site by courting more high-quality original content and adding a system of close to 100 channels of content in partnership with other "old media" companies as well as independents.[7] The company believes it will make YouTube more attractive to big brand advertisers, enable it to compete with online TV sites such as Hulu, help move it away from acting as a repository for legally troublesome copyrighted material, and alter its form and content to better fit their newly released smart TV platform, Google TV. As David Cohen, an executive VP at the media buying-agency Universal McCann noted, "Many brand advertisers were previously scared off by the large amount of user-generated, lower-quality content on YouTube." However, in recent years, YouTube has accumulated higher-quality video and "its new channels strategy is a clear signal of its commitment to creating immersive and engaging original content."[8]

One of the results of YouTube's rebranding is a four-tiered system of content providers: (1) amateur users; (2) partners; (3) creators; and (4) established media companies/producers. In the first two tiers, there is less chance that the video creators will be acknowledged as serious or successful producers, unless they have already established a career in entertainment outside the realm of YouTube. It is in the latter two categories that YouTube hopes to find brands—branded channels and fresh branded talent. This hierarchical system is an attempt to cultivate teams of specialized content producers, manage the quality of their product, and establish an economic and institutional relationship and reward system with select members. It also represents a larger trend in the way that online media companies exploit both non-professional and professional labor and are attempting to dislodge traditional characteristics and implications of media authorship. This new financing and culture of online content producers signal a shift for not only YouTube's business strategies, but also for the way in which amateurs are rhetorically courted by commercial media organizations. It is also a telling example of how amateurism and authorship are, once again, being redefined through digital media. In this

chapter, I will use YouTube's recent strategies as a way to explore the questions of authorship, celebrity in online video shorts, and social networks in relation to the history and discursive construction of television, independent video/film communities, and amateur media production.

prosumers, produsers, amateurs, creators, partners, and users

In recent years, much scholarly work has been published on the meanings and implications of the participatory culture of Web 2.0. Many media scholars agree that participation in social media often represents a breakdown of longstanding bifurcations of categories such as amateur/professional, producer/consumer, and active user/passive viewer. And there has been an effort to define in more detail the specific behaviors of users who also act as creators that moves beyond traditional television-based models of participatory culture. In a 2007 article, Axel Bruns details his concept of "produsage," a model that he claims encapsulates the environment of user-led content creation.[9] Noting that social networking is moving beyond the notion of a "prosumer" (a term originally used to describe a consumer in an era of mass customization, which has more recently been applied to blurred categories of professional and consumer/amateur) and into an era of new user-led paradigms and informational economic models, he identifies relations around the user as central to the paradigm shift he is elaborating on and coins the term "produser" to describe user engaged in collaborative, ongoing, production of and improvement on content. This term also suits a wiki user quite well. However, it does not fit as well for those users who engage with sites that generate profit from user-generated content (USG), as their relationship with companies such as YouTube are not collaborative or absent of power relations. In trying to shift definitional frames to better get at the relationship between YouTube and its users, Jean Burgess notes that "early dominant discourse around the democratization of media technologies (whether celebratory or alarmist) did nothing to disturb the existing roles and relationships of the cultural industries but merely reassigned the roles—consumers were transformed into DIY producers, and audiences had apparently activated themselves as citizen journalists or publishers."[10] Instead, Burgess proposes, we should consider the practices and productions of YouTube users as a "medium of everyday cultural practice, including the practices of audience-hood and cultural citizenship."[11]

Burgess's argument, along with terms such as "produsage" and "user-generated," certainly help us identify and define particular practices and practitioners in our online economy. However, they also have a tendency to distance us from traditional notions of media authorship and from questions of power and exploitation. Of course, the collaborative practices that are at the center of Bruns's produsage concept work against a notion of an

individual creator, but so do our descriptions and construction of prosumers, users, partners, and members. Much like traditional media audiences, they are envisioned as a mass who, while participating in online media, are only extending their roles as audience members and consumers. What is being obfuscated, as a result, is the manner in which online media companies depend on free or cheap user-generated material to attract and retain their users and advertisers. In fact, in many instances, the results of users' non-paid labor is exactly what attracts eyeballs and advertisers.

Mark Andrejevic has published extensively on the political economy of Web 2.0, focusing primarily on the exploitation and surveillance of consumer-users. In writing about YouTube, he has argued that user-generated content is a product of immaterial and/or affective labor, the latter a concept developed by Michael Hardt and Antonio Negri which is meant to distinguish a form of immaterial labor that is focused on "the creation and manipulation of affects."[12] The promises of fame, fortune, and shared community inherent in the invocations of YouTube users' creativity and participation elide the very basis of Web 2.0's economic structure. As Andrejevic argues, "the form of exchange that characterizes interactive sites such as YouTube might be understood as a second-order result of forcible appropriation of labor power: users are offered a modicum of control over the product of their creative activity in exchange for the work they do in building up online community and sociality upon privately controlled network infrastructures."[13] He also notes that, in addition to exploiting their labor, companies such as YouTube/Google go on to profit from the data derived from users' engagement with their sites. In his analysis, Andrejevic does not address the company's revenue sharing initiative, but José van Dijck does in her 2009 article on agency in user-generated content. Van Dijck argues that, in a revenue sharing program, "labour relations thus shift from a user-controlled platform, run largely by communities of users mediated by social and technological protocols, to a company-steered brokerage system, where platform owners play the role of mediator between aspiring professionals and potential audiences."[14] And yet, I would argue that there is more than mediation going on at YouTube when it comes to its partners—especially when we consider how they manage, shape, and discipline their creators.

YouTube's new hierarchical structure of users represents, the company hopes, both an intensification of its control over its revenue streams and its content. Although the company shares the ad profits from its most valuable users, creators in particular are indoctrinated fully into the ideal aesthetic and pitch of their reconceived "high-quality" brand via their participation in training on university campuses and other corporate seminars and camps. Through flattery, audience appreciation (in the contests), cash awards, and promises of regular income and worldwide celebrity, these creators are wooed into positions as model YouTube workers,

creating profitable and premium (if not artistic) content for the company which is intended to attract audiences, advertisers, and alter the site's overall aesthetic by not only contributing to it directly, but also by representing its economic and aesthetic ideal. And yet, while they have achieved an enviable level of attention and funding in comparison to the bulk of YouTube users, creators are also trained in such a way as to remain within the YouTube system, to become its stars and to be, for the most part, ill-equipped to break into more traditional forms of entertainment—despite YouTube's promises otherwise. These limitations are in no small part related to the way they are dislocated from their potential identities as authors, artists, or professional practitioners of craft and are instead inculcated into the logics of DIY celebrity culture.[15]

content and celebrity

Mobilizing some of the most well-worn utopian discourses about social media, the video introduction to the YouTube Creator Institute opens with a Soviet-style graphic of a collection of multiracial fists raised in the air holding microphones and flip cameras in front of a (blank) flying flag and over the word "REVOLUTION."

Appealing to "a new generation of media leaders," which includes movie makers, musicians, "gaming gurus," and "mom[s] on a mission," the video promises that educators, entertainment experts, YouTube "stars," and "thought leaders of all kinds" will "build your identity, refine your skills, and gain you the audience and following you'll need to lead this content revolution." Based on the way that the creator's contest and rewards are structured by YouTube, it is clear that they are not looking to find aspiring film or video makers seeking to learn a craft, cultivate their artistic

Figure 16.1
The video introduction to the YouTube Creator Institute.

abilities, and break into Hollywood. Rather, they are looking for individuals who have good track records in generating views, who can be trained to better produce, extend, and promote their work into a regular series in order to better suit the flow of a channel. In other words, in exchange for providing training, backing, and exposure to their creators, YouTube gets the opportunity to discipline, regulate, and standardize their users and their product.

The "quality" that YouTube is seeking does have something to do with production values, but what is most important to the company is this all-encompassing term "content." As a result, the chosen creators have a wide range of talents—most of them having to do with being star of their own videos, whether as an instructor in crafting or in performing as a musician or comedian. Certainly, YouTube wants to refine the creators' technical and performance skills, but, more importantly, they want to refine creator viral marketing skills so that they can be more productive ad revenue generators. The company's priorities are glaringly apparent in *The New York Time's* coverage of one of their creator "boot camps." The paper reported that the primary tips offered in a camp held at the Google offices in Manhattan and taught by Next New Network employees and former YouTube "stars" were as follows:

> Don't upload videos on Friday afternoons. Send e-mails to at least a dozen key bloggers and ask them to post a link. Surprise your audience. Don't forget: there is key light, front light, flood light. And never, ever put the word sex in a title or tag. It could cost you some of the advertising revenue that YouTube shares with its content creators."[16]

Professionalism as a content creator in these training sessions appears to be about creating a brand, strategically employing social networks, and taking into account how your content might best appeal to advertisers. The "revolution" that YouTube wants is not the use of its site to connect activists in political uprisings or the inspiration of aesthetic practices, but rather to convert a select number of their users into semi-professional viral marketers who still carry with them the home-grown appeal of an amateur media maker. Creators and partners are reminded of the "best practices" taught in training through the "Creator's Playbook" which is helpfully posted on the site's Creator Channel, which also includes a series of "creator tutorials" and a guide to setting up local creator meet-ups.[17]

YouTube is not alone in employing the strategy of cultivating a top-tier set of creators. Initially centered on user-generated content, Yahoo Video, which launched in 2006, tried unsuccessfully to compete directly with YouTube. However, in 2007, it began to move away from UGC and started to concentrate on attracting and developing aspiring professional video makers. It also sought to increase the production values of all videos on its

site by, for a short time, offering JumpCut, its own online editing software, as well as offering production tips to all of its users. Sony's purchase of the video sharing site Grouper in 2006 led to a rebranding of the site as Crackle the following year, and the company also moved from a focus on amateurs to emerging talent, offering cash, training, and career opportunity to aspiring film and video makers. (Crackle now is a multi-platform video network offering Hollywood films and television series.) As John T. Caldwell wryly notes about the move by Sony, "Clearly, what started as the ad hoc, ground-up populist media making of UGC has been transformed into something Hollywood has mechanically mastered for a century: talent scouting and central casting."[18]

Caldwell makes a good point. Still, it should be emphasized that while there are those content creators that may become working professionals in the media industry, the promises of fame and fortune are largely false (as perhaps, they have always been). It is also important to note that YouTube's cultivation and then containment of its users is an extension of a much longer historical relationship between amateur media makers and media institutions. For example, scholars such as Patricia Zimmerman and Laurie Ouellette have pointed out that, historically, the discourses around amateur film and video production have tended to limit its potential—most often relegating it to domestic use (home movies) and/or within the realm of "accidental witnessing" (amateur footage of news events, weather, etc.).[19] Now that amateur media has moved out of the margins and into the center of the Internet's production of cultural material, there once again seems to be some opening of opportunity for escape from that containment, even as the majority of amateurs of all stripes exist on the margins. And, even though the blurring of amateur/professional is occurring online and may offer new potentialities for amateur video, once this material is caught within the dominant modes of production and marketing, these boundaries are most often re-inscribed—no matter what YouTube or Sony promise. I would assume that the creators who go through YouTube's training still hold to the idea that they are the creative authors of unique material, which is one of the ways they might distinguish themselves from those who are partners. It is also likely that they believe they have already achieved a level of recognition and achievement, a notion fanned by YouTube's promotion of them as their next "stars," and their appearance in promotional videos for YouTube's programs and upcoming contests. However, the rhetorical move away from terms such as "authors," "producers," and "practitioners" and toward terms such as "creators" and "partners" not only signals a shift in production culture and economic practices, but also highlights a new discourse working to marginalize amateurs.

Instead of relegating amateur video to the domestic, YouTube's promises of celebrity, while seeming to offer an introduction into the

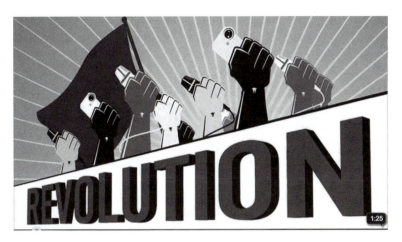

Figure 16.2

The YouTube Creator Institute promises celebrity through "content revolution."

mainstream, actually serve as a distraction away from professionalization and full economic participation. Part of this stems from the manner in which they frame their discovery and cultivation of talent—almost exclusively through contests.

The idea that top-level content creators are found through contests is quite logical, given how the online economy is structured. Of course, contests have historically also been one of the most visible points of entry for amateur entertainers and media producers and have only become more visible in the age of reality television. There is actually much cross-over in the structural logics of reality television and that of sites such as YouTube when it comes to promises to and use of amateur talent. After over a decade of reality television's domination of prime-time network and cable television schedules, most Americans have been exposed to all the various permutations of amateur talent that exist within reality TV's various subgenres. And from the nationwide search for the next *American Idol* and *America's Next Top Model* to the pre-selected contestants of *Survivor*, *Top Chef*, and *Project Runway* to the casting of "non-actors" in Bravo's *The Real Housewives* franchise, viewers have repeatedly been exposed to the way reality TV presents "ordinary people" with opportunities to become rich and famous through the exploitation of their (non-unionized and often free) labor. Graeme Turner has coined the term "demotic turn" to refer to the "increasing visibility of the 'ordinary person' as they turn themselves into media content through celebrity culture, reality TV, DIY websites, talk radio and the like."[20] He notes that, in recent years, there has been an acceleration and proliferation of celebrity culture and heightened claims about ordinary people's access to it that signal a shift in not just media culture but also in particular forms of cultural identity and ideology.

269

Participation and performance of self are the most typical UGC of reality television and are given in exchange for the promise of celebrity and/or professionalization (as, ironically, the economics of reality TV eat away the work available to those already in professional guilds and unions). YouTube employs similar rhetoric in its calls for applicants for its programs, contests, and initiatives, with its address to the "future stars of YouTube" and also in ways that it has begun to search for talent within particular genres.

In October 2011, YouTube unveiled a new series of NextUp contests, YouTube Next Chef and YouTube Next Trainer, genres chosen because "traffic analysis revealed spikes in cooking and training videos, particularly around the holidays," which speak to a further mimicking or dovetailing of address to hopefuls in reality TV and YouTube as they follow in the "tradition" of something like Bravo's *Top Chef*.[21] As YouTube calls for "stars" in such instructional video subgenres, it overtly reveals the company's intention to find the on-screen talent of tomorrow rather than cultivating and training behind-the-scenes talent such as writers, directors, and cinematographers. While this was part of the promotion for their creators program since it was first announced in 2010, the initial publicity and labeling of the program (early on "grants" was part of the title, a term more familiar to the independent film/video maker than the latest Internet celeb) was presented with specific notions of professionalization and craft. That has changed, however, as YouTube's creator programs have more fully taken shape over the past year or so, and their promotion seems to more overtly resonate with larger cultural discourses about access to celebrity and economic prosperity under neoliberalism. In a time when class mobility has notably lessened and the income gap has widened for Americans, promises of access to free (and quick) training, easy money, and worldwide celebrity status are simultaneously both more alluring and more deceptive than ever before.[22] And yet, in an economy that largely subsists on the unpaid or underpaid labor of its users, this is an increasingly common strategy. In exchange for the ownership rights, residuals, and the right to organize, YouTube creators and partners are given a moment in the spotlight and an opportunity to be indoctrinated into the marketing and production practices of YouTube. It is the revised American Dream— to be selected by a corporation (or by fellow users/viewers) out of the anonymous mass of laborers dedicating their leisure hours to the production of content—and to be granted the opportunity to possibly hit it big in the online media economy.

conclusion

YouTube's desire to create a hierarchical relationship with and between its users and to improve upon and standardize its aesthetics and form

reveal more than just the way that the company understands its users' contribution to its brand. The Creators and Partner programs highlight, among other things: the (often false) promises of inclusion and professionalization commonly made by online media companies; the ephemeral nature and disposability of labor in the new media economy; the nebulous nature of the term "content"; and the complicated and contradictory discourses currently circulating around amateur video and its connections to forms of mainstream television, such as reality television. However, it should be noted that there are other Web 2.0 models for the cultivation and training of production and creative talent. John T. Caldwell, for example, points to the formation of Pixel Corps, an unofficial guild for online creators of video content, which was formed with the intent of not only offering training in production, but also to organize for recognition as professionals, equal to those working in traditional television and film production.[23] Nick Marx, in his article on web comedies, notes that comedy websites such as My Damn Channel or FunnyorDie.com have provided a model for the presentation of online comedy shorts that actually have a real shot at jumpstarting careers of writers, performers, and other creative talent. As Marx writes, "web comedy is uniquely positioned as a bridge between the competing impulses of transgressive and conservative, offering formal innovations in the largely unregulated online domain on the one hand, while serving as cost-efficient talent development for major studios, on the other."[24] YouTube's continued investment in tutorials, memes, and other genres typically associated with amateur users will likely keep its creators closely tied to the site and serving to underscore the site's reliance on UGC. And the addition of more professional channels on YouTube (in 2011 Disney entered into a partnership with YouTube which has led to a channel and will lead eventually to an original video series) will likely only serve to highlight the distinctions between the output of traditional media creators and the content of YouTube's "stars."

notes

1. Claire Cain Miller, "Cashing in on Your Hit YouTube Video," *The New York Times*, October 26, 2011, accessed February 6, 2011, http://www.nytimes.com/2011/10/27/technology/personaltech/cashing-in-on-your-hit-youtube-video.html; "David Goes to the Dentist," YouTube video, posted by booba1234, January 30, 2009, accessed February 5, 2012, http://www.youtube.com/watch?v=txqiwrbYGrs.
2. Jennifer Preston, "At YouTube Boot Camp, Future Stars Polish Their Acts," *New York Times*, May 29, 2011.
3. Brad Stone, "YouTube seeks Creative Video Makers," *International Herald Tribune*, July 13, 2010, B6.
4. YouTube Creator Institute, "Apply to YouTube Creator Institute's Inaugural Class," March 10, 2011, accessed January 30, 2012, http://youtube-global.blogspot.com/2011/03/apply-to-youtube-creator-institutes.html.

5. YouTube Creator Institute.

6. Marc Hustvedt, "YouTube NextUp Winners Announced," YouTube Filter News, May 2, 2011, accessed February 6, 2012, http://news.tubefilter.tv/2011/05/02/youtube-nextup-winners/.

7. See Smir Efrati, "YouTube Nears Offering 'Channels'," *Wall Street Journal*, October 27, 2011: B6.

8. Amir Efrati, "Corporate News: YouTube Turns Pro with Original-Content Deals," *The Asian Wall Street Journal*, October 5, 2011.

9. Axel Burns, "Produsage: Towards a Broader Framework for User-Led Content Creation," *Proceedings in Creativity & Cognition* 6 (Washington, DC, 2007), accessed February 6, 2012, http://snurb.info/files/Produsage%20(Creativity%20and%20Cognition%202007).pdf.

10. Jean Burgess, "User-Generated Content and Everyday Cultural Practice: Lessons from YouTube," in *Television as Digital Media*, ed. James Bennett and Nikki Strange (Durham, NC: Duke University Press, 2011), 312.

11. Burgess, "User-Generated Content and Everyday Cultural Practice," 326.

12. Michael Hardt, "Affective Labor," *boundary 2*, Vol. 26, No. 2 (Summer 1999), 95.

13. Mark Andrejevic, "Exploiting YouTube: Contradictions of User-Generated Labor," in *The YouTube Reader*, ed. Pelle Snickars and Patrick Vonderau (Stockholm: National Library of Sweden, 2009), 419.

14. José van Dijck, "Users Like You? Theorizing Agency in User-Generated Content," *Media Culture Society* 31, no. 1 (2009), 31; 42.

15. For more on DIY celebrity culture, see James Bennett, "Architectures of Participation: Fame, Television, and Web 2.0," in *Television as Digital Media*, ed. James Bennett and Nikki Strange (Durham, NC: Duke University Press, 2011), 333–57.

16. Preston, "At YouTube Boot Camp."

17. YouTube Creator Playbook, accessed February 6, 2012, http://www.youtube.com/creators/playbook.html.

18. John T. Caldwell, "Worker Blowback: User-Generated, Worker-Generated and Producer-Generated Content within Collapsing Production Workflows," in *Television as Digital Media*, ed. James Bennett and Nikki Strange (Durham, NC: Duke University Press, 2011), 289.

19. See Patricia Zimmerman, *Reel Families: A Social History of Amateur Film* (Bloomington: Indiana University Press, 1995), and Laurie Ouellette, "Camcorder Dos and Don'ts: Popular Discourses on Amateur Video and Participatory Television," *Velvet Light Trap* 36 (Fall 1995), 33–44.

20. Graeme Turner "The Mass Production of Celebrity: 'Celetoids', Reality TV and the 'Demotic Turn'," *International Journal of Cultural Studies* 9, no. 2 (2006), 153–65.

21. Tom Loftus, "YouTube Builds Mentor Program for Future Stars," Digits blog, *Wall Street Journal*, November 10, 2011, accessed January 10, 2012, http://blogs.wsj.com/digits/2011/11/10/youtube-builds-mentor-program-for-future-stars/.

22. Jason DeParle, "Harder for Americans to Rise from Lower Rungs," *New York Times*, January 4, 2012.

23. Caldwell, "Worker Blowback," 291.

24. Nick Marx, "The Missing Link Moment: Web Comedies in the New Media Industries," *Velvet Light Trap* 68 (Fall 2001), 14–23.

publish. perish?

the academic author and open access

publishing

p o l l y t h i s t l e t h w a i t e

During the September 2011 dissertation deposit period—my first as Acting Chief Librarian at the City University of New York's Graduate Center (CUNY)—I found my inbox visited by a humanities faculty email expressing anxieties about my institution's requirement that graduating doctoral students upload a PDF of their dissertations to ProQuest Electronic Thesis Depository. I traced my colleagues' anxieties to warnings reported by other academics on various listservs. For example, English professor and academic career advisor Kathryn Hume posted a blog in August 2011 entitled "The Perils of Publishing Your Dissertation Online." She baldly warns: "You could ruin your chances of getting tenure if your thesis is freely available."[1] Hume's blog cites American literature Professor Leonard Cassuto's similar concerns where he advises in *The Chronicle of Higher Education*: "Don't make your dissertation available online. Book editors seem unanimous on that point for obvious reasons. Many university libraries routinely add dissertations to their electronic holdings. If yours does, then opt out. If your thesis is already online, then have it taken down. Information may want to be free, as the earliest hacker generation first avowed, but if

it's free, then you can't expect a publisher to pay for it, even in a later version."[2] These warnings are born, of course, through historical experience with academic review for tenure and promotion. At the same time, the concerns presume a self-evident and uniform truth. This is to say, Hume and Cassuto echo longstanding sensibilities associated with the arbitration of academic authorship and institutional protocols, specifically those related to scholarly publishing and academic review.

Are these concerns warranted? This chapter addresses this question and others raised around academic authorship as it is increasingly situated online, particularly as it relates to one of the first and most significant acts of academic publishing: the dissertation. In today's media environment, discussions about open access publishing prove to be both fractious and transformative. How, then, might a new academic author negotiate this rapidly shifting terrain?

a history of access

In 1939, University Microfilm (later, University Microfilm International, UMI) launched *Dissertation Abstracts*, the primary finding tool for North American dissertations. This resource, then-as-now, is crucial to any comprehensive literature review. Universities sought to make graduate works discoverable—to liberate them from un-indexed obscurity—but no single public institution or university coalition was equipped to support such a large-scale feat of scholarly communication. Instead, entrepreneur Eugene Power, from Ann Arbor, Michigan, financed and assembled a central repository to collect, preserve, describe, and distribute North American dissertations to scholars anywhere.[3] Power provided means—book format annotation, annual indices, and ready-made catalog cards for libraries purchasing dissertations—to facilitate subject-based discovery. From its beginnings, UMI sold its index to nearly every academic library and, additionally, sold selected dissertation copies on-demand to interested scholars and to libraries in microform (film or fiche, and eventually print). In this manner, UMI simultaneously built both a successful business and an essential academic resource. ProQuest (UMI became Bell & Howell in 1971 and, in 2001, ProQuest) continues to sell dissertations to university libraries and to interested readers.

During the 1980s, *Dissertation Abstracts* revised its microform cache into an electronic one, evolving its formats and distribution methods. In 1997, ProQuest's by-then online index introduced free 24-page previews and added (for sale) full-text PDFs that supplemented the microform and print formats. ProQuest's secret to success in this niche market is that the company never assumed a dissertation writer's copyright. In other words, ProQuest has only licensed with writers for non-exclusive distribution of works, thereby allowing writers to retain sole ownership and copyright.[4]

polly thistlethwaite

274

Graduating students have always been free to deposit dissertations with ProQuest while leaving another copy in a university's library or repository. It is only later that writers hand over copyright to academic publishers who demand copyright ownership, ostensibly in order to satisfy publication standards for tenure and promotion.

In 1997, Virginia Tech University (VTU) became the first institution to require that dissertations be uploaded to an online university repository, in lieu of a paper version being deposited in the library. Between 1997 and 2007, readership of Virginia Tech's dissertations skyrocketed 701 percent.[5] Commonplace search engines discovered VTU dissertations freely available to web searchers sufficiently skilled and motivated to find them. VTU's open access dissertation publishing model demonstrated quick transformations in access with the open online dissertations garnering 145,000 percent more visitors than their paperbound counterparts.[6] While the VTU results are extraordinary, open access publishing steadily gathers larger audiences than print and exclusively licensed works. The increased frequency of citation of any open access work over traditionally published works is repeatedly found to be significant, ranging from 25 to 250 percent, depending on the discipline.[7] This easier encounter with material through open access publishing promotes wider readership, and greater impact for scholarly work over print-only or licensed works. This new kind of access is both challenging and altering the way academic value is assessed.

ProQuest and repository-based electronic theses and dissertations provide access to a particular class of unedited, non-peer-reviewed, and (as some view it) unpublished, works. Moreover, and in addition to its on-demand sales, ProQuest now licenses its entire authorized full-text dissertation repository to libraries, a popular resource now indispensable for any comprehensive literary review. In 2006, ProQuest added an open-access option to its dissertation publishing service. Any dissertation author, in other words, may pay the $95 open access publishing fee to guarantee perpetual non-toll open access for any reader who discovers the work.

Supplementing ProQuest's successful commercial full-text dissertation database, a growing number of universities sponsor online repositories for dissertations and other scholarly work. Since the 1930s when ProQuest began, technology has developed so that universities can now self-publish scholarly work in digital formats. Crucially, authors and librarians describe the publications' contents so that the work is discoverable through search engines. The project to make dissertations accessible has become a massive collaborative effort.

Yet, we must return to the concerns expressed on humanities listservs. The academic relationships among publications, tenured positions, and budgetary constraints are already fraught with anxieties. With graduate student enrollments high during and leading up to fall 2011, a wave of new PhDs is about to flood a stagnant university market.[8] Academic

unemployment alarms are blaring. In tandem with the glut of graduates, trimmed library budgets allow for fewer book purchases. This institutional budget slashing follows decades of rising journal prices that bit into library book spending.[9] Universities scaled back funding for presses while publishers' lists were cut and shaped to increase income from sales. Academic presses slowed production to levels below that which can support book-for-tenure standards, especially for this newly minted super crop of doctoral-degree graduates.[10] Scholarly e-publishing shaped itself in this recession environment to rely on tightly controlled access to and draconic licensing of every use of a published work. Academic publishers re-formed lists to appeal to wider markets, reducing publication for titles with smaller market predictions. While access may be immediate, it is inconvenient, expensive, and restricted.[11] How can current academic standards be maintained when models of scholarship, publication, and funding are irrevocably altered?

Addressing these new uncertainties, advisors (as seen in the listservs referred to in the preceding text) caution newly degreed scholars to withdraw dissertations from online repositories, or to block them from view for a given period of time. The gesture is intended to calm publishers who may fear over-exposure of a competitive yet unpublished work, and to protect new graduates bound to have a tough time in this down academic market with a book contract, let alone without one. To threaten the relationship between publishers and authors, as advisors see it, puts new scholars in peril. Though instability fogs the future of publication and academic review, publishers and academic reviewers attempt to forge clarity by reinforcing traditional processes. The result is, though, that many dissertations, innovative if imperfect early academic works, remain hidden from the digital light of day.

Despite the anecdotal and empirical evidence of threats to and unease with the current state of academic publishing, recent surveys indicate that the great majority of academic presses continue to accept books and articles derived from manuscripts previously published electronically. Angela McCutcheon's 2010 survey of authors indicates, for example, that publishers refuse fewer than 2 percent of book proposals because of previous appearance as online dissertations.[12] The 2011 Networked Digital Library of Theses and Dissertations (NDLTD) survey of 48 academic publishers indicate that 96 percent affirmed that they do not disqualify books and articles from consideration if these works have previous iterations in an electronic thesis.[13] In fact, this statistic reflecting increased acceptance of electronic dissertations and theses is up from 82 percent in 2001.[14]

This survey-based evidence that measures key data is under-cited in the critiques of online dissertation depositing practices. In March 2012, for instance, the American Historical Association (AHA) moved to make constituents aware that "there is evidence to suggest that some university

press editors are reluctant to consider for publication those studies that have been posted online and made generally accessible to the public." The statement urges universities to develop policies that balance individual rights to control of a work with "promoting the interests of the historical profession to disseminate scholarship as widely as possible."[15] An article that accompanies the AHA statement cites Jennifer Howard's fairly reported anecdotal evidence about publishers being both frightened by the competition posed by theses and dissertations previously published electronically, and welcoming popular works previously published electronically, but overlooks the empirical evidence supplied by current surveys of publishers and reports made by their author clients.[16]

As practices shift, misunderstandings—as I argue here—arise. The University of Nebraska Press prompted the Society for the Study of Women Writers, whose journal they publish, to announce in fall 2011: "Henceforth, we will no longer be able to consider any works that have been previously published. Publication, according to our definition of the term, includes print publication as well as electronic publication in any and all forms (for example, a blog, a personal or professional website, a conference website, a social networking site, an online journal, etc.). Essays that duplicate or closely resemble chapters of dissertations that have been uploaded to the web will be excluded as submissions, as will essays that have been published as parts of dissertations available in hard copy from UMI."[17] Here, the press may be excluding iterations of previously published online work because they fear competition, or perhaps because they believe ProQuest's author license assumes exclusive distribution rights to works derived from dissertations. Varieties of interpretation stand at the heart of argument about online and open access publishing.[18]

Similarly, advisors continue to urge writers to "take dissertations down" from electronic repositories, or call for libraries to revert to paper- and microform-based storage instead of engaging in contemporary modes of discovery and distribution. These advisors and writers seek to impose embargoes on work that would, without the new forms of electronic repositories, ultimately remain obscure. However, and as the McCutcheon survey shows, 76 percent of universities either automatically impose or allow students themselves to impose embargoes, providing some publication delay.[19] In addition to preserving exclusive access for reviewing publishers, electronic publication delays give dissertation authors time to resolve use rights for excerpted content, for example, while meeting a deposit deadline for graduation. The 2011 NTDLT survey indicates that only 7 percent of university book presses (but none of the journal publishers) find restricted access, or publication delay, key to publisher review and acceptance. The delay-embargo option, a feature of nearly every repository whether it is announced or not, is key to easing the anxieties of advisors and students if not their publishers, even though publishers make little of

them in actual practice. With every author bestowed complete control over the appearance and distribution of a work, the number of dissertations embargoed at my institution is up from less than 2 percent to 12 percent of total deposits, between 2008 and 2011. Perhaps more significantly, authors are at greater rates (from less than 1 percent of deposits in 2008 to 23 percent in 2011) opting to prevent ProQuest dissertation sales by third parties such as Amazon.com and Google Books. This allows works to be discovered by third-party search engines and to appear in and to be sold by ProQuest's resources, but not vended through popular book sales sites. The open access dissertation publishing is up over the same period, too, from less than 1 percent to 6 percent.[20] Together, this suggests that a variety of strategies are at play in negotiating a shifting and uncertain terrain of academic publishing.

the dissertation and standards for publication

Doctoral dissertations are produced as a requirement for a degree. Dissertations are shaped and adjudicated by a committee of author-selected faculty advisors. Like academic pre-prints, dissertations have been vetted and improved by a committee of advisors, but they have not endured the academic trials that accompany publication: editorial selection, peer review, content editing, and copyediting. Libraries are the standard resting place for dissertations that are traditionally submitted in typescript, bound, and shelved to preserve them, which limits distribution to wide-ranging audiences (wider distribution is the traditional role of publishers). This process preserves and geographically fixes the work so that it may be accessed and retrieved only occasionally by readers who have the time and motivation to conduct on-site review during regular and (more-and-more) limited library hours.

University press representatives and academic advisors both repeatedly point to—now as in pre-Internet times—the quality of a standard six-chapter dissertation, and most importantly, to the extensive revision required to transform any dissertation into an academic press title.[21] And though new authors (and perhaps their advisors) live in hope of only minor revisions of a dissertation-derived first book, dissertations and pre-prints are not accepted unmodified for the market. A publisher's attention and peer review usually, and considerably, improves a work; publishers are not merely re-printers who contribute artwork, production, and marketing. According to the 2011 NDLTD survey, 27 percent of university presses report that submissions are considered only if the manuscript is substantially different from the electronically published dissertation.[22] This reconfirms well-entrenched wisdom proffered by academic advisors and suggests that open access changes little in the dissertation-into-book process.[23]

Fortunately, leading academic presses continue to experiment with business models that embrace varieties of open-access publishing. Minnesota, Michigan, New York University, California, Indiana, Florida, Purdue, MIT, Fordham, and Penn State university presses (among others) offer small and large open access runs of backlisted titles. No evidence of commercial ruin has thus been seen as a result of this experimentation. In 1994, the National Academies Press began publishing all new work from the National Academy of Sciences, the Institute of Medicine, the National Academy of Engineering, and the National Research Council for free, online, downloadable PDFs.[24] Yet, experiments with open access may not always promote reductions in costs of production and distribution. Hybrid open access publishers may, on the one hand, inflate costs for some titles to maintain profits while, on the other hand, make other titles free or offer a handful of open access titles "free with purchase" of a mandatory package deal. The system is imperfect and in progress, but these experiments are paving the way for significant revision of academic publishing and review.

Despite its reputation for radicalism, the academy can cling to conservative ideals, particularly where the processes of scholarship are concerned. In this down-market environment—one that coincides with the possibilities of quick and easy access to academic work—some advisors continue to insist on pre-digital modes of publication and review. There are those, of course, who seek to revise these earlier models; notably revisionists are often scholars involved now in new media and digital studies. Resistance to open access publishing bubbles to the surface when new modes of publishing challenge academic markets *and* the institutional systems they maintain. Twenty-first-century technologies enable new processes of academic review. Rather than call for retreat, the academy can more productively ask: In what way might we put this new technology in the service of bettering contemporary scholarship, intellectual curiosity, and the dissemination of ideas?

Kathleen Fitzpatrick, the Modern Language Association's Director of Scholarly Communication, argues that traditional publishing models are unsustainable and must be transformed. The traditional publishing model, Fitzpatrick argues, works to suppress scholarship and to narrow its form. Authority may better be conferred, and improvements in works achieved, by open and public comment than by closed anonymous adjudication. Peer review conducted openly in conjunction with the digital public appearance of a work (and not privately in advance of its academic debut, or its pre-natal demise) might usefully expand academic discourse and engage a larger-than-academic public.[25] Tellingly, Fitzpatrick's book is already in its second printing with NYU Press; this printing that follows an initial publication online, in the digital scholarly network MediaCommons (an open access peer-to-peer review format). Open access publishing can

accommodate a blind peer-review process, but it also allows for new varieties of academic review. Fitzpatrick reconsiders peer review and academic review—assessments, publication vetting, tenure, and promotion—as practices that must be transformed to ensure the future relevance of scholarly work. The public, shared impact of academic work, not its marketability, its profits, and certainly not the meager royalties academic authors garner, best gauge the values of scholarship.

futures

Academic publishers and, de facto, academic authors, are in the midst of a great shift. Scholarly production already assumes a mix of technologies, methods, and formats likely to diversify further. Publishers must accommodate new forms of production and manage competition by adding value in new ways, perhaps in collaboration with libraries and repositories. This is something of an uphill battle. Academic publishers provide ample anecdote about the threat of open access publishing.[26] While some embrace experimentation with open access publishing, some leading academic publishers doubt its quality, efficiency, and sustainability.[27] Institutional realignment, some of which is underway, is bound to be disconcerting for some stakeholders

As academic presses draw back traditional production of scholarly monographs, new forms of publication emerge, and the mix of options thickens. A next step may be for publishers to contribute expertise in the mechanisms of open access publishing, or university presses collude with university libraries to do the same. Spending to support open access publishing generally shifts—from a subscription model to one where publication costs are paid by funders, authors, or their institutions. University press subsidies and library spending can be shifted to provide support where it is needed.

Unless academic authors hire agents, like fiction writers do, and manage to reach general readerships, they profit only modestly from traditional publication, or they do not directly profit at all. Scholarly book authors and editors usually garner modest royalties compared to trade counterparts. Academic authors of articles and book chapters routinely cede copyright and exclusive distribution rights to publishers in exchange for selecting, vetting, editing, marketing, production, indexing, and distribution. Publishers apply copyright to sell back books as well as journal subscriptions to university libraries and readers. Distribution garners readership, contributes to the public good, and offers individual reward that is administered by university employers in the form of job retention and promotion. However, then, in a skewed turn of events, university libraries buy back at high price the products of their academic's free labor. In other words, the academy pays twice—three times if you

count the often donated work of peer review. In this cycle where commercial publishers' profits are often enormous, the question is begged: Why do academic authors sacrifice profit?[28] The answer: Because academic jobs and careers depend on peer assessment, a collective valuation traditionally exercised only on published works.

To put it bluntly, academic authors have a lot to figure out. Decisions about dissertation publishing loom large when advisors warn against open access in any form based on nervousness expressed by academic publishers. Academic advisors absorb publishers' anxieties that are subsequently passed along to students, even though surveys of scholarly publishers indicate that revised dissertations first published online continue to be welcomed with little apprehension. Depending on the plans an author has for a dissertation, the publishing politics at work in an author's discipline, the interest an author holds in reshaping academic publishing, and the stock an author holds in survey data over anecdotal evidence, open-access publishing may just be the ticket for a strong future career in academia. If, however, authors continue to resist open access publishing and to elect long embargoes, the outcomes will only stave off short-term anxieties.

It may be more productive to consider how scholarship may be rewarded by open access publishing. The results are already clearly demonstrated. Open access publishing for journal articles and book chapters is now common, and often mandated by science funders. "Gold" open access publishing and "green" self-archiving with institutional and subject-based repositories allow multiple routes for discovery and download, while maintaining academic reviewers' prestige values associated with leading subject-based journals.

And, yet, academic reviewers must play an active role in these transformations since they are key to this process of academic reform. The very same advisors who now shape critical decisions for the untenured are also those who eventually evaluate, years later, the academic careers for others. Many issues remain to be resolved. Will scholars write for greater readership and impact, or will they attempt to satisfy discipline-specific, sometimes idiosyncratic notions about academic prestige? Will the academy support work that combines formats and disciplines, or will academic reviewers continue to value traditionally published texts more than new forms of scholarly production? How large is the gamble that an untenured academic must undertake in order to resist old-guard models? Will academic presses embrace open access, or will they cling to digital rights management schemes to preserve licensing and subscription income? Will presses and advisors continue to threaten against online publishing and publicity for work exposed online during development? Academics decide now to make their work search-engine-discoverable by a worldwide audience or to keep it under-the-radar to be discovered and read only by those with the licensed indexes, interlibrary loan privileges, and

the good fortune to find it. Scholars who would choose to collaborate on non-traditional projects may be pressured instead to produce in text only. Student bloggers who share works-in-progress openly may learn to fear overexposing their own ideas before they are engraved in text. Students and their advisors love to read every dissertation they can get their hands on, but negotiate fear and warning about overexposing their own.

The mechanisms of scholarly production and communication are in flux. However, no matter how the technology changes, academic success remains tied to peer evaluation of scholarly activity. While advisors are insightful about traditional methods for the academic-review process, academic authors are urged time and again to attend to discipline-specific and local-evaluation practices that only satisfy near-term goals. Just as scholarship sustains multiple points of view, the academy will increasingly trade in a mix of formats. As new modes of scholarly production emerge, new, careful, and fair valuations of it must be practiced by academic reviewers.

notes

1. Kathryn Hume, "The Perils of Publishing Your Dissertation Online," guest post on The Professor Is In, ed. Karen Kelsky, August 24, 2011, accessed February 20, 2012, http://theprofessorisin.com/2011/08/24/the-perils-of-publishing-your-dissertation-online/.
2. Leonard Cassuto, "From Dissertation to Book," *The Chronicle of Higher Education*, May 30, 2011, accessed February 20, 2012, http://chronicle.com/article/From-Dissertation-to-Book/127677/.
3. Austin McLean, "Extending the Reach and Impact of Graduate Works," ProQuest, August 25, 2011, 5, accessed April 30, 2012, http://www.infodocket.com/2011/08/25/new-white-paper-from-proquest-scholarly-publishing-extending-the-reach-and-impact-of-graduate-works/.
4. Until 1999, UMI licensed exclusively for microform distribution only. Austin McLean, email message to author, January 30, 2012.
5. Based on analysis of VTU server logs, the author explains. Angela M. McCutcheon, "Impact of Publisher's Policy on Electronic Thesis and Dissertation (ETD) Distribution Options within the United States." (PhD diss., Ohio University, 2010), 24, accessed March 31, 2012, http://rave.ohiolink.edu/etdc/view?acc_num=ohiou1273584209.
6. John H. Hagen, "Over 10 Million WVU ETDs Served," March 23, 2009, accessed March 24, 2012, http://www.libraries.wvu.edu/open-access/files/over10millionwvuetdsserved.pdf.
7. A. B. Wagner, "Open Access Citation Advantage: An Annotated Bibliography," *Issues in Science and Technology Librarianship* (2010), accessed April 30, 2012, http://www.istl.org/10-winter/article2.html.
8. According to Jeff Dunn, "How Hard Is It For a PhD to Find a Job?," *Edudemic.com* (January 5, 2012).
9. Between 1986 and 2008, academic library spending on serials rose 374 percent, and spending on books rose only 86 percent. "ARL Statistics 2007–2008," Association of Research Libraries, Washington, DC, accessed

March 31, 2012, http://www.arl.org/stats/annualsurveys/arlstats/arlstats08.shtml.

10. Kathleen Fitzpatrick, "Planned Obsolescence: Publishing, Technology, and the Future of the Academy," *ADE Bulletin* 150 (2010), 41–54, accessed March 30, 2012, http://www.ade.org/cgishl/docstudio/docs.pl?adefl_bulletin_c_ade_150_41.

11. On digital rights management, for example, see Barbara Fister, "First Thoughts on Sustaining Scholarly Publishing | Peer to Peer Review," *Library Journal*, March 10, 2011, accessed March 30, 2012, http://www.libraryjournal.com/lj/newslettersnewsletterbucketacademicnewswire/889625-440/first_thoughts_on_sustaining_scholarly.html.csp.

12. McCutcheon, "Impact of Publishers' Policy," 145.

13. Gail McMillan, et al., "An Investigation of ETDs as Prior Publications: Findings from the 2011 NDLTD Publishers' Survey," *Proceedings of the 14th International Symposium on ETDs* (2011). Cape Town, South Africa, accessed March 31, 2012, http://dl.cs.uct.ac.za/conferences/etd2011/papers/etd2011_mcmillan.pdf.

14. Gail McMillan, "Do ETDs Deter Publishers?," *College and Research Libraries News*, 62, no. 6 (2001), 620–21, accessed March 31, 2012, http://scholar.lib.vt.edu/staff/gailmac/publications/pubrsETD2001.html.

15. "Statement on Electronic Publications of Theses and Dissertations," AHA Professional Division, March 19, 2012, accessed March 30, 2012, http://historians.org/grads/StatementonElectronicPublicationTheses-Dissertations.cfm.

16. Debbie Ann Doyle, "AHA Today: Publishing Your Dissertation Online – Understanding Policies," American Historical Association, March 27, 2012, accessed March 30, 2012, http://blog.historians.org/publications/1605/publishing-your-dissertation-onlineunderstanding-policies.

17. *Society for the Study of Women Writers Newsletter*, Fall 2011, 2, accessed March 31, 2012, http://public.wsu.edu/~campbelld/ssaww/ssaww12-2.pdf.

18. The University of Nebraska Press declined to comment on their practices.

19. McCutcheon, "Impact of Publishers' Policy," 163.

20. ProQuest, data transfer to author, May 2012.

21. Jennifer Howard, "The Road from Dissertation to Book has a New Pothole: the Internet," *The Chronicle of Higher Education*, April 3, 2011, accessed March 31, 2012, http://chronicle.com.ezproxy.gc.cuny.edu/article/The-Road-From-Dissertation-to/126977/. Survey evidence is reinforced in this anecdote, "Mr. Alexander, the Penn State press director, says that for many presses, the decision becomes easier—and more likely to go the author's way—when the proposed book differs significantly from the graduate-school version. 'The more crucial question for us, especially in the case of a dissertation, is whether the author can explain the extent to which and how the submission differs from the original version,' he said via e-mail. A work written to satisfy a graduate committee should probably look very different from a book meant for a somewhat wider audience. That was true long before electronic repositories, and it holds true for dissertations in any format." Leonard Cassuto, "It's a Dissertation, Not a Book," *The Chronicle of Higher Education*, July 24, 2011, accessed March 31, 2012, http://chronicle.com/article/Its-a-Dissertation-Not-a/128365/.

22. McMillan et al., "An Investigation of ETDs as Prior Publications."

23. William P. Germano, *From Dissertation to Book* (Chicago: University of Chicago Press, 2005).

24. "Sustaining Scholarly Publishing: New Business Models for University Presses. A Report of the AAUP Task Force on Economic Models for Scholarly Publishing," March 7, 2011, accessed April 30, 2012, http://mediacommons.futureofthebook.org/mcpress/sustaining/new-approaches-to-scholarly-publishing/publishing-open-digital-plus-paid-print-editions/.

25. Kathleen Fitzpatrick, *Planned Obsolescence: Publishing, Technology, and the Future of the Academy* (New York: New York University Press, 2011), published 2009 for open peer review, http://mediacommons.futureofthebook.org/mcpress/plannedobsolescence.

26. Cassuto quotes Chris Chappell, an associate editor at Palgrave MacMillan: "The more of your book that has been previously pubished, the less exciting it becomes for us." Cassuto, "From Dissertation to Book." And, "if authors have an opt-out option, I would recommend that they do opt out, at until their first book is published," says Ann Donahue, a senior editor at Ashgate Publishing Group, which puts out a number of books that began life as dissertations. Quoted in Howard, "The Road from Dissertation to Book Has a New Pothole."

27. Stanford G. Thatcher, "The Challenge of Open Access for University Presses," *Learned Publishing*, 20:3 (2007), 165–72, accessed March 30 2012, http://dx.doi.org/10.1087/095315107X205084.

28. Scientific, technical, and medical journal publishers have steadily profited 30 percent or more annually, in recent years. Heather Morrison, "The Enormous Profits of STM Scholarly Publishers," *The Imaginary Journal of Poetic Economics*, January 7, 2012, accessed March 30, 2012, http://poeticeconomics.blogspot.com/2012/01/enormous-profits-of-stm-scholarly.html.

contributors

Jane Anderson is Assistant Professor in the Centre for Heritage and Society, Department of Anthropology, University of Massachusetts, Amherst, and Adjunct Professor of Law at New York University School of Law. Since 2007, Anderson has worked as an Expert Consultant for the World Intellectual Property Organization on a number of policy proposals for the protection of traditional knowledge and cultural expressions. With Kim Christen and Michael Ashley, Anderson co-founded localcontexts.org, a platform for Traditional Knowledge Licenses and Labels, a legal and non-legal strategy enabling community attribution and recognizing culturally specific conditions for accessing and using Indigenous cultural materials.

Mark Andrejevic is an ARC QE II Postdoctoral Research Fellow at the Centre for Critical and Cultural Studies, University of Queensland. He is the author of *Reality TV: The Work of Being Watched* (2003) and *iSpy: Surveillance and Power in the Interactive Era* (2009), as well as numerous journal articles and book chapters on surveillance, popular culture, and digital media.

Inna Arzumanova is a doctoral candidate in Communication and Annenberg Fellow in the Annenberg School for Communication at the University of Southern California. She has published reviews in the *International Journal of Communication* as well as *American Quarterly*. Arzumanova has written a chapter for an anthology on Hollywood dance, an essay on race and stardom, and a journal article on reality makeover shows and masquerade.

Patricia Aufderheide is University Professor in the School of Communication at American University in Washington, DC, and founder-director of the Center for Social Media there. She is the co-author with Peter Jaszi of *Reclaiming Fair Use: How to Put Balance Back in Copyright* (2011), and author of, among others, *Documentary: A Very Short Introduction* (2007), *The Daily Planet* (2000), and *Communications Policy and the Public Interest* (1999). She heads the Fair Use and Free Speech research project at the Center, in conjunction with Professor Jaszi, in American University's Washington College of Law.

Sarah Banet-Weiser is Professor of Communication at the Annenberg School for Communication and Journalism and the Department of American Studies and Ethnicity at the University of Southern California. She is author of *The Most Beautiful Girl in the World: Beauty Pageants and National Identity* (1999), *Kids Rule! Nickelodeon and Consumer Citizenship* (2007), and *Authentic™: The Politics of Ambivalence in a Brand Culture* (2012). She is co-editor with Cynthia Chris and Anthony Freitas of *Cable Visions: Television Beyond Broadcasting* (2007), and co-editor with Roopali Mukherjee of *Commodity Activism: Cultural Resistance in Neoliberal Times* (2012).

Boatema Boateng is Associate Professor of Communication at the University of California, San Diego. Her research interests include critical legal studies in relation to intellectual property law and the global circulation of culture, as well as critical gender studies with a focus on globalization and transnational feminism. She is author of *The Copyright Thing Doesn't Work Here: Adinkra and Kente Cloth and Intellectual Property in Ghana* (2011).

Cynthia Chris is Associate Professor in the Department of Media Culture at the College of Staten Island, City University of New York. She is author of *Watching Wildlife* (2006), and co-editor, with Sarah Banet-Weiser and Anthony Freitas, of *Cable Visions: Television Beyond Broadcasting* (2007). Chris has contributed to *Camera Obscura*, *Television and New Media*, *The Communication Review*, and *Feminist Media Studies*, among others, as well as the collection *Animals and the Human Imagination* (2012).

David A. Gerstner is Professor of Cinema Studies at the City University of New York's College of Staten Island and Graduate Center. His books include

Queer Pollen: White Seduction, Black Male Homosexuality, and the Cinematic (2011); *Manly Arts: Masculinity and Nation in Early American Cinema* (2006); *The Routledge International Encyclopedia of Queer Culture* (editor); and *Authorship and Film* (2003; co-edited with Janet Staiger). He is currently co-authoring a book with Julien Nahmias on the French filmmaker Christophe Honoré. His essays appear in several anthologies and journals.

Nate Harrison is an artist and writer working at the intersection of intellectual property, cultural production, and the formation of creative processes in modern media. He has exhibited at the Whitney Museum of American Art, the Centre Pompidou, and the Los Angeles County Museum of Art, among others. Harrison has also lectured at institutions including the Experience Music Project, Seattle; Volunteer Lawyers for the Arts, New York; and SOMA, Mexico City. Currently, Harrison serves on the faculty at the School of the Museum of Fine Arts, Boston.

Elizabeth Losh is the author of *Virtualpolitik: An Electronic History of Government Media-Making in a Time of War, Scandal, Disaster, Miscommunication, and Mistakes* (2009) and the Director of the Culture, Art, and Technology program at Sixth College at the University of California, San Diego. She writes about institutions as digital content-creators, the discourses of the "virtual state," the media literacy of policy-makers and authority figures, and the rhetoric surrounding regulatory attempts to limit everyday digital practices. She has published articles about videogames for the military and emergency first-responders, government websites and YouTube channels, state-funded distance learning efforts, national digital libraries, the digital humanities, political blogging, and congressional hearings on the Internet.

Ken S. McAllister is Professor of Rhetoric at the University of Arizona and co-director of the Learning Games Initiative (LGI), a research group established in 1999 for the study of computer games and their cultures. He also co-curates the LGI Archive, one of the largest publicly accessible computer game collections in the world with over 12,000 games, over 200 game systems, and innumerable game-related paratexts. McAllister has published and lectured extensively on topics as wide-ranging as ancient Greek conceptions of *techne*, the rhetoric of virus writing, the politics of collaboration, as well as computer-game-related rhetorics, archiving practices, and critical pedagogies.

Edward D. Miller is author of *Emergency Broadcasting and 1930s American Radio* (2003) and *Tomboys, Pretty Boys, and Outspoken Women: The Media Revolution of 1973* (2011). He is a founder of the Department of Media Culture at the College of Staten Island and is on the faculty of the Theatre Department

and the Film Studies Certificate Program at the Graduate Center of the City University of New York. He has contributed to numerous journals, books, and online publications, most recently for *Cinema Journal*'s special section on performance (2012) and the collection *Pornographic Art and the Aesthetics of Pornography* (2013). His work on the Occupy Wall Street movement continues with a focus on depictions of Native Americans in artwork produced by the movement.

Susan Murray is Associate Professor of Media, Culture, and Communication at New York University. She is author of *Hitch Your Antenna to the Stars: Early Television and Broadcast Stardom* (2005) and co-editor with Laurie Ouellette of two editions of *Reality TV: Remaking Television Culture* (2004; 2009). Murray has also published widely in journals such as *Journal of Visual Culture*, *Cinema Journal*, and *Television and New Media*.

Laikwan Pang is a professor in the Department of Cultural and Religious Studies at The Chinese University of Hong Kong. She is the author of *Building a New China in Cinema: The Chinese Left-wing Cinema Movement, 1932–37* (2002), *Cultural Control and Globalization in Asia: Copyright, Piracy, and Cinema* (2006), *The Distorting Mirror: Visual Modernity in China* (2007), and *Creativity and Its Discontents: China's Creative Industries and Intellectual Property Right Offense* (2012).

Judd Ethan Ruggill is Assistant Professor of Communication Studies at Arizona State University and co-director of the Learning Games Initiative, a transdisciplinary, inter-institutional research group that studies, teaches with, and builds computer games. His essays have appeared in a variety of journals, anthologies, and periodicals, and his books include *Gaming Matters: Art, Science, Magic, and the Computer Game Medium* (2011), and *Fluency in Play: Computer Game Design for Less Commonly Taught Language Pedagogy* (2008), both co-authored with Ken S. McAllister; and *The Computer Culture Reader* (2009), co-edited with Ken S. McAllister and Joseph R. Chaney.

Usman Shaukat is a PhD student, adjunct instructor, and filmmaker in the Department of Communication Studies at the University of North Carolina at Chapel Hill. He was one of the panelists and organizers for the UNC Communication Studies conference on mass media in the Muslim world, held on January 26, 2012. Shaukut is currently making a film against the proposed anti-gay marriage amendment to the North Carolina constitution. His research interests include the emergence and impact of the Pakistani new-wave films produced and directed by women filmmakers.

Michelangelo Signorile is the host of *The Michelangelo Signorile Show* on SiriusXM, and editor-at-large of *Huffington Post Gay Voices*. He co-founded,

edited, and was a columnist at the influential queer magazine *OutWeek* (1989–1991). He has also served as a columnist and editor-at-large at *The Advocate*, *Out Magazine*, and *Gay.com*. His books include *Queer in America* (1993), *Outing Yourself* (1995), *Life Outside* (1997), and *Hitting Hard* (2005). In 2011, he was inducted into the National Gay and Lesbian Journalists' Association's LGBT Journalists Hall of Fame.

Pam Spaulding is editor and publisher of *Pam's House Blend*, ranked in the top 50 progressive political blogs in the country. She was named one of *Huffington Post*'s Ultimate Game Changers in Politics, honored with the Women's Media Center Award for Online Journalism, and selected as one of the OUT 100 for 2009. Spaulding was named one of Politics Daily's Top 25 Progressive Twitterers and was nominated for the inaugural Best Blog prize at the 2011 GLAAD Media Awards. She provided commentary during the 2008 presidential election cycle and covered the 2008 Democratic National Convention. Spaulding is a senior manager at Duke University Press in Durham, North Carolina.

Polly Thistlethwaite received her MLS from the University of Illinois at Urbana-Champaign in the early 1980s and has worked as an academic librarian since. Much of her career has been in libraries of the City University of New York (CUNY), previously at Hunter College, and since 2002 at the CUNY Graduate Center, where she is now Chief Librarian. She served on the Board of Directors for CUNY's Center for Lesbian and Gay Studies from 2004 to 2008. Her previously published work stems from her interests in queer archival practice and AIDS activism. She is currently engaged with CUNY's open-access publishing initiatives.

Matthew Tinkcom is Associate Professor in Communication, Culture, and Technology at Georgetown University, and has served as Associate Dean in the Edmund A. Walsh School of Foreign Service in Qatar. He is the author of *Working Like a Homosexual: Camp, Capital, Cinema* (2002), *Grey Gardens* (2011), and the co-editor with Amy Villarejo of *Key Frames: Popular Cinema and Cultural Studies* (2001). His articles have appeared in *Cinema Journal*, *Film Quarterly*, and *South Atlantic Quarterly*. He is currently working on a book on Andy Warhol's film and video.

Gregory Turner-Rahman is Associate Professor of new media theory and design history in the Art and Design Program at the University of Idaho. His current research explores communal cultural production in the electronic realm as a form of visual reasoning. Turner-Rahman has contributed to *The Journal of Design History*, *Post-Identity*, and *The Fibreculture Journal*. As part of an editorial team, his writing and design work has garnered Apex and Clarion awards.

Patricia White is Professor and Chair of Film and Media Studies at Swarthmore College. She is the author of *Uninvited: Classical Hollywood Cinema and Lesbian Representabiliy* (1999), and numerous articles and chapters on women's and LGBTQ cinema. She is co-author, with Timothy Corrigan, of *The Film Experience* (2008) and co-editor, with Corrigan and Meta Mazaj, of *Critical Visions in Film Theory: Classic and Contemporary Readings* (2010). She is a member of the editorial collective of the feminist film journal *Camera Obscura*, and she serves on the board of Women Make Movies. Her new book on global women's filmmaking in the twenty-first century is forthcoming from Duke University Press.

bibliography

———. "Wenhuabu dangwei guanyu jinyibu jiandi baokan tushu gaochou de qingshi baogao" [Report from the Party Committee of the Ministry of Culture regarding further reductions in remunerations for newspaper, journal, and book publications]. In Zhou and Li, *Zhongguo banquanshi yanjiu wenxian*, 264–66.

Al-Bukhari, Imam. *Sahih Al Bukhari*. Translated by Muhammad Muhsin Khan. Riyadh, Saudi Arabia: Dar-us-Salam, 1997.

Alekseev, Viacheslav, Leonid Ashkinazi, and Alla Kuznetsova. "The Author and the Internet." *Russian Studies in Literature* 41, no. 2 (Spring 2005), 75–93.

Alford, William. *To Steal a Book Is an Elegant Offense: Intellectual Property Law in Chinese Civilization*. Stanford, CA: Stanford University Press, 1995.

American Council of Learned Societies. *Beyond Illustration 2d and 3d Digital Technologies as Tools for Discovery in Archaeology*. Edited by Bernard D. Frischer. Oxford: BAR International Series 1805; Archaeopress, 2008.

Ames, E. Kenly. "Beyond *Rogers v. Koons*: A Fair Use Standard for Appropriation." *Columbia Law Review* 93, no. 6 (October 1993), 1490–99.

Anderson, Benedict. *Imagined Communities*. New York: Verso, 1983.

Anderson, Chris. *The Long Tail: Why the Future of Business Is Selling Less of More*. New York: Hyperion, 2006.

Anderson, Jane. *Law, Knowledge, Culture: The Production of Indigenous Knowledge in Intellectual Property Law*. Cheltenham: Edward Elgar Press, 2009.

Anderson, Jane. *Indigenous/Traditional Knowledge and Intellectual Property Issues Paper*. Centre for Public Domain; Duke University Law School, 2010. Accessed 5 May, 2012. http://www.law.duke.edu/cspd/itkpaper.

Anderson, Jane. *Intellectual Property and Indigenous Knowledge Project: Access, Ownership and Control of Indigenous Cultural Material*. Preliminary Report, AIATSIS/IPRIA, Canberra, April 2005.

Andrejevic, Mark. "Exploiting YouTube: Contradictions of User-Generated Labor." In *The YouTube Reader*, edited by Pelle Snickars and Patrick Vonderau, 406–23. Stockholm: National Library of Sweden, 2009.

Aoki, Keith, James Boyle, and Jennifer Jenkins. *Bound by Law?: Tales from the Public Domain*. Durham: Duke University Press, 2008.

Arberry, A. J., trans. *The Koran Interpreted*. New York: Collier Books; Macmillan Publishing Company, 1986.

Arendt, Hannah. *The Origins of Totalitarianism*. London: André Deutsch, 1986.

Arthur, G. F. Kojo. *Cloth as Metaphor: (Re)-reading the Adinkra Cloth Symbols of the Akan of Ghana*. Legon, Ghana: Centre for Indigenous Knowledge Systems (CEFIK), 1999/2001.

Astruc, Alexandre. "The Birth of a New Avant-Garde: La Caméra-Stylo." *L'Écran Française* (March 30, 1948). Reprinted in *The New Wave*, edited and translated by Peter Graham, 17–23. New York: Doubleday, 1968.

Aufderheide, Patricia, and Peter Jaszi. *Reclaiming Fair Use: How to Put Balance Back in Copyright*. Chicago: University of Chicago Press, 2011.

Aufderheide, Patricia. "How Documentary Filmmakers Overcame Their Fear of Quoting and Learned to Employ Fair Use: A Tale of Scholarship in Action." *International Journal of Communication* 1 (2007), 26–36.

Austin, J. L. *How to Do Things with Words*. Cambridge, MA: Harvard University Press, 1976.

Barnes, Ruth and Joanne B. Eicher, eds. *Dress and Gender: Making and Meaning in Cultural Contexts*. New York: Berg, 1992.

Barth, Fredrik, Andre Gingrich, Robert Parkin, and Sydel Silverman. *One Discipline, Four Ways: British, German, French, and American Anthropology*. Chicago: University of Chicago, 2005.

Barthes, Roland. "Listening." In *The Responsibility of Forms*. Translated by Richard Howard, 245–60. Berkeley: University of California Press, 1985.

Barthes, Roland. "The Death of the Author." In *Image, Music, Text*, edited by Stephen Heath, 142–48. New York: Hill and Wang, 1978. Originally published as Roland Barthes, "The Death of the Author," translated by Richard Howard, *Aspen* 5–6, item 3 (1967).

Barthes, Roland. *The Pleasure of the Text*. Translated by Richard Miller. New York: Hill and Wang, 1975.

Bartow, Ann. "Women in the Web of Secondary Copyright Liability and Internet Filtering." *Northern Kentucky Law Review* 32 (2005), 449–505.

Bateson, Gregory. "A Theory of Play and Fantasy." In *Steps to an Ecology of Mind*, 177–93. Chicago: University of Chicago Press, 2000.

Bazin, Andre. "On the *Politique des Auteurs*." In *Cahiers du Cinema: The 1950s: Neo-Realism, Hollywood, New Wave*, edited by Jim Hillier, translated by Peter Graham, 248–59. Cambridge, MA: Harvard University Press, 1985. Originally published in 1957.

Benjamin, Walter, *Selected Writing: Volume 2, part 2, 1927–1934* , eds. Michael W. Jennings, Howard Eiland, and Gary Smith (Cambridge, MA: Harvard University Press, 2005).

Benjamin, Walter. "Theses on the Philosophy of History." In *Illuminations: Essays and Reflections*, edited by Hannah Arendt, translated by Harry Zohn, 253–64. New York: Schocken Books, 1968.

Bennett, James. "Architectures of Participation: Fame, Television, and Web 2.0." In *Television as Digital Media*, edited by James Bennett and Nikki Strange, 333–57. Durham, NC: Duke University Press, 2011.

Benveniste, Émile. "The Nature of Pronouns." In *The Communications Theory Reader*, edited by Paul Cobley, 285–91. London: Routledge, 1996.

Berkoff, Adam T. "Computer Simulations in Litigation: Are Television Generation Jurors Being Misled." *Marquette Law Review* 77 (1994), 829.

Biagioli, Mario, Peter Jaszi, and Martha Woodmansee, eds. *Making and Unmaking Intellectual Property: Creative Production in Legal and Cultural Perspective*. Chicago: University of Chicago Press, 2011.

Biagioli, Mario, and Peter Galison, eds. *Scientific Authorship: Credit and Intellectual Property in Science*. New York: Routledge, 2003.

Bishop, Claire, ed. *Participation*. Cambridge, MA: The MIT Press; London: Whitechapel Art Gallery, 2006.

Blackwell, Peter. *Miners of the Red Mountain: Indian Labor in Potosi 1545–1650*. Albuquerque: University of New Mexico Press, 1984.

Boateng, Boatema. *The Copyright Thing Doesn't Work Here: Adinkra and Kente Cloth and Intellectual Property in Ghana*. Minneapolis: University of Minnesota Press, 2011.

Bollier, David. *Viral Spiral: How the Commoners Built a Digital Republic of Their Own*. New York: New Press, 2008.

Booth, Wayne C. *A Rhetoric of Irony*. Chicago: University of Chicago Press, 1974.

Borges, Jorge Luis. "Tlön, Uqbar, Orbis Tertius." In *Collected Fictions*, translated by Andrew Hurley, 68–81. New York: Penguin Books, 1998.

Bourriaud, Nicolas. *Relational Aesthetics*. Dijon: Les Presse du Reel, 1998.

Bowrey, Kathy, and Jane Anderson. "The Politics of Global Information Sharing: Whose Cultural Agendas are Being Advanced?" *Social and Legal Studies* 18 (2009), 479–504.

Boyle, James. *Shamans, Software, and Spleens: Law and the Construction of the Information Society*. Cambridge, MA: Harvard University Press, 1996.

Boyle, James. *The Public Domain: Enclosing the Commons of the Mind*. New Haven, CT: Yale University Press, 2008.

Boytha, György. "The Berne Convention and the Socialist Countries with Particular Reference to Hungary." *Columbia-VLA Journal of Law & the Arts* 11, no. 73 (1986), 57–72.

Burgess, Jean. "User-Generated Content and Everyday Cultural Practice: Lessons from YouTube." In *Television as Digital Media*, edited by James Bennett and Nikki Strange, 311–31. Durham, NC: Duke University Press, 2011.

Butler, Alison. *Women's Cinema: The Contested Screen*. London: Wallflower, 2002.

Butler, Judith. *Excitable Speech: A Politics of the Performative*. New York: Routledge, 1997.

Caillois, Roger. *Man Play and Games*. Translated by Meyer Barash. Champaign: University of Illinois Press, 2001.

Caldwell, John T. "Worker Blowback: User-Generated, Worker-Generated and Producer-Generated Content within Collapsing Production Workflows." In *Television as Digital Media*, edited by James Bennett and Nikki Strange, 283–309. Durham, NC: Duke University Press, 2011.

Christen, Kim. "Gone Digital: Aboriginal Remix and the Cultural Commons." *International Journal of Cultural Property* 12 (2005), 315–45.

Christensen, Jerome. "Studio Authorship, Warner Bros., and *The Fountainhead*." *Velvet Light Trap* 57 (Spring 2006), 17–31.

Christensen, Jerome. "Taking It to the Next Level: You've Got Mail, Havholm and Sandifer," *Critical Inquiry* 30, no. 1 (Autumn 2003), 198–215.

Christensen, Jerome. "The Time Warner Conspiracy." *Critical Inquiry* 28, no. 3 (Spring 2002), 591–617.

Coombe, Rosemary. *The Cultural Life of Properties: Authorship, Appropriation and the Law*. Durham, NC: Duke University Press, 1998.

Crimp, Douglas. *On the Museum's Ruins*. Photographs by Louis Lawler. Cambridge, MA: The MIT Press, 1993.

Crimp, Douglas. "Pictures." *October* 8 (Spring 1979), 75–88.

Csikszentmihalyi, Mihaly. *Creativity: Flow and the Psychology of Discovery and Invention*, 1st ed. New York: HarperCollins Publishers, 1996.

Deazley, Ronan. *On the Origin of the Right to Copy: Charting the Movement of Copyright Law in Eighteenth Century Britain (1695–1775)*. Oxford: Hart Publishing, 2004.

Deleuze, Gilles, and Félix Guattari. *A Thousand Plateaus: Capitalism and Schizophrenia*. Minneapolis: University of Minnesota Press, 1987.

Derrida, Jacques. *Archive Fever: A Freudian Impression.* Chicago: University of Chicago Press, 1995.

Derrida, Jacques. "Signature Context Event" [1972]. In *Margins of Philosophy*, translated by Alan Bass, 307–39. Chicago: University of Chicago Press, 1982.

Dirks, Nicholas. *Castes of Mind: Colonialism and the Making of Modern India.* Princeton, NJ: Princeton University Press, 2001.

Drahos, Peter, and John Braithwaite. *Information Feudalism: Who Owns the Knowledge Economy?* New York: The New Press, 2002.

Duncan, Emma. *Breaking the Curfew: A Political Journey Through Pakistan.* London: Penguin Group, 1989.

Durovicová, Natasa, and Kathleen Newman, eds. *World Cinemas/Transnational Perspectives.* London: Routledge, 2009.

Dusollier, Severine. "Open Source and Copyleft: Authorship Reconsidered." *Columbia Journal of Law and the Arts* 26 (2003), 281–96.

Eklund, Douglas and Metropolitan Museum of Art, *The Pictures Generation: 1974–1984.* New York: Metropolitan Museum of Art; New Haven, CT: Yale University Press, 2009.

Elsaesser, Thomas. "Film Festival Networks: New Topographies of Cinema in Europe." In *European Cinema: Face to Face with Hollywood*, 82–106. Amsterdam: Amsterdam University Press, 2005.

Ernst, Carl W. *Sufism: An Essential Introduction to the Philosophy and Practice of the Mystical Tradition of Islam.* Boston, MA: Shambhala Publications, 1997.

Ezra, Elizabeth, and Terry Rowden, eds. *Transnational Cinema: The Film Reader.* London: Routledge, 2006.

Fitzpatrick, Kathleen. "Peer-to-Peer Review and the Future of Scholarly Authority." *Social Epistemology* 24, no. 3 (July–September 2010), 161–79.

Foster, Hal. "The Passion of the Sign." In *The Return of the Real: The Avant-Garde at the End of the Century.* Cambridge, MA: The MIT Press, 1996.

Foucault, Michel. "Governmentality." In *The Foucault Effect: Studies in Governmentality*, edited by Graham Burchell, Colin Gordon, and Peter Miller, 87–104. Chicago: Chicago University Press, 1991.

Foucault, Michel. *Security, Territory, Population: Lectures at the College De France 1977–1978.* Translated by Graham Burchell. New York: Picador, 2004.

Foucault, Michel. "What Is an Author?" In *Textual Strategies: Perspectives in Post-Structuralist Criticism*, edited by Josué V. Harari, 141–60. Ithaca, NY: Cornell University Press, 1979. Also published in Paul Rabinow, ed., *The Foucault Reader*, 101–20. New York: Pantheon Books, 1984.

Friedrich A. Kittler. *Gramophone, Film, Typewriter.* Translated and introduction by Geoffrey Winthrop-Young and Michael Wutz. Stanford, CA: Stanford University Press, 1999.

Fukumoto, Elton. "The Author Effect After the 'Death of the Author': Copyright in a Postmodern Age." *Washington Law Review* 72.3 (1997), 903–19.

Fuller, Matthew. *Media Ecologies: Materialist Energies in Art and Technoculture.* Cambridge, MA: The MIT Press, 2005.

Fuqiang, Hao. "'Shiqi Nian' Wenyi Gaochou Zhidu Yanjiu" (A Study of the "Seventeen Years" Art and Literature Remuneration System)*. Jianghai Xuekan* [Jianghai Academic Journal] no. 4 (2006), 200–205.

Gallop, Jane. *The Deaths of the Author: Reading and Writing in Time.* Durham, NC: Duke University Press, 2011.

Garon, Jon M. "Wiki Authorship, Social Media, and the Curatorial Audience." *Journal of Sports & Entertainment Law* 1, no. 1 (Spring 2010), 96–144.

Gault, Rosalind, and Karl Schoonover, eds. *Global Art Cinema: New Theories and Histories.* New York: Oxford University Press, 2010.

Geertz, Clifford. *Negara: The Theatre State in Nineteenth-Century Bali.* Princeton, NJ: Princeton University Press, 1980.

Gerstner, David A. "The Practices of Authorship." In *Authorship and Film,* edited by David A. Gerstner and Janet Staiger, 3–25. New York: Routledge, 2003.

Gerstner, David A., and Janet Staiger, eds. *Authorship and Film.* New York: Routledge, 2003.

Ghosh, Amitav. *In an Antique Land: History in the Guise of a Travel Tale.* New York: Vintage Press, 1994.

Gitelman, Lisa. *Always Already New: Media, History and the Data of Culture.* Cambridge, MA: The MIT Press, 2006.

Goodenough, Patrick. "Pakistani Islamists Protest U.S. Embassy's 'Gay Pride' Event." CNS News, July 5, 2011. Accessed March 9, 2012. http://cnsnews.com/news/article/pakistani-islamists-protest-us-embassy-s-gay-pride-event.

Gopinath, Gayatri. *Impossible Desires: Queer Diasporas and South Asian Public Cultures.* Durham, NC: Duke University Press, 2005.

Grgorinić, Natalija, and Ognjen Ra en. "Authors' Rights as an Instrument of Control: An Overview of the Ideas of Authorship and Authors' Rights in Socialist Yugoslavia, and How These Ideas Did Not Change to Reflect the Ideals of The Socialist Revolution." *Law and Critique* 19, no. 1 (April 2008), 35–63.

Gross, Larry. *Contested Closets: The Politics and Ethics of Outing.* Minneapolis: University of Minnesota Press, 1993.

Guattari, Félix. *Chaosmosis: An Ethico-Aesthetic Paradigm.* Bloomington: Indiana University Press, 1995.

Haebich, Anna. *Broken Circles: Fragmenting Indigenous Families 1800–2000.* Fremantle, Western Australia: Fremantle Press, 2000.

Halberstam, Judith. "Technotopias: Representing Transgender Bodies in Contemporary Art." In *In A Queer Time and Place: Transgender Bodies, Subcultural Lives,* 97–124. New York: New York University Press, 2005.

Halbert, Debora J. "Feminist Interpretations of Intellectual Property Law." *American University Journal of Gender, Social Policy and the Law* 14, no. 3 (2006), 431–60.

Hamilton, Carolyn, Verne Harris, Michèle Pickover, Graeme Reid, Razia Saleh, Jane Taylor, eds. *Refiguring the Archive.* Cape Town: David Philips Publishers, 2002.

Hanson, Ellis. "The History of Digital Desire, vol. 1: An Introduction," *The South Atlantic Quarterly* 110, no. 3 (Summer 2011), 583–99.

Harrigan, Pat, and Noah Wardrip-Fruin. *Third Person: Authoring and Exploring Vast Narratives.* Cambridge, MA: The MIT Press, 2009.

Harvey, David. *Limits to Capital.* London: Verso, 1999.

Havholm, Peter, and Philip Sandifer. "Corporate Authorship: A Response to Jerome Christensen," *Critical Inquiry* 30, no. 1 (Autumn 2003), 187–97.

Hayles, N. Katherine. *How We Became Posthuman: Virtual Bodies in Cybernetics, Literature, and Informatics.* Chicago: University of Chicago Press, 1999.

Hilmes, Michele. *Hollywood and Broadcasting: From Radio to Cable.* Urbana: University of Illinois Press, 1990.

Hobbs, Renee. *Conquering Copyright Confusion: How the Doctrine of Fair Use Supports 21st Century Learning.* Thousand Oaks, CA: Corwin, 2010.

Holmes, Eben. "Strange Reality: Glitches and Uncanny Play." *Eludamos* 4, no. 2 (2010), 255–76. Accessed October 3, 2011. http://eludamos.org/index.php/eludamos/article/view/vol4no2-9/188.

Horkheimer, Max, and Theodor Adorno. "The Culture Industry: Enlightenment as Mass Deception." In *Dialectic of Enlightenment* (1944), translated by John Cumming, 120–67. New York: Continuum, 1993.

Huhtamo, Erkki, and Jussi Parikka. *Media Archaeology: Approaches, Applications, and Implications.* Berkeley: University of California Press, 2011.

Huizinga, Johan. *Homo Ludens: A Study of the Play-Element in Culture.* Boston, MA: Beacon Press, 1955.

Human Rights and Equal Opportunity Commission, *Bringing Them Home: Report of the National Inquiry into the Separation of Aboriginal and Torres Strait Islander Children from their Families.* Sydney, 1997.

Hyde, Lewis. *Common as Air: Revolution, Art, and Ownership*, 1st ed. New York: Farrar, Straus and Giroux, 2010.

Hyde, Lewis. *The Gift: Creativity and the Artist in the Modern World*, 25th Anniversary ed. New York: Vintage Books, 2007.

Ishaq, Ibn. *The Life of Muhammad: Translation of Ibn Ishaq's Sirat Rasul Allah*, 17th ed. Edited by Ibn Hisham, translated by A. Guillaume. Lahore, Pakistan: Oxford University Press, 2004.

Ito, Mizuko. *Hanging Out, Messing Around, and Geeking Out: Kids Living and Learning with New Media.* Cambridge, MA: The MIT Press, 2010.

Jacobson, Roman. "Shifters and Verbal Categories." In *The Communications Theory Reader*, edited by Paul Cobley, 292–98. London: Routledge, 1996.

Jaggar, Alison M. *Feminist Politics and Human Nature.* Lanham, MD: Rowman & Littlefield, 1983.

Jaszi, Peter, and Martha Woodmansee. "Beyond Authorship: Refiguring Rights in Traditional Culture and Bioknowledge." In *Scientific Authorship: Credit and Intellectual Property in Science*, edited by Mario Biagioli and Peter Galison, 195–223. New York: Routledge, 2003.

Jaszi, Peter. "Is There Such a Thing as Postmodern Copyright?" In *Making and Unmaking Intellectual Property*, edited by Mario Biagioli, Peter Jaszi, and Martha Woodmansee, 413–28. Chicago: University of Chicago Press, 2011.

Jaszi, Peter. "Is There Such a Thing as Postmodern Copyright?" *Tulane Journal of Technology & Intellectual Property* 12 (2009), 105–21.

Jaszi, Peter. "On the Author Effect: Contemporary Copyright and Collective Creativity." In *The Construction of Authorship: Textual Appropriation in Law and Literature*, edited by Peter Jaszi and Martha Woodmansee, 29–56. Durham, NC: Duke University Press, 1994.

Jaszi, Peter, and Martha Woodmansee eds. *The Construction of Authorship: Textual Appropriation in Law and Literature.* Durham, NC: Duke University Press, 1994.

Jaszi, Peter. "Toward a Theory of Copyright: The Metamorphoses of 'Authorship'." *Duke Law Review* 1991, no. 2 (1991), 455–502.

Jenkins, Henry. *Convergence Culture: Where Old and New Media Collide.* New York: New York University Press, 2006.

Kael, Pauline. "Circles and Squares." *Film Quarterly* 16, no. 3 (Spring 1963), 12–26.

Kerlogue, Fiona. "Interpreting Textiles as a Medium of Communication: Cloth and Community in Malay Sumatra." *Asian Studies Review* 24, no. 3 (2000), 335–47.

Khatib, Lina. *Lebanese Cinema: Imagining the Civil War and Beyond.* London: I. B. Taurus, 2008.

Kidwai, Saleem. "Introduction: Medieval Materials in the Perso-Urdu Tradition." In *Same-Sex Love in India: Readings from Literature and History*, edited by Ruth Vanita and Saleem Kidwai, 107–125. New York: St. Martin's Press, 2000.

Kim, Minjeong. "The Creative Commons and Copyright Protection in the Digital Era: Uses of Creative Commons Licenses." *Journal of Computer-Mediated Communication* 13, no. 1 (2007). Accessed May 9, 2012. http://jcmc.indiana.edu/vol13/issue1/kim.html.

Kinnane, Stephen. *Shadow Lines.* Fremantle: Fremantle Arts Centre Press, 2002.

Kirschenbaum, Matthew G. *Mechanisms: New Media and the Forensic Imagination.* Cambridge, MA: The MIT Press, 2008.

Kitchin, Rob, and Martin Dodge. *Code/Space: Software and Everyday Life.* Cambridge, MA: The MIT Press, 2011.

Klein, Norman M. *The Vatican to Vegas: A History of Special Effects.* New York: New Press, 2004.

Kockelkoren, Petran. *Technology: Art, Fairground and Theatre.* Rotterdam: NAi Publishers, 2003.

Kohn, Nathaniel. "Standpoint: Disappearing Authors: A Postmodern Perspective on the Practice of Writing for the Screen." *Journal of Broadcasting & Electronic Media* 43, no. 3 (1999), 443–49.

Kraidy, Marwan M. *Reality Television and Arab Politics: Contention in Public Life.* Cambridge, UK: Cambridge University Press, 2009.

Krapp, Peter. "Of Games and Gestures: Machinima and the Suspensions of Animation." In *The Machinima Reader*, edited by Henry Lowood and Michael Nitsche, 159–174. Cambridge, MA: The MIT Press, 2011.

Kraszewski, Jon. "Authorship and Adaptation: The Public Personas of Television Anthology Writers." *Quarterly Review of Film and Video* 25 (2008), 271–85.

Kugle, Scott. *Sufis and Saints' Bodies: Mysticism, Corporeality, and Sacred Power in Islam.* Chapel Hill: University of North Carolina Press, 2010.

Kugle, Scott. "Sultan Mahmud's Makeover: Colonial Homophobia and the Persian-Urdu Literary Tradition." In *Queering India: Same Sex Love and Eroticism in Indian Culture and Society*, edited by Ruth Vanita, 30–46. New York: Routledge, 2002.

Landow, George. *Hypertext 3.0: Critical Theory and New Media in an Era of Globalization.* Baltimore, MD: Johns Hopkins University Press, 2003.

Lanham, Robert. *The Electronic Word: Democracy, Technology, and the Arts.* Chicago: University of Chicago Press, 1993.

Lehmann, Klaus-Dieter. "Making the Transitory Permanent: The Intellectual Heritage in a Digitised World of Knowledge." *Daedalus* 125 (1996), 307–29.

Lemley, Mark. "Romantic Authorship and the Rhetoric of Property." *Texas Law Review* 75 (1997), 873.

Levy, Steven. *Hackers: Heroes of the Computer Revolution.* Garden City, NY: Anchor Press/Doubleday, 1984.

Li, Mingshan. *Zhongguo jindai banquan shi* [History of modern copyright in China]. Kaifeng: Henan Daxue chubanshe, 2003.

Li, Yufeng. *Qiangkouxia de falü: Zhongguo banquanshi yanjiu* [Law under the gun: A study of Chinese copyright history]. Beijing: Zhishi chanquan chubanshe, 2006.

Longo, Mariano, and Stefano Magnolo. "The Author and Authorship in the Internet Society." *Current Sociology* 57, no. 6 (November 2009), 829–50.

Lovink, Geert. *Zero Comments: Blogging and Critical Internet Culture.* New York: Routledge, 2008.

Lunenfeld, Peter. *Snap to Grid: A User's Guide to Digital Arts, Media, and Cultures.* Cambridge, MA: The MIT Press, 2000.

Lynch, Michael. "Archives in Formation: Privileged Spaces, Popular Archives and Paper Trails." *History of the Human Sciences* 12, no. 2 (1999), 65–87.

Macpherson, C. B. *The Political Theory of Possessive Individualism: Hobbes to Locke.* Oxford: Clarendon Press, 1962.

Malinowski, Bronislaw. "The Problem of Meaning in Primitive Language." In *Magic, Science, and Religion and Other Essays 1948*, with an introduction by Robert Redfield, 228–76. New York: Free Press, 1984.

Manovich, Lev. "Models of Authorship in New Media" (2002). Accessed July 30, 2011. http://www.manovich.net/DOCS/models_of_authorship.doc.

Manovich, Lev. "The Practice of Everyday (Media) Life: From Mass Consumption to Mass Cultural Production?" *Critical Inquiry* 35, no. 2 (Winter 2009), 319–31.

Manovich, Lev. *Software Takes Command.* November 20, 2008. Accessed May 2, 2012. http://lab.softwarestudies.com/2008/11/softbook.html.

Manovich, Lev. *The Language of New Media.* Cambridge, MA: The MIT Press, 2002.

Mao, Zedong. "Lun Zhengce" [On policy]. In *Mao Zedong Xuan Ji* [Selected Works by Mao Zedong], 2, 759–67. Beijing: Ren Min Chu Ban She; Xin Hua Shu Dian Fa Xing, 1964.

Marvin, Carolyn. *When Old Technologies Were New: Thinking About Electronic Communication in the Late Nineteenth Century.* Cary, NC: Oxford University Press, 1990.

Marx, Nick. "The Missing Link Moment: Web Comedies in the New Media Industries." *Velvet Light Trap* 68 (Fall 2001), 14–23.

Mazloomi, Carolyn. *Spirits of the Cloth: Contemporary African American Quilts.* New York: Clarkson Potter Publishers, 1998.

McConvell, Patrick, and Nicholas Thieberger, "State of Indigenous Languages in Australia – 2001." *Australia State of the Environment Technical Paper Series (Natural and Cultural Heritage).* Canberra: Department of Environment and Heritage, 2001.

McDougall, Bonnie S. *Mao Zedong's "Talks at the Yan'an Conference on Literature and Art": A Translation of the 1943 Text with Commentary.* Ann Arbor: Center for Chinese Studies, University of Michigan, 1980.

McHugh, Kathleen. "The World and the Soup: Historicizing Media Feminisms in Transnational Contexts." *Camera Obscura* 72 (2009), 110–51.

McLeod, Kembrew. *Freedom of Expression: Overzealous Copyright Bozos and Other Enemies of Creativity,* 1st ed. New York: Doubleday, 2005.

McLeod, Kembrew. *Owning Culture: Authorship, Ownership and Intellectual Property Law.* New York: Peter Lang, 2001.

McLuhan Marshall. *Understanding Media* [1964]. London: Routledge, 2005.

McLuhan, Marshall and Barrington Nevitt. *Take Today: The Executive as Dropout.* New York: Harcourt Brace Jovanovich, 1972.

Merritt, Bishetta D. "Bill Cosby: TV Auteur?" *Journal of Popular Culture* 24 (1991), 89–102.

Merry, Sally Engle. *The Colonization of Hawai'i: The Cultural Power of Law.* Durham, NC; London: Duke University Press, 2000.

Merry, Sally Engle. "Measuring the World: Indicators, Human Rights and Global Governance." *Current Anthropology* 52 (2011), S83–S95.

Michael, Collier, Wyn Cooper, Rita Dove, Cornelius Eady, David Fenza, Kate Gale, Kimiko Hahn, Lewis Hyde, Fiona McCrae, Robert Pinsky, Claudia Rankine, Alberto Ríos, Don Selby, Rick Stevens, Jennifer Urban, and Monica Youn. *Poetry and New Media: A User's Guide.* Chicago: Poetry and New Media Working Group, Harriet Monroe Poetry Institute, Poetry Foundation, 2009.

Mignolo, Walter. *The Darker Side of the Renaissance: Literacy, Territoriality, Colonization.* Ann Arbor: University of Michigan Press, 1995.

Mignolo, Walter. *Local Histories/Global Designs: Coloniality, Subaltern Knowledges and Border Thinking.* Princeton, NJ: Princeton University Press, 2000.

Mignolo, Walter. *The Darker Side of Western Modernity: Global Futures, Decolonial Options.* Durham, NC: Duke University Press, 2011.

Mohanty, Chandra Talpade. *Feminism Without Borders: Decolonizing Theory, Practicing Solidarity.* Durham, NC: Duke University Press, 2003.

Moore, Phoebe. "Subjectivity in the Ecologies of Peer to Peer Production." *The Fibreculture Journal* no. 17 (2011), 82–95. Accessed May 23, 2012. fibreculturejournal.org.

Mougayar, Walid. *Opening Digital Markets: Battle Plans and Business Strategies for Internet Commerce.* New York: McGraw-Hill, 1998.

Murray, Janet. *Hamlet on the Holodeck: The Future of Narrative in Cyberspace.* New York: The Free Press, 1997.

Musser, Charles. *The Emergence of Cinema: The American Screen to 1907.* Berkeley: University of California Press, 1994.

Nancy, Jean-Luc. "Listening." In *Listening,* translated by Charlotte Mandell, 1–22. New York: Fordham University Press, 2007.

Nancy, Jean-Luc. "Of Being Singular Plural." In *Being Singular Plural,* translated by Robert D. Richardson and Anne E. O'Byrne, 1–100. Stanford, CA: Stanford University Press, 2000.

Negroponte, Nicholas. *Being Digital.* New York: Knopf, 1995.

Nicholson, Reynold A. *The Mystics of Islam.* New York: Arkana Publications of the Penguin Group, Inc. 1989.

Nitsche, Michael. *Video Game Spaces: Image, Play, and Structure in 3D Game Worlds.* Cambridge, MA: The MIT Press, 2008.

Nunes, Mark, ed. *Error: Glitch, Noise, and Jam in New Media Cultures.* New York: Continuum, 2011.

Osborne, Thomas. "The Ordinariness of the Archive." *History of Human Sciences* 12, no. 2 (1999), 51–64.

Ouellette, Laurie. "Camcorder Dos and Don'ts: Popular Discourses on Amateur Video and Participatory Television." *Velvet Light Trap* 36 (Fall 1995), 33–44.

Owens, Craig. *Beyond Recognition: Representation, Power, and Culture.* Edited by Scott Bryson, Barbara Kruger, Lynne Tillman, and Jane Weinstock. Introduction by Simon Watney. Berkeley: University of California Press, 1992.

Owens, Craig. "The Discourse of Others: Feminists and Postmodernism." In *Beyond Recognition: Representation, Power and Culture,* edited by Scott Bryson, Barbara Kruger, Lynne Tillman, and Jane Weinstock, introduction by Simon Watney, 166–90. Berkeley; Los Angeles: University of California Press, 1992.

Pang, Laikwan. "'China Who Makes and Fakes': A Semiotics of the Counterfeit." *Theory, Culture & Society* 26, no. 6 (2008), 117–40.

Pang, Laikwan. *Creativity and Its Discontents: China's Creative Industries and Intellectual Property Rights Offenses.* Durham, NC: Duke University Press, 2012.

Parker, Andrew, and Eve Sedgwick. "Introduction: Performativity and Performance." In *Performativity and Performance,* edited by Andrew Parker and Eve Sedgwick, 1–18. Routledge: New York, 1995.

Paz, Octavio. *Alternating Current.* New York: Arcade Publishing, 1990.

Pearce, Celia. *Communities of Play Emergent Cultures in Multiplayer Games and Virtual Worlds.* Cambridge, MA: The MIT Press, 2009. http://site.ebrary.com/id/10331661.

Phillips, Victoria F. "Commodification, Intellectual Property and the Quilters of Gees Bend." In *American University Journal of Gender, Social Policy and the Law* 15, no. 2 (2007), 359–77.

Polan, Dana. "Auteur Desire." *Screening the Past* 12. Uploaded March 1, 2001. Latrobe.edu.au/www/screeningthepast/firstrelease/fr0301/dpfr12a.htm.

Poynor, Rick. *No More Rules: Graphic Design and Postmodernism.* New Haven, CT: Yale University Press, 2003.

Puri, J. R., and Shingari, T. R. *Saaien Bulleh Shah.* Lahore, Pakistan: Fiction House, 2004.

Raley, Rita. *Tactical Media.* Minneapolis: University of Minnesota Press, 2009.

Rand, Paul. "Design and the Play Instinct." *Paul-Rand.com; American Modernist; 1914–1996.* Accessed September 16, 2011. http://www.paul-rand.com/site/thoughts_designAnd-thePlayInstinct.

Ratto, Matt. "Epistemic Commitments, Virtual Reality, and Archaeological Representation." In *Technology and Methodology for Archaeological Practice: Practical Applications for the Past Reconstruction (Technologie Et Méthodologie Pour La Pratique En Archéologie: Applications Pratiques Pour La Reconstruction Du Passé)*, edited by Alexandra Velho, Hans. Kamermans, and International Union of Prehistoric and Protohistoric Sciences. Oxford: Archaeopress, 2009.

Renmin wenxue chubanshe. "Renmin wenxue chubanshe chuban hetong, yugao hetong ji gaochou banfa" [The publication contract, commission contract, and remuneration methods of People's Literature Press]. In Zhou and Li, *Zhongguo banquanshi yanjiu wenxian*, 273–81.

Rittel, Horst W. J., and Melvin M. Webber. "Dilemmas in a General Theory of Planning." *Policy Sciences* 4 (1973), 155–69.

Robertson, Douglas. *The New Renaissance: Computers and the Next Level of Civilization.* Oxford: Oxford University Press, 1998.

Rose, Mark. "The Author as Proprietor: Donaldson v. Becket and the Geneaology of Modern Authorship," *Representations* 23 (Summer 1988), 51–85.

Rose, Mark. *Authors and Owners: The Invention of Copyright.* Cambridge, MA; London: Harvard University Press, 1993.

Rowse, Tim. "Official Statistics and the Contemporary Politics of Indigeneity." *Australian Journal of Political Science* 44 (2009), 193–211.

Rowse, Tim, and Len Smith, "The Limits of 'Elimination' in the Politics of Population." *Australian Historical Studies* 41 (2010), 90–106.

Sakai, Naoki. "Subject and Substratum: On Japanese Imperial Nationalism." *Cultural Studies* 14, nos. 3 & 4 (July 2000), 462–530.

Sandler, Kevin S. *The Naked Truth: Why Hollywood Doesn't Make X-Rated Movies.* New Brunswick, NJ: Rutgers University Press, 2007.

Sarris, Andrew. "Notes on the Auteur Theory in 1962." *Film Culture* 27 (Winter 1962–1963). Reprinted in *Film Culture Reader*, edited by P. Adams Sitney, 121–35. New York: Praeger, 1970.

Saunders, David. *Authorship and Copyright.* London; New York: Routledge, 1992.

Schimmel, Annemarie. *As Through a Veil: Mystical Poetry in Islam.* New York: Columbia University Press, 1982.

Schimmel, Annemarie. *Calligraphy and Islamic Culture.* New York: New York University Press, 1990.

Schimmel, Annemarie. *I Am Wind You Are Fire: The Life and Works of Rumi.* Boston, MA: Shambhala Publications, 1992.

Schoelwer, Susan Prendergast. "Form, Function, and Meaning in the Use of Fabric Furnishings: A Philadelphia Case Study, 1700–1775." *Winterthur Portfolio* 14, no. 1 (Spring 1979), 25–40.

Scott, David. "Colonial Governmentality." *Social Text* (Fall 1995), 191–200.

Seeger, Anthony. "Who Got Left Out of The Property Grab Again: Oral Traditions, Indigenous Rights, and Valuable Old Knowledge." In *CODE: Collaborative Ownership and the Digital Economy*, edited by Rishab Aiyer Ghosh, 75–84. Cambridge, MA: The MIT Press, 2005.

Sekula, Alan. "The Body and the Archive." *October* 39 (1986), 3–64.

Sell, Susan, and Christopher May. "Moments in Law: Contestation and Settlement in the History of Intellectual Property Law." *Review of International Political Economy* 8, no. 3 (2001), 467–500.

Shah, Idries. *The Sufis*, 7th ed. New York: Anchor Books, 1995.

Shaw, Robert. *Quilts: A Living Tradition.* New York: Hugh Lauter Levin Associates and Beaux Arts Editions, 1995.

Shepard, Benjamin. *Queer Political Performance and Protest.* New York: Routledge, 2010.

Sherman, Brad, and Lionel Bently. *The Making of Modern Intellectual Property: The British Experience 1760–1911.* Cambridge, UK: Cambridge University Press, 1999.

Shohat, Ella. "Post-Third-Worldist Culture." In *Rethinking Third Cinema*, edited by Anthony R. Gueratne and Wimal Dissanayake, 51–78. London: Routledge, 2003.

Shohat, Ella, and Robert Stam. *Unthinking Eurocentrism: Multiculturalism and the Media.* London; New York: Routledge, 1994.

Siegel, Katy. "Banality 1988." In *Jeff Koons*, edited by Hans Werner Holzwarth. Köln: Taschen GmbH, 2009.

Sielman, Martha. *Masters: Art Quilts.* New York: Lark Books; Canada: Sterling Publishing Co., 2008.

Signorile, Michelangelo. *Queer in America: Sex, the Media and the Closets of Power.* New York: Anchor, 1993.

Singer, Alan. "Beautiful Errors: Aesthetics and the Art of Contextualization." *boundary 2.* 25. no. 1 (1998), 7–34.

Siraj, Abdul Syed. "Critical Analysis of Press Freedom in Pakistan." *Global Media Journal* 1 (2008), 44. Accessed March 29, 2012. http://www.aiou.edu.pk/gmj/artical1(b).asp.

Smith, Linda Tuhiwai. *Decolonizing Methodologies: Research and Indigenous Peoples.* London: Zed Press, 1999.

Sobchack, Vivian. *Meta-Morphing: Visual Transformation and the Culture of Quick-Change.* Minneapolis: University of Minnesota Press, 2000.

Soutter, Lucy. "The Collapsed Archive: Idris Khan." In *Appropriation*, edited by David Evans, 166–168. London: Whitechapel; Cambridge, MA: The MIT Press, 2009.

Spector, Nancy and Richard Prince. *Richard Prince.* New York: Guggenheim Museum, 2007.

Spyer, Patricia. *The Memory of Trade: Modernity's Entanglements on an Eastern Indonesian Island.* Durham, NC; London: Duke University Press, 2000.

Stahl, Roger. "Becoming Bombs: 3D Animated Satellite Imagery and the Weaponization of the Civic Eye." *MediaTropes* 2, no. 2 (February 2010), 65–93.

Staples, Donald E. "The Auteur Theory Reexamined." *Cinema Journal* 6 (1966–1967), 1–7.

Stirratt, Betsy, and Eugene Tan, eds. *Jason Salavon: Brainstem Still Life.* Bloomington: School of Fine Arts Gallery, Indiana University Bloomington, 2004.

Stocking, George. *Victorian Anthropology.* New York: Free Press, 1987.

Stoler, Ann Laura. *Race and the Education of Desire: Foucault's History of Sexuality and the Colonial Order of Things.* Durham, NC: Duke University Press, 1995.

Stoler, Ann Laura. "Colonial Archives and the Arts of Governance." *Archival Science* 2 (2002), 87–109.

Stoler, Ann Laura. *Along the Archival Grain: Epistemic Anxieties and Colonial Common Sense.* Princeton, NJ: Princeton University Press, 2009.

Streeter, Thomas. *The Net Effect: Romanticism, Capitalism, and the Internet.* New York: New York University Press, 2010.

Sundara Rajan, Mira T. *Copyright and Creative Freedom: A Study of Post-Socialist Law Reform.* London: Routledge, 2006.

Tasker, Yvonne, and Diane Negra, eds. *Interrogating Postfeminism: Gender and the Politics of Popular Culture.* Durham, NC: Duke University Press, 2007.

Teitel, Martin, and Hope Shand. *The Ownership of Life: When Patents and Values Clash.* Freeston, CA: The CS Fund; New York: The HKH Foundation, 1997.

Toffler, Alvin. *The Third Wave.* New York: Pan Books, 1980.

Trachtenberg, Alan. *Reading American Photographs: Images as History, Mathew Brady to Walker Evans.* New York: Hill and Wang, 1989.

Trotsky, Leon. "Class and Art." In *Art and Revolution: Writings on Literature, Politics, and Culture*, edited by Paul N. Siegel, 66–86. New York: Pathfinder, 2008.

Truffaut, Francois. "A Certain Tendency of French Cinema." Reprinted in *Movies and Methods* V. 1, edited by Bill Nichols, 224–37. Berkeley: University of California Press, 1976. Originally published in 1954.

Turner, Graeme. "The Mass Production of Celebrity: 'Celetoids', Reality TV and the 'Demotic Turn'." *International Journal of Cultural Studies* 9, no. 2 (2006), 153–65.

Turner-Rahman, Gregory. "Parallel Practices and the Dialectics of Open Creative Production." *Journal of Design History* 21, no. 4 (2008), 371–86.

Turner-Rahman, Gregory. "Doing-Making-Meaning: Processual Visual Literacy in Recent Digital Cultures." In *From Power 2 Empowerment: Critical Literacy in Visual Culture. Proceedings of the 2008 International Conference on The Critical Examination of Visual Literacy, Dallas, Texas, USA, June 6 and 7, 2008*, 50–61. Dallas: University of North Texas, 2009.

Vaidhyanathan, Siva. *Copyrights and Copywrongs: The Rise of Intellectual Property and How It Threatens Creativity*. New York: New York University Press, 2001.

Van Dijck, José. "Users Like You? Theorizing Agency in User-Generated Content." *Media Culture Society* 31 (2009), 41–58.

Vanita, Ruth. "Introduction." In *Queering India: Same-Sex Love and Eroticism in Indian Culture and Society*, edited by Ruth Vanita. New York: Routledge, 2002.

Warhol, Andy. *The Philosophy of Andy Warhol: From A to B and Back Again*, 1st ed. New York: Harcourt Brace Jovanovich, 1975.

Williams, Raymond. *Keywords: A Vocabulary of Culture and Society*, Revised edition. New York: Oxford, 1983. Originally published in 1976.

Winston, Brian. *Media Technology and Society, A History: From the Telegraph to the Internet*. London: Routledge, 1998.

Woodmansee, Martha, and Peter Jaszi. *The Construction of Authorship: Textual Appropriation in Law and Literature (Post-Contemporary Interventions)*. Durham, NC; London: Duke University Press, 1994.

Woodmansee, Martha. "On the Author Effect: Recovering Collectivity." In *The Construction of Authorship: Textual Appropriation in Law and Literature*, edited by Peter Jaszi and Martha Woodmansee, 15–28. Durham, NC: Duke University Press, 1994.

Woodmansee, Martha. "The Genius and the Copyright: Economic and Legal Conditions of the Emergence of the 'Author'." *Eighteenth-Century Studies* 17, no. 4 (Summer 1984), 425–28.

Worton, Michael. "Cruising (Through) Encounters." In *Gay Signatures: Gay and Lesbian Theory, Fiction and Film in France, 1945–1995*, edited by Owen Heathcote, Alex Hughes, and James S. Williams, 29–50. Oxford: Berg, 1998.

Wu Jijing. "Youhua Mao Zhuxi qu Anyuan de fengfengyuyu" [The debates and disturbances around the oil painting Chairman Mao to Anyuan]. *Dangshi zongheng* [Over the history of the party], 2008, no. 2, 27–33.

Xinhua Shudian. "Xinhua Shudian zongguanlichu shugao baochou zhanxin banfa caoan (1950 nian)" [1950 Draft of the method of remuneration for book manuscripts by Xinhua Bookstore management headquarters]. In Zhou and Li, *Zhongguo banquanshi yanjiu wenxian*, 264–66.

Zhonghua Renmin Gongheguo Wenhuabu. "Guanyu gaige gaochou zhidu de tongzhi" [Notice regarding the reformation of the remuneration system]. In Zhou and Li, *Zhongguo banquanshi yanjiu wenxian*, 328–29.

Zhou Lin and Li Mingshan, eds. *Zhongguo banquanshi yanjiu wenxian* [Collected research documents on Chinese copyright history]. Beijing: Zhongguo fangzheng chubanshe, 1999.

Zhou Yang. "Guanyu zhengce yu yishu: *Tongzhi, ni zoucuo liao lu* xuyan" [On policy and art: Foreword to Tongzhi, ni zoucuo liaolu]. In *Zhou Yang xuba ji* [Forewords and afterwords by Zhou Yang], edited by Miao Junjie and Jiang Yin'an, 64–68. Changsha: Hunan renmin chubanshe, 1985.

Zimmerman, Patricia. *Reel Families: A Social History of Amateur Film*. Bloomington: Indiana University Press, 1995.

about the american film institute

The American Film Institute (AFI) is America's promise to preserve the history of the motion picture, to honor the artists and their work and to educate the next generation of storytellers. AFI provides leadership in film, television and digital media and is dedicated to initiatives that engage the past, the present and the future of the motion picture arts. The *AFI Film Readers Series* is one of the many ways AFI supports the art of the moving image as part of our national activities.

AFI preserves the legacy of America's film heritage through the **AFI Archive**, comprised of rare footage from across the history of the moving image and the ***AFI Catalog of Feature Films***, an authoritative record of American films from 1893 to the present. Both resources are available to the public via AFI's website.

AFI honors the artists and their work through a variety of annual programs and special events, including the **AFI Life Achievement Award**, **AFI Awards** and **AFI's 100 Years ... 100 Movies** television specials. The **AFI Life Achievement Award** has remained the highest honor for a career in film since its inception in 1973; **AFI Awards**, the Institute's almanac for the 21st century, honors the most outstanding motion pictures and television programs of the year; and **AFI's 100 Years ... 100 Movies** television events and movie reference lists have introduced and reintroduced classic American movies to millions of film lovers. And as the largest non-profit exhibitor in the United States, AFI offers film enthusiasts a variety of events throughout the year, including the longest running international film festival in Los Angeles and the largest documentary festival in the U.S., as well as year-round programming at the **AFI Silver Theatre** in the Washington, DC metro area.

AFI educates the next generation of storytellers at its world-renowned **AFI Conservatory**—named the number one film school in the world by *The Hollywood Reporter*—offering a two-year Master of Fine Arts degree in six

filmmaking disciplines: Cinematography, Directing, Editing, Producing, Production Design and Screenwriting.

Step into the spotlight and join other movie and television enthusiasts across the nation in supporting the American Film Institute's mission to preserve, to honor and to educate by becoming a member of AFI today at AFI.com.

Robert S. Birchard
Editor, *AFI Catalog of Feature Films*

index

 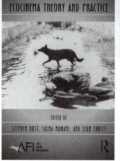